THE CONSECRATION OF GENIUS

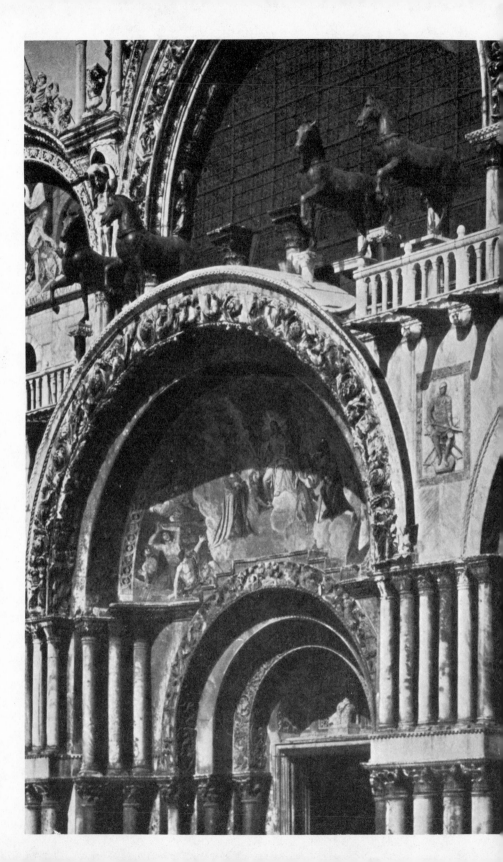

THE CONSECRATION
OF GENIUS

An Essay to elucidate the distinctive significance
and quality of Christian Art and Literature
by analysis and comparison of
certain masterpieces

By

ROBERT SENCOURT

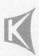

KENNIKAT PRESS
Port Washington, N. Y./London

THE CONSECRATION OF GENIUS

First published in 1947
Reissued in 1970 by Kennikat Press
Library of Congress Catalog Card No: 76-105833
ISBN 0-8046-0978-0

Manufactured by Taylor Publishing Company Dallas, Texas

τοῦτο γὰρ τῷ ὄντι μέγα, οὗ πολλὴ μὲν ἡ ἀναθεώρησις,
δύσκολος δέ, μᾶλλον δ'ἀδύνατος ἡ καταναξάστασις, ἰσχυρὰ
δὲ ἡ μνήμη καὶ δυσεξάλειπτος.

ὅλως δὲ καλὰ νόμιζε ὕψη καὶ ἀληθινὰ τὰ διὰ παντὸς
ἀρέσκοντα καὶ πᾶσιν.

De Sublimitate, VII, 3, 4.

For that is indeed great which long absorbs our
contemplation: it would be difficult, or rather im-
possible, to resist its claim upon us: the memory
holds it firm and will not let it go. For, in general,
that which is truly beautiful and sublime is accepted
in all ages by all kinds of judges.

Regina Colorum Lux.

St. Augustine, *Confessions*, X, 51.

Ciò che non muore e ciò che puo morire
Non è se non splendor di Quella Idea
Che partorisce, amando, il nostro Sire

Chè quella luce che si mea
Dal suo Lucente, che non si disuna
Da lui, ne dal amor che a lor s'intrea.

That which dies not, that also which can die
Is but the splendour of the Idea Supreme
Which amorously our Sire conceives on high

So that the living light which thence doth stream
From His effulgence, from Him never strays,
Nor from their trinal love's uniting gleam.

Dante : Paradiso, XIII, 52–58.

PREFACE

THE aim of this book is to trace the effect of Christian religion upon genius, to develop a theory of beauty and art, and finally to trace the effect of beautiful achievements on religion itself. In other words, it explores the theology which stimulates and inspires the layman. As the theme develops, it claims so to show the inspiring value of the Christian faith as to be an apology for it. In a rather paganized world its interest in culture, its standards, and its arguments are those of the Christian religion.

Bosanquet gave us a history of æsthetics, and Chateaubriand in *Le Génie du Christianisme* pointed out how noble were the fruits of Christian inspiration. This book, however, is humbler; it works on a narrower field: seeing that on Christian culture no book could be exhaustive—while none should be generalized and superficial—it selects certain typical and outstanding examples of uncontested eminence in the history of culture: it so concentrates on these as to reveal even to the specialist a new aspect of each of them; from a comparison of the religious significance of one and another it adds to Bosanquet and Chateaubriand some elucidations of the main tendencies and theories of Christian inspiration.

I have concentrated on certain men or masterpieces generally, if not universally, discussed among cultured people; and in each instance by intense study, not alone through working on authorities, but also by personal observation and experience during wide travel, as well as in years of reflection, I have pursued my subject.

The work is in the frontier regions where divinity, though ruling still, meets and welcomes the powers of literature, of the arts and of history, and speaks an idiom other than her own. Though in ranging over the history of Christian culture no book could be exhaustive, the author hopes he has carried the subject farther than before.

No one can be a specialist on each of the subjects this work treats: and in each case I have referred my book to the judgment of an expert. The late Professor Margoliouth read the chapter on the Song of Songs; the late Professor Collingwood, Mrs. Eugenie Strong and Professor Ashmole read those on the Aphrodite of Cyrene; Dr. Edwyn Bevan read those on Philo, St.

Paul, Plotinus and St. Augustine. Professor Cresswell has read those on Santa Sophia and San Marco. The late Fr. Cuthbert read the one on St. Francis; the late Mr. Laurence Binyon that on Dante; Mr. Ernest Richmond (formerly director of archæology in Jerusalem) that on The Gothic Cathedral; Professor Foligno that on Michelangelo; Dr. Thomas Armstrong, Mr. P. J. Taylor, and the Rev. Illtyd Evans that on Palestrina; Don Alberto Jimenez that on St. John of the Cross and From Venice to Seville; and Mr. Goodhart Rendel that on St. Paul's. The book as a whole has been read by Mr. T. S. Eliot, by Mr. F. J. E. Raby, C.B., Litt.D., F.B.A., by Mr. W. F. Stead, formerly Fellow of Worcester College, the Rev. Gervase Mathew, O.P., and Mr. J. R. Liddell, B.Litt., formerly an assistant at the Bodleian, as well as by other scholars at Oxford. Wherever suggestions and criticisms were made from any of these, they have been gratefully incorporated.

So as to elucidate the arrangement and complete the synthesis, I have attached to each chapter a list of the principal books of reference,[1] and made a summary of the main points of discussion.

I ought to add that the book incorporates several articles contributed to *The Times Literary Supplement*, as well as others to the *Quarterly Review*, the *Nineteenth Century*, the *Fortnightly*, the *Dublin Review*, the *Criterion* and *Blackfriars*.

<div align="right">R. S.</div>

[1] See p. 317.

CONTENTS

THE EXORDIUM

PART I
THE RISE

PART II
THE MEDIEVAL CULMINATION

PART III
THE SPLENDOURS AND DANGERS OF BAROQUE

LIST OF ILLUSTRATIONS

SYNOPSIS

The scope of the book is to define what the highest genius owes to the inspiration of the Christian religion and what, in turn, the life of the Church owes to the triumphant creations of Christian culture.

Genius is itself a kind of inspiration, for it attains the beautiful and sublime stamped by the intermingling
of reason, which gives order;
of passion, which gives the great instinctive forces of love and life;
of imagination, which, linking thought with images, is essential to creation.

All become sublime when linked in the pursuit of beauty. Art completes our relation to nature. But it receives a more definite consecration when dedicated to worship. Worship can indeed have vulgar and unworthy forms; but true religion raises them to the sublime. Since Christianity makes us sharers of the Divine, Faith gives an elevation all its own to reason, passion and imagination.

How does art differ from theology? Art suggests the highest mysteries, theology deals direct with the intellectual scheme of faith.

But this is a realm which requires symbols, and therefore inspires creative genius, and provides it with a theory.

This book will trace the mode of inspiration, and the resultant philosophy of beauty, by concentrating on a number of outstanding examples, taking the first two from those precursors of Christian genius, the Old Testament, and Hellenic culture.

I

THE SONG OF SONGS

1. From the time of Goethe, a number of scholars, Umbreit, Ewald, Delitzsch and Réville, Rothstein and Renan have believed this poem to be a love-drama. They all follow Luis de León. Their theory was completed in 1934 by the work of Jean Guitton.

2. Guitton arranges these love-poems, which may be an anthology, into a drama where the daughters of Jerusalem, in the harem of Solomon, provide a chorus: where the Shulamite is taken into this harem from a peasant lover, where she receives the addresses of the King, and rejects them, and finally returns to her lover.

3. This poem therefore celebrates fidelity to natural attraction: it is ingenuous and chaste, with its own moral lesson.

4. It thus had a value other than symbolic.

5. In rapturous love there is already a mystical quality. The mystics delight in this poem, even before they use it as a symbol.

6. It is one with a sense of the rightness of nature, and this in truth with the sense that God made the world, and saw that it was good, and, as good, the world could be enjoyed.

7. It reveals a supernal meaning, completed in Christianity, with the help of Greek idealism.

II

THE APHRODITE OF CYRENE AS AN INDEX TO THE TEMPER OF HELLAS

1. Philosophy and plastic art the Church owes to Greece, a place of scenery impressive and wild, where tragedy finds a home.

2. Archæology recaptures Greek life, sculpture shows a passion at grips with the ideal, but the Hellenic carvers tell us more of the body than the soul.

3. This Aphrodite shows all their subtlety. It reminds us that behind this was a philosophy as well as a mythology.

4. Sculpture, even in its excellence, has, however, its limitations. It is more suited to the language of the human body than to show the spirituality of a face. In art, there is always an expression of personality.

5. Elegant as this statue is, it shows that the Greeks had to bind themselves with restraint.

6. Plato thought of art as a game, but Aristotle allowed for the energy of reason, and therefore of a creative concept.

7. A gleam of ideal truth beautified the Hellenic mind.

8. But the Greeks had great defects, which, as we see in their colony at Arles, survived even when associated with the majority of Rome. Vitality refined to a spiritual strength is lacking. Greek art decays.

9. Though they taught of an ideal love and beauty, their philosophy was clouded and incomplete. So it continues till the Age of the Antonines; Provence shows the claims of Greece and Rome. Their art has poise, dignity, restraint and calm, but something is lacking—something suggested by a sarcophagus at Arles, inscribed *Pax Eterna*. For Christianity glorified and ennobled humanism.

III

ST. PAUL, WITH CONTRIBUTIONS FROM PHILO AND PLOTINUS

1. It is necessary briefly to examine the contribution of Philo to the Christian theory of art before continuing with a study of a Christian genius. Philo applied by the Greek temper to allegorising the Old Testament into a philosophy. He identifies reason with the creative impulse, and the generation of life with both. This completes the doctrine of the right concept.

2. In concentrating these two ideas in the Logos, he shows that thought is analogous to generation, and art is a creative act combining both.

3. St. Paul, the first great Christian artist, provides genius with something more personal than philosophy, and more vital. He makes man partaker of the highest in a nobler and subtler scheme than was yet offered to man.

4. The new life and light, indeed, were the beauties of charity, and therefore of the riches of God.

5. Although expressed informally and for poor men, it had a subtlety, elasticity and elevation marking an intenser vitality and delicacy of style. This was the spirit of Christ Himself.

6. Paul surpasses criticism: and one cannot appreciate him without admiring. His measure is sublimity, and this in turn permeates and subtilises Platonism. It was the peculiar function of St. Paul to make the Christian faith into a light of reason. He makes grace his exordium of glory, and unites both with the Cross.

7. His life shows him to be a more exciting man, with wider powers and tenderer sympathies. All these gifts are in direct relation to the person of Christ, whom his contemporaries knew.

8. Plotinus shows the Platonic theory of beauty at its finest and most mystical. St. Paul had affected the New Platonists.

9. He insists that its pursuit requires a spiritual discipline and that beauty dwells in spiritual places apart, but his ideas are too vague and abstract to have universal interest or power.

IV

THE *CONFESSIONS* OF ST. AUGUSTINE

1. Yet Plotinus believed in an archetypal world, and imbued Augustine with this teaching.

2. Art and beauty interested Augustine, a man of refined intellect and intense passion, deep in physical experience and idealistic Platonism. But from St. Paul and his gospel he takes something more than these. He refines and strengthens his original subtlety.

3. His, too, is a clearer idea of beauty: a richer and more personal style, while at the same time it attains a more exquisite sublimity.

4. All these it owes to the grace of charity joined with faith and hope, grace which he shared with St. Paul, and this, leading him to the idea of heavenly peace, finds its completion in his essay on the Church as a social ideal, in a book, *The City of God*, which, like the *Confessions*, has captured the layman's imagination.

5. This book, in spite of all its sublety, has a dynamic power, and sums the learning of an age.

6. In its social sense it prepares us for the building with the Christian social purpose: for Christian architecture.

V

SANTA SOPHIA

1. The Christian temple of Santa Sophia surpasses any building of imperial Rome. It has been admired from Procopius to the Elizabethans.

2. It takes the arch from Rome, pendentives from the East; Phillipps claims it as the last word in classic architecture. But it is subtler, more harmonious, more complete and fuller of light.

3. Its light was wonderful both night and day. It took décor from nature and made natural images symbols of the Christian faith.

4. It expresses Constantine's zeal for unity and harmonises Greek and Roman ideals with one another and with Hebrew religion in its inspiration from Wisdom of the Word. It taught the majesty of mercy and the excellence of Divine grace.

5. It ravaged heathen splendours, and framed the imperfect lordship of Justinian.

6. The Moslems disfigured the Christian significance, though bringing in some good ornaments, and keeping it religious, while they chalked over the mosaics.

7. The mosaics outlined the saints of Christ against a blaze of glory and taught the worshipper through glittering pictures, which taught him the story of his religion, and translated the goodness, truth and beauty of Platonic idealism into the light, life and love of Christian mysticism.

VI

RAVENNA AND SAN MARCO DI VENEZIA

1. Ravenna is richer in Byzantine monuments than any other city of its rank.

2. The greatest of these is San Vitale, which celebrated the theme of sacrifice.

3. In Sant Apollinare there is a more delicate sense of natural beauty.

4. 5. But San Marco at Venice has still more beautiful mosaics, and a far finer façade.

6. It owes much to the symbolism and the suggestion of water.

7. And water in time gave the symbol of the fish which it nourished, as it nourished plants.

8. To water, the sight of mountains added idealism. All these suggestions of imagery were dedicated to Christ.

CONCLUSION TO PART I

Pagan art had been beautiful and splendid. What had the Church added? She had taught that art was generation and eternal beauty had an incarnate form. Christ was a much nobler conception than the calm, nude Gods of Hellas. All creation could supply imagery, but nature was always subdued to Christian virtues, though they had the sense of glory, and welcomed the abundance of life. The light was queen of colours and of Nature. Love was personal, passionate, yet imagination was given a finer scope and wider opportunities. Already in the year 1000 the Church's colonies were richer than the empires that had been.

PART II

THE MEDIEVAL CULMINATION

VII

ST. FRANCIS OF ASSISI AND GIOTTO

Through five centuries when the Western Church was united, and when its ruling minds had a firm grip of culture, the masterpieces of an age

impress a sense of huge effort of refined intelligence busy on that return to nature, that discipline of science, and that loyalty to the classics which combined to give the ages of pagan achievement a Renaissance in Christianity.

1. As a suitable contrast to the Oriental sumptuousness of Byzantine architecture, St. Francis of Assisi appears as a figure of spontaneous charity, pure simplicity and charm.

2. His love of poverty and his naïf dramatisation were united with a love of animals.

3. His sufferings and death complete a fascinating and impressive picture.

4. The charms of his personality were one with the mildness and joy of his perfection in the spiritual life.

5. The combination of his personality, his charm, and his love of Nature gave Giotto and Cimabue a new fidelity to nature.

6. This, combined with mysticism and a sense of outward values in Christian Aristotelianism, produced a tension of high genius.

7. Which in turn was inspired by a sense of universal unity.

VIII

THE *DIVINA COMMEDIA*

1. Dante, the poet who sums the Christian mind of the age, combined religion with an exact care for technique.

2. He saw in events four significances: historic, allegorical, moral, and anagogical.

3. He found in Aquinas a universal guide to knowledge.

4. In Catholic philosophy the temporal is real, but reveals the invisible and eternal.

5. Catholic thought is a Christianised humanism.

6. The power of the *Inferno* makes it great as literature.

7. Dante reduces sin to an ordered scheme, and makes it part of a universe governed by God Almighty.

8. He leads through Purgatory to Paradise by control of the imagery of light and fire.

9. His sublimity is upborne by hard judgment and sinewy strength.

10. The secret of the Universe was accordance with the will of God.

11. This prevents his love ever losing itself in vagueness.

12. The secrets of his success as a religious poet, therefore, are highly complex, making a simultaneous appeal on many different scales of taste and feeling.

13. His soul was in communion with a truth more profound than the vital conception of his style.

14. By music, beauty and surprise, he leads reason, passion and imagination into the world of timeless being.

IX

THE GOTHIC CATHEDRAL

1. The same care for technique with the same spiritual vigour explains the Gothic cathedral.

2. It resolves conflict into harmony.

3. Originating around Paris, it spread to the north, and mastered new gorgeousness.

4. Like Dante, it incorporated mundane interests.

5. Its temper was not humanistic, but savage, kindred to forest and flame.

6. But these affinities it ordered for its purpose of worship.

7. Originally narrow, it broadened in the south of France to suit a more intelligent temper, and so leads on to humanism and baroque.

8. Its windows tempered the light and made it significant till they add to the impression of fire.

9. These windows are best studied at Chartres.

10. In general their beauty, though intense, is also rather fierce.

11. It softens in Florence, but little survives to show this temper of stained glass, which, however, does show that the Thomist conception was losing its grip.

X

TUSCANY'S CONTINUOUS RENAISSANCE

It is imperative to realise that in that age of Christian genius, culture in Italy was a continuous progress.

1. The thirteenth century was the crown of Christian achievement in a Renaissance. The succeeding century was Christian, but not marked by supreme things. In the fifteenth century the humanism broadened.

2. In Florence we can trace a continuous Renaissance through these centuries. Bonaiuti paints forty years after the death of Dante ; the Pope returns in 1377 to Rome, and from then on Florence develops a succession of geniuses.

3. Of these the most religious is Fra Angelico, whose spirituality is intense, while the genius of Van Eyck moves from idealism to solid fleshiness.

4. The spirituality of Fra Angelico is paralleled in the revived Plotinianism of Ficino.

5. In the sixteenth century this movement of general Renaissance is consummated by a great outpouring of genius: in the north in Shakespeare, it returns to the paganism of Greece, but in the Mediterranean brought a Christian triumph, which is the final expression of the Middle Ages, culminating in Raphael and Michelangelo.

XI

THE SISTINE MADONNA

1. This, though marred by reproductions, is, as has been recognised through the centuries, a picture of incomparable grandeur.

2. It is rich in great ideas. It is perfect in technique: it is a superb composition. It combines great variety with a new unity instinct with new delightfulness, yet not without poignancy.

3. The theme of the Mother and Child is perfectly adapted to beauty.

4. Raphael painted it after a course of study.

5. The Stanze in the Vatican show how, gaining in power with years, he had become bold and majestic.

6. His Madonna is pictured with elaboration to show the spiritual prerogatives of Mary.

7. But the main emphasis is on the Child.

8. He combines the gifts and art of a great succession of painters.

9. His majesty is combined with an elaborate and diverse expressiveness.

10. Yet it owes its grandeur to religious inspiration; his mind was ennobled by the dignity of the Church.

XII

MICHELANGELO

1. In the travail of Michelangelo we are reminded that we must both think and feel.

2. Taking up the idea of form from Plato and Aristotle, he translates the traditional philosophy of idealism; the word concept is associated with intuition into the idea or intention of the Divine mind.

3. The artist's mind has come from the eternal world, and can give nature an ideal beauty.

4. Michelangelo continues to be absorbing, just as Donne does, and for similar reasons.

5. But Michelangelo had a much intenser sense of the ideal quality of love, and wrote nothing in praise of its carnalities.

6. The power which mastered his skill and his philosophy was the Christian religion.

7. Yet he had plumbed the depths of tragedy, and therefore knew the meaning of suffering.

8. It was from grief that he learnt that love is eternal.

9. It was the Church and the Bible that dominated the vast range of his conception.

10. His supreme achievement was St. Peter's, and as a sonnet shows the supreme impulsion of his genius was the love of Christ and his Cross.

CONCLUSION TO PART II

The eleventh century begins a Renaissance founded on a return to nature and the classics. St. Francis taught men to love creation, St. Dominic made faith more intelligent. The influence of both of these on reason and passion combined with the highest poetic imagination in Dante:

while science formed from passion and imagination the enginery of the Gothic Cathedral.

Italy maintained through the succeeding centuries a continuous Renaissance in which faith continued to control reason, passion, and imagination, but even while it triumphed, the struggle entered a sublimer phase.

Both Dante and Michelangelo define more precisely the ideas of beauty and the creative concept.

PART III

THE SPLENDOURS AND DANGERS OF BAROQUE`

After these triumphs of the long Renaissance of the Middle Ages, we pass out into a new period where Christian genius is at war with the wealth and splendour of life, and where passion struggles to master reason and imagination. This is the baroque period.

XIII

TWO PASSIONATE POETS

1. Spenser is the Poet's Poet.

2. Although many of his sources are classical, yet even his love poems show the refining influence of Christianity.

3. When he speaks of Christ directly, we see something tenderer and purer than we expect from the Elizabethan age.

4. Luis de León had a far more powerful and poignant religion, working on a stronger temperament and mind to create stronger poetry.

5. And as St. John of the Cross is a far deeper mystic, so he is intenser as a poet; by direct religious experience his view of religion ennobles his vision of nature and therefore his poetry.

6. It is his mystical theology that ennobles his whole being, and so shows new splendour in nature as well as in man.

7. By having a spiritual longing exceeding that of other lovers and by expressing it with great power of technique in his poetry of love, he illumined poetry with brilliant lights.

XIV

PALESTRINA

1. It took 1500 years of Christianity so to free music from suspicion as to give it scope for sublimity.

2. Music has a unique and mysterious power over us.

3. Palestrina displayed this power superbly and joined it to suitable words.

4. He insisted that for solemn words there should be a uniquely lofty music, yet into this he infuses emotion.

5. With him passion enriched music while religion chastened and ennobled it.

6. This he specially exemplifies in the Mass of Pope Marcellus.

7. The Mass offers musicians a unique opportunity.

8. In counterpoint Palestrina combines chaste with rich effects.

9. He gave music pathos, solemnity and grandeur.

10. And this because he combines with the Oratorians in the Counter Reformation.

11. His combination of artistic power with piety shows the splendid possibilities of the baroque age and explains his success.

XV

FROM VENICE TO SEVILLE

1. The new sense of amplitude in the world fascinated such painters as Titian and Veronese ; but though their chief interest was in gorgeousness, they yet acknowledged the Christian faith as supreme. We can see this in certain outstanding examples: Titian's *Presentation of the Virgin*, and Tintoretto's *Feast in the House of Levi*. At this juncture painting became more objective, less idealistic.

2. Velazquez subjects painting to the eye, and is a painter of truth. Could this unconsecrated sincerity serve religion?

3. Perhaps El Greco will give the answer. There was religion in his *St. Maurice*, but in the *Conde de Orgaz* he gave a picture of the soul of Spain, and showed it serene in the face of death. But his troubled temperament disturbs his painting of women, of nudes and of saints. He understood the mystics without attaining their strength in faith.

4. Murillo, the Sevillian, is a happier spirit, mystical yet easily understood, the Bunyan of Spanish painting.

5. But though his Madonnas are marred by a touch of the theatrical, he was inspired by the dogma of the Immaculate Conception to see how people could be saintly though warmly human. His finest paintings are both ethereal and strong.

6. But the peculiar master of Andalusia is Montañés, whose polychrome statuary is on the supreme scale: his masterpeice the *Jesus of Great Power*.

7. But were these men able to subdue the world to religion? Which at this period produces the greater work: pagan interests or the saints?

XVI

MILTON

1. He was, though a Bible Puritan, an exponent of the Italian Renaissance in its pagan phase.

2. He had a Roman majesty and is a counterpart to Bernini, who, like Michelangelo, subjected his materials to power in a religious spirit. This makes him sublime.

3. But Milton cared more for religious names than for the supremacy of spirit.

4. The baroque age of Milton is replete with complications and reactions, yet has its own recognisable temper as an age.

5. Milton was sensuous and passionate, though not ignorant of the joys of contemplation. But imagination was an end in itself: it was not, as with St. John of the Cross, the servant of mysticism. Therefore Milton's Paradise was distinctly tangible and earthly.

6. His work seems less like truth than a fable: he was not interested in religion as Bernini was. Satan dominates him. He glorifies Satan. Even Christ is pale beside the gorgeousness of Satan.

7. Most fantastic of all, Milton makes the temptation on the Mount the drama of redemption. He therefore eliminates the Passion and Resurrection.

8. Like Satan, he was himself a rebel, a personification of pride against discipline and orthodoxy.

9. With culture escaping from faith, imagination from worship and piety from the Church, were not religious masterpieces coming to an end?

XVII

BUNYAN

1. Bunyan, homely, virtuous and shrewd, was a sincere Christian.

2. Modelled on the Bible, his allegory had the fancy and charm and vividness of a morality.

3. He was an ardent mystic, one in religious experience with Christ.

4. But his mysticism had certain limitations and exclusiveness. If Murillo was sometimes too sentimental, Bunyan was, with his strength, sometimes too crude.

5. Schism was threatening the supremacy of Christian art, even if Bunyan had many catholic excellences.

6. The Pilgrim's Progress is very practical; in it the most exquisite beauties, as in the Paradiso, go with ruthless assaults at spinelessness in religion. When religion slackens, when men cling weakly to God, imagination will suffer as much as the individual's moral life. Through Bunyan can be discerned disquieting signs, at variance with the Christian mysticism, which gives him loftiness and strength.

XVIII

ST. PAUL'S CATHEDRAL

1. Wren was " as a boy a prodigy, as a man a miracle."

2. As an architect, he came full into the Palladian tradition, the architecture of humanism.

3. It brought him under the influence of women and of Bernini. St. Paul's is modelled on St. Peter's.

4. The age of Louis XIV aimed by all means at superb effects characteristic of the baroque age.

5. Wren was himself a baroque artist.

6. He made several designs for St. Paul's, but kept his sense of unity through many disappointments, and it maintains central in London the tradition of Roman order.

7. His patience, which survived many disappointments for making St. Paul's more impressive, is one with the compromise and mildness of the British character, and at the same time shows its scientific thoroughness.

8. The superb effect of façade and dome is hardly sustained within St. Paul's, where there is a lack of spiritual glory, and this, too, points to the fact that the most alert and powerful minds were gradually ceasing to be Christian.

XIX

PASCAL AND BOSSUET

1. In Descartes we find an example of a disintegration of Catholic philosophy which was more disturbing than schism, and cut intellect from the supremacy of revealed truth.

2. Even mysticism was assailed by quietism: but piety still produces two great religious writers, Pascal and Bossuet.

3. Pascal, a scientist, beautifully expresses the value of personal piety and holiness against both paganism and worldliness.

4. While Pascal, intense and personal, looks to a future of individual survivals of holiness, Bossuet—reintegrating and refining the Christian philosophy of art—sees the prerogatives and dignity of men as gifts and invitations of God. In him Catholic ideas of genius reach their consummation.

5. He saw men as temples of God's grace and glory.

6. And this enabled him to give a splendid interpretation to individual lives.

7. His style itself shows the magnificence of his concepts.

8. And his depth of wisdom is equal to his style. He combines reason with sympathy, and loftiness with both.

9. Yet he is not an angel of the Church triumphant. He saw paganism gaining the world of culture. From his time on, religion saw its splendour less in the world than in eternity. Theology no longer reigned, but, like an exiled sovereign, gathered the faithful around her in a diminished court.

XX

CONCLUSION

1. The artist is spiritual.

2. He has the inner secret of ethics and theology.

3. He unites a sacred exhilaration with scenes and events.

4. Fine art aims at perfection, and delights in the forms and laws of creation. Its constituents in reason, passion and imagination relate it to the

Trinity in Unity ; this relation gives the believing artist a more immediate inspiration through faith, hope and love. Grace refines and elevates genius not only because it exhibits nature in relation to redemption but because it transforms the human heart. At the same time in the generation of the Word, it gives a Divine example to the imagination and to the creative concept ; and, in the gift of the Holy Spirit, in a supernatural clearness to the idea of inspiration.

5. Since art refines the imagination and aspires to the ideal, it purifies the more concrete religion by idealistic philosophy. It keeps religion close to the life of the heart: it celebrates the grandeur of creation. It makes the senses minister to worship: it envisages a primal artist. It interprets truth individually, yet makes religion social and liturgical. It bridges time: it conserves treasures of ardour and holiness. It enforced the doctrine of the Incarnation, and therefore the doctrine of grace.

6. If art is the bloom of faith, what has the Church given to art? She sees nature as the art, and expression of God. Her doctrine identifies wisdom and generation. Her beauty is the love of Christ, and she draws men towards the Unseen. She makes a reality of peace, and therefore makes new harmonies which are more sumptuous. Her spirituality exalts passion.

7. In the thirteenth century Christian genius fought hard to maintain order against savagery and vice. If it had joy, it had it through spiritual strenuousness. The artist worked with intensity against scandal, and so attained peace on the heights.

8. The new achievement did not maintain its flood, but in the fifteenth century had to engage against natural vitality, and passion's control of imagination. In the south it succeeded, not in the north, where Descartes completed what Ockham had begun, while the Mediterranean's spiritual life was also enervated.

9. For this change no Church was prepared. In spite of some triumphs, there were proofs of disintegration; and when mysticism survived it was in music or in wild nature, and Christianity no longer dominated civilization. Has its reign ceased?

The past shows how slow and rare were Christian triumphs, and at what cost they were attained: mysticism must be strong enough to sway gigantic energies before religious inspiration is triumphant.

10. In the centuries of her triumph, the Church assimilated great impulses of vitality to her ideas of order and love. Such ideas, surviving, are particularly valuable to spiritualise science and invention, and improve the successes of material progress not only in human charity, but in communion with the energy of nature.

Man's nature responds to vibration, and imagination suggests an etheric element in man; love is the secret of his life: he lives in a series of magnetic attractions. Once the Church dominates these, we may well see a new consecration of the noblest genius.

I

DOES culture at its finest and highest owe anything particular to Christianity? If the supreme creations of genius are Christian, are they different in splendour or significance from other supreme creations of genius? Such questions can be answered only when we define the scope of creative genius.

Gifted men in pursuit of grandeur and beauty in the course of ages have invented the arts of music, sculpture, painting, architecture, and, with their literature, the art of words. These arts are generally studied separately, but in reality they are always reacting on one another. Their finest examples have continued mutually to give, and to receive, the intercourse of life. Like the enterprise which Ulysses recommended to Agamemnon, they inevitably become *"l'éternel entretien des siècles à venir"*.[1] And, indeed, as different people have studied and enjoyed them, in the course of ages, the very character of their grandeur has taken on a different shape and colour, and its eminence has been more or less significant, like that of a towered hill seen from different points of vantage, with different backgrounds of cloud and light. Let us now study them together, and compare them with one another; though their expression and their stature alter, masterpieces are the children of one royal race, offspring of the sons of the gods who intermarried with the daughters of men. They all remind us how, in the keenest life, man's mind is impregnated with something loftier than itself: in an intermingling of reason, passion, and imagination, it attains to the beautiful and sublime. Each of these answers to religious inspiration. Let us see how.

II

If art witnesses one fact more than another, it is that the mind is lord and master. It is the stamp of reason which gives art its specific nature, whatever the medium of expression. Vital, dynamic, splendidly luminous, reason is the expression and the intellectual measure of order. It sees into the secret of the latent order of the world, and imitates that order in its own pattern or arrangement: it gives a co-ordination, a sequence, a

rhythm which mingle sameness with variety: it can think its way, and at times fly with an intuitive swiftness into the sublime unity of the universe, even while it is paying the most alert attention to common and perhaps incongruous things. In literature and the other arts, beauty is dependent on the sense of pattern of which the essence is still rhythm, of returns after variations, which keep our feelings strong and sensitive. This pattern means in pictures or sculpture a sense of balance: in prose and poetry, as in music and dancing, a regularity of exercise where again certain movements or cadences return, while others vary. In novels it is the combination of incidents arranged in plot with something accurate and high in character and feeling, and often with a background of pleasure in nature or circumstance. Everywhere alike in art it needs—and therefore it exemplifies—the rule of a governing intelligence, vitalized and deeply moved. Everywhere it is an arrangement, and therefore a simplification, of the complexity of life.[2] But it is still a choice of things that please or move us, things also to admire, and everywhere alike it will first surprise us by its freshness, as later it will haunt us by its poignant suggestion of a profound but elusive and rare significance. It holds communion with truth, truth not merely as known by discourse and reason, but as the reality apprehended by man's whole nature and, above all, his spirit.

> Reason has moons, but moons not hers
> Are mirror'd in her sea,
> Confounding her astronomers,
> But oh! delighting me.[3]

It makes use, therefore, of our feelings. "Deep thinking", said Coleridge in fact, "is only attainable by a man of deep feeling." [4]

It is when feeling burns with the fire lit by nature's power within us that we experience passion. Passion is the responsiveness of our nature to the intense magnetism and forces of the one life within us and abroad. Its cravings are desire: its fulfilment is joy. Though reason can criticize and control it, it directs all motion and becomes its soul. Rivers, said Pascal, are roads which move and carry us to our journey's end.[5] So is it with passion. Launch out upon its stream, and you will be carried forward not merely in even flow, or in quiet reaches, but by the roar of cataract and the full urgency of flood. It may or may not burst its banks; but it has always its own instinct for the deep, universal laws of life which reason surveys: it

feels them in single scenes and events and characters which it endues with the force and poignancy of those inter-reactions of body and soul which are the result of deep love, a love which strengthens all the forces of life until its final issues are involved in a look or word. "Nothing", said Bunyan, "can stop the current of desires; if they be strong they carry all away with them." [6] This is true not alone of the intercourse of love and friendship. It involves our every relation with nature as well as flesh and blood.

> . . . the array
> Of art and circumstance and visible love
> Is mainly to the presence of the mind
> What passion makes them; though meanwhile the forms
> Of nature have a passion in themselves
> That intermingles with those works of man
> To which she summons him. [7]

The mind, when reacting to its fullest powers, sees much that is outside itself; at the highest moments the mind believes the whole universe linked together by love, and one in an act of excitement, joy and knowledge with its own perceiving faculty. It is so that the highest minds *conceive* their most vital thoughts and images. They are wedded to these objects of their interest in love and holy passion to generate their thinking and their style.

But reason and passion cannot become creative till they combine to image forth what they have known. What is poetry itself which "lifts the veil from the hidden beauty of the world" but "the expression of the *imagination*"? [8] "Imagination", wrote Vauvenargues, "is the inventor of the arts and the ornament of wit. It speaks to our senses, because it is the gift of conceiving things in the guise of figures, of expressing thought in images. And so it is of all man's powers the most directly creative. As passion applies to the spirit the profoundest instincts of natural life: as reason adds to observation the power of reflection or the insight of intuition, so it is imagination which shows how in that middle world of sense and spirit, of unseen thought and ordered matter, man can interpret and arrange. Linking sensation with ideas, he can either form the outward world to his pleasure, or arrange his experience of it to show his spiritual power." [9] In this faculty of imagination, therefore, we find our analogy to the creation of the universe. The order of a unified variety is stamped on formlessness, both in the universe of

nature and in what Stevenson calls a work of human art. Nature, as Sir Thomas Browne said in other words, is the art of God.[10] So imagination is a splendid extension of the faculty of reason. It is not merely creative in the realm of perceivable things; but it is also a reaching out to the things unseen from which passion draws an ideal power. It is therefore the power which gives experience its ability to build an ideal world, rich in suggestion of that which heart and soul crave, and yet at the same time it gives a sense of the closeness of the actual world, the world we feel that we know intimately.

But since it does this in exercising and entertaining reason, imagination is one with our sense of order. When it is refined by taste and shows in style its power over its materials, it creates an excellence which is delightful, so that we can enjoy it spontaneously, as we drink in the notes of a bird's song, without effort and without science. The claim of this excellence on our attention is as sweet and natural as the voice of a lark : a voice rich with the charm of spontaneity, and insistent on its charm. "Fret not after knowledge", it urges,

> O fret not after knowledge. I have none
> And yet my song comes native with the warmth.
> O fret not after knowledge. I have none
> And yet the evening listens.[11]

When this naïf amusement, deepening into intuitive communion, awakens vital feelings of excellence and delight, then we find that we are face to face with beauty. "Wherever there are thought, imagination, energy," said Landor, "grace inevitably follows." [12] It conveys to us a longing for, and in a sense an attainment of perfection. Beauty, therefore, is the delightful resplendence of a mysterious excellence, which calls to the soul with a penetrating and persuasive voice, and makes it long for what it enjoys, and enjoy what is longed for, and all in perfecting and strengthening the sense of order. For communion with beauty means the setting of the will to a state of receptivity, as well as providing play or exercise for the mind. As we enjoy beautiful things, especially if their beauty is on a grand scale, we find that we have been raised also to a spiritual life, having lifted up our hearts and minds towards a heavenly region. And if we are not disobedient to the visions then seen, we are changed into images of their glory.

None of the arts, therefore, not even literature, can be

finally explored till we see how they reach out into the spiritual life. "All truth", as Coleridge said, "has the nature of inspiration." [13] "Nature", we are told by the first great writer on the Sublime, "determined man to be no low nor ignoble animal; but introducing us into life and into the entire universe as into some vast assemblage to be spectators, in a sort, of her contests, and most ardent competitors therein, did implant in our souls an invincible and eternal love of that which is great and by our standard more divine." [14]

It is art which completes our relation to the living images of nature. These in themselves are beautiful, for each tells the laws of its own life and breathes the presence of a creative power. The beauty of the star-shaped shadow of the mountain daisy thrown on the smooth surface of the naked stone, and the flower which unfolds its velvet petals against the crannied wall tell of hidden subtleties of design. Each bloom is arrayed in rich, surprising, baffling intricacies of colour, texture, and composition, and each suggests, as the grand scenes of nature urge, that it is "pregnant with religion and poetry".[15] But created things receive a fuller hallowing when they are made the theme of adoration, or when they are themselves invited to magnify their Creator. Their value to the imagination is heightened to something more. There is some light from moon and stars when they are dimmed by floating vapours, but that splendour of the Divine which shines in us always as we contemplate beauty is revealed to faith and worship with that intensity with which the full moon shines out of bare heavens through the dry air of the wilderness of Sinai.

And so a creative artist can give an added consecration to his genius when he celebrates the themes of worship; for it is when admiration loses itself in worship that it comes to its final end.

Unfortunately, worship is not always a work of art. It can stultify reason, passion, and imagination in playing with the tawdry. Its intellectual scheme can be crude, its adjuncts bare. It is more often homely than sublime. But at its finest it means a heart on fire: it looks beyond, longing for more than earth offers: it becomes conscious that even words do best when they are neither precise nor final, but are, in Stevenson's phrase, full of "elegant and pregnant implication".[16] The Church of Christ makes its members "partakers of the Divine nature" [17] by a grace which gives them an inclination to the highest: therefore they must transcend the best they can conceive. If

their religion is sincere, it must be high and pure; and, being so, sublime and beautiful.

True religion, therefore, makes that spontaneous choice of the finest associations convenient, which is taste: such a choice is akin to contemplation. Taste chooses an atmosphere congenial to the sublimity of revelation: while that, in its turn, gives an ampler ether than taste alone could give. A creative genius is always ennobled by a constant ascription of its gifts to the Divine glory, for this makes a greater claim on worship, and therefore on admiration, than the symbols and images of the exterior world. The relation of the creative genius to faith, therefore, is not only a special department of criticism. It throws an intenser light on the source, and on the object, of artistic creation. Faith gives an elevation all its own to reason, passion, and imagination.

Where, then, does creative genius merge into worship, and where are they distinct? Where is the artist working with the Saint, and where apart from him?

Expressions of good taste and fine imaginative creations made in the pursuit of beauty do not, of course, speak direct to conscience or to faith. Compact of love and thought and joy, if they are vital, they move us—as religious music does—through charm.

> Charm is the glory which makes
> Song of the poet divine.
> Love is the fountain of charm.[18]

By opening hidden springs of emotion, they keep suggesting excellence; for through the most elegant of human associations, they look on what is before and after them. They kindle a desire to pierce, if not the secrets of the universe, at least the urgent mysteries of life and love: they seem to fulfil this desire by amusing us for a time with some new aspect of this pleasing, anxious being of ours: but they never quite fulfil it: they tantalize us with the sense that they are something afar. If we can lay hold of the vanishing excellence and make it ours, then our joy in it is that contemplation which is akin to the mystical communion of the Saint.

The Saint, for his part, has little interest in the science of beauty which we call æsthetics: the beauty in which he worships is that of holiness. Faith treats direct of things that lift the heart towards heaven: it has an intellectual scheme all its own; but since the worshipper identifies creation with his praise:

since he rises from symbols to reality, from shadows to the day: since beautiful words are a lantern to his mind: since the light he seeks is often as fugitive and shy as it is gracious; and since he cannot love God unless he has loved men, the true believer has an intense interest in the created world. When he speaks of it, or portrays it, he too, in the limits of his technique, will be a creative artist.

Religious art shares with secular art a wide region which for art's sake interests lovers of art, even if they are quite devoid of interest in the intellectual scheme of the believer, or are even definitely hostile to it.

III

Since art has upon it the stamp of an individual mind, the beauty of the work of great creators who were profoundly Christian should have an artistic quality, and an intellectual significance peculiar to itself. It has certain forces of excellence which are connected with a definite artistic or, as we say, æsthetic doctrine, just as it implies, because it springs from, the belief and worship of the Church. We shall trace these in the art of building, but also in sculpture which, in reproducing the human form in marble, tells its own story of the passions; we shall trace it again in painting, where colour replaces relief in its appeal to the eye and taste. But it speaks also in poetry, and in the prose of literature, where words have their own music and share the pattern of sound with music, and can at the same time suggest an image (though perhaps more often the feeling of an image), while spontaneously they address themselves to the order of thought. It is not by attempting a connected history, but by attentive study of particular examples, that we can best trace the ideas inspiring them.

In the realms alike of worship and of culture we shall find men who were gifted with the most eminent powers of imagination, so as to create masterpieces instinct with passion and beauty, and marked with the double order of reason, so as to convey through the patterned representation the sense of universal law—we shall consider these men giving over their genius to celebrating the mysteries of the faith. We shall see how, in their pursuit of sublimity and beauty, in their search for an ideal significance in these delightful things, they set out religion in the imagery of works or art;—either, being saints

themselves, they saw a fresh way to the understanding of beauty through their religion and spoke of its relation to holiness, or else, being creative artists, they found their inspiration in the lives and writings and souls of the Saints. As we survey them we shall begin to understand in what sense, and with what results, their genius was inspired; what was their philosophy of beauty in itself; what in their view was the scope of creative genius; and finally what this suggests in the history of the arts and literature.

And so, taking such works of art, or such men of genius as are generally admitted to be of outstanding excellence, we shall trace the particular significance of a strongly conscious Christianity which was intent on building or painting or carving or writing poetry or prose. In doing so, we shall approach precision as to the nature and theory of Christian art. These are questions of no small importance for criticism. They provide a problem hardly short of fundamental for the cultured believer; they are not to be escaped by the cultured unbeliever. As we have seen, they involve the very question of what the fine arts, with literature, are and what they ought to be.

Even in the present day, when there is a sort of disinclination for doing, or for discovering, anything on the grand scale, and when men are more inclined to be touched by what happens in the alley or the tavern than by their worship in the temple, they yet, like the exiles from Eden, crave that which they refuse to seek. Their feeling is that of Adam leaving Paradise:

> I now
> Gladly behold though but his utmost skirts
> Of glory, and far off his steps adore.[19]

We shall not understand this output of outstanding genius in the service of the Church until we take some cognizance both of their idea of inspiration as shown in the literature they venerated as sacred, and also of those theories and examples of beauty which they inherited from the culture of the ancients in which they found the fountain both of their arts and of their philosophy. And then we shall trace the development of sublimity through two masters of the art of prose to masterpieces of architecture, decorated with mosaics, till we can see how art was endued with magnificence: either when it was absorbed in dominion and power, or when it passed from kings' palaces to the fruitfulness of nature. In this way we shall see how consecrated genius becomes the sultan of a special empire.

The whole of the Hebrew classics is dominated by the faith that in the beginning God made the heavens and the earth, and saw that they were good; furthermore, they were made for the service and frame of man. The things that God had made were an invitation to praise Him: His law set a course for the sun as well as for the heart and soul;[20] and through this law of worship of the one Creator the gateway was open both to acceptance of the world as God had made it, and also to a spiritual joy in nature. These were the themes of David:

> He sang of God—the mighty Source
> Of all things, the stupendous force
> On which all strength depends;
> From whose right arm, beneath whose eyes
> All period, power, and enterprise
> Commences, reigns, and ends.[21]

But that is not all: the adoring poet can go on to write:

> Use all thy passions: Love is Thine,
> And joy, and jealousy divine.

There is even in the Canon of the Old Testament a fervent celebration of natural passion. The one great love poem of the Israelites they placed as sacred in their Scriptures. Let us see why. For until we have understood that, we cannot understand how passion and imagination gave genius in Christendom a proper scope. And then, too, we shall see hat passion in this high poetic sense must no more be confused with animality than imagination with deceit or reason with a shallow intellectualism. For these words must be taken in their highest ranges in the significance in which they have been now explained. Passion in that sense is rather what Dante called *amore*; the principle of attraction, and imagination, the faculty of expressing and therefore creating beauty.

INTRODUCTION

[1] Racine, *Iphigénie*, Act I, sc. v.

[2] "The simplicity of art allows us to take our way more surely among the complexities of life."—Ramiro de Maeztu.

[3] R. Hodgson, *Poems*.

[4] Coleridge, Letter to Poole, March 23, 1801.

[5] Pascal, *Pensées*, I, 17.

[6] Bunyan, *Works* (1852 edn.), Vol. I, p. 751.

[7] Wordsworth, *Prelude*, Book xiii, 287–293.

[8] Cf. Shelley, *Defence of Poesy*, "A poem is the very image of life expressed in its eternal truth".

[9] Vauvenargues, *De l'Esprit Humain* (edn. of 1929), Vol. I, p. 12.

[10] Sir Thomas Browne, *Religio Medici*, Sec. 14.
 To raise so beauteous a structure as the world,
 and the creatures thereof was but his art.
[11] Keats, *Letters*, No. 48, to Sir J. H. Reynolds, Feb. 19, 1918.
[12] Landor, *Imaginary Conversations*, Vol. 5, p. 286 (edn. G. E. Welby).
[13] Coleridge, Letter to Poole, March 23, 1801.
[14] Longinus, *De Sublimitate*, xxxv.
[15] Gray, *Letters*, Vol. I, p. 44 (1900).
[16] Stevenson, *Essay on Style*.
[17] II St. Peter I, 4.
[18] Matthew Arnold, *Heine's Grave*.
[19] Milton, *Paradise Lost*, XI, 331-333.
[20] Christopher Smart, *A Song to David*.
[21] The reference is to Psalm XIX, *caeli enarrant*.

I

THE Song of Songs is a poem indeed, as Milton believed a poem ought to be, "simple, sensuous, and passionate". [1] It is such pure poetry that it lifts the imagination on viewless wings, and through the ages its verses have been the classical language of virginal ardours of the soul: yet, taken in themselves, its words, alone of all the books of the Bible, say nothing of moral or spiritual things,[2] and it is when the descent is made from poetic rapture to analytic observation, from the flights in realms of beauty to what in comparison is but the dullness of the brain, that there is much in this rapturous song that both perplexes and retards.

Even as an epithalamium, it is an enigma. And though its phrases are indeed as simple as they are sensuous, and follow at times in flowing sequences, and though the Hebrew, by its clear distinction between the genders, makes it clear when a man is speaking and when a woman, and that there is therefore an exchange of speeches, the piece cannot easily be explained simply as a lyrical dialogue, nor yet as a collection of lyrics, as Goethe believed it to be when he translated it into German.[3] In his later life he accepted the suggestion of the German scholar, Umbreit, who had urged that there were at least three speakers.[4] In fact, he finally believed the poem to be a lyrical drama.

The contention that the Song of Songs was a romantic drama was, however, brought prominently forward two hundred years before it was worked out by Goethe. A Spanish scholar, priest and poet, Luis de León, Professor at the University of Salamanca, and an Augustinian Canon, made a beautiful verse translation of it; in the preface to this he wrote it was indeed a living sketch of the charm and joy of a love story, which began and continues between bride and bridegroom until the wedding-day when the seals are affixed: [5] in other words, it is a pastoral dialogue in which two lovers, bridegroom and bride in the guise of shepherd and shepherdess, speak to one another, answering in turn.[6] He puts in a chorus of attendant ladies, and assigns a part of the drama to Solomon, but he does not introduce Solomon as an actor. The idea that the theme of the poem was the fidelity of a shepherdess to her shepherd, in spite of the advances of a great king whom she rejects, this is the special work of a scholar of our own time.

Its essence, he wrote, is this: a young and beautiful shepherdess, to whom her brothers have committed the watch over a vineyard, is carried away and led into Solomon's harem. The King loves the beautiful shepherdess and wishes to make her the first among his queens. But the girl has already vowed her love, among the fields in which she was born, to a young shepherd. It is with him that she remains in her vigils and her dreams, and her beloved also aims at finding her. This is the thesis, afterwards supported by Ewald,[7] to which a French scholar, M. Guitton, has returned, and which, with acute scholarship and much ingenuity, he maintains with support from our Oxford orientalists, the late Dr. Driver and Professor Margoliouth, against Budde and Professor Wheeler Robinson.[8] M. Guitton recognizes that Delitzsch had analysed it as an epithalamium, but he ignores not only the fine work in which Albert Réville, writing in the *Revue de Théologie* of Strassburg in 1869, almost approached his own arrangement, he ignores also the support of Rothstein and of Cannon.[9]

According to M. Guitton, the poem, with its bold opening: "Let him kiss me with the kisses of his mouth",[10] begins with the young shepherdess already in the harem of a palace of Solomon on the hillside of the Lebanon, and finds her in company with those other and more sophisticated inmates of the harem, whom she addresses as "the daughters of Jerusalem". She explains that if her comeliness was of a darker tint than theirs, it was because she had been sunburnt in the vineyard; and while she is answering, as best in her simplicity she could, their teasing and rather ironic compliments, the King enters and greets her with flattering comparisons. These begin at the ninth verse of the first chapter, and bring another tone into the poem.

In the voice of the royal lover there are notes of luxury and sumptuousness of which we have heard nothing in the impulsive confessions of the shepherdess; there are references to chariots and jewellery in his opening phrase. But they have no interest for the young bride, and after a short exchange of talk, he leaves her with the daughters of Jerusalem, to whom she voices her amorous longings in words as frank as her opening-cry for kisses, but more elaborate: "He brought me into the banqueting-house and his banner over me was love: stay me with flagons, comfort me with apples, for I am sick with love. Let his left hand be under my head, and his right hand enfold me."

Quia amore langueo. The swooning cry of the amorous bride, her warning to her companions not to excite love (for in this sentence M. Guitton follows the Septuagint against the Vulgate and the Authorized Version) before it has itself awoken, brings her young bridegroom near. She hears a cry. "It is the voice of my beloved," she answers, "leaping upon the hills; he is looking at me through the lattice [or trellis]," and he summons her forth in the voice of spring to rejoice with the budding flowers, the singing birds, and the voice of the turtle.

A verse follows: "Take us the foxes, the little foxes". M. Guitton puts it into the mouth of the bride: it might as well have come from the lips of the women of the harem, or the bridegroom's own; but the bride answers with her personal directness: "My beloved is mine and I am his". She cannot yet come freely to him, however, and he withdraws, while she falls again into the blissful reveries which she exchanges with the daughters of Jerusalem, culminating in the refrain: Do not excite love before it has itself awoken.

We are now at the sixth verse of the third chapter. Again the tone of luxury is heard: "Who is this that cometh out of the wilderness like pillars of smoke perfumed with myrrh and frankincense, with all the powders of the merchant? Behold his litter, the litter of Solomon; three score valiant men about it, of the valiant of Israel." [11] The monarch is proceeding in state, wearing on his head the crown that his mother gave him on the day of his espousal. He rapidly approaches. With the opening of the fourth chapter he compliments the woman on her charms, taking rather sophisticated comparisons from the shorn sheep or lamb, the pomegranate, the tower of David, the warriors' bucklers, the thread of scarlet, the hill of frankincense, the mountain of myrrh. His addresses are interrupted by a more intimate voice. The young bridegroom speaks, using the terms of closer relationship—my sister, my spouse—to insist that she should leave the Syrian palace to which she has been carried; for him Hermon and Lebanon have few charms. "How much better", he pleads, "than wine is her love, and the smell of her ointments than all spices." [12] She, whose virginal love had preserved her as a sealed fountain or a garden enclosed, was to him all in all. Her presence breathed forth the living odours of the hills in bloom, the perfume of her garments was the perfume of Lebanon: would that the south wind and the

north wind would blow upon this garden, that its perfume might be spread forth.

It was only to be expected, after this eloquent but audacious interruption of the monarch's suit, that the lovers should be forced to part, and it appears that the guardian of the walls showed some roughness to the young lovers: "they smote me, they wounded me," [13] the bride complains. "*Ils l'ont brutalisée*", says the French of M. Guitton.

In the fifth chapter, still sick with love and desire, still blissful with memories and dreams of her lover's approach, she resumes her tone of amorous reverie. Her tone awakens the curiosity of the daughters of Jerusalem, whose questioning (in the ninth verse) calls her to a new enumeration of his physical perfections: his eyes, his cheeks, his lips, his hands, his belly, his thighs, evoke comparisons with the beauties of nature, according to a convention to which all love poetry, and especially Arab poetry, has been apt to return. "This is my beloved," she concludes, "this is my friend, O daughters of Jerusalem." [14]

The sixth chapter opens with the answer of these ladies, and having heard it the shepherdess evokes the picture of her absent shepherd pasturing his flock. Then again, at the fourth verse, the royal voice is heard, in accustomed compliment, suited at first to the rustic tastes of the bride, but soon turning to an enumeration of the crowded harem, and to the words of princely praise, which pass from the washed sheep to the morn, the dawn, the sun, and the pomp of the bannered army.

The young bride answers these approaches with a dance which M. Guitton explains as another gesture of fidelity. The sword dance was the exercise of the bride on the evening of her wedding-day, and this dance was intended to convey to the King that her duty, as well as her heart, was wholly given to another. Her graceful movements, however, have the effect— not surprising—of arousing the King to a yet more unrestrained admiration of her beauties; and it is at this point that the poem becomes most daring in its frankness. The Sovereign's passion, now at its height, can hardly be contained, and at the last he leans forward to the beautiful dancer with the words, "Thy mouth is an excellent wine".[15] The combination of his passion and her excitement suggest that she will yield to his kiss: but the tension is relaxed with the clear, and even sharp, answer that she gives him:

"Qui coule droit pour mon bien-aimé
Mais qui glisse sur les lèvres des vieux." [16]

After this snub, the King leaves her for ever. Sure of herself, and yet in rapture, she again fills her mind with memories of her beloved: and while at one moment she imagines the sweetness of his embrace, at another she is firm in the thought that she is set as a seal upon his heart, and that love is as strong as death: "I am a wall," she concludes, "and my breasts are like towers." [17] In these last lines of the poem, as light as playfulness of youth, as aerial in movement as a sonata of Mozart, she invites her bridegroom to flee to the mountains of spices from whence he had come in the days when he had found her.

III

Such is the arrangement, which is now offered us, of the Song of Songs, and it goes far towards a complete solution of its enigma as a composition. It would add much to its literary excellence that each of its component passages should be in character, and each should be related to one another so as to make an arresting sequence of events. The epithalamium would appear rather to be a lyrical drama which is as closely knit as it is practical, maintaining the unities of action, time, and place. We would recognize it as the first great love story which has found a place in the classic heritage of Europe.

It has a quality of its own, a joy in nature frequent in Hebrew poetry, the same love of cedars and cypresses, of corn and of "lilies"—though, as its lily is compared with bright red lips, it was more probably the scarlet anemone, which is now generally recognized as "the lily of the field". It is the earliest and loveliest of the Songs of Spring, the season when the lower slopes of Hermon, which lose themselves in the upper valley of the Jordan, are bright with wild flowers, when the air is fresh and bracing as on the snowy heights of Hermon above, and when the Galilean landscape is apparelled in a gentle light congenial to the fancies of Love. The whole poem "breathes in one great presence of the Spring".[18]

Full of appeal to the sense of smell, delighting in nard and frankincense and perfumed ointments, and rich in all their subtle evocations of memory and feeling, the verses are as wholesome, as sweet as a bunch of carnations, or a bank where

the wild thyme blows. They are, from beginning to end, even in the speeches of the Sovereign and of the harem, true to all that is fresh and good in the thrills of natural attraction. Shelley used a phrase that suits it well when he wrote of "passion's golden purity".[19]

IV

This sense of wholesomeness which distinguishes the glow of its appreciation of physical beauty, and gives it the freshness of flowers and trees, is enhanced by M. Guitton's arrangement of the verses. In spite of Dean Stanley's welcome of Renan's suggestion of a lyrical drama, Bishop Wordsworth with Theodore of Mopsuestia rejected it as an episode unbecoming to the holiness of Scripture. But if the poem, in spite of its lack of references to moral law or spiritual life, were to uphold an ethical sense above the accepted morals of its time, the story would thus provide its own moral: in those polygamous days, in which the claim of a monarch for his harem was accepted as indisputable, it was indeed a novelty for a shepherdess to refuse a prince so as to remain faithful to a shepherd. Such a theme of romantic love might well end with a flight of the roe or the young hart to the mountain of spices.

For here, for the first time, Love in the simple, natural sense of the mutual attraction of man and woman would appear something finer than the luxuries of kings' palaces, and fidelity to it as the noblest, as well as the simplest, instinct of woman's heart. Never before had the inspired writer expatiated on the romance of passion. But such a romance was lesson enough; and so, though the interpretations from the Targum through Origen were always allegorical, we would find an additional reason for the fact that from the beginning this fine poem, in spite of the fervour of its frankness, found a place in the sacred Scriptures of a people to whom nothing was so sacred as the strictness of the Law. And, as M. Guitton remarks, there is no tendency among the actors of this drama to ignore the Law: each respects it; and even the monarch, in his power and luxury, does nothing to violate the inclinations of the young woman whose charms enthral him.

The tones and motives are those of Spenser in his wedding-songs: they are passionate, but they are pure. The expressions are sensuous, and often so in the highest degree, but they are

not gross. The attractions are undisguisedly physical; but they are not licentious. And the ethical tone is so apparent that, as we noticed, there is no need to state a moral. And yet there is one phrase which has the nature of a commandment: *I charge you, daughters of Jerusalem, not to awaken love before it stirs.*[20] The impulses of such strong attraction should be kept intact from precocious excitement, the attractions of nature should be left to act in an atmosphere of reserve. It is only with this proviso —that amorous experience should come in the order of nature, and not be sought or cultivated as an end in itself—that one could preserve for the nobility of poetry and love the simple, natural sensuousness of passion.

<p style="text-align:center">V</p>

But it is not for the naked beauty of its poetic imagery, nor yet the frankness of its psychology and even physiology of natural love, that readers of the Old Testament set so high a price upon the Song of Songs. The Rabbi Aquiba, in 135, said of all the holy books, it was the holiest of all. Through the ages they have looked on it as an allegory of the love of Jehovah for His chosen people, and then of Christ for the chosen in His Church. Its glowing embers have been the fuel not of concupiscence, but of the holy ardours which set the spirit aflame for the joy of mystical union with the Most High.

M. Guitton treats of this subject, but, we think, with excessive reserve. He does point out that in human love there is a rhythm of desire and joy, of longing and fulfilment, which are admirably expressed in the tones of the bride, and that a psychology precisely similar is found in the spiritual life. *"Jesus Christ s'en va et revient à ses fidèles,"* said Bossuet, *"par des retours ineffables."* The longings and joys of the person to whom love has become the breath of life might make use of the same expressions, whether the love was for a human lover or for the Divine lover. But we think that there is another reason why the passionate expressions of the Song of Songs are so suitable for the language of mysticism: it is because mysticism is in itself a life of intimacy and passion. Like the lover's, the whole nature of the mystic lives from hour to hour by memory and contemplation: for the mystic longs for unity, and contemplates its joys just as the bride pictures the physical perfections of the bridegroom, and as she lives in the sense and atmo-

sphere of his personality united to hers in the "crystallization" and romance of new love.

It is not, therefore, by a regrettable accident that the word love is used alike for human passion and for religious experience. The human heart is incomplete in itself. Whether in the order of nature, or in the life of prayer, it can attain to peace only in intimate harmony with a life outside its own. And so excellent and essential is love in the order of nature, that the very procreation of life depends on this fact: that the joy of the heart—which means the richest exchange of harmony between the mind and soul on the one side, and the body on the other— can be attained only when the mind and body of one person are in harmonious unity with the mind and body of another in the pulses of high excitement where rapture directs the battle between conquest and surrender.

Such, we say, in the order of nature, is the experience, such is the mutuality of relation, such is the unity of act which is essential to the conception of life that in the natural order living beings are most nobly the delegates of the original creative power of life. This conception is the consummation of love, and therefore love—the tendency towards this life-giving unity—is the fitting subject of poetry and prose. In fact, our Elizabethan and Victorian epochs tend to suggest that it is the highest occupation of human beings, the occupation most instinct with that splendour of truth which Plato hailed as beauty, and which is indeed the spontaneous and enjoyable resplendence of a reasoned order of perfection. There is therefore a high natural poetic excellence in the direct, human, simple, sensuous significance of the Song of Songs. It has the highest value as a lyric of love.

Therefore, also, its value as a love lyric is exactly what suits it for its central place in the long history of mystic faith. It is not only that it speaks of those ineffable returns by which the Prince of love mingles as it were in the rhythm of breathing, or in the beating which empties and refills the chambers of the heart, with those interchanges of desire and joy which give to the deepest peace of the soul such an exquisite poignancy of joy and pain. But they lead also to that deeper unity, to that spiritual marriage (treated with especial clearness by Ruysbroeck and Richard of St. Victor), which gives to the elect of mysticism so rich an intimacy with the God whom they adore. It is true that in comparison with this union, the procreative union of

flesh with flesh in marriage is in a different and lower order of being: and the things which are lower are to be eschewed, for a decline towards them is sin; yet in the peculiar realm of mysticism the mysterious power of words and images—working endless changes in the subtle organism of man—still complete a process so similar to the consummation of love that it may well be symbolized by marriage, and which perhaps better understands the essentials of marriage than any fleshly experience could do. There is a power in words independent of any exact knowledge of their significance, or any experience of the precision of their imagery. And it is this power of love and unity in their essential reality which has given the Song of Songs a power in the spiritual life as strong as its original imagery was vivid. It was a favourite with St. Bonaventura. St. Bernard preached from it eighty-six times.[21] "I receive great spiritual consolation", said St. Teresa, "every time I hear or read certain words in the Song of Songs of Solomon, to such a degree that without clearly understanding the meaning of the Spanish translation from the Latin, my soul then feels more recollected and more deeply touched than it is in reading religious books which I do understand." [22] This faculty of St. Teresa to use a poetic formula to deepen her sense of the mysteries of the spiritual life need not imply anything sensuous in the quality of her mysticism. The Song of Songs as translated for Europeans speaks little of the sense of touch, and not at all in relation to passion in its narrower and more concentrated sense, where the sense of touch awakens violent psychological reactions.

It is more closely related to that rapturous quality of human love, where joy in the contemplation of a particular person's beauty, joined to a conviction of the exchange of intuitive sympathies so as to give a sense of the fusion of separate existences, leads to an experience of romance and wonder so rich that it gives a new significance to nature and the universe. In love poems such as this, the scenes of nature are not merely a vehicle of compliments: they are loved in themselves with a personal love because the lover is made one with nature and hears the voice of his own love in nature's music. He finds in the woods and fields, in the company of sea and sky, a place to be alone with heaven; he has found in his beloved a "beauty that makes holy earth and air". And in the sense of close bodily nearness, and with that his deep sense of "the great chime and

symphony of nature",[23] his rapture is so exalted that he can hardly distinguish it from worship. He dreams of

Vollen goldnen Stunden
Ungemischter Lust ;

he finds perfection in the presence of his beloved:

Wo du , Engel, bist, ist Liebe und Gute,
Wo du bist, Natur.[24]

And so what Goethe made of human love, and Meredith after him,[25] explaining how lovers through eyes and lips and fingers pour the endless, ever-fresh treasures of their souls, is one with Goethe's joy in the Song of Songs. At first he loved it only for its poetry. But the poetic rapture, sensuous and passionate as it was, was yet of so pure a quality, so full of the higher joys of sensuousness, that, containing in itself the essentials of a spiritual experience, its expressions, in conveying that enhancement of life rather than any other, were perfectly suited to the mystic's fervour.

Far from there being any incongruity in the mystic's use of these love lyrics for the food and wings of his flights to the heart's purest heaven, the process is so natural as to be almost inevitable. The natural and the supernatural are distinguishable realms, but they are not always distinct; to the poet and the seer the world of sights and scents have been

The testament of beautysprite,[26]

and revealed a secret within: they have been symbols of another order of truth: and the heart of praise, as it contemplates them, has burst into the cry, "O that men would therefore praise the Lord for his goodness and declare the wonders that he doeth for the children of men".[27] It is at His word that the stormy wind arises: [28] the lions roaring after their prey seek their meat from Him:[29] it is to His praise that

To the mermaid's pap
The scaled infant clings.[30]

VI

And so, as we examine the Song of Songs, we find that in seeing how its poetry has appealed to those who live by the heart, we have understood what is meant by its inspiration. The

principle of inspiration is that the human voice can reveal a truth which is supernal, holy, divine. And just as all spiritual knowledge and expression is drawn from the experience of sense—as when it is said: "In Thy light shall we see light"— so it is found that human histories and events can be instinct with this higher significance. A Jewish chieftain has children by a slave woman and a free woman: a sower goes forth to sow his seed: a woman came to a well to draw water; and in a flash the light of sense has gone out and revealed the invisible world, and we are learning the inmost truths of Christ's dealings with the soul. The sense of God's nearness becomes the means of His revelation: so it is with the Song of Songs. There the sense of rightness was so simple: there the fervours of love were so rapturous that God was with the lovers when they knew it not, and the mere expressions of their ardour were inspired with significance as to that holier and intenser love which unites the Redeemer with the redeemed.

If, then, we have a sense of the unity of history under the governance of Wisdom, to whom times to come are present with times past, the problems of revelation and inspiration are solved. "While everyone tries to understand in the Scriptures the meaning which the writers understood, yet what harm is it", asked St. Augustine, "if a man understands what Thou, the Lord of all true hearts, doth show him to be true?" [31]

On this foundation of a world created by God—good in itself and designed as the theatre of redemption—on the basis of a law set up as natural and universal and yet as the shadow of better privileges to come, when men's efforts of obedience should merge into the impulses of grace, and when righteousness should be raised up to holiness, the inheritors of the Hebrew religion, when it was fulfilled in Christ, saw in a new light both the significance of their own history, the appeal of their own literature, and also those Hellenic ideals of beauty of which they, in their ignorance of art and of philosophy, had hardly dreamed.

CHAPTER I

1 Preface to *Samson Agonistes*.
2 Theodore of Mopsuestia first suggested that it was simply a love poem.
3 Goethe, *Sämtliche Werke*, XXXVII, 117, 118.
4 Umbreit, *Lied der Liede*, V, 150 (1820).
5 Luis de León, *Cantar de Cantares*, p. 16 (1806).
6 *Ibid.*, p. 12 (1806).
7 Ewald, *Erklärung des Hohenliedes* (1826).

[8] Professor Wheeler Robinson has, however, not yet read Guitton.

[9] See Delitzsch, *Das Hohelied untersucht und ausgelegt*, 1851; Réville, *Revue de Théologie*, Strassburg, Vol. XIV (English translation, 1873). Cannon, *The Song of Songs*, Cambridge, 1913.

[10] *Song*, I, 2.

[11] *Song*, III, 6, 7.

[12] *Song*, IV, 10.

[13] *Song*, V, 7.

[14] *Song*, V, 16.

[15] *Song*, VII, 9.

[16] Much turns upon the translation, but Professor Margoliouth assured me that this one is perfectly acceptable. If we take the word to be יְשֵׁנִים, yeshānim, it means "the old": if we take it to be יְשֵׁנִים yeshĕnim, it means "those who sleep". But another reading is וְשִׁנִּים, weshinnīm "and teeth". This is preferred by Cannon, who adopts a dramatization similar to that of Guitton. The meaning of the verse, VII, 9, the juice of those grapes goeth down so sweetly that it makes the lips of those that are asleep to speak, is discussed by Luis de León in his *Cantar de Cantares*—pp. 211, 212. He compares it with Proverbs XXIII, 31, and takes it to mean that it flows down sweetly and then intoxicates, and makes the drinker speak vaguely, as those speak who are overcome with sleep.

[17] *Song*, VIII, 10.

[18] Wordsworth, "Vaudracour and Julia", l. 41. This passage echoes Goethe, who refers to it as "den Zartesten und Unnachahmlichsten was aus von Ausdruch leidenschaftlicher anmutiger Liebe Zugekommen" (*Werke*, V, 150).
This view is supported by Dennefeld, *Introduction à l'Ancien Testament*, p. 40, and H. H. Rowlers, *J.R.A.S.*, April 1938, p. 74, though without mention of M. Guitton.

[19] Shelley. Epipsychidion.

[20] Cf. *International Standard Bible Encyclopædia*, V, 2833: Love should not be excited by unnatural stimulants.

[21] Réville, *Song of Songs*, p. 7.

[22] Silverio's edn., IV, 213, 214.

[23] H. Vaughan, *The Morning Watch*.

[24] Goethe, *In Belinden*.

[25] Meredith, *Richard Feverel*.

[26] R. Hodgson, *The Song of Honour*.

[27] Psalm CVII.

[28] *Ibid.*

[29] *Ibid.*

[30] Smart, *A Song to David*.

[31] St. Augustine, *Confessions* XII, 8. "Understanding it is always a complex business, consisting of many phases, each complete in itself, but each leading on to the next. A determined and intelligent audience will penetrate into this complex far enough, if the work of art is a good one, to get something of value, but it need not on that account think it has extracted the meaning of the work: for there is no such thing. The doctrine of a plurality of meanings, expounded for the case of Holy Scripture by St. Thomas Aquinas, is in principle perfectly sound . . . in some shape or other it is true of all language."
R. G. Collingwood, *Principles of Art*, p. 311.

I

SATISFIED in their belief in one God as Creator, uncom-
promising in their belief in His guidance, and rejoicing in
His worship, the Hebrews cultivated neither philosophy
nor art. It is from the fountains of ancient Greece that Europe
finds the sources of these. The historians, the poets, the
orators and, above all, the philosophers who wrote with such
intuitive discernment of friendship, love, beauty, and eternity,
that when we catch their enthusiasm we seem, in seeing the ideal
of one of these, to know the true meaning of them all—they
are the primal humanists. Nature, even though they did not
recognize it as God's art and handiwork, was very pleasing to
them: and Chateaubriand was no doubt right when he insisted
their genius drew much—even if it were unconscious how—
from the play of sunlight on the purple sea, on the grey and
silver of the olive, on the cypress raising its sable column into
the blue serene, or the declivity of the wild mountain, Helicon,
Parnassus, or Taygetos.[1] There still hangs over Grecian
landscape a wildness far more striking than the bare hills of
Thabor or Hebron, of the wide greenness of Esdraelon, or the
sheen and mildness of the waters of Galilee as seen from
Capernaum: and the harsh Zeus of Æschylus, like the grim
Sophoclean fate, might well have been inspired by the rugged
declivities of Greek hill and valley in sunlight and storm. The
scenery of Hellas is the property of any traveller with eyes to see:

> Yet are thy skies as blue, thy crags as wild,
> Sweet are thy groves, and verdant are thy fields,
> Thine olive ripe as when Minerva smiled,
> And still his honied wealth Hymettus yields;
> There the blithe bee his fragrant fortress builds,
> The free-born wanderer of thy mountain air;
> Apollo still thy long, long summer gilds,
> Still in his beam Mendeli's marbles glare;
> Art, glory, freedom fail, but nature still is fair.[2]

Peak and headland, island and valley, Rhodes, Chios, and the
Icarian Sea, Olympus, Argos, Delphi were gorgeous enough
before genius and passion gave to their names a glory not
their own.
 For the life of Hellas, and above all its spiritual life, was so

23

rich that there is a mystery, rich for the soul, in the monuments and images they left us. The artist's interplay of skill and fancy draws from raw materials a portraiture of life instinct with truth. And the archæologist, who busies himself with the old works of man, becomes also a minister of enchantment. He, too, aims at a truthful portraiture of life. He aims at unearthing from the dust or sand some fact to relate to other facts, or preferably some mould of beauty with which to arrange one of history's living pictures.

Watching, for instance, the designs of the vases, he is able to piece together the whole life of which they formed so intimate a part. He watches the child giving her doll its dinner, and the young athlete oiling himself in the palæstra. He goes with the peasant among his wines and oil, and sits with the men of wealth at their banquet. He may imagine "what a subject of jesting it must have been for everyone to find painted on the vases he was using a picture of the banquet, of the preparation for it and its various pleasures, to compare himself with the figures before his eyes, and to seek in these scenes of gaiety, and often of licence, encouragement to enjoy the present".[3] The sister used the vase hardly less than the brother. From it she took the paint for her complexion and the perfume with which she scented herself. The vase not merely leads us into her wedding-procession, it even takes us with her into her bath.

. It brings us at last to the room of the dying. The voice of mourning for the dead arose beside those urns: hands filled them with the ashes of beloved bodies; men faced the mystery of death with efforts at self-control.

Their spirit was intimate with the poignancies of earth: it felt an imprint at times terrible, at others sublime, in the shape of the human form from neck to toe. Though the Greek mind was simple, and its classical expression is distinguished above all by restraint, yet the Greek's self-discipline enabled him to feel and to express all the intensity with which the flesh endues the spirit. "Passion", said the most eloquent of their critics, "is as large an ingredient in sublimity as a sense of character in an agreeable style." [4] Fullness of feeling gave them immortal longings, and identifying these with the outward grace and gesture which had first inspired them, the sculptors conveyed their eagerness to the marble; for they were as intimate with it as with the expressiveness of the model, and their instinct added something of their own.

In their portraiture three separate aims can be distinguished, though they often mingle: firstly, to represent a man in the light of ideas,

As when a painter poring on a face,
Divinely through all hindrance, finds the man
Behind it,

and, in finding him, finds something finer than either he or the finder, finds some hint or promise of what Aristotle taught— that we are human insomuch as something divine assumes sway within us;[5] or again, to sieze a salient characteristic and present it picturesquely like Sargent—or Dickens—giving the full force of an unqualified fact; or lastly, like the caricaturists, to throw all the emphasis on some obviousness of shape, some outward oddness. In this the Roman portrait was to anticipate the tendencies of our own age; but in all ages that was a device that stamped the cheaper kind of art. It is when art aims at the first of these devices that it is noblest and most memorable. So it is in the *Idolino* of Florence, the finest example of the School of Argos; so it is with the Dying Persian of the School of Pergamos; and it is also true of the Aphrodite Anadyomene in the Baths of Diocletian, which is admirably suited to a discussion of the art and ideals of ancient Hellas.

III

The painter Botticelli, in one of the most famous pictures of the Uffizi Gallery at Florence, depicted Aphrodite issuing from the waves in her full stature and standing on a pearly shell, the new-born daughter of Heaven and the Sea. Two Zephyrs with filled cheeks are blowing her to the land, where a damsel awaits her with a garment. The air over earth and sea is filled with falling flowers. Such was Botticelli's application of the beautiful myth repeated by both Hesiod and Homer.[6] The same idea was, nearly two thousand years earlier, the theme of this *Aphrodite Anadyomene*. The new-created daughter of the gods has issued from the water: she is on neither wave nor shell: but, setting foot for the first time on the substantial world, she employs a marble dolphin, suborned in the very moment of swallowing a fish, to hold the simple robe she will presently put on. She pauses for a moment, perhaps to comb her hair before the mirror of the water. She rests lightly upon one hip, and the other

knee turns gently forward. At that moment the sculptor has portrayed her, graceful and un-selfconscious, in the marvellous beauty of her youthful but dignified and satisfying proportions. He has carved her in a Parian marble of a soft, warm colour which now, due doubtless in part to the action of the golden sands of Libya, faintly suggests the tingle of blood beneath the skin, and the marble brings to a conventional finality the firmness of the flesh. She remains in her arresting excellence of beauty: a riddle of dignity to us all and a riddle of attraction— fit type and portrait of Aphrodite: a woman's form in an Olympian perfection.

The climate and the games of Greece gave her early inhabitants opportunities of studying the human form which have been since unrivalled. Their eyes were trained to beauty by the harmonies of the scene in which they lived, and the taste so cultivated was refined with the development of thought to a profound and passionate philosophy of beauty. The fascination of the human form appeals to the senses by its intricate nature and to the mind by the intricate excellence of its construction; it was displayed without concealment in the most bracing circumstances by young athletes at their exercises. Here the delightful qualities of health and youth, of strength and grace, were displayed in an endless variety of symmetry and rhythm. The Hellenes had but to look and they must perforce learn the harmonies of which the body was the instrument. Such were the multitudes of models from which they learnt what to express in marble or in bronze.

Sometimes they were content merely to portray the naked athlete, but often they sought to express their ideals by giving him the qualities of a divine being. Then in the mould of muscles, in balance of proportion, and in symmetry of pose, they expressed the life of the gods upon Olympus. At other times they excelled in exact portraiture, and both excellences were shown in a high order by Apelles.[7] But there were others who surpassed him.

Greatest of these, we are told, was Pheidias, whom Pausanias and Lucian, Plutarch and Pliny praised among the ancients. He among them all was said not only to have been the first to reveal the possibilities of sculpture, but to have excelled in the sublimity of his conception. The majesty of his art, said Quintilian, was adequate to the gods, as was seen by his *Athene* at Athens and his *Zeus* at Elis.[8] But Pliny tells us, though in a

story of doubtful value, that in the temple of Artemis at Ephesus the statues of the Amazons by Polycleitos were preferred to those of Pheidias.[9] Polycleitos excelled in the charm and the proportion of his figures—he forfeited majesty to an exquisite sensitiveness to the human body's own attraction. But the great age of Praxiteles, Scopas, and Euphranor was seventy to a hundred years later, in the middle of the fourth century, and it was probably some time in this period that a master executed the *Aphrodite* of Cyrene. It was not Praxiteles, for the perfect roundness of this figure is emancipated from his convention. It is hardly likely to have been Scopas, for though, like Apelles and Praxiteles, he executed an Aphrodite that seemed a marvel among the representations of gods and men, his spirit was too wild and poignant for so serene a work.

Might it not have been Euphranor? For he is described by Pliny as excellent with an even excellence on everything he touched; he was a master of symmetry, and first delineated the dignity of heroes.[10] Here is one, furthermore, who was careless, as the carver of this Aphrodite was careless, of ankles and feet. But was even his art equal to this finish of technique, this skill and delicacy of workmanship, or is it a masterpiece from a later age?

For the more fully we consider it, the more completely does it answer to all that we demand from the art of statuary. That the head is wanting releases us from being tormented by the too obvious deficiencies of ancient sculpture: at the same time it assists the symmetry of the composition, for the model is unusually tall. The eye, being undistracted by the face, is free to observe at a glance the beautiful contours of the torso and the lower limbs, for they are so beautiful that even the missing arms, which might have played so great a part in the rhythm of the piece, are unnecessary. As it is, the statue is perfection. The balance of the arm is atoned for by the dolphin which forms the pedestal and carries the fringed garment of the goddess. It is indeed in this that the unknown sculptor has displayed his genius for composition.

Rising, as it does, to the hips of the figure, just an inch more than half-way from the sole of the foot to the neck, it compensates the eye for the missing head, while throwing emphasis on the roundest, and therefore the most beautiful, curves of the body. It also balances the projecting knee, which is the same height as the twist of the dolphin's tail. It throws,

therefore, into prominence the delicate ripple of muscle just above the straight knee. The deep shadow, which the robe throws over the dolphin, accentuates the planes of light on the figure, as the sharp twist and bloated form of the dolphin contrast with the delicate outlines of the young human form. The contrast in sentiment is even sharper. Both fish and dolphin are allowed their eyes. The head of the fish expresses helpless agony, that of the dolphin a triumph of cruelty and greed. These passions of animal weakness and animal impulse reveal the noble calm of Aphrodite Urania, for such this statue surely is, and not that lower goddess who expresses the appreciation of love and beauty felt by earthly spirits.

What the two animals do in the sphere of sentiment is done solely, or almost solely, in the pure sphere of art by the drapery they carry. That the drapery should be beside the figure is itself a subtle consummation. It leaves the naked form its full openness of majesty, while introducing both the idea of clothing and the folds of drapery. These are arranged firstly to form a singularly attractive subject in themselves in their delightful lines and intricate diversities of light and shade, and secondly with the diagonal trend of their curves to give the eye the fullest freedom to realize the rich simplicity of this Olympian creature's dignity and freshness.

IV

There is a mystery in proportion, for proportion is not in its beauty mathematical, but is a concession to our way of seeing, and the eye regards it with tireless fascination. Far more interesting than the best draperies is the human body. This figure is among the most beautiful of them all. A taste was not uncommon among the ancients to find the culmination of physical beauty in a form between that of the man and the woman. Sometimes they boldly named their ideal in memory of that mythic son of Hermes and Aphrodite who bathed with the nymph Salmacis in a fountain till her characteristics became his. More often Hermes had a girlish delicacy and a girlish grace such as we see in the *Apollo Belvedere*. In this statue the goddess has in her slim feminine muscles the firmness and the strength of a boy who is becoming a man. This gives the triple division of shadow on the abdomen and the quadruple division of the shoulders to the waist; and it is something of the same kind

which restrains the breasts to two firm cones and clearly distinguishes the thighs between hip and knee. This goddess is a woman, but a woman at the threshold of her womanhood, active in exercise and virginal, with some of the distinctive qualities of a boy. Yet she has none which are to mar her womanhood and turn her, by being nearer a man, into a monstrosity.

Such, then, is what Hellenic sculpture was at its best, as we see it in the Nike on the Acropolis, or that bronze statue newly discovered from the sea, which some have thought to be Zeus, and some Poseidon, which is now the glory of the Museum at Athens, and which is admirably reproduced in the Ashmolean Museum at Oxford.

It may well lead us to ask, What do we mean by beauty, and why do we find beauty in undraped human contours? Sculpture is one of the most constrained of the arts. It lacks, in what we have generally accepted as its masterpieces, both luminance and colour, the texture of skin, the delicacy of hair and eyebrow, the richness of fabrics. It lacks the vastness, the fancifulness, the usefulness, and the fixed order imposed by the human mind in architectural art: it gives, therefore, small scope for composition, and that composition of movement which we see in music. It bears no comparison with the complicated and various compositions of good prose or poetry. It might seem almost more, in its fixity, its austerity, and its chill, an art rather of death than of life. And yet because it is in three dimensions, because it offers something to the touch, and to the memory and psychology of touch, because it gives a different aspect from innumerable angles, it is the most sensuous of the arts.

The sensuousness of art is so strongly felt by the Moslem religion that it forbids the portrayal of any living creature, under the plea that it might encourage idolatry. That is why in the Taj Mahal the exquisite decoration is constrained to conventional convolutions in fretted stone and to bas-reliefs of the lotus and the lily, as palms and trees mingle with other conventional designs in the charming fretted windows of the Sidi Said mosque at Ahmedabad, which rival the more ancient fretwork in the mosque of Cordova. The Christian Church, however, as we shall see, was to look with a more unflinching eye at the allurements of the senses, and from the time of Niccolò Pisano to Bernini and Montañés showed that she could produce a spiritual rather than a sensuous sculpture.

But sculpture, both in bas-relief and in the three-dimensioned marble, reached that height which its habitual admirers were apt to claim as its culmination among the Hellenic sculptors some centuries before Christ. Then it was sensuous (as it must always be) and passionate, but it was excellently restrained; it was significant of inward life; beneath the lovingly carved forms of flesh there breathed the spirit's life in art. For what is art? A record of experience. It is that device which, under the constraints of convention imposed by the medium, and of the laws of mind, depicts beauty in its portrayal of nature and life; it is the voice by which a contriver, an object, and a beholder commune in terms of one another.

A language in which the Greeks were most eloquent was the human body: not the human face, for, when all is said even of the Aphrodite of Melos and the Delphi charioteer, their sculpture does not best lend itself to that. For it (at least as we know Greek statuary now) the eye does not shine, the flesh does not glow,[11] the lips do not redden, the skin does not darken, the eyebrows and the hair lose their delicacy; only those busts are successful where facts depend for their character on strongly marked features and distinct planes, or on round contours and tranquillity of expression. In faces of the classic type, noble in line and true in proportion, it has attained to truth of imitation. Certain of the Roman emperors have been well portrayed in bronze and marble, and there is genuine charm in the face of Lord Leconfield's *Venus* at Petworth. But, in the mystery and movement of expression, Hellenic sculpture was—more often than not—imperfect. What we seek of the energy of character, of the lights and shades of personality, of thoughts and feelings, either evanescent, or in their promises and records, from our study of the human countenance—and nowhere as on it are temperament and character, either in moods or trends, so warmly, so intimately, revealed, nowhere is life so inwardly itself—we hardly ask from Hellenic sculpture. In turning muscle and eye and hair to the stillness of bronze or clay, it must portray a face almost as constrainedly as when it arrays the grape and vine-leaf in a rhythmic pattern: it turns still, cold, and clear the most mobile and elusive object of the eye's attention.

But if the human countenance was not yet, in spite of some successful examples, the field of the sculptor's triumphs, sculpture then reigned in its profound expressiveness over the forms of animals and men. Here its very limitations give it an

advantage. Art is not reproductive: it is a self-expression through more or less conventional devices of representation; and its first object will be what Aristotle said[12] was to imitate, meaning to represent, what the artist has seen. The artist can conventionalize from life into line, and idealize from nature to a type. He can plead that he has attained an artistic effect, or that he has given a conventional rendering, or that he has expressed something nobler than what he had before him: that in any case he has compensated himself for his limitations by taking advantage of them.[13]

But his object must be truth to life, as far as his constraint allows him. One may presume that it has never been the custom of people to speak the language of affairs in metre; but we will accept the metrical play in so far as within the constraints of metre the artist expresses character, or provides interest, or attains a noble effect. But if the artist's eye wanders from truth, if his device distracts him from the actual nature of men and things, even when he is still able to express it, he will be at best fanciful, and soon grotesque. His characters will become mechanical, his interest will flag, and his effect will be trivial, vulgar, or repellent. If, on the other hand, an artistic work is true to life, it will please by its excellence of imitation, by the mere cunning of its device, for workmanship always gives that sense of satisfaction: it appeals to that subconscious instinct of imitation within us by which we learn everything that we know and evolve everything that we are.

So sculpture which expresses the mobile human form in wood, or stone, or metal, or clay, and must therefore adapt the contours of the flesh to the planes of these hard substances, must yet retain, in whatever convention it still chooses to express itself, a faithful regard to its original. After this it will depend for its excellence of beauty on not only its artistic convention, but on the model and on the personal appreciation it expresses.

Personal appreciation is the secret both of temperament and of skill. For we see in one sense what we can and in another what we will; and we remember that which is congenial to us. The artist, who, having chosen, has first to see his model, sees there according to his energy and his desire. Not only is his wish father to his thought, but his thought, which is both habit and inclination, is father to his perceptions. And when he has perceived, he must perform a thousand acts of memory in

transferring his perception to his work, and in each act of memory his temperament will again assert itself.

V

Such are the principles which, sometimes more and sometimes less clearly understood, have informed the appreciation of art in Europe from the time of Aristotle to the present; or at least until the time, well within our memories, when the Surréaliste school of art arose; for it was founded on having no foundations. But if Wisdom, who is justified of her children, has not yet claimed to be the parent of the futurists, there is no cubic crudity of planes in the Venus of Cyrene. This sublime conception was realized at a time when sculpture, which was always the highest of the imitative arts among the Hellenes, was at the period of its most faultless form.

Such, then, is the success, such the theory which Hellenic sculpture had offered to civilization before Christian art arose. Hellenic nudes were to remain suspect to the Church till the time when Giovanni and Niccolò Pisano went back to study ancient art and to found on it a Christian Renaissance. The Gothic artists gave sculpture a quality suited to the architecture of their time, but it was not until the seventeenth century that Bernini at Rome and Montañés at Seville changed the temper of carving from sensuousness to spirituality, and gave not merely to form and limbs, but even to the face the intense vitality and emotion which the Greeks were proud not to have. For if they had not understood restraint so well, their passion would lose its beauty in lasciviousness, their strength would harden into tyranny, their grief into despair. They dared not feel, they dared not live, too much. They were distrustful even of the beauteous forms they carved.

VI

How does this statue stand to that classic philosophy of Athens which we know as idealism? What was the place of art in the thought of Greece? The most famous of their philosophers was too oriental, and too spiritual, to be typical of his countrymen,[14] it is true: but his feeling for art was, above all, distrust. Plato thought art but a game, even if a noble game, for in his view it revealed no ultimate ideas. He thought

THE APHRODITE ANADYOMENE, IN THE BATHS OF DIOCLETIAN. It answers to all that we demand of the art of statuary. How does it stand to that classic philosophy of Athens which we know as idealism? Why do we find beauty in undraped human contours? [Photo by Anderson.

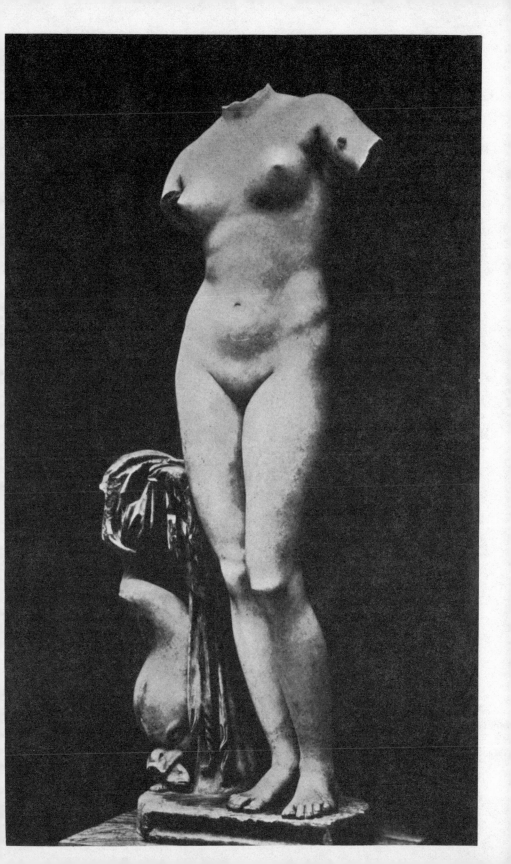

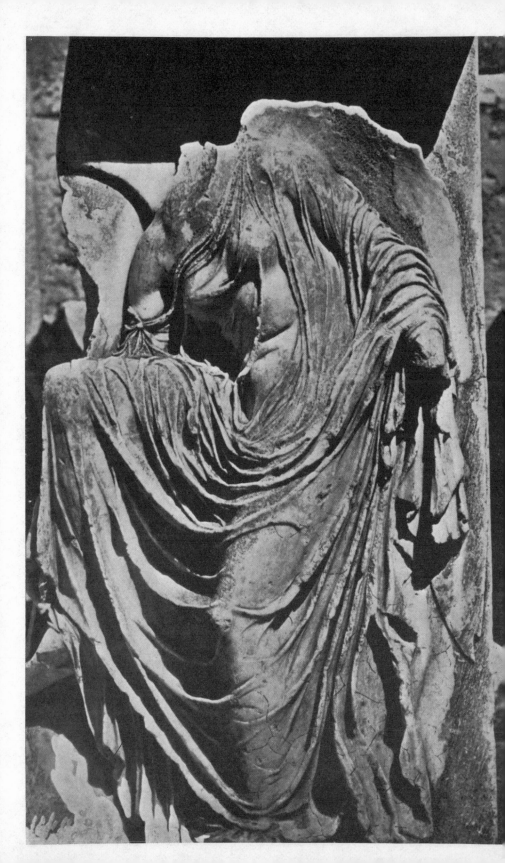

the right name for the artist's gift was imagination, and its creations were phantoms,[15] which contained no truth, being clothed only with a glamour of delightfulness. For, in his view, poetry and song and dance could be true only to the outward nature of things, as he argued in the *Republic*, and not to their invisible reality in the realm of ideas, not to their original patterns in the supernal world of spirit from which all things derived the truth of their existence. On the contrary, it was but the image of a shadow, the shadow of a dream.[16] He thought that the outward nature of things, copied in art, was only an appearance, almost a delusion; art therefore, though shadows are a necessary and refreshing element in life, must never be taken as giving a vision of the truth.[17] This theory points forward to all the tendencies which lead towards an elimination of art from the service of religion. Nevertheless, even in the *Republic*, music, literature, and the fine arts can convey certain ethical characteristics to the soul.[18]

But Plato's pupil, Aristotle, though also looking on the supreme reality as spiritual, insisted that the world of touch and eye and ear is no deceit. The exterior world also is, as common sense would have it, a reality, even though a subsidiary reality. Aristotle insisted that it is the function of the human mind to realize not the outward or accidental characteristic, but that distinctive, underlying, formative power which makes a thing what it is in the realm of lasting and effective reality. If a man can attain, therefore, through outward things, to a grasp of this their true and essential reality, he can have a right idea, a right idea rightly expressed, a right concept of it. The artist, therefore, must represent the action of the original formative idea upon the potentiality of raw material.[19] The notion was taken up by Horace in the *Ars Poetica* when he wrote: *Scribendi recte, sapere est et principium et fons.*[20]

Aristotle, however, conceiving reality in terms of mind, or spirit, rather than of ideas, saw more clearly the part that the reason should play in knowing truth. He had a full theory of the function of art as imitation, meaning by that not reproduction but expression or individual representation. Life and nature show us the reality of things which the artist will know and interpret, according to the laws of nature, but in the terms of reason. And to be true to life will be his object, because the energy of right reason gives us truth.

His words or expressions, therefore, must be chosen, to

THE VICTORY OF THE ACROPOLIS. Though the Greek mind was simple and its classical expression is distinguished above all by restraint, yet the Greek's self-discipline enabled him to express the intensity with which the flesh endues the spirit. Hellenic sculpture is at its best in the Victory on the Acropolis.

convey his concepts to his hearers in a language common to him and them, in a style they will understand. It will depend on *an inter-reaction of temper*.

VII

What was the temper of Hellas?

Behind the careless majority who thought of nothing but fashion and pleasure (for these, as the vases show, were but too faithful to Aphrodite Pandemos) there were others who had an elevation about them. These had learnt from their long training in the rhythms of music and naked exercise the fitting use of both strenuousness and sentiment. These were to fix their minds on living heroically, not alone in unfaltering endurance of effort and pain, either in games or war, but also in those things which the harmonizing physical proportions signify, the virtues of justice, temperance, fortitude, and chastity.

> Self-reverence, self-knowledge, self-control,
> These three alone lead life to sovereign power.[21]

Indeed, man sees in Nature nothing finer or higher than his own spirit: it is, above all, the spirit's virtues which "dispose to stateliness and high mood and sublimity".[22] The Hellenes attained to this because in their philosophy the forms of outward things were shaped by an inward grace discernible of reason and given by the awful workings of an unseen power; all forms of beauty pointed to an unseen and eternal beauty: and what Plato wrote of beauty in the *Phaedrus* and the *Symposium* foretold what Plotinus was to write in the *Enneads*:

"Intellection, and all that proceeds from intellection are the soul's beauty, a graciousness native to it and not foreign, for only with these is it truly Soul. And it is just to say that in the Soul's becoming a good and beautiful thing it is like to God, for *from the Divine comes all the Beauty and all the good in beings*." [23]

VIII

One may doubt, however, whether in the age of Pheidias or in that of Myron the Greeks were clear as to the height towards which their sublimities were pointing. Meanwhile we gain nothing if in exalting their greatness we pass over their deficiencies. Kingsley noticed that they allowed their divinities a

licence they did not regard as lawful for themselves.[24] Beyond all their metaphysical speculations was a void that humanism unaided could not fill. They saw but through the mirror of the mind, in riddles and guesses. And though they aspired for high thoughts and magnanimity, and passionately admired the natural human excellence of character or body, they failed to identify the dignity of heroes with the spirit that frees the soul of goodness from things evil.

They never really cared about the lowly, the poor, the wretched: failing, therefore, to attain the idea of a society which was united because it was benevolent, they failed also to realize that the ideal beauty must also be the informing principle of life and movement. While, therefore, their system could merge into the fuller glory towards which they aspired, it could also degenerate into the conventions which mar, for example the classical remains in Provence.[25] There we find monuments which show the final effect of Greek sculpture on what was peculiar to the Roman Empire.

Take Arles as an example. For there we can sum the characters of both ancient Greece and Rome, and compare them with monuments of early Christianity. Arles was the headquarters of the Sixth Legion. Julius Cæsar established it in 46 B.C., with the rights and privileges of a Roman colony, giving it the name of Cesarina Julia Paterna Arelate Sextanorum. The bull, which was the emblem of Cæsar himself as well as of the Sixth Legion, was carved upon the monuments of Arles, which to this day brings its bulls from the Camargue to fight in the arena. In the first century it rose from the surrounding marshes with much of the eminence that to-day makes its walls so striking from the hill of Montmajeur. Built of stone, under the sign of the bull, the new city reproduced on the Rhône the massiveness of the Imperial capital. No people in the zenith of their power built so much as the Romans. Building was a passion with them, a manifestation of their force, a claim for lasting honour. Grand and strong, their buildings are distinguished by massiveness, wealth, and usefulness. Their architecture insists on vast materials: not only in the Baths of Caracalla or of Diocletian, or in the triumphal monuments of Constantine or Titus, in the Colosseum or the Pantheon, but in general in their bridges, aqueducts, gates, sewers, markets, theatres, baths, arenas, palaces, and temples, its essence is the arch. Its play of harmonious forces symbolized the social unity which

they aimed at giving to civilization. It was the symbol of the rich interplay of life, the co-ordinated strength of the *Pax Romana*. Arles was made a partaker of this majesty, and the order it implied gave unity to the style of the new city. Powerful corporations—or *collegia*—developed its earlier importance as a centre of traffic, and it became the emporium of the grains of Gaul.

Arles, however, was not originally Roman: it owed an earlier importance to being sought out by Eastern traders. Some have hazarded the suggestion that Greeks could feel at home there, for the wild Provençal hillsides, silvered with the olive, looked very like those of Hellas. From Greece Arles took the fineness and purity of taste with which her statues, pictures, bas-reliefs, altar cups, and candelabras were drawn and modelled. The harmony of lines which to the Greek became one of the very forms of thought mark those fragments of triumphal arches which Arles still preserves in her museum and her Roman theatre, where two marble columns proportioned with Hellenic judgment throw the shadows of their height into a bed of clover. Carved capitals and stones with traces of a design in low-relief, or of inscriptions, are grouped nearer the trees of the garden; Greece gave to Arles the famous Aphrodite now in the Louvre. It gave that head of Diana or Ceres, sculptured about 100 B.C., which some thought the finest of ancient marbles discovered in Gaul.

Gifted with opportunities of appreciating sculpture, the great merchants of Arles had also a link with literature. Pliny the Elder made mocking references to Pompeius Paulinus as a *nouveau riche*, but his daughter married Seneca, who dedicated to the old merchant the treatise *De brevitate vitæ*, and the virtues of the wife are celebrated in the *Annals* of Tacitus.[26] Among the sons of Arles, Clodius Quirinalis taught eloquence at Rome in the age of Claudius, and the philosopher Favorinus, who himself wrote in Greek, was the friend of Plutarch and Epictetus.[27]

Fifteen or twenty miles across the Rhône was yet another centre, Nîmes. "Strange and attractive city!" writes Jullien, "its origin is mysterious: it draws from the past a subtle charm, and its life is difficult to realize."[28] It was the most sacred of all the cities of Gaul. Its sacred spring, Deus Nemausus, issuing from one of its highest hills, now in peaceful eddies, now rushing in waves of foam, gave a constant sense of the presence

of the gods; in the Maison Carrée itself are two fine statues, one of a lady, one apparently of the Goddess Ceres, which are each more life-like and individual than the head of Venus, which is in fact a reproduction of the Venus in the Capitol. But as we look at these, we see that, exquisite as was the feeling for line, and therefore for drapery, there is a lack of animation in the face. The fires of vitality refined to a spiritual strength are not there. Understanding as it did felicity of proportion, both in architecture and in this draped or naked figure, this sculpture could not draw aside the muddy vesture of mortality. So ever had it been with Hellenic art itself. Roughness, then grandeur, then grace, and at last voluptuousness: such were the human counterparts of nature's process of growth, completion, and decay. In Hellenic art these principles are clear. At the beginning, when the influence of Ægina was supreme, it was hard, full of vigour, archaic. In the age of Pheidias it has nobility, restraint, calm. And then a change was felt. A delicate sensuousness took sharpness from the chisel; grace appears where once was majesty, and one feels that, like Pygmalion, the sculptor loves Galatea rather than perfection. It is to the sensuous imagination rather than to the sense of moral grandeur that the sculpture of the School of Praxiteles had appealed.

IX

A similar sense of ease and comfort invaded the Provence of the Antonines, where Greek culture impregnated the Roman Empire. For six centuries the Romans were the masters of Provence. They had brought thither order, pleasures, and conventions oddly similar to our own. In the amphitheatres each rank had its place; crowds watched the exciting races of the chariots; water was plentiful, although brought from far away; baths, with a restaurant and library attached, were forerunners of some London clubs; the sanitary arrangements were completed by a sewer system. Huge theatres drew crowds to their plays, pantomimes, and dances; brass memorials recorded the capacity of the race for prowess. In the temples—which were meant not as homes of silent prayer, but as places where men assembled to pay a social tribute to the symbols of power, or the power of convention—there was, provided that neither the standards nor the system of the Empire were touched, a broad

and tolerant attitude towards the supernatural. Coins stamped with the head of the ruler were used for marketing; the towns were carefully planned; in the private houses collections of pottery stamped with classic figures gave elegance to the table; and tombs with inscriptions, on which were set shapes of the finest glass for the ashes of the dead, seemed, like Horace, for a season to defy death.[29]

But with all this culture and distraction laid over the poignancies of life, there was yet in Imperial Provence an unseen want. "In living from day to day," says their great historian, "without the stimulus of lofty political thoughts, military ambition or moral reform, the Emperors upheld millions of men in the desire for comfort and easy living. The world was full of people who were devoted to the majesty of the Prince." [30] The formula *majestati eius devotus* appears as a favourite in inscriptions; it was used by the humblest citizens, and one may well believe it was sincere. But this devotion resembled neither that of the Athenian for his country, nor that of a knight for his king, still less of a Christian for his God. The peace of the Imperial epoch did not permit lives so beautiful. With regard, then, to his ideal, a man was satisfied by an altar, a prayer and an inscription, by a few words and a few conventions. But no soul surpassed the habitual sentiments, the mediocre qualities, the decent virtues.

All that was noblest and most poignant in Greek and Roman culture offered but this; with a power, both more tender and more strong, genius had begun to find in the Church the inspiration for its masterpieces. There the ideal of a benevolent sovereignty of the race survived, and, with it, a heightening of the ancient virtues, a solution of the enigmas of both conduct and philosophy. There both duty and sacrifice were ideas more precise and more heavenly. The new religion was still a humanist culture, glorying in the works and life of man. "It resembled", says Jullien, "the religions of the East in its mysteries, and those of the Mediterranean in its human realities. It took from the mysteries only the most simple, from human life only the most pure." [31] And whereas humanism left man disquieted by the devices and desires of his own heart, the Christian faith offered him a means of calm which was itself a solid ground of hope even in the depths of suffering. In the museum at Arles there is an excellent opportunity to see in what light these people of the new religion looked at death; for it has the finest

collection of Christian sarcophagi outside the Lateran. The simple words, *Pax eterna*, promised to Christian genius a higher and serener spirit than all the monuments of the Romans in their greatness.

Idealism, culture, dignity, restraint combined with a system of philosophy—these a sensitive Jew or Christian could admire in the masterpieces of building and sculpture in pagan Greece or Rome. But he would not find even in their subtlest suggestions the elation, the vigour, or the life which his poets owed to their belief in a personal God, as Creator, and therefore Artist, of the world around them. No episode of love in Greek or Roman literature came near the healthy raptures of the Song of Songs, or could have been so transmuted into mysticism. Nevertheless, one could hardly see how, without a certain infusion of Greek idealism, the Hebrew could have attained to art or a philosophy of art. The fusion took place in Alexandria in the mind of an Egyptian Jew steeped in Platonism.

Could one look into men and things and through them till one saw beyond them? Could the mind, by thinking of what it admired, develop at the same time an intuitive communion with a glory it could worship? That was the question which had come across the Mediterranean from Athens to Alexandria, and was being discussed by philosophic Jews on the Egyptian coast, when eastwards, beyond the desert and the palms of the Sinai peninsula, it had begun to dawn on other Jews that Christ was all in all.

CHAPTER II

1 Chateaubriand, "De Paris à Jerusalem", *Œuvres*, IV, 103 (edn. 1853).
2 Byron, *Childe Harold's Pilgrimage*, Canto II, stanza 87.
3 Dugas, *Greek Pottery*, Eng. trans., p. 38.
4 Longinus, *De Sublimitate*, VIII, 4.
5 See *Ethics*, XI, 77, b 26.
6 Hesiod, Th. 195; Homer, *Iliad*, III, 374; V, 312.
7 Pliny, *Natural History*, Book XXV, ch. 36.
8 Quintilian, XII, x, 8.
9 Pliny, *Natural History*, Book XXXIV, sec. 50.
10 Pliny, *Natural History*, Book XXXV, sec. 128.
11 In the "blonde head" and the Κοραῖ in the Acropolis Museum, the patina gives a subtler glow than deliberate colouring could ever have given.
12 Aristotle, *Poetics*, XXIX.
13 Cf. R. G. Collingwood, *Principles of Art*, p. 53. It is, therefore, not a mark of incompetence in the representative artist that his works are not literally exact copies of their originals.
14 Sir R. Livingstone, *The Greek Genius*, p. 181.
15 εἴδωλα.
16 σκιᾶς ὄναρ.
17 Plato, *Republic*, 377 E.

[18] Plato, *Republic*, 401 C–402 A.

[19] Aristotle, *Ethics*, II, civ, 3.

[20] *Idem, Ars Poetica*, p. 309.

[21] Tennyson, *Oenone*; cf. *Republic*, IV, 430; b–c 443.

[22] Longinus, *De Sublimitate*, d–e, III, 412 a–XXXIX.

[23] Plotinus, *Enneads*, I, 6.

[24] C. Kingsley, *The Heroes*, Preface.

[25] See my "Roman Provence", in *Times Literary Supplement*, 1928, p. 56 (Jan. 26).
A summing up of Platonic Aristotelianism is in my "Margins of Philosophy", *Times Literary Supplement*, 1925, p. 225 (Nov. 5).—R. S.

[26] XV, 60, 64.

[27] Gellius, I, 3, 27.

[28] C. Jullien, *Histoire de la Gaule*, VI, 339. Cf. Fernand Benoit, *Arles*; Espérandieu, *Recueil Général des Bustes, Statues et Bas-reliefs de la Gaule Romaine*.

[29] See "Roman Provence" in *T.L.S., loc cit.*

[30] C. Jullien, *Histoire de la Gaule*, VI, 298.

[31] Jullien, *op. cit.*, VI, 201; cf. IV, 487, 488.

I

IT was the mystical Hebrew interpreter, Philo of Alexandria,
who, although he never believed in a Saviour promised by
God, came nearest to the idea of the Incarnate Word. For
he, too, had taught that there was a Word or Concept which
was the living Mind of heavenly wisdom. Believing in God as a
Creator who guided with His eye the souls of men, who had
revealed to them a law and a way to lift up themselves to Him,
and who had promised them a Saviour, Philo's deep, spiritual
mind was able to give a new meaning to the philosophy of
Plato and Aristotle.

Plato, through eager and relentless questionings, had come to
teach the immortality of the soul and the spiritual nature of
truth; Aristotle, less of poet, less of a seer, but with a mind of
harder common sense, had taught that the essential realities
were known through the world of sight and touch: for to him
the exterior world was also a reality, as common men took it to
be, though a reality of less cogent import. To be the master of
things, Aristotle had, as we have seen, begun with a right concept
of things, a thought of them rightly expressed. To a Platonist
like Philo, however, this applied not only to general conduct
and cognition; it applied not only to the world as a whole, but
also to the Universe; and ultimately this understanding of the
Universe, rightly expressed, was the Spirit of Wisdom which
was its Creating Soul. Just as the sculptor's thought had
created his Aphrodite, so the thought of a Creative Spirit had
planned and moulded the Universe. Thus, finding an analogy
from the work of the artist and of the artisan, Philo taught that
the life of the Universe was a Soul whose reality was mirrored in
the successiveness of time.

Philo taught that the human mind and heart are the meeting-
place of two scales of being, one a finite world of outward
things, and the other a divine and happy soul, sharing ideas with
the Architect of the Universe.[1] When the mind receives an
impress, either from within or without, it becomes pregnant
and labours to bring forth its Conceptions. The human voice,
he actually said, is the midwife of this birth by which the
conceived thought is brought forth. Like a thing hidden in
darkness until light shines upon it and shows it out, so the con-

ceptions are stored away in an invisible place in the mind, until the voice, like light, sheds its beams upon them and reveals them all.[2] "Beautiful words", as Longinus was to say, "are the very light of the mind." [3] He that opens the womb of each of these—of mind to mental apprehension, of speech to the activities of the voice, of the senses to receive the picture presented to it by objects, of the body to the movements and postures proper to it—is the invisible, Seminal Artificer, the Divine Word.[4] Already in Philo the ideas of word and genera-tion were intermingling: this suggested both the creation of the artist, a life that was the light of men, and the connection between right concepts and noble expression: "When we perfectly know the thing we are saying, our speech, rejoicing, is rich in words of emphasis and dignity: it runs fluently and amply: it presents a distinct and powerful picture".[5]

II

So far had the Platonic tradition gone in its philosophy of truth and beauty when it first joined the new preaching of Christianity. All know that the philosophy of the Logos became so near to the theological doctrine of the Incarnation that the writer of the last and greatest of the evangels of Christ takes over from the Platonists, possibly from Philo himself, the very word Logos for the Christ. He thus made the Saviour an answer to those problems of philosophy which Alexandria had inherited from Athens. It was in the terms of Neoplatonism that Christianity found its most classic expression in the century after Christ. It is from the Platonic theories of beauty that it takes its ideas of artistic grandeur. But it makes them more distinct because it identifies in Christ the formation of the thought with the generation of the Son. It insists, in other words, that to think is to conceive.

It is Philo who leads us to this central doctrine of Christian art. He wrote that the created world was a work of art, built according to the picture of it elaborated in the mind of God, as the artist pictures in imagination the shapes which he is to give to his material, or the architect makes a design for the city he is to build. Reason, Philo argued, was the image of the creative mind, and the World, as the human reason understood it, was an archetypal seal, or model, and this model, the idea of ideas, was the Reason of God, who, when He had determined to

create this visible world, previously formed that one which is perceptible only to the intellect.[6]

Though Philo, knowing that God had made the sea, and that His hands had prepared the dry land, thus found a way of spiritualizing the outward world, although he offered a basis to the Christian Origen for an elaborate, and indeed almost fantastic Christian symbolism, the idealism of the Platonic tradition survived, and was to reach its consummation of subtlety and spirituality in the third century in the system of Plotinus.

Before Plotinus wrote, however, Christianity and Platonism in St. John the Evangelist, St. Paul and Origen had been interpenetrating one another. "We are taught", wrote Justin Martyr, "that Christ is the Word (or Reason) of whom the whole human race are partakers, and those who lived according to reason were Christians, even though accounted atheists. Such among the Greeks were Socrates and Heracleitus." [7] Such a temper marks also Clement of Alexandria,[8] and though we see from Plotinus the atmosphere of Platonism in a Roman colony not yet Christian, neither will really be understood till we turn back to St. Paul. He was the first great Christian artist. In passage after passage he shows himself a master of style. Even if he had been taught well in the schools of rhetoric at Tarsus,[9] Christianity gave him in subject and style an entirely new scope, as it made him a new man who had seen unspeakable things.

III

The great convert owed his Christianity to a personal experience.[10] Whether or not there was anything material in it, it was a great reality which altered his whole attitude and character. From this point of view he presents his new religion, reasoned from the beginning and forced by reason to transcend reason.

He looks out on the outside world. It implies a power behind it, a power going back beyond the dawn of time.[11] This power is what he recognizes as God, whom almost all around him instinctively or rationally believed to exist. Whether or not they were Jews, men should be rationally interested in the relation of this Supreme Being to themselves. He had made the heavens and the earth, the visible and invisible. He therefore gave to all men life and breath and all things. He made of one blood all races of men to dwell on the face of the earth; defining

their appointed times and the bounds of their habitations, if haply they might feel after Him and find Him, seeing He is not far from every one of us; for in Him we live and move and have our being.[12] For if, indeed, creation is upheld in life and movement, it can be upheld only by that Power which originally produced it. And it was rightly said that we also are His offspring.[13]

But if God thus created and upholds the world, can He leave it ignorant of Himself? How can He, the Lord and Giver of Life, be other than beneficent? Yet if He is beneficent, must He not first reveal, and then transmit, the mystery of His own spiritual life? It was felt that He must, and there were many prophets and oracles of God. How choose between them? Only by One who showed the same mastery of phenomena, the same power of life, as the Upholder of all things. The revelation of God was the Man who had risen from the grave.[14]

But though there were many witnesses of the fact, they would not in themselves carry conviction to the incredulous. Men would accept the evidence only if there was in them a certain conformity to the Divine Mind which would make them accept as real what they felt to be desirable and give them an interior evidence of what they could not see. This was a quality, a gift of inner power. St. Paul called it faith. It came in different ways to different men's minds. For his own part, it had broken into all his ways with an astonishing interruption: "I was not disobedient to the heavenly vision",[15] he said in his telling way, in which speech so often bordered on poetry. In whatever way the revelation came, it carried intense conviction and became the dominant motive of life and reason.

It opened, indeed, a whole new world of thought, a world where the mind assisted the heart, and the heart assisted the mind, to accept a scheme in which all that has been laid low should be raised up, and in which all things should return to perfection through Him from whom they took their origin.[16] From the beginning of the world this restoration to perfection had been in the Divine design.[17] This was the purpose of the world. This was the riches of the mystery hidden in the Incarnation, the Passion, the Resurrection of One whom St. Paul declared to be the fullness of Him that filleth all in all; and it was accomplished by God taking Man's nature into His own, and adopting men to continue His process into this abounding fullness. "He hath chosen us in Him before the foundation of

the world that we might be holy and immaculate in His sight in love, who predestined us to be adopted as sons, through Jesus Christ, into Jesus Christ, according to the purpose of His will, for the praise of the glory of His grace in which He made us accepted in His beloved Son." [18] What was this grace? It was that of which faith was a part, it was a sharing in the mind and life of God, so as to understand what was beyond the highest speculations of human wisdom. It was the gift of and participation in that Spirit, Who, mysteriously united with Christ, was at once the pledge and the agency of the new inheritance of incorruptible life in giving which God had so signally manifested His glory.

This was the doctrine by which St. Paul elaborated and elucidated the teaching and the system of the apostles. It accounted for the peculiar position of Israel, for they were chosen as the people through whom the mystery of God's beneficence was fulfilled.[19] It solved the difficulties of pantheism by showing that God had marked the Universe with His creative fashioning; it transcended the wisdom of the philosophers, and it offered a revelation to the simple: God's desire for creation was to raise it to His own perfection.[20] It therefore gave a man a certain divine and heavenly scope, which gave a different significance to all he did, and all he made.[21]

If we are to regard this thesis as a work of human reason, is not Socrates himself outdone? Subtle, mystical, profound, St. Paul's doctrine presented Christianity as a system not outraging but, as we have said, surpassing reason. Christ was not merely He who had risen again, but also He who enjoyed all power and domination, and who exercised that supreme power in uniting with Himself His Church, which was His Body, so that it also became the fullness of Him who filleth all in all.[22] Ultimate reality was neither a pattern and abstraction, nor yet a mere interchange of potentiality with act; it was the mind and power of God drawing into Himself, through the unity of mind and body in man, the whole scheme of the visible universe; it so made it a means of the perfection of human character; it created beauty in the lives and minds of men, who contemplated it. For where the spirit of the Lord is there is liberty; but we all, beholding as in a mirror the splendour of the Lord, are changed from splendour to splendour, as it were by the spirit of the Lord.[23]

IV

The mystery of revelation which set forth the scheme became, therefore, the mystery of transcendent qualities of character. Members of the Church were to be one body and one spirit—outwardly, that is to say, and inwardly one, joined by a bond of peace, through the one life and grace which united them with that One who was above all varieties and who ordered them all. They had with Him, and with one another, the pledge of one baptism, which was "a washing of regeneration" [24]—the cleansing of a new life; they had with Him, and with one another, the pledge of a mysterious communion in the Body and Blood which meant also the Soul of Christ.[25] Let the Spirit of Christ dwell in them richly in all wisdom,[26] and let their practice be in conformity with that Divine Life which they saw through faith that they had inherited. For did it not fill them with a charity which believed and hoped, suffered and sustained, was patient and kind, and which, like a delicate instrument, responded in vibration to the feelings of other hearts, whether that was suffering or joy? [27] Did it not fill them with joy and peace, so that they might abound in hope and in the power of the Holy Spirit? [28] Let the peace of God which passeth all understanding keep their hearts and minds in the knowledge and love of God;[29] let them rejoice in the Lord always, and yet again rejoice.[30] The fruits of the spirit are love, joy, peace, patience, benignity, kindness, long-suffering, gentleness, faith, modesty, continence, chastity.[31]

The apostle knew the effects of the great mystery of which he was speaking: grace had been sufficient to him. He had begun by obedience to the heavenly vision; and now to live was Christ.

His heart flowed over as he thought of all that God was giving to him, and to all men. It had not entered into the heart of man to conceive the good things that God had prepared for them that loved Him.[32] "O the depth of the riches both of the wisdom and of the knowledge of God: how unsearchable are His judgments, and His ways past finding out!" [33] And in the meantime let man refrain from abrogating the privileges of His perfect knowledge. The time would come when He would open the hidden counsels of men's hearts, and then, when all was known, all men would have His praise.[34] And St. Paul, for his part, could write to his converts at Philippi: "I thank my God upon every remembrance of you".[35]

V

Christianity in such a writer had found either a new development or a new expression. The counsels of perfection are still there, but they are not so much categorical imperatives as the inevitable consequences of accepting a view of the universe. Grace and faith found their inevitable realization in the life of charity. The Messiah of Israel was the Master of all things that were, and of all that were to come.

The Gospel and the Acts fall into a different scheme. Their difficulties were resolved, as far as one can tell, before they were written: for St. Paul was certainly the earliest contributor to the New Testament. He insisted that the unique and startling Personality who dominated it was endued with all authority and power. If He rebuked, it was because He was the Judge, seeing into the counsels of men's hearts; if He healed, or even destroyed, it was because He was the Master of changing creation, and, as One transcending time, might accomplish in a moment the works of His omnipotence. If His counsel sounded impossible, His life showed to those who shared it the mildness and wisdom of His system. Powerful and unequivocal, it has yet the serenity of a supernal truth which made men free, in knowing—and conquering—suffering and death.

Such was the doctrine which creates St. Paul's style, and was to alter the scope of all Christian genius. And we can better assess its energy when we see that it found no formal expression. All that we know of it we owe to some conversations, speeches, or occasional letters, written to scattered colonies of Christians in various towns, almost all in the Levant. But in these, dealing with causes of solicitude or of thankfulness, he pours out his mind. Each was, therefore, particular and appropriate to a small community living in towns like Ephesus or Corinth, in conditions considerably more primitive than men are living in them to-day. To each he had already spoken in sermons that sometimes lasted far into the night; with each he tried to express himself in the way they would best understand. Yet in these letters, so written, was expressed a view of the universe, of the Church of God, which, surpassing all others in its mysticism and its loftiness, shows how the Christian faith could give genius a loftier inspiration, a clearer view, an intenser feeling, a subtler luminance, a more delicate sensitiveness. If St. Paul was the first of Christ's artists, none was ever to be more powerful.

"Rome, the mistress of the world, which had listened to so many of the orations of Cicero, found in the letter which St. Paul addressed to her citizens the title to a higher honour. He had a source of persuasiveness that Greece had never taught and Rome had never learnt. It was a supernatural power, which delighted to throw into a prominence something which the proud had disdained, that spreads and mingles with the august simplicity of his words. And so it is that in his epistles we admire a superhuman power which persuades us against the rules, or rather persuades less than it captures our understanding: which does not flatter our ears, but strikes upon the very heart. As one may see a great river, as it flows through the plain, still holding the violent and impetuous force which it gained from the mountain where it rose, so this celestial power, in the writings of St. Paul, keeps, even when the style is most naïf, all the power which it brings from the Heaven from whence it comes." [36]

Gregory of Nyssa had already admired his skill and enterprise to convey ranges of meaning beyond what words had till then conveyed.[37] St. Jerome said his words were as thunder and lightning, and that he captures everything he touches.[38] Renan, though he criticized the roughness of his style, described it as the most personal ever known.[39] Grimm said that he had, if not the genius of style, yet the style of genius.[40] It was the expression of the most vivid and vigorous concepts, and of a life which he communicated to others by expressing it, the new and more abundant life of grace. This generative life within the mind gives a new scope and intensity to the meaning of style.[41]

He illustrates faith so as to make it a light of reason. In accepting a theory of the universe, the believer sees his own place in it: he finds himself part of the Divine personality and receiving a power to act divinely. Holiness is his vocation, which he is to work out in a great awe, yet steadfast and immovable, abounding in the work of God,[42] thinking of whatever things are good and beautiful and true,[43] looking at all around him as a mirror not only of himself, but of God, till his own likeness becomes changed from glory to glory, and he himself becomes the perfect beauty that he contemplates.[44] Yet St. Paul had hardly mentioned beauty. Beauty had been transcended by something higher, more gorgeous, more like a fire or rainbow, something which had come into Hebrew

SANTA SOPHIA, DETAILS OF INTERIOR. Procopius wrote of Santa Sophia: "It is distinguished by indescribable beauty, excelling both by its size and in the harmony of its measures." Worship was the means of wisdom and the principle of order.

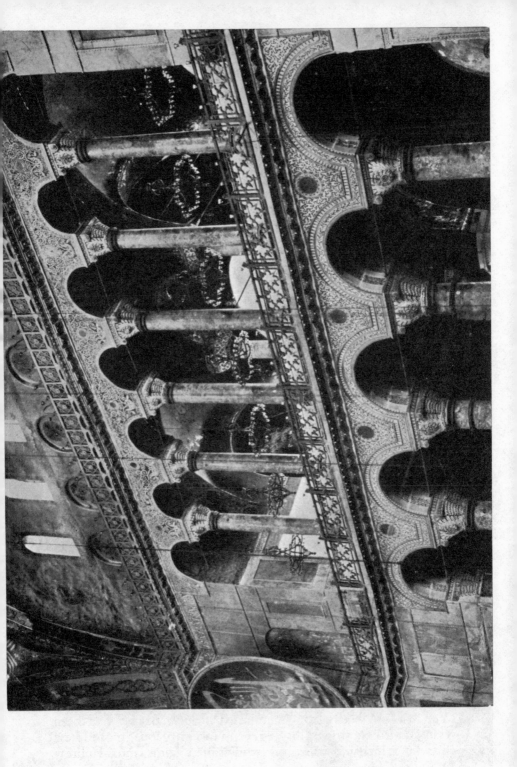

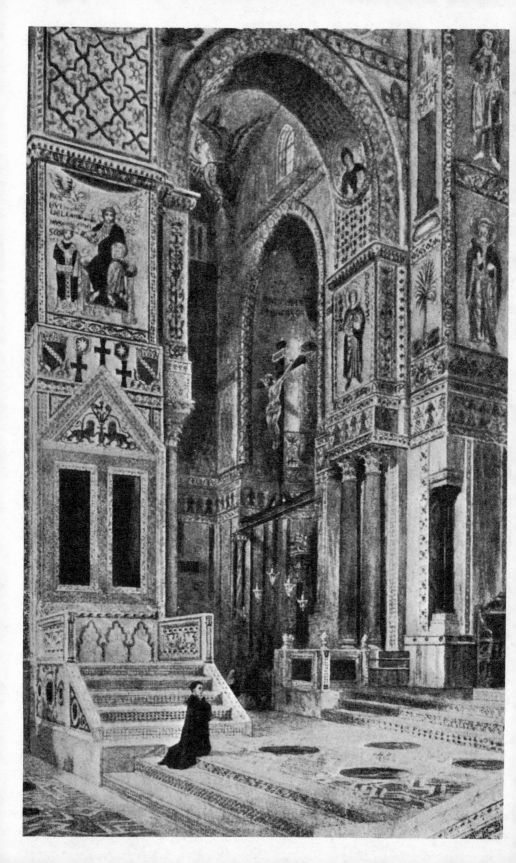

literature with its personal spiritual sense of a living Creator. The mark of St. Paul's own fervent, eager style, the distinctive quality of the sublime genius of the Church, was the word St. Paul most loved to associate with grace: it was glory; glory given yet nobler grandeur by the Cross.

VI

The great artist made this glory personal and intimate by linking it with the stress of every personal trial,—want, the severities of climate, personal violence in the form of stoning and of the scourge with all its terrors, again and yet again, the dangers of constant journeys on roads infested with bandits, the storms breaking upon the little boat, till thrice they actually wrecked it—such hardships as clinging to a spar for hours, as floods, as treacherous friends, and the religious hatred of his race, the uproar of heathen fanatics, the peril of the Roman law,[45] and through all these, more piercing, a sensitiveness which made him feel that he—and Christ Himself—were at stake with the virtue of every convert, and with the unity of the Church. And, besides these illness, hunger, thirst, exhaustion, a sense of looking unworthy of his message, the pangs of penitence for his own sins, and a rigid asceticism, left him no solace, and no ambition, but the crucified Lord he preached.

This marvellous example of the mind and life of a saint is one with the vitality and finish of his eloquence. The range and vividness of his experience, the rapid turning of his thought, the freshness of his images, the vigour of his argument, the pointed quotation, the sway of impassioned eloquence were all part of a genius that was a literary genius. He was a master of phrases, and has made them a part of our civilization:

O grave, where is thy victory? [46]

You are our letter, written in our heart, known and read of all men; written not with ink, but with the Spirit of the living God, not on tables of stone, but on the fleshy tables of the heart.[47]

Though I speak with the tongue of men and of angels, and have not love, I am as sounding brass and a tinkling cymbal.[48]

Christ being raised from the dead dieth no more; death hath no more dominion over Him.[49]

The God and Father of our Lord Jesus Christ, who is blessed for evermore, knoweth that I lie not.[50]

THE BASILICA AT MONREALE, A CORNER OF THE INTERIOR (from a painting by Axel Haig). Ravenna is a city that awakens the historical imagination to the inspiration and splendour of the Christian religion and we see in it extended what is shown in the Cathedral of Monreale.

In view of this new power of words, it is not surprising if some have urged the hypothesis that St. Paul himself was the real founder of Christianity. This contention, however, receives little support from the full record: the Saint himself referred at every point to his Leader, who was not an abstract ideal, but a Person, known well to his contemporaries, One who had lived among them, died, and risen again. The Saint puts himself in complete touch with the followers of Jesus, who had known Him, and between Paul's record and theirs there is no discord, no discrepancy. He claims no originality, nor have we any reason to think that he had any other than what is known as inspiration. He shared with the Church in which he lived the gifts of the Spirit, which was the Spirit of Jesus: what was unique in him was his function, as apostle of the nations, to state a doctrine which he had received from Jesus Christ, and the letters he wrote, together with his sermons, prove to be its informal recapitulation.

When he wrote, if not all the gospels were yet unwritten, one at least was. But written by one who spoke with every sign of intimacy and certainty, this gospel revealed an aspect of Jesus which was in perfect conformity with the mystical Redeemer whom St. Paul had preached. Full of grace and truth, Christ gave to those that received Him the power to become sons of God. Christians were to be related to Him as the branch is to the Vine.

There are epistles in the New Testament which were not written by Paul. But most of them have such close correspondence with those he did write that either his influence was strong upon their writers, or else a community of mind and of power of expression marked them and him with kindred signs of great mystical genius. The same Spirit inspires them all.

VII

This fact is made remarkably clear when we consider the earliest Christian writings apart from the Canon of the New Testament: the martyrdom of St. Polycarp, the epistle of St. Clement, the *Shepherd of Hermas*. The writers of these documents were men of an entirely different order. The power of eloquence, the saintly elevation, the subtle mystical doctrine, the amazing present intricate applicability which mark the New Testament, are exchanged for something not appreciably above

the Jewish prophets to whom they so constantly refer. And as an ethical teaching, there is very little peculiar to either Judaism or Christianity. The later Hebrew prophets, Buddha, and Plato taught the same virtues. Marcus Aurelius, who persecuted the Christians, had, like Seneca before him, the same ethics as the Gospel. There are likewise many parallels both to the miracles of the Gospel and to its central mysteries of baptism and communion. But to the combination of its teachings, its miracles and its mysteries with the system of St. Paul and with the moral elevation of the society of the Saints, as exemplified and taught by St. Paul—to this combination there is no parallel. It presents as a whole that for which neither Christianity, nor the world, had yet found an expression. St. Peter had indeed believed with a belief that had been declared to be given by God, and not of flesh and blood, with a belief which made him the Rock on which to found the Church. St. Peter had said, "Thou knowest that I love Thee",[51] and had been commissioned to feed Christ's sheep. St. Peter had become the fisher of men, even though they were not Hebrews, showing them how to become "partakers of the Divine nature".[52] But to present Christianity as a light to the mind, as an explanation of life and the universe, as a great reasoned system in which reason rose above itself, surpassing all wisdom and knowledge in the truths of faith revealed and completed by the power of grace, this was the peculiar function of St. Paul and sets a model to all the inspired apostles.

This great artist can be understood only by a veneration which puts the critical faculties into the secondary place. Faith, as St. Paul argued, is a gift more powerful than that of a suspended judgment. What we know to be true in personal relations and in practical life, that, more obviously, we must first accept as the only way to understand a supreme man, or a supreme truth. St. Paul first made it clear that love and admiration are indispensable, for before the sublime, appreciation is juster than criticism and shows us more. For the more we think of the sublime, the better we know that by it our common thought is lifted to a realm where the sublime itself becomes the measure. There the standard is things hoped for; there man has a taste of things which pass his understanding; there another light discloses what to more ordinary eyes must have remained hidden to the end.

This example, never to be surpassed either in personal force,

in solicitousness, or in elevation of theme, was to mingle for centuries with the Platonism of the Eastern Mediterranean, till few knew on either side just where the one ended or the other began. It was in these border regions, where the natural was becoming supernatural among the mystics of Egypt and Carthage, that Christian genius bloomed and where its theory was elucidated. As Philo had been in the first century, so was Plotinus in the third. And from Plotinus, Christian genius learns new lessons in mystical idealism which give subtlety, as St. Paul gives power, to the genius of St. Augustine.

PLOTINUS

VIII

Two hundred years after St. Paul, Plotinus was still insisting that the origin of creation was a spiritual reality who was the Good, the One, of which Thought (Nous) is an emanation, as the soul in turn is an emanation of this thought; for nothing in Plotinus suggests that the One thinks, as the God of Aristotle thought, if only his own thoughts. Plotinus taught that after the practice of virtue has strengthened and purified man's soul, he could rise from glory to glory till he had become like to the perfection which he contemplated, imprinting on his soul the image he admired and worshipped. Thus the admiring soul imaged the beauty of the Good, the True, the One.

Plotinus saw two realms of beauty, one earthly and visible, discerned by sense, though shaped by a spirit of beauty, and the other a beauty which was intelligible or intellectual, understood by the admiring mind, which was rapt with the delights of contemplation; yet the more general process was to delight the eye, and through the eye to awaken the mind to the delights of intuitive communion with the reality that its visible charm had brought before the imagination and the spirit. Thus to Plotinus the admiration of beauty became more spiritual, more religious than it had been before ; for as the new light spread, Platonism took on a Christian tint, and saw more clearly.

IX

To Plotinus the contemplated truth shone with a beauty which irradiated love. He taught that love was the central attraction of the Universe, and each individual spirit had been magnetized by it so as to be a source and centre of attraction. He had had an intuition of this irradiation of love into a

delegation of ennobling and redeeming influences from a hidden heart beating beneath creation, beating in each human heart that loved; he believed that this intuition told man the best that he could know of his true heart and home: at the origin of all things, therefore, was the Good, the True, the One, who emanated the wisdom and spirit of the Universe, and that from these, in their unity with one another, came a penetrating and pervading spirit of love. Here, then, at the fountain of life, beauty is truth, truth beauty. What need of more to know? Looking into this glory, till they beheld it as it were with the face unveiled, men would themselves be changed from glory unto glory, till the spirit of love seemed to dwell within them, making them into images, then inspirers, and then creators of beauty.

And so beauty is "the communication of a thought that flows from the Divine".[53] It is a formative idea corresponding to a thought of heavenly perfection, which in its unity can shine in the shining of a star, or on the surface of a stone:[54] or even, if it is not single, it can show the unity of a single plan in the diversity of parts when it rallies confusion into co-operation and makes the sum one harmonious coherence.[55] The perception of beauty, therefore, is the power to see the formative thought giving shape to matter, till upon common shapes is stamped "a shape excellent above the common".[56] So that through this excellence we may catch a glimpse of the eternal beauty. Then it is that an awe and trouble come upon us, for we have moved from the cosiness of the common world to the rare, sweeping air of the scarcely realized tablelands of truth to which certain souls are apt, though not without effort and exhaustion, to climb and take their pleasure. All, indeed, are apt to take delight in the beauty of a body; but all are not striving so sharply: it is only some that feel the keenest pang, and these are those that love. And so with the lovers of true beauty. All will agree as to what was admirable: but there are some who are so sensitive to beauty that it pierces them to the quick; they suffer from a pain of longing which is sweeter to them than all they have ever felt beside, a sort of troubled wonder which is at the same time an exquisite delight, a longing, a trembling, and with these a foretaste of joy which is the dawning of love in a heart, and is its response to the shining of the eternal beauty.[57]

But love can lose itself in the lower magnetisms, seeking to fulfil the instincts of eternity in a moment of time: or it can

make the moment a sacrament of eternity, taking all that sense
has told it as a symbol, which calls it to the eternal in a response
of gratitude and ardour. All, even the profane, can see some-
thing pleasant to the sight in the common ways: but it is only
those who dwell in consecrated places apart who can hope to
have the vision of that glory which shines in the inaccessible
light.

Is there not a myth of one who saw a beautiful shape playing
on the swift waters of a river, and sought to capture it, and, as
he sought, it sank into the current and was carried away? So
(in the teaching of the *Enneads*) is it with those that crave for the
possession of physical beauty and the thrills of natural love.
"He that has the strength, therefore," wrote Plotinus, "let him
arise and withdraw into himself, foregoing all that is known
by the eyes, turning away for ever from the material beauty
which once made his joy. When he perceives those shapes of
grace that show in bodies let him not pursue: he must know
them for copies, vestiges and shadows and hasten towards that
of which they tell. Let us flee then to the dear land of our
fathers," he cried, "the land of our fathers is there whence we
have come, and there is the Father." [58] Therefore the search
for true beauty becomes the discipline of the soul. The soul,
therefore, must not look for mere physical symmetries, but for
nobleness and virtue; it must seek these not only in others,
but within. "And if you do not find yourself beautiful yet, act
as does the creator of a statue that has to be made beautiful; he
cuts away here, he smooths there, he makes this line lighter,
this other purer, until upon his work we see a lovely face has
grown. So do you also: cut away all that is excessive, straighten
all that is crooked, bring light to all that is overcast, labour to
make all one glow of beauty. And never cease chiselling your
statue until there shines out on you from it the godlike splendour
of virtue, until you see the perfect goodness set surely in the
inviolate shrine." [59]

This is the man whom Aurelius Augustinus studied and
followed before he found Platonism completed by Christianity.

CHAPTER III

[1] Philo, *De Opificio Mundi*, ch. LI. *Legum Allegoria*, Book I, ch. XIII. *Cf.* Kennedy,
Philos' Contribution, 74–5.

[2] Philo, *De Congressu*, XXIV–V. *De Generalione Caini*, XIII. *Questiones de Genesi*, III,
but especially *Quod deterius*, XII, XXXIV.

[3] *De Sublimitate*, 30.

4 Philo, *Quis Divinarum*, XXIII, sec. 119.
5 Kennedy, *op. cit.*, 163-5. Philo, *Quod deterius*, XXXIV.
6 Philo, *De Opificio Mundi*, IV, VI. This had been adumbrated, however, by Aristotle. "In each of the three modes of production—natural, artistic, spontaneous—similar conditions are involved" (Sir W. D. Ross, *Aristotle*, pp. 173-174).
7 Justin, *Apology*, I, xlvi, p. 4.
8 St. Clement, *Stromateis*, VI, 67; for further discussion see C. Bigg, *Christian Platonists of Alexandria*, pp. 76, 77.
9 Such is the contention of Farrar and Ramsay, though denied by Deissmann.
10 Acts XXVI, 12-19.
11 Romans I, 20.
12 Acts XVII, 25-28.
13 Acts XVII, 28.
14 Acts XIII, 30, 41.
15 Acts XXVI, 19.
16 Roman Missal, Collect for Easter Even.
17 Ephesians I, 9, 10.
18 Ephesians I, 4-6.
19 Romans III, 1-3.
20 Colossians I, 26-29.
21 Colossians III, 16, 17.
22 Ephesians I, 22, 23.
23 II Corinthians I, 18.
24 Titus II, 5.
25 I Corinthians XI, 23-26.
26 Colossians III, 16.
27 I Corinthians XIII, 4, 5.
28 Romans XV, 13.
29 Philippians IV, 7.
30 Philippians IV, 4.
31 Galatians V, 22.
32 Romans XI, 8; cf. Isaiah.
33 Romans XI, 33.
34 I Corinthians IV, 5.
35 Philippians I, 3.
36 Bossuet, *Panégyrique de St. Paul*.
37 Gregory of Nyssa.
38 Quoted in Farrar, *St. Paul*, Vol. I, p. 619.
39 Renan, *St. Paul*, p. 232.
40 Grimm, *Letters*, 1788.
41 This phrase introduces a definition of Bonghi which will be elaborated in the course of the work. For further discussions of St. Paul's style, see Milligan, *Thessalonians*, LII-LXIII, and Farrar, *St. Paul*, Vol. I, Excursus I and II.
42 I Corinthians XV, 58.
43 Colossians IV, 8.
44 I Corinthians III, 18.
45 II Corinthians XI, 21-28.
46 I Corinthians XV, 55.
47 I Corinthians III, 3.
48 I Corinthians XIII, 1.
49 Romans VI, 9.
50 II Corinthians XI, 31.
51 St. John XVI, 15.
52 II St. Peter I, 4.
53 *Enneads*, I, 6, 2.
54 *Ibid.*, I, 6, 1.
55 *Ibid.*, I, 6, 2.
56 *Ibid.*, I, 6, 3.
57 *Ibid.*, I, 6, 4.
58 *Ibid.*, I, 6, 8.
59 *Ibid.*, I, 6, 8.

PART I

THE RISE

I

WHEN we come to St. Augustine, we find a man of the most rich and varied gifts. His mind was subtle, for it could combine contemplation with prolonged and exacting study. At the same time he had an artistic temperament, susceptible both to music and to beauty; and not least, he lived passionately by the heart. In his search for an ideal, Plotinism (in his own phrase, "the Platonists"), seemed best to satisfy his idealist speculations: but the whole argument of his great work is that no art, no beauty, no philosophical system can satisfy the taste and mind of man.

He found in Christianity a life so much more varied, so much vaster, that all his former pleasures and interests seemed arid. His range of interests was immense; for he wrote on rhetoric, on music, on patience, and on justice, as well as many tracts against heretics, on portions of the Bible, and a great treatise of mystical theology on the Trinity. While these establish him among theologians as a central fountain of authority, two of his works, *The City of God* and the *Confessions*, are landmarks, the one in history, the other in culture.

For as Aurelius Augustinus was himself a man of intense culture, so he took into the service of religion the wholeness of his nature. It is the competence of his mind, joined to the intensity of his human temperament, which provides the material of those works, which, though religious, have so strongly held the respect of laymen, and take their place in the history of culture. But as we consider them we shall see that the Christian faith gave St. Augustine a clearness of vision, and with it a refined elevation in the form and character, that stamp his work, and qualities which reveal the quality and significance of his conversion to Christ.

If we begin by seeing what his work owes to Plotinus, we shall the better be able to watch the intensity of the new dawn. Like Plotinus, he saw that beauty implied virtue. But of course

56

the quest for beauty was not merely the quest for virtue; for Plotinus, like Plato and Philo, believed in an archetypal world; he taught that we can attain to some notion of this archetypal world if we first picture the whole of the exterior universe we know—seeing part of it in motion and part of it at rest—and then try to rid it of the idea of space; and then, "taking care not merely to alternate it", cast out the infirm sense of matter: and call on God, praying Him to enter. "And may He come," Plotinus prays, "bringing His own universe with all the Gods that dwell in it, He who is the one God and all the Gods, where each is all, blending into a unity distinct in powers but all one God in virtue of that one divine power of so many facets." [1]

Such was the notion of the archetypal world which was pictured by Plotinus of Alexandria for this Carthaginian. He had drawn from the Platonists all those metaphysical faculties for moving in the world of thought, and in the realms of the unseen, among the invisible realities of good and truth and beauty, which contested with his blood a direction for the subtle interpenetrating faculties—so physical and metaphysical, so passionate and so idealistic—which made the love of his heart and occupied the fine energies of his intellect. Aurelius Augustinus could become a Christian only when his love could be made one with the spiritual vigour which gave the trend of idealism to the brain's genius of competence, though from early childhood he had known of the Redeemer who had given peace, patience, and purity to Monica his mother, and given her, too, a clearer vision of the unseen than Plotinus had depicted in the *Enneads*.

II

In his youth, Aurelius Augustinus had also studied the questions of symmetry and æsthetics and written a treatise on them, and later he was to write on music. Beauty and good taste were, however, not the only passions of his vigorous life. Endowed with a craving for amusement and an intensely metaphysical and vigorous intellect, and a blood that sent a thrill through every nerve, he loved exercise, and he loved love. To those of either sex he was drawn with the intrinsic force of strong physical attractions, and it was through the thrill by which excitement of physical sensation acted upon Augustine that his inflammable temper first burned for joy and beauty.

Life, in its power to radiate and expand, vibrated from his presence. It gave the lead to the ideal cravings of his genius. The pulses of his blood, so often heightened by the magnetism of his emotions, reached to the finest windings of his brain, and passed like an exhalation into the ardours of his soul.

At last it dawned on him that not in rioting, nor in wantonness, could he satisfy his cravings, but from the charity, the presence of Christ.[2] His minglings of revelling with idealism were exchanged for a new path to joy, a new image of beauty— an image so old and yet so new that, in the poignancy of his regrets for vain search and wasted time, he felt he had found it too late. There always, and always fresh, it drew him to admire and to enjoy his admiration, while it both satisfied his cravings and answered his curiosities. He saw that the truth must satisfy not only the metaphysical skill of the mind, but must make known the ways of life. The Platonists had taught him in their own language of thoughts and ideas that he could postulate at the origin of things a Mind to which his own, as the image, was in some sort the key.

For on Plotinus and his school Augustine realized that much of the mystery of eternal life had dawned. They had taught him that the Word was in the beginning with God, and that by the Word the world was made. And he learned that the soul of man, though it bears witness to the Light, yet is not that Light itself, but the Word which is God is that Light which lighteneth every man that cometh into the world. And that Word was in the world, and the world was made by Him, and the world knew Him not. So much the Platonists had taught him in their idealizations of wisdom, of truth and of the radiance of truth in beauty.

And this Word, this concept, was in truth before all time, and through all time unchangeable, and of His wisdom did all souls receive what made them blessed, because they are renewed by their participation in the wisdom and, in the renewal, are themselves made wise.[3] This also could Platonism teach him: so far did Platonism and Christian theology interpenetrate. Both agreed that in God we live and move and have our being.

But Platonism could not show the seeker what he saw by the shining of another light, a light which showed him both his nature and its own. It was, he said, the light by which he had been made. He that knows that light, he cried, knows truth and

knows eternity. There, in one glory, was that mingling of eternal truth with true charity, which made eternity dear to the heart.[4]

Now he had passed into the pure world of spirit. From there he looked back: he saw that the soul of man must make use of his bodily senses to establish contact with an exterior world; and from these senses his mind can rise to the faculties of imagination, by which the vibrations of sense are translated into the realm of thought; then above the faculties of all sentient creatures there comes the discourse and judgment of reason. And finally, in the flash of one trembling glance,[5] he fled from the multiplicity of images to a realization of the invisible world, and the order of all things in the unity of the mind of God.

But it is one thing to see the celestial city, and another to keep in the way that leads thither. For that one high way was made secure from highwaymen by a heavenly Ruler and His guards. The sensitive boy who had loved his games better than Greek, who had prayed when the thongs stung his young flesh, who had stolen pears, because the other boys liked to be disorderly, who had craved for and enjoyed the bodies of his young companions, who had searched the Platonists, and written on taste and beauty, had found at last, in the voice in which the Bible of his Redeemer spoke to his heart of grace and love, a truer beauty than in the sculpture of Praxiteles and the mystic contemplation of Plotinian idealism.

III

And so, though still to him—as they had been to Plotinus—beauty and glory were from within, there was in the contemplation of nature the personal interest of finding that its Creator was the Spirit whom his heart knew and worshipped. "I searched for Thee abroad," he wrote, "and blind to beauty, sought Thee in the beauty Thou hast made. And I was held far from Thee by things which, but that they were in Thee, might have no existence. Thou didst call, and shout and break my deafness: Thou didst glitter and shine and turn to flight my blindness. Thou didst throw out fragrance, and I drew in my breath—and now I pant for Thee; I tasted, and now I hunger and thirst. Thou didst touch me, and I was consumed in a flame of desire for Thy peace." [6] Augustine had turned

away from wantonness and selfishness, and from the wearying strain of earthly passion, to surrender himself to God. "He is Thy best servant which looks not so much to hear from Thee that which he himself has wanted, as to want that which he has heard from Thee." In this service he came to the discovery of beauty.

To Augustine, therefore, his joy in it must always be, as again Plotinus had taught, a communion with that Being who Himself is Splendour. Not perfume, not music, could enchant him, that his senses might rest, but there was something subtler and more enticing in clear colours free from gaudiness, and in the variety of pleasing shapes. This it was not easy to escape: how could he flee from that light which, as Aristotle had said in his treatise on the soul, was the means by which we see every· colour? [7] Thus, said Augustine in one of the most telling of his sentences, "the light, that queen of colours, which laves all that we behold, is ever gliding by me in unnumbered guises wheresoever I may have been through the day, and soothes me when I am intent òn other things, and so perceive it not. And so powerfully does it entwine itself that if it be suddenly withdrawn, we long for it and insist on having it again: and if it fail for long, our souls are plunged in gloom." [8]

But this was the light of the eyes—not that true light which makes all one who see and love it. And as it could entice men to let their hearts rest on natural beauties, so it could guide them to works of art of their own devising. But there was, he saw, a holier art than theirs. And so he said, "For that also do I sing a hymn to Thee, my God and my Glory, and make a sacrifice of praise to Him who offers sacrifice for me, since those beauteous patterns which are transmitted through men's souls to the skill of their hands as artists or engineers come from that beauty which is above their souls, that beauty for which my soul sighs day and night. But those who achieve and cultivate these works outwardly beauteous draw from that heavenly beauty the means of admiring it." [9] It is there, and they see it not: for fear it should demand too strenuous an effort, or lest they should forfeit those delicious languors in which so easily men and women of artistic temperament sink their souls; [10] they must either lose their sense of enjoying admiration, or rise through it to a spiritual contemplation of Him who had implanted in the order of the universe the secret of His own perfection: the very form of the world was as it were a voice

which answered the man whose musing questioned it that it was made by God.[11]

The purer beauty, therefore, was to be seen, as Plotinus had taught him, in a mystical contemplation of the transcendent glory. To such a contemplation his thought turned one evening when, after his conversion, he sat with his mother near the mouth of the Tiber at Ostia and looked out on a garden there. The beauties of Italy, its cypresses, its lilac, its arches, its orchards and flowers, its serene accord of shapes and colours, were behind them; before them the blue waters of the Mediterranean, their space, their waves, their sparkle, their openness to all the changes of light in night and day, of hues in dawn and evening. And then, as they reflected that even the keenest delight of the senses in the loveliest light of the eyes was not worthy to be compared with the gladness of the life to come, they passed above considerations of the sun and moon and stars, and, pressing on by the exchange of ideas to a yet intenser admiration, past all the miracles of mind to the realm of unfailing fullness, the pastures of eternal truth; there life is the wisdom by which all things were made, both things past and things to come, and which in itself was never made, but so is as it was and will be always; for it is that Word which is our Lord, who remains ever ageless within Himself, and so makes all things new. And as St. Augustine remembered how they spoke, he composed their talk into a passage of extraordinary felicity and loftiness: "If the tumult of the flesh were silent, silent the images of the earth, the waters and the air, if the poles of heaven were silent, and silent also the very soul in thinking not on its ways, but rising high above them, if dreams were silent and silent the revelations which are innate in outward symbols, if every tongue and every sign and everything which has existence in a transient state, if all these were wholly silent (for their voice says to him that hath ears to hear: 'We made not ourselves but He made us who abideth for ever'); but if this voice of theirs was stilled after it had called our ears aloft to Him who made them, and *He* should speak alone, not through them, but through Himself that we might hear His word—not through the tongue of flesh nor the voice of angels nor the thunders of the clouds, nor the dark riddles of similitude, but that we should hear Himself without these—Himself whom we love in these—just as we now strain ourselves forth and in the swiftness of our thought attain to the eternal wisdom which

remaineth above all things, and if this attainment should be held fast, and other visions far unlike in mind be eliminated, and this cry ravish and absorb him who hears it and steep him in inward joys so that life for ever should be such as that one moment of understanding for which we sighed, would not this be 'to enter into the joy of the Lord' and 'we shall all rise but we shall not all be changed'?" [12]

IV

Such were the powers of eloquence which Aurelius Augustinus commanded. The *Confessions* owe their literary power, their power to hold the attention of centuries of culture, to the openness with which the writer speaks, to his power to unfold the secrets of his feelings and his thoughts, to his memory, which he himself compared to a palace, and where rare varieties of learning and experience were ordered together in one personal life by a mind powerful because refined. In him his learning of the ancient world met that deep sense of a personal God which gave the Old Testament a power to satisfy the hearts and minds of men as a whole which was wanting in all the sculptures, the painting, the pottery, the poetry, the philosophy, and the architecture of Hellas, as it was also wanting in the learning and monuments of the Egyptians. The voice of God rang as the voice of man's heart. Augustine sought for redemption, and he found it. He found an escape from sin; for melancholy and suffering a better remedy than mere fortitude. There is in the *Confessions*, therefore, an energy of feeling not to be found in Praxiteles or Scopas, in Plato or in Plotinus, in Aristotle or in Philo, even when their hearts were tender or their style most happy. For the fusion which Philo had made of Hellenic philosophy with Hebrew religion had gone far, but it had not that personal intensity, that intimacy, that delicacy, that humanity or that mystical completion which St. Augustine owed to the dawning of the Catholic faith.

With the grace in his own heart had come the system of St. Paul, the burning zeal, the eagerness of strength, the clear vision of order, the mystical theology, the constructive faith, the sure and certain hope, the dissolving, constraining charity, with its tenderness and its joy, which meant that the spirit of Christ was dwelling within the heart and soul of man. This was true not for metaphysicians only, but for a Church in which

the poor and mean and lowly could grow to the measure of the stature of the fullness of Christ, and share with one another the fullness of Him which filleth all in all.[13]

And so it made St. Augustine not merely the writer of the *Confessions*, but also of *The City of God*. He was not only the metaphysician and æsthete who found that his admiring and questioning mind sought the Wisdom, which was the Word, of God: he was not only the passionate heart which saw from far the light of a beauteous companionship, and sighed for its repose: he was also the first to know something of the philosophy of history, and relate the system of Roman government to the instincts of the spirit.

V

"That most glorious society and celestial city of God's faithful which is fairly seated in the course of these declining times wherein he that liveth by faith is a pilgrim among the wicked: and partly in that solid state of eternity which as yet the other part doth patiently expect until righteousness be turned into judgment, by then by the proper excellence to obtain the last victory and be crowned in perfection of peace." [14]

Thus at the commencement did St. Augustine define his subject. It was other than the visible Church: it was the elect, the spiritual, the holy, "God's faithful", who were the salt of the earth, and gave a sense to history and civilization. He explained, not the Church as a society of good and evil men, but the ideals of the Church in relation to the cults and cultures and governments which St. Augustine knew: to Assyria and to Rome as Empire; to Memphis and Hellas as civilizations.

In the first ten books he defended the elect against the pagans; and then he discusses through four books the original progress and limits of the two cities, God's and the world's, and so on from Adam to the Flood, and thence to Abraham, and so on to the birth of Christ; so through all he traced "the great and manifold promises of God from the beginning until He in whom they all were founded, and to be fulfilled, were come to be born of the Virgin". Greek wisdom was in itself not free from subtleties: Vives, the great scholar of the Spanish Renaissance who worked in English, and added famous annotations to *The City of God*,[15] said that the philosophers of

Athens have left truth sick at the heart, they have so cloyed
it with excellence and wrapped it up in clouds. Augustine is not
content with that, but here and there casts in hard walnuts and
almonds for us to crack which puts us to shrewd trouble ere we
can get out the kernel of truth.

But nevertheless, amidst all that range of curious errors and
subtleties with which Augustine deals, he leads onward in his
last four books to his picture of the perfect society in glory:
not content with imagery, nor yet with mysticism, but pausing
in every interval of eloquence to throw on his subject all the
light that learning and ingenuity could bring with regard to
death, judgment, resurrection, and eternal life. In the beginning
of his work "he looked for a city which hath foundations, whose
builder and maker is God".[16] And at the end, he beheld, like
John in Patmos, the vision of "the holy city, new Jerusalem,
coming down from God out of heaven, prepared as a bride
adorned for her husband".[17] And so he comes to the secret and
mystery of the city of God, where heavenly things should not
be understood through the dark riddle of similitudes, nor
through symbols, however transparent, however closely identi-
fied with what they signified; but where heaven should
remould the earth to the heart's desire. "I heard a great voice
out of heaven saying, Behold, the tabernacle of God is with men,
and he will dwell with them, and they shall be his people, and
God himself shall be with them, and be their God. And
God shall wipe away all tears from their eyes; and there shall be
no more death, neither sorrow, nor crying, neither shall there
be any more pain: for the former things are passed away. And
he that sat upon the throne said, Behold, I make all things
new." [18]

VI

That was the theme to which all St. Augustine's long
disquisitions led at last, and so his idea of peace becomes
sublime. It was, he said, "the sweetest sound to our ears and
our best and most glorious possession". And here again he
shows his power; for peace is a social virtue, and meant an
increase of life by an interplay of work and a reciprocity of
possession. It gave an organic power to his ideals: it enriched
them with the traditions of the Roman Empire and made it a

prophecy of the architecture of the metropolitan temples, which now began to represent not merely justice, as the basilica had done, but the virtues, richer in blood, stronger in shape, and higher in their soaring, that were the fruits of incorporation into Christ.

To realize to the full the brilliance of light which outshone what the starry sky of Plotinus had shown to St. Augustine, to see the meaning of incorporation into Christ, to understand what the Church had added to the culture of the Levant, let us turn our gaze to the great Temple dedicated to that Wisdom which had been first revealed to the Hebrews, which had suggested to Aristotle the most Christian of his thoughts, which had been brought back into the Hebraic tradition by the son of Sirach and by Philo, and which after its brilliant application by St. Paul to the Person of the Redeemer, had been the supreme inspiration of Aurelius Augustinus.

CHAPTER IV

[1] *Enneads*, I, 6, 9.
[2] For a vivid picture of Augustine at the time of his conversion, see Edwyn Bevan: *Hellenism and Christianity*, Ch. VI.
[3] *Confessions*, VII, 13, *passim*.
[4] *Ibid.*, VII, 16.
[5] *Ibid.*, VII, 17. *In ictu trepidantis aspectus.*
[6] *Ibid.*, X, 38.
[7] *De Anima*, II, 7 (419 a).
[8] *Confessions*, X, 51. *Ipsa enim regina colorum lux.*
[9] *Ibid.*, X, 53.
[10] *Ibid. Eam spargant in deliciosas lassitudines.*
[11] Cf. Augustine on Psalm CXLIV, 13.
[12] *Confessions*, IX, 25.
[13] Ephesians IV, 13; I, 23.
[14] Opening of the first book (John Healy's translation, 1610).
[15] His edition was not published till 1610.
[16] Hebrews XI, 10.
[17] Revelation XXI.
[18] Revelation XXI, 3–5 (A.V).

I

FOR in spite of all the buildings we can admire in Rome or Provence, it was not the Romans who built to the fullest and finest on the principle of the arch. After the conversion of Constantine to Catholicism and his departure for Byzantium, the central temple of the new capital had been burnt down; it was his successor, Justinian, who gave orders to rebuild it, and dedicated it once more to the Holy Wisdom which the Christians of Greece believed, in the light of their faith, to have been incarnate in the Christ. The new church was at once accepted, and has ever since continued to be admired, as a satisfying, an unquestionable monument of the genius of Christendom. Procopius, who was a contemporary, wrote: "It is distinguished by indescribable beauty, excelling both by its size, and in the harmony of its measures".[1] Evagrius, writing a little later, called it "a great and incomparable work, which, excelling in beauty, far surpasses powers of description".[2] Paul the Silentiary, a contemporary of Evagrius, says that after the dedication of the church, as they came to the sacred courts, it seemed to them "as if the mighty arches were set in heaven", and "whoever puts foot within the sacred fane", he added, "would live there for ever, and his eyes well with tears of joy".[3] Our own medieval travellers were hardly less enthusiastic. William of Malmesbury speaks of it as "surpassing every edifice in the world"; to Mandeville also it was the finest church in all the world: in Capgrave's Chronicle it is "a marvellous and costful temple", to Sandys, writing in the reign of our King James I, it "exceedeth all fabrics whatsoever throughout the whole universe. A long laboure it were to describe it exactly, and having done, my eyes, that have seen it, would but condemn my defective relation." [4] Yet when he proceeds to description the sense of glory remains. "The principall part thereof riseth in an oval, surrounded with pillars admirable for their proportion, manner and workmanship. Over those others, through which ample galleries, curiously paved, and arched above, have their prospect unto the temple, dignified with the presence of Christian Emperors at Divine Service. The roofe compact and adorned with Mosaike painting. The rest of the Church, though of another propor-

66

tion, doth joine to this with a certaine harmonie. The sides did bloom all fiery red with excellent marble." [5]

II

This church has been claimed as a special achievement of oriental builders, of Roman builders, and finally as the supreme achievement of Greece. Among the arches and vaults of the Imperial City the dome was apparently never applied to a square plan. To do so it was necessary to invent at the corner of the square a special construction on which the unsupported segment of the circle might rest or hang, and this device was known as the pendentive.

The dome on pendentives was at that time known only in the East. There had been earlier examples in Asia Minor and in Syria, at Jerash, at Kusr en Nueijis in Amman, and probably at Samaria.[6] The architects themselves, Anthemius and Isidorus, came from Tralles and Miletus, cities in the neighbourhood of Ephesus; and it was apparently on Eastern models they had founded the perfection of their own style.

Yet if the device of the pendentive was Asiatic, and Rome had never known it, the arch itself could not but be Roman, and the ribbed construction of the dome was specially so. For Rome was the central city of the Mediterranean, to which the sky itself was a dome toning in colour to the sea, saving the day alike from glare and greyness, and bright with stars or moon from sunset to sunrise. The philosophers of architecture have seen something more particularly Roman both in dome and arch. They have seen beyond the value of this construction in drains and aqueducts, or yet again in bridges—in the architecture that first made water its servant—the fact that the Romans used it alike for the ornaments of their processional triumphs, and for the stupendous masonry of their baths. In the balance of brick with brick, or stone against stone, the noblest of their domes, rising above their Pantheon, was to give a model for that of Santa Sophia. It gave to these monuments of civic and social life an expression to that co-ordinated, complex, unsleeping energy which centred the law and governance of their empire on Cæsar's power in Rome, just as to-day the joints and members of the compact diversity of the Catholic Church find freedom in their unity with the Holy See. The Roman arch was the complement of the Roman road, which not only gave the

man of the provinces a way to Rome, but which also enabled
Rome to throw out its life and its ideals into the provinces.

Rome, which had met Greek civilization at Arles, met it
again in the Ægean. And where the Greeks influenced the
culture of their conquerors, they simplified it. In their own
classic buildings they had reduced the lintel of Karnak to the
purity of the Doric temple. The fluted columns and the pro-
portioned entablature were together logical, graceful, and
mysterious. What the Greeks had done hundreds of years
before with the lintel, they now did with the arch. They
recognized the essential principle and reduced everything to its
application. In the great temple of Justinian all was a concen-
trated unity of domes and arches leading to the central height
of the building. "All these parts", wrote Procopius, "sur-
prisingly joined to one another in the air, suspended one from
another, and resting only on that which is next to them, form
the work into one admirably harmonious whole." [7] Nothing is
irrelevant, nothing redundant, nothing jars. The curves unfold
in a perfect sequence and order from vault to vault, until the
instinct of balance has soared through regions of space and
light to that lofty heart of the full-breasted dome which, said
Procopius, seemed to hang from heaven, as though swinging
on a golden chain. Mass, space, and line cohere into a perfect
whole.

The absolute unity of order is unique even in Byzantine
architecture. Santa Sophia, said Lethaby, is alone among
churches. In the plan of its structure, said Ferguson, it seems
to stand alone.[8] "It has never been repeated," said Van
Millingen.[9] And yet we generally accept it as the supreme
monument of Byzantine art. With Byzantine, as with Roman
and Romanesque, it shares the apse, the dome, the vault: with
these, and with all Byzantine churches, it shares also the glitter
of mosaic and the elaborate finish of marble panelling. But in
the actual composition of the building, in the dominance of a
single principle through all its piers and vaults, it is so unique
that it has been claimed by Lisle March Phillipps as "the last
word in classic architecture".[10] He meant that it is the applica-
tion of the chaste intellect of Greece to the principle of the
arch, saving that from its conflict and confusion with the lintel,
clearing it of every superfluity, reasoning it out to its essential
principles, and then combining it, as Rome had never thought
of doing, into a complex unity in which, as we saw, all leads up
to the central arch.

For here is the supreme example of a dome resting on
pendentives. It was to this problem of supporting the dome to
which the architects of Santa Sophia addressed themselves;
and for the first time they met its full complexity. To the un-
supported curves and angles they applied the segments of
subordinate domes descending in order. These segments, says
March Phillipps, not only fill in the gap and afford a proper
foundation for the dome to rest on, collecting the thrust of it
at the angles immediately above the great supporting piers,
but they are in themselves a perfect logical application of the
domical theory, and their expanding, mounting curves are in
harmony with the scheme of the whole interior.[11] And so here
Greek reason lays bare the naked majesty of the device which
expressed Rome's order of balance, and then arranged it in
proportioned spaces in dim perfumed air of the censers, that
Eastern worshippers might raise sensuousness and fancy into
awe.

All was instinct with the spirit with which St. Paul, after he
had been steeped in Greek culture, wrote from Rome to the
Ephesians.[12] Here the soul of man had called forth a soul from
stone and marble, and made it one with light and air. For
softened and yet welcomed at every height, the light melted
through the walls, and pervaded in its spiritual and insistent
presence the simple yet sublime proportions of the building;
taking from the walls a glory not its own, it had been enthroned
not only in the gold of the mosaic, but on the reflections of
metal, of enamel, and of marble, so reigning as queen of many
colours, taking from each a lustre for its crown.[13]

III

Space, mass, and line had cohered not only with one another,
but with a surface of colour, softened but never obscured, to
give to the sublimest spaciousness yet known in building a
concert of tones which had, if not the movement, yet the
emotion and the soul of music. "All that is best of dark and
light" [14] met in its aspect—mellow, tender, and suffused, as in
the dawn. Nor was the effect to be admired only by day; from
the heights of the circle of stone which bore the dome into the
air hung pendent discs of silver which reflected the flames of
lamps; these were repeated with such frequency that at night,
as Paul the Silentiary said, it seemed as though the glories of the
temple were lit up by a midnight sun.

Sometimes in the form of a circle, sometimes in a cross, sometimes fixed aloft to throw out the detail of the mosaics, the lamps poured through the temple their light, their gleam, their consecration. "Some are placed in the aisles," wrote the poet, "others in the centre or to east and west, or on the crowning walls, shedding the brightness of flame. Thus the night seems to flout the day, and be itself as rosy as the dawn. And whoever gazes on these lighted trees, with their crown of circles, feels his heart warmed with joy, and looking on a boat swathed with fire, or some single lamp, or the image of the divine Christ, all trouble leaves the mind. So with wayfarers through a cloudless night, as they see the stars rising from point to point . . . the whole heaven scattered with glittering stars opens before them, while the night seems to smile on their way." [15]

It was not only the worshippers in the church who saw in this illumination the symbol of that true light which lighteneth every man that cometh into the world, but it spread light far out over the city and over the sea; "as it taught the sailor how to guide his ship to his desired haven, so also it showed to wandering souls the way to the living God".[16]

Whether it was day or night, the great temple of wisdom expressed in the wondrous order of its stones the life and soul of its builders, whose wisdom had seen that men of good will would attain to peace only when they raised their souls to the highest to give glory to God: the chime of man to man was suggested in the rising curves which spoke of the tuning of man to heavenly perfection. Here no Gothic striving, no arrowy aspiration called men to leave the darkness of the forest and shoot up like the windows of Chartres in colours of flame. This was the tabernacle of God with men, the Word of Wisdom made flesh, that He might dwell with *them*.

This temple, therefore, was not merely the architecture of humanism, convinced that man was the measure of creation: nor yet merely the architecture of religion, with a dome sown with stars like the sky above it; for it was also set out below with patterns: with green and coloured marbles, porphyry from Egypt, marbles from Carystus, Libya and Sparta which, when they were first arranged, could remind the poet who saw them of a stream in Thessaly with flower-enamelled banks, and corn in bud, and woods beyond. He could see the stream, the snow, the cornflowers in the field, and the crocus which

Paris saw break out into fire at the feet of goddesses passing by. He could see the flocks at play, the sage-green and silver of the olive trees in the wind, the tendrils of the vine in June, the play of the spray between oars and ship in the breeze, and "the deep blue peace of summer sea".[17]

It would be hard now to picture these, for in the long centuries the tones have dulled and mingled, as colours do, to dominant shades of green and amber. The reflection of the lustrous gold in the roof mingled with the watery quality of thick glass to something of the hue of alabaster lit from within. It threw a light warmer, though less intense, than day on to the polished artifices of porphyry, of verd-antique and marble. The crowning dome so

> stately set
> Many an arch high up did lift,
> And angels rising and descending met
> With interchange of gift.
> Below was all mosaic choicely planned,[18]

planned, not as in *The Palace of Art* with cycles of the human lot, but of the choicest Life with which the heavens had upraised man's fallen nature, the life of grace.[19]

IV

The first impulse towards the building of Santa Sophia came from the migration of Constantine to the Bosphorus. His genius for order had seen that true peace was centred upon the unity of faith: and for him the problem of administration was one with the soul's relation to the King of the Universe: and so his hope for all most prosperous and excellent things was that all, found together in brotherly concord, should adore the most holy God with the worship of the Catholic religion.[20]

On the one side we can see his policy in the Edict of Milan: its toleration—and toleration meant establishment—to the Church.[21] On the other we see his foundation of his new capital at the point where Greek civilization could stretch its hand to the continent of Asia. It was the marriage of Roman order with Hellenic Christianity which first generated the genius of fine art among the family of Christ. For Greek thought made religion a thing of the mind. As the great Hellenic thinkers had given the sinews of their intelligence, whether in metaphysical intuition or in hard logic, to the problem of Truth, reaching to the idea

that there was something divine in thought, so the ancient Jews had found that the essential was a law, dearer to them than thousands of gold and silver. The Greeks apprehended the Divine either as the origin of mind, or the president of the immortals; but the Hebrews believed that the heavens were the work of His hands, and He gave them blessing out of Sion; He was the Comforter of His people, as no other could be: and in the heart's communion with Him it was possible for men to mount up with wings as eagles. Therefore, to a people who could worship Him in the beauty of holiness came the Saviour, who, even in the womb of the Virgin, upheld all things by the word of His power, who atoned for sin by His life and passion, and who, in His resurrection, assumed dominion over death.

Plato had known well the nobleness of love and beauty, and his highest philosophy is the record of a genius for friendship. But Christ, for those who had seen Him as King in His beauty, was a view into that far-off land where truth and virtue were perfected in love. Love, in fact, had changed its nature: it was so close a unity of high with low, that it became divinest when most emptied of majesty to save what was lowly, mean, or base.

Here, then, since this was Christ, was a religion for the people as a whole; it was, therefore, the answer to the questions which the great ruler had to ask of his counsellors, his governors, and his own heart. Worship, alike for Cæsar and his people, was, indeed, the means of wisdom and the principle of order.

This was the idea which Constantine brought to a people whose traditions of thought were keener and subtler than the Romans had known, and which he planted at a spot where he had met, and restrained, those Anatolian hordes to whom worship meant so much and civilization so little.

But, for a cultured people, to be conquered is to teach: and the new rule was to be educated by its new subjects. It was not alone that two of the mightiest powers of civilization had met, but each was also touched with a new sense of the majesty of mercy.

v

As those ideas had met in the wealth of these conceptions, so, to enhance the skill of builders, many an ancient temple was ravaged. The eight great serpentine columns on either side of the nave are from the temple of Diana of the Ephesians; the

eight columns of porphyry arranged double between the piers were taken by Aurelian from the temple of the Sun at Baalbec after the conquest of Zenobia; other columns of marble have come from the temple of Pythian Apollo at Delphi and from that of Pallas Athene on the Acropolis. The sixty columns of the gallery are of verd-antique, of jasper, and of granite.[22]

Into this sumptuous scene came Justinian for the most significant ceremonies of his reign. Alike in his wars, in his administration, in his statutes of justice, he pursued one end: to be the champion of the Church—to reign as God's regent. If he built a temple better than Solomon's, it was because he believed that, as the master and governor of wisdom, Christ was greater than Solomon, and greater than the temple. He had no quarrel with Rome, for Rome was not near enough to trouble him: during his reign it became a mere provincial city, no longer Cæsar's and hardly yet the Pope's. Justinian sought to praise the Lord in righteousness—even in holiness—but so much a Cæsar was he as almost to be Pope as well. His temple therefore spoke less of holiness than of dominion and might. And it was for a worship that became almost an apotheosis that he and his successors came to Santa Sophia.[23]

VI

The imperial ceremonies of Santa Sophia continued for a thousand years: the ritual of its worship was in perfect accordance both with the proportions and decorations of its building and with that mosaic which Sandys described as presenting an inexpressible stateliness and being of marvellous durance [24]— where Seraphim and Saint shone out with all the glitter of enamel and glass, as in a robe of jewels against the golden hues of dawn, or a palatial canopy of cloth of gold. But at the last, as Christianity turned westward, the city of Constantine, after nine hundred years of Christian worship, fell to the power of the religion of Arabia; in 1453 a Moslem Emperor rode into Santa Sophia. Around the Dome was written that God alone is the Lord of Heaven and Earth. Discs were inscribed in Arabic with names and words sacred to Mahommedans. The mosaics were covered with a coating of whitewash.

From 1453 until a few years ago Santa Sophia was a mosque. After the Turkish conquest, as in many a church at the changes in Western Europe some seventy to a hundred years later, the

beauties created for the Church were destroyed to suit another taste in worship. This expressed itself in words, and in the absence of other symbols or representations such as the Church was wont to assemble as the background of the Mass. Not only were the mosaics of the domes covered over with chalk; the altar was torn down, and the silver ikonostasis, which had veiled from the people the holy mysteries, was borne away, to leave the central apse bare but for the Mihrab.

The Moslems brought in, from time to time, ornaments of their own: they covered their gallery for the Sultan in a fretwork of gold; they placed at the entrance great vases of alabaster, as fine in shape as they were warm in hue, raising the simple magnificence of their line to a height above a tall man's head against the purple of the polished porphyry columns; they gave a marble pulpit, delicately pierced with carving, like the ancient fretwork in the mosque of Kerouan; the two great candlesticks, which stand on either side of the Mihrab, stood one on either side of the altar of a church in Hungary before Sultan Suleiman I pillaged them and brought them hither. So, although defaced in the tenth century, Santa Sophia still bore witness that God is the Lord of heaven and earth, and in the month of Ramadan its lamps and candelabra threw out on to the sea a brilliance not so much paler than in the days of Justinian.

But balancing losses with additions, and pictures against lettering, the admirer of its brilliance, if a Western visitor, was apt to receive an impression not always of majesty and peace, but to have sensations of astonishment, sometimes of recoil. The story written there was not a simple one, any more than it is simple in St. Peter's. The exterior was squat and without character: the new interior, like the minaret at the four corners of Santa Sophia, told more of the Turks than of Justinian, and even of him Santa Sophia revealed more than his sublimest conceptions. Within its spacious harmonies of line, holiness had engaged in war with wantonness, with savagery, with pride. Among those fretted portals, those polished pillars, those towering piers, those gigantic arches, those mountainous heights rising over tribune and gallery through streams of softened light, come impressions not alone of order. The classic mingles with the oriental, and in the mingling come memories of fashion and faction, recalled by additions and ornamentations which are bizarre.[25] Caprice and presumption were not absent from the princes, whether Emperor or Sultan,

who decked out this temple in such magnificence to stamp with their own natures the glory they gave to the Most High. There also the pagan Court, and temple which had been merged into the potentate's Cathedral, had met both a new sensuousness and a new ardour from the dry air and sunswept sand of Arabia. But even as a mosque it bore its ancient name of Sancta Sophia. The piety of Islam—like that of the Church—believing that wisdom is true only when it is holy, hailed God as all in all.

The mosque still kept hidden under its coating of chalk—for us to re-discover—the portraits of Christ and His faithful, worked out in a medium which suggested the scales of a fish and recalled both the ancient symbolism of the Church and also those great quantities of fish which the stronger currents bore down the Bosphorus, and which, as many think, had given its name to the Golden Horn.

VII

For Santa Sophia is not merely unique in the unity of its vaulted construction: it is the highest example of the unity of these architectural curves with the separate art of mosaic.

This art is one of the most ancient: an example of it, held to date back to several thousand years before Christ, has been found at Ur.[26] It is a kind of inlay where several small tesseræ are arranged in symmetrical or conventional patterns: for floors these are usually made of opaque stone, but on walls the workers in mosaic make use of small pieces of coloured glass, of enamels, or of brilliant stones, such as agate, jasper or chalcedony, to prepare an elaborate design. The work long survived among the jewellers of Egypt, and had a particular vogue in later centuries in Alexandria. From there it spread over the Roman Empire, and a famous example of it is found in Rome in the Church of Santa Costanza, dating back to the first half of the fourth century; almost coinciding with Constantine, it is marked with influence from Persia.[27] From this time the art of mosaic was developed both in Italy and at Byzantium, and the two influences, as we shall see, met at Ravenna.

The roundness of the designs, the immense even spaces on the walls of the Byzantine buildings invited decoration: the roughness of the workmanship was an encouragement to the bold simplicities of line and colour to which the workers with

tesseræ were constrained. When painting was practically impossible, a fresco could not vie with a mosaic. In the sixth century alike in Constantinople and in Italy, by the generous use of gold tesseræ, these, made by inserting gold-leaf between two pieces of glass, gave to the whole effect a flash, a lustre and a scale of values which made the saints live, as it were outlined, against a blaze of glory. In the Roman basilicas, more often towering in the background in the soffits of the apse, and strengthening belief in the mysteries of the Altar, rises in strength and power the presence of the Christ: here, as they rose from the Altar, the eyes of the worshippers would rest.

They saw no representation of the figure of the natural man surveyed by their natural eye. They saw a figure vast, conventional, symbolic, as though the ideal of faith looked to something different from nature, and more like the order of deliberate imagination.[28] When this figure stood out against a background such as is seen only in the most dazzling changes of light, the bold, vast lines of the figure became even more august, and mingled with the vast space of building to steep the soul of the worshipper in awe.

"The Byzantine builder", says Symonds,[29] "directed his attention to securing just enough light for the illumination of his glistening walls. The radiance of the Northern Church was similar to that of flowers, or sunset clouds, or jewels. The glory of the Southern Temple was that of dusky gold and gorgeous needlework. The North needed acute brilliancy, as a contrast to external greyness. The South found rest from the glare and glow of noonday in these sombre splendours. Thus Christianity, both in the North and in the South, decked her shrines with colour." They were more even than the symbols of the Presence of the Redeemer, or of one of His Saints. They were, as Ruskin says of San Marco of Venice, "a vast illuminated missal bound with alabaster instead of parchment, studded with porphyry pillars instead of jewels, and written within and without in letters of enamel and gold".[30] They were, in fact, for rich and poor a Bible: a Bible that spoke more vividly to imagination perhaps than is often done by words. "The old architect", said Ruskin, "was sure of readers." [31] It is truer still of the *imaginarius*, as the designer of mosaics was called, and truer of the workers in stained glass who followed him in centuries to come when at Torcello, at Palermo, at Monreale, at Salonika, or at Daphni near Athens or at the abbey of Phocis,

which is a day's expedition from Delphi, he gave them a new impulse; such a designer knew that he was writing, for his own generation and for countless generations after, a story, a sermon, and a poem. His manuscript, written with glittering tesseræ on his page of wall, took the place of book or manuscript for such as could not read, and gave a more vivid and personal sense of its meaning even to those who could. The trouble is that the sense may be wearied by monotony or by excessive stimulation.

Such is the work which first gave specifically Christian significance to Santa Sophia. The mosaics were long hidden from us: from 1847 to 1849 they were uncovered by the Fossati, two Italian Swiss architects who did brilliant work for the Sultan Abdul Mejid, and who left a record of their impressions of mosaic and inlay in a series of coloured engravings which are one of the finest architectural records ever made.[32] Once again a ruler and a savant have been combining to give back these masterpieces to the world; and we can now realize of what capital importance to all work in mosaic is that which was done for the basilica of Justinian.

There is something Eastern in them, a direct appeal to feeling and to action more Asiatic than the references to symbol and sacrament which distinguished Catholicism in Europe; but it is also classical:[33] that is, it is to the spirit an interpretation of a symbolic truth; the soul is freed by the subtle appeal of the composition; while appreciating the ordered arrangements of the whole, it may commune at the same time with Plato's ideals of beauty, truth, and goodness, and feel them living with a new vitality in the trinity of life, light, and love. All these are combined in Santa Sophia, but they are not completed there. We see the sense of this original development of the first thousand years of Christian genius when we trace it on from Justinian's work at Ravenna to San Marco at Venice, not forgetting the Cathedral of Monreale. Only then shall we be able to sum it up.

CHAPTER V

[1] Translation of Procopius by Aubrey Stewart, quoted by Lethaby and Swainson, *S. Sophia*, p. 22.
[2] *Historia Ecclesiæ*, IV, Ch. 31.
[3] Lethaby and Swainson's translation, *op. cit.*, p. 36.
[4] George Sandys, *A Relation of a Journey begun in 1610*, p. 31.
[5] *Loc. cit.*
[6] The Church of the Trinity at Ephesus was probably, and the Santa Sophia at Salonika was certainly, later, as also the pendentives at Koja Kalessi near Isauria. For the evolution of the pendentive, see K. A. C. Cresswell, *Moslem Architecture*, Ch. VII.

[7] Quoted by Lethaby and Swainson, *op. cit.*, p. 26.

[8] Ferguson, *History of Ancient and Medieval Architecture*, Vol. I, p. 144.

[9] Van Millingen, *Byzantine Churches*, p. 33.

[10] Lisle March Phillipps, *The Works of Man*, Ch. V.

[11] March Phillipps, *op. cit.*, pp. 137, 138.

[12] See specially Ephesians IV, 16.

[13] Cf. R. Byron, *The Byzantine Achievement*, p. 202.

[14] Byron, "She Walks in Beauty".

[15] Translation in Lethaby and Swainson, *op. cit.*, p. 51.

[16] *Ibid.*, p. 52.

[17] It is these mosaics which are now being once again opened to our view.

[18] Tennyson, "The Palace of Art".

[19] Lethaby and Swainson, *op. cit.*, p. 93.

[20] See Norman Baynes, *Constantine and the Christian Church*, pp. 12, 13.

[21] Toleration in the Edict *Qui Religiosa Mente* of 1921. Prof. Norman Baynes takes the view that there was no Edict of Milan.

[22] See Salzenberg, *Altchristliche Baudenkmale in Konstantinopel*, 1854, I, 23–24.

[23] "Borne along like some venerated idol through streets perfumed with incense and hung with oriental silks and rugs, over a pavement scattered with the petals of flowers, the figure of the Emperor, wearing a gold turban embroidered with pearl, was borne in his golden car under a canopy of purple silk, while heralds proclaimed his glory in the tongues of Babel. As he entered the temple he was met by patriarch and priests, and round their two processions streamed a crowd of functionaries, of courtesans, of intriguers, surprised into an act of worship, which seemed to add another brilliance to their sheeny robes, their jewelled headgears, their glittering swords. A soft perfume made the air faint; and the Emperor passed on to the tribune, and entered the ikonostasis to find in the gold and jewels of the altar the hint of a magnificence not less sublime than his own."—Edmondo de Amicis, *Constantinopile*, pp. 183, 184. (New York, 1886, trans.)

[24] Sandys, *Relation*, p. 31.

[25] These are now so prominent in the arrangement of the Museum, the scaffolding in the apse is so disfiguring, the bareness so desolate that one can perhaps better gain an idea of the original temple from Sancta Sophia at Salonika, where the ikonostasis, and indeed full Christian worship, have been restored.

[26] See *Illustrated London News*, June 23, 1928.

[27] Josef Strzygowski, *Origin of Christian Church Art*, p. 133 (trans. from German).

[28] Strzygowski, *op. cit.*, p. 211.

[29] Quoted in C. H. Sherrill, *Mosaics*, p. 14.

[30] Ruskin, *Works*, Vol. X, p. 112 (Library Edn.).

[31] *Op. cit.*, p. 133.

[32] C. and G. Fossati, *Aya Sophia* (1852).

[33] Thomas Whittemore, *Mosaics of Santa Sophia* (Preliminary Report, Oxford, 1933).

I

FOR we need not go so far as Constantinople to see the qualities of Byzantine art. Before Constantine had built his capital on the Golden Horn, the attractions of the style had been set forth by the Romans at Ravenna. There the arches and columns of Corinthian grace and lightness which they had built at San Clemente, and used also in the basilica of what is now Santa Maria Maggiore, had already been used in churches in the century which followed on Constantine's conversion, and which, in conjunction with Christianity, did much to orientalize the spirit of Rome. Augustus had made Ravenna's harbour, Classis, his port on the Adriatic and decorated it with marble; the Emperor Honorius chose it as his capital at the beginning of the fifth century. It was in the same century that the descendant of Honorius, Galla Placidia, was made a prisoner of the Visigoths, and, as captive, charmed and was affianced by the successor of her captor. Later, in the same fifth century, Ravenna was the Goths' capital in Italy. Then, recaptured by Belisarius, it was again an imperial capital; it was glorified with memorials of Justinian and Theodora, leaving in its mosaics portraits of them with their courtiers, and completing the record of Santa Sophia.

The same harmonies are set before us on a smaller, though still an impressive scale. Similar lustrous gold reflects the lights and shadows of the vaulting, a similar enamelling depicts a similar type of figure, a similar marble intarsio is arranged in similar geometrical patterns on the walls; the very proportions of the columns, the arches and the vaultings in San Vitale seem to carry us far into the East; there is, in fact, nothing in style so oriental in Western Europe until we come to the Alhambra of Granada and the Alcázar of Seville.

The town leads us from the ancient monuments: the Mausoleum of Galla Placidia, Sant Apollinare in Classe, Sant Apollinare Nuovo, and San Vitale to the chapel and cemetery of the Braccioforti and then to the Renaissance, as shown in Santa Maria delle Croci or the statue of Guidarelli; lastly there is the baroque of the Rasponi Palace or of Santa Maria in Porto; in its embracing of all ranges of spiritual ideas Ravenna thus provides a fitting frame to the tomb of Dante. It leads us through Byzantine art back to Greece. It leads us on from

Byzantine and Romanesque architecture through the Middle
Ages to the late Renaissance. All these monuments are preg-
nant with the significance of the Catholic religion.

Ravenna, like Venice, was built on marshes, or rather on belts
of sediment, because of the security they offered alike from land
and sea. For in the time of Strabo it was what Venice is still,
a city built on piles and traversed by canals, with the tide
flowing through them and keeping its air pure.

But the dim blue waters of the Adriatic have receded and left
Ravenna lonelier than its shore. So "it stands there", wrote
Hutton, "laden with the mysterious centuries as with half
barbaric jewels, weighed down with the ornaments of Byzan-
tium, rigid, hieratic, constrained, and however you come to it
whether from Rimini by the lost and forgotten towns of Classis
and Cæsarea, or from Ferrara through all the bitter desolation
of Comacchio, or across the endless marsh from Bologna or
Faenza, its wide and empty horizons, its astonishing silence,
and the difficulty of easy approach will seem to you a fitting
environment for a place so solitary and so imperious." [1]

II

The greatest of Ravenna's memorials is the Church of San
Vitale, which was consecrated in 547. Its cupola does not rest,
like that of Santa Sophia, upon true pendentives, but rather
upon niches. Yet the effect of the mosaics in the dome, of the
double capitals of the columns—and of the carving—takes us
back to the Bosphorus, as we are taken by the marble veneers
of Grado in the marshes north of Venice, and by those of
Parenzo on the Istrian coast. These, though little known, are
the most gorgeous of all.

San Vitale gives the first verses in the epic of which San
Marco di Venezia is the consummation, and which, under the
impulse of Pope Victor III, found its way southwards into
Sicily in the Palatine Chapel and Zisa at Palermo, and the
Cathedrals of Cefalù and Monreale, and then back across the
Liparean Sea to Salerno.

In the three Byzantine churches of Ravenna the columns rise
from the tessellated pavements, grey like the pillar of cloud
which guided the Children of Israel. In San Vitale, as in Sant
Apollinare in Classe, this shade of green is the ground of every
picture, just as in the Mausoleum of Galla Placidia it is the

*IN SAN MARCO DI VENEZIA. Nowhere is the design and pattern so prodigal
and complex; nowhere is the effect more single. What distinguished Christian architecture
was the sense of glory.*

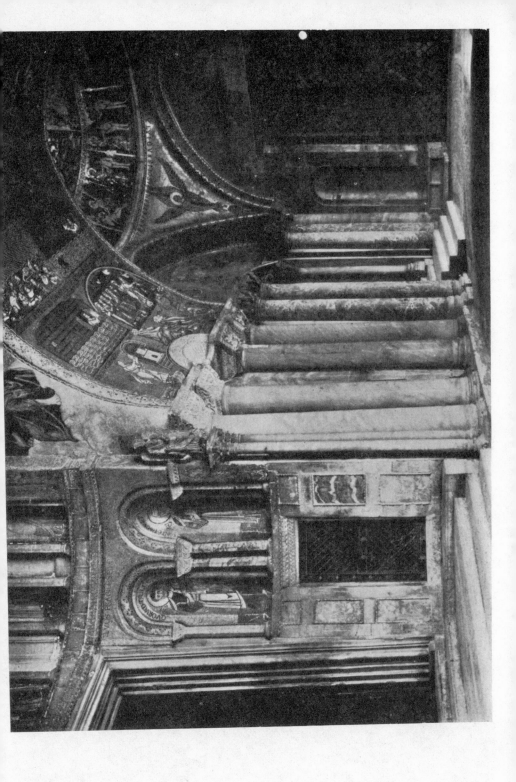

deepest blue of the sky, the colour of the Virgin's robe, from whom, as Dante was to say, the upper heaven takes the hue of sapphire. And as the pastures were one with that which grew from them, and as the wheat was the element of the Body of Christ, so all the mosaics of San Vitale tell forth His glory and associate Him with the Sacrifice of the Altar. In the vaults of the apse He is, as we saw, enthroned upon the globe, beardless, youthful, rounded, like Apollo, above clouds of blue and crimson against the golden glow of sunrise. In the arch the symbol of His Name, \mathcal{R}, is surrounded by a ring coloured like the rainbow. Crowning the chancel (and an altar of plain marble, simple as a table, stands immediately below), the Lamb of God, His head clothed with the Sun, and His hair white against the stars—framed in leaves and fruit, all flashing with gold as in the sun of Morning—is in the central height of a brilliant coloration of gold and green. Here leaves and fruit grow from the fan-spread tails of peacocks, and from volutes and bands of gold. Yet among them is the white pelican, which typifies the willingness of Christ to give His flesh and blood for the sustenance of His people. This design leads up to winged seraphs whose hands hold up the floral ring which encircles the Lamb. On the upper walls, the four Evangelists, each with his Gospel in his hand, suggest the story of the Redeemer's life on earth; below these are Moses and Isaiah, who prepared for His coming by ordinance and prophecy, and below these, on either side an Altar, Abel and Melchizedech, each offering his sacrifice. On the opposite wall of the Sanctuary Jeremiah is with Moses, and Abraham raises his sword over Isaac's head, while a lamb plucks his flowing robe.

Finally, in the great arch leading from the central space of the Church into the Sanctuary, saints and apostles, each in his medallion of mosaic, lead up to the solemn portrait of the bearded Messiah, who, as the fish between them testifies, had made them fishers of men. So that here in actual mosaic we see—frankly shown—one of those scaled skins which are Nature's model for mosaic and which, as we saw, had suggested many a design to the workers in mosaic in Constantinople.

Such, then, is the significance of the design of green and gold which sparkles like the flash of sunshine on twinkling grass after showers of rain in spring. It was a study of sacrifice.

It was into this design that the famous portraits of Justinian and Theodora were inserted. Theirs, too, was a sacred office.

THE MEETING OF ST. FRANCIS OF ASSISI AND ST. DOMINIC, BY ANDREA DELLA ROBBIA, IN THE LOGGIA DI SAN PAOLO AT FLORENCE. "His dearest desire was ever to seek among wise and simple the means to walk in the way of truth." [Photo by Alinari.

In these portraits they are met by a deacon who comes forth both to guide them and receive their gifts. They stand above the clergy and beneath the Christ, gazing out at us after fourteen hundred years with the *naïveté* and directness of youth; which, though now consecrated to the Church, is the fresh, healthy youth of the god of sun and genius.

III

As Sant Apollinare in Classe it is but the apse which shines with mosaics above the open space of the nave and the grey pillars which bring into the basilica the grace of a prince's palace: but in Sant Apollinare Nuovo, though the apse is grey and weakened by some of the poorest work of the seventeenth century, the nave raises above its columned arcades, and the diaper of grey and rose marble on its floor, a long procession of figures glittering with gold, leading from the port and the walls of Classe over a long field of green grass towards the enthroned Mother and Child. These virgins had been fed among the lilies; behind them are the fronded palm-trees of Engedi. Each virgin bears in her hands the martyr's crown, as she moves forward in her spangled garments and her cincture of pearl and gold in the train of Gaspar, Melchior, and Balthasar; these, separated by bands of colour and walls of Troy from the white-robed Saints who stand above them, hasten forward in their Eastern garments to offer to the new-born King their several gifts of gold, frankincense, or myrrh.

Between the Saints and the gold reliefs, which throw the conventional form of leaf or flower against the black medallions, stand doves or Saints. At Sant Apollinare in Classe, as in the apse of San Vitale, the artist had taken pains to show the varied hundreds of plants and of animals, so here in Sant Apollinare Nuovo the golden heights are peopled with birds. The martyrs clothed in white robes are headed by St. Martin, who wears over his shoulders a purple cope similar to those robes of entire purple in which the Christ is vested as He sits, mature and kingly, but with no signs of age, upon the purple cushions studded with pearl, which are placed upon His throne. The long line of figures, the elaborate decoration are neither so subtle nor so gorgeous as at San Vitale, but the effect of so much beautiful work above the graceful columns and arches of the nave make the church the most delightful in Ravenna.

Lest the dazzle of Southern light should blind us either to the toil, the detail, or the significance of their work, the windows—as also at Sant Apollinare Nuovo and the Mausoleum of Galla Placidia—are panels of alabaster that bathe the whole in a soft amber clearness in which the recurring spaces of glittering colour change, as one moves, through all shades from lemon to copper.[2]

At Sant Apollinare in Classe the polished marble columns share the greyness of the mists : they throw out into relief the mosaics of the apse, which rise above them.

Ravenna is a city that awakens the historical imagination to the inspiration and splendour of the Christian religion, and we see in it extended what is shown in the Cathedral of Monreale.

IV

But, for the most part, as the mists swathe it, so it remains remote in its seclusion : secluded, too, from the parade and ennui of travellers are Grado and Parenzo : even Cefalù and Monreale are secluded. And the Golden Horn is far away. So that the one great monument of Byzantium which is on the thoroughfare of travel—though even it is "far from the dust and rumbling" which beat through in Florence and Oxford—is the metropolitan temple of San Marco at Venice. Here is no place of stillness or of mourning : this is "rich Venice, riotous and human" : here

> There's the secret of the Indies to unravel,
> And then the Turk to beat.[3]

This is not the Venice of Shelley and the lagoon, where

> Within a furnace bright,
> Column, tower, and dome, and spire
> Shine like obelisks of fire,
> Pointing with inconstant motion
> From the altar of dark ocean
> To the sapphire tinted skies.[4]

At the time of the building and decoration of San Marco, Venice held dominion over the Eastern Mediterranean. She had a colony of some two hundred thousand in Constantinople, and these fought not only with their Eastern neighbours, but also with their Lombard rivals. They monopolized the profit of merchandise, and bore themselves with overweening pride. Under the instructions of the Doge, Domenico Selvo, who

wished to complete the initiative taken by his predecessor, Domenico Contarini, not only the merchants who secured for Venice the wares and spices of the East were all commanded to bring home materials, but also the ambassadors and officers who represented the official dignity of the republic made every effort to secure fresh rarities for the fabric of the temple of their patron.[5]

New treasures were heaped up with the spoils of other churches, and what Justinian had done for Santa Sophia, the sons of Venice did for San Marco. Persia, Arabia, Syria, as well as Byzantium were ravaged; even the plan was taken from the Church of the Holy Apostles which Justinian built and Procopius described. The interior was arranged in domes and arches in the shape of a Greek cross while it threw out on every side the softened lustre and coruscation of gold. There are many designs within it making portraits of the Redeemer, of the Virgin Mother, and of the Saints.

These perhaps have best been enumerated by John Evelyn, after his visit in 1605. "The floor", he wrote, in his diary, "is all inlaid with agates, lazulis, chalcedon, jaspers, porphyries and other rich marbles, admirable also for the work: the walls, sumptuously incrusted, and presenting to the imagination the shapes of men, birds, houses, flowers and a thousand varieties. The roof is of most excellent mosaic; but what most persons admire is the new work of the emblematic tree at the other passage out of the Church. In the midst of this rich *volto* rise five cupolas, the middle very large and sustained by thirty-six marble columns, eight of which are of precious marbles; under these cupolas is the high altar, on which is a reliquary of several sets of jewels, engraven with figures, after the Greek manner, and set together with plates of pure gold. The altar is covered with a canopy of ophite on which is sculptured the Story of the Bible, and so on the pillars, which are of Parian marble, that support it. Behind these are four other columns of transparent and true oriental alabaster, brought hither out of the mines of Solomon's temple."

Yet the wholeness of the effect is never broken, never even interrupted. In the unity of those balanced curves of arch and dome there is, in spite of the smaller scale, the same sympathy, as in the great monument of Justinian, with the ideas of majesty and power. Nowhere, not even in Santa Sophia, is the design of the mosaic, and the pattern of the marble inlay, so prodigal

and complex: yet nowhere is the effect more single and effective.

"Churches are best for prayer that have least light," [6] wrote Donne, but Evelyn thought San Marco "much too dark and dismal". He may, however, have had other reasons than prayer for entering it. For even Ruskin, who was so easily shocked by the "impiousness" of Italy, could feel at ease to worship here: he was reassured by the recurrence of the Cross "lifted and carved in every place and upon every stone; some-times with the serpent of eternity wrapt round it, sometimes with doves beneath its arms, and sweet herbage growing forth from its feet . . .",[7] but no matter how designed, or where found, the figure of Christ was supreme in San Marco, majestic in the hollow of every dome and vault; and even as one looked towards the altar: "It is the Cross that is first seen and always burning in the centre of the Temple".[8]

But it is, of course, the façade as seen from the end of the piazza which moves Ruskin to his most impassioned and most familiar description:

"Beyond those troops of ordered arches there rises a vision out of the earth, and all the great square seems to have opened from it in a kind of awe, that we may see it far away;—a multi-tude of pillars and white domes, clustered into a long, low pyramid of coloured light; a treasure-heap, it seems, partly of gold, and partly of opal and mother-of-pearl, hollowed beneath into five great vaulted porches, ceiled with fair mosaic, and beset with sculpture of alabaster, clear as amber and delicate as ivory." [9] He expatiates upon the sculpture, and the mosaics, the columns and the decoration of the capitals; and the chain of language in the archivolts, and above these again pinnacles and arches—"a confusion of delight amidst which the breasts of the Greek horses are seen blazing in their breadth of golden strength, and the St. Mark's Lion, lifted on a blue field covered with stars, until at last, as if in ecstasy, the crests of the arches break into a marble foam, and toss themselves far into the blue sky in flashes and wreaths of sculptured spray, as if the breakers on the Lido shore had been frost-bound before they fell, and the sea-nymphs had inlaid them with coral and amethyst." [10]

V

Opulent as is Ruskin's fancy, involved as are his cadences,

their intricacies shine with three truths : First, that the design
which he celebrates makes an effect both immediate and pro-
found : Santa Sophia suffers from the lack of pictorial genius
which deals here with an outward bulk and makes it a dazzling
bravura; secondly, the façade of San Marco is a prophecy of
that gift of design which gives such impressiveness of Eastern
effect to Gothic and Baroque façades; and thirdly, in spite of all
the fancy, the sensuousness and the strangeness which it shares
with Asia, it is not less impressive than they. They combine to
give an effect which suggests the Arabian Nights, but which is
yet gloriously Christian.

Lastly, this effect is one with the waters which even before
we see them we know so well from the greys and greens of
Guardi and the reflections and hazes of Turner, for the painters
have shown those waters in all their ways of reflecting the sky,
its sun, and colours on its shadows and gloom, or the glitter of
lamps and stars in lines of sparkling or mellowed light. The
architecture of Venice is one with the gleaming reflections of it
in the canals.

It is the property of water to give us light around as well as
light above, light, in Venice more than ever queen of colours—
and gliding by us in guises more numerous and varied than
Aurelius Augustinus knew. Water is an element which has
kinship with the clouds from which it is distilled and with the
air which carries them; and though the Venetians knew it as the
salt sea, yet from it arose the exhalations which added splendour
to the morning, and fell on them in showers.

They learned, Easter by Easter, in the ritual offices of the
Church, that water was not merely the agency of cleansing, or
the satisfaction of thirst, but also the means of fruitfulness.
The Holy Spirit had moved upon the face of the waters when
the earth was yet without form and void; it was the rush of
rivers which had made glad the City of God. Above all, as the
water of baptism, water was the symbol and instrument of a
second birth.[11]

<center>VI</center>

We have seen where in San Vitale the mosaic returned to the
fish which had been one suggestion for it : the lagoon offered
another. Over its smooth waters the reflections of lamps would
shine in columns of light which would be ruffled also by the
gentlest breeze. Those pictures in enamel and glass, therefore,

owed a triple debt to the crystalline streams of the Adriatic or
the Bosphorus : firstly to the waters themselves as reflectors of
light, secondly to the scaled creatures which the waves
nourished, and thirdly to the flowering plants which lived from
the showers and streams.[12]

Far away, across the Venetian lagoon, the eye was gladdened
by the sight of mountains. Beyond Padua, the Euganean Hills
rose green against the sunset; far to the north, the vivid host of
Alps caught on their snows the earliest hues of morning, before
those had turned the sea to opal, or the sun had laid upon it a
pillar of blinding fire.[13] So far as almost to fade from sight, the
lofty whiteness was left in the comparative colourlessness of
day to fade, or, impalpable as clouds, suggested angelic pre-
sences with "wings traversing infinity".[14]

VII

So from sky and sea and distant mountains, effects almost too
ethereal for earth or air gave the imagination of the Venetians a
tincture of idealism, and their artifices a firmness and lightness
which recalled that Hellenic epoch,

> When holy were the haunted forest boughs,
> Holy the air, the water, and the fire.[15]

The Venetians were, as we have noticed, very far from being
saints. Not only was their colony in Constantinople scandalous;
at one time they sacked Santa Sophia, and at a later age they
bombarded the Parthenon. Poor men far away were pillaged
to give glory to the Saint who repeated with simplest directness
the uncompromising lessons of Christ. And yet, whatever
were the Venetians' faults, their genius not only kept true to
what their city offered them of beauty; they were not even
content to make it a mirror of coloured light, of stainless waters,
and of heights soaring from Alpine meadows to the clouds which
sailed the sky. But they insisted that their art and architecture
should be consecrated to the themes of the Faith.

As the figure of Christ recurred in San Marco and reigned in
the warm shining of its vaults—the model of the cardinal
virtues of Aristotle as well as of the gifts of the Holy Ghost—
so the scenes of His life on earth, and His triumph in heaven, or
the heroes of His Church who, like Thecla, Dorothea, or Julian,
had shown His courage and mildness, were the preoccupation

of Venetian artists. The result is an integration of religion and genius which they themselves continued for centuries in the gradual completion of the mosaics in their basilica.

VIII

As soon as it had been built, however, it summed up a thousand years of culture, in which the Church had engaged with the culture she found around her—with the art and thought of Hellas, with the majesties of Rome and Constantinople, with the subtleties of Alexandria and Carthage, with Asia's sense of powers behind and beyond, expressed in puzzling pattern, with Israel's belief in God as Maker, Law-giver, and Protector, taken up again by the Arabs crying, There is no God but God. Here the Church had refused much, but accepted what she found true, and seeing among those growths of nature how many were "wild plants indeed but living",[16] she had nourished them in her own earth to new luxuriance, or grafted them on her own growths.

CONCLUSION TO PART I

As works of creative culture, the inventions consecrated to Christianity had rarely surpassed what had been done elsewhere. The Church had no object in raising on heights of sand the heaven-kissing geometry of a Pyramid. No column she could raise had been more graceful than those of the temple of Olympian Zeus built by Syrian Epiphanes between the Ilissus and the monument of Lysicrates; none had a quieter Doric strength than the temple of Philæ or the Parthenon; none had more regal lines than the Hieron of Æsculapius; none were mightier than at Baalbec. In sculpture she had not even attempted works like the Nike of the Acropolis, or the Zeus Keraunios of the Museum at Athens; her hymns entered into no rivalry with classic tragedies or epics; her churches were as graceful as temples of the Corinthian order or Roman palaces, but seldom, if ever, more so.

It seemed doubtful in the thousandth year of Christ whether His Church would produce things sublimer than had been done without Him. Nevertheless, the Church had already played a not negligible part in the world of culture. She had conserved in her own form the most refined essence of Hellenic philosophy : in the things of art she had gone farther. Plato's doctrine

of an ideal beauty had been combined with Aristotle's doctrine of the right concept and both with the inspiration of the Hebrew scriptures by Philo. The notion of thought had been combined with the notion of generation in the doctrine of the Trinity. The result was a belief in a creative concept, in art as the reproduction of the process of creation, and as a search for the manifestation of the eternal beauty; this eternal beauty was not a mere ideal, but rather a picture of Christ as the Incarnation of all ultimate ideals, or of the Saints as the partakers of His grace.

Thus new inspiration had come to creative artists. Neither physical health nor symmetry was now taken as symbolic of the ideal: if God had become man, it was not by His conversion into flesh, but by taking man's nature into Himself; how different, therefore, from those calm, nude, muscular men whom the Greeks had carved as portraits of their gods was the portrait of the Christ.

For His house the subtle proportions of neither column, nor pediment, nor vault, nor dome were enough. These all in turn were wanted, but they must be arranged in the completest unity of order, and enriched by all that could be suggested by the air, the water, and the fire as elements which made the earth creative. These, though no longer holy in themselves, could be the symbols of holiness, as well as the ground of praise. For though created things were in themselves of an order subordinate to the Divine, God's stamp was upon all His works; it was peculiarly manifest in the scenes of the Mediterranean coast, in their rose, their cypress, and their palm, their outgoings of morning and evening. And yet there was no sense of wildness or tumult in the wealth of Christian art. Order was centred on a pervading concept of unity, which gave Christian literature final qualities of distinctness, of holiness, and of hope. Its finest passages were so intense, so delicate, so pure that they were poignant in their hint of aspiration for a heavenly beauty, and eternity hovered about them like the scent of orange blossom, but more intimate and intangible, as though its perfume came from within direct to the nerve of sense.[17]

Christianity was not harshly distinguished from the pagan culture around it. On the contrary, it delighted in all that was good. Its Christ was the light that enlightened every man. Its God was the Father of lights from Whom comes every good and perfect gift. His love was spread abroad through their hearts by His spirit dwelling within them.

His Providence was subtle and far-reaching: the Christian revelation was prepared not only by the Hebrew prophets, but also by Greek metaphysics, Roman law. The work of grace perfected human nature and prevenient grace was always tending to make the natural man supernatural. But just as grace, being a participation in the Divine, is of a quality infinitely higher than nature, so gradually, both in philosophy and art, the Christian contribution grows more distinct.

If, then, one were to ask what distinguished the monuments of Christian architecture from those which had gone before, the answer was what St. Paul had taken over from the Septuagint, *the sense of glory*.

It was the fullness of their unity, the flash and wealth of colour, the brilliance of light on intricate and significant pattern, the welcome to nature's living images, the joy in life as in abundance. The Christians no longer feared nature or feeling. They owed to the new power which they gave to the word light, to their sacramental use of water, to the profound significance they gave as symbol to the fish, their new triumphs in mosaic; light, as the queen of colours, was ever with them, and they had in the portraits of the Gospels, as well as in the letters of St. Paul, conceptions more vivid, more subtle, more complete, more pregnant with joy, with sensitiveness, and with life than could be found in other literature.

Their worship added to the piety and exaltation of the psalms an environment of images which to the Hebrew had been denied. Genius was allowed the fullest play over materials. It could picture the sacred themes with all the personal variety of imagination: it could connect these with nature, it could base them on the subtleties of metaphysics; it could associate them with the passions of the heart. And knowing that the human spirit was nobler than the visible frame of its imaginative conceptions, and closer therefore to the ends of art, the Church taught them that there was a yet higher gift than the spiritual reason, better suited therefore to art; the faith itself, in relation to man, is in turn

. . . in beauty exalted
As it is in quality and fabric more divine.[18]

Though, therefore, they might seek out many inventions, they were persuaded that to hallow the ideal they should seek it in their themes of worship. For a thousand years the Church had been growing up as heiress to the culture of civilization.

She now stepped forth to rule it as apparent Queen; in her train the imitative arts, the arts where imagination had arranged according to reason its own pictures of nature on its own foundation of philosophy, moved with the strength and grace of a nobler assurance to clearer and loftier ends. For their scope was wider, their opportunities finer. Already to the creative order of the mind, already to the quickening beat of the heart, already to the generative interaction of both—to reason, to passion, and to imagination—the colonies of the Church were richer in life than the Empires that had been.

Reason, passion and imagination combined to create things of sublime beauty, and so to reproduce in art the beauty given to nature by the Trinity in unity; for reason imaged the mind of the Father who created all things, and imagination the Son who was the express image of His father's glory, and passion the love which made these two one, and gave to all things their relation to one another, and to all life its love.

CHAPTER VI

[1] E. Hutton, *Ravenna*, p. 34.
[2] See S. P. Richter, *Die Mosaiken von Ravenna*.
[3] Herbert Trench, *Canzone di Sebastian Valler*.
[4] Shelley, *Lines Written Among the Euganean Hills*.
[5] H. Brown, *Venice*, p. 100.
[6] "Hymn on Going into Germany."
[7] Ruskin, *Stones of Venice*, Vol. X, pp. 88, 89 (Library Edn.).
[8] *Loc. cit.*
[9] Ruskin, *Works*, Vol. X, p. 82 (Library Edn.).
[10] *Ibid.*, p. 83.
[11] Roman Missal, Office of Easter Even, Blessing of the Font.
[12] These plants, which Paul the Silentiary had recalled in Santa Sophia, were themselves to suggest enamelling to Milton. He tells us that in Paradise, beneath the firm and fragrant leaves of laurel, or myrtle,

> Acanthus, and each odorous bushy shrub,
> Fenced up the verdant wall; each beauteous flower,
> Iris all hues, roses, and jessamine,
> Reared high their flourished heads between, and wrought
> Mosaic, underfoot the violet,
> Crocus, and hyacinth, with rich inlay
> Broidered the ground, more coloured than with stone
> Of costliest emblem.

> > (*Paradise Lost*, Book IV, 696–704.)

In Venice the flowers and leaves of climbing plants hung over the lucent mirror of the canals.
[13] Just after writing this phrase, I found the following passage in *Browning's Life and Letters*, by Mrs. Sutherland Orr, p. 384. The poet sees from the window at dawn: "the clouds, a long purple wrack behind which a sort of spirit of rose burns up till presently all the ruins are on fire with gold, and last of all the orb sends before it a long column of its own essence."
Cf. also the opening of *Pippa Passes*.
[14] Meredith, *Beauchamp's Career*, Ch. IX, p. 90 (1897 edn.).

[15] Keats, "Ode to Psyche". For an account of the influence of water and sky on Venetian genius, see Symonds, *Renaissance in Italy*, Vol. III, The Fine Art, pp. 348–353.

[16] Newman, *Essays*, Vol. II, p. 231. The full quotation, with comments, is in my *Genius of the Vatican*, p. 158.

[17] Cf. Shelley, *The Sensitive Plant*,

A perfume so delicate, soft and intense
That it seemed like an odour within the sense.

[18] Wordsworth, *Prelude*, XIV, 503, 504.

PART II

THE MEDIEVAL CULMINATION

I

THE date which saw San Marco completed marks the end of that dark age when Europe had been lost to the control of Rome and Byzantium, and was not yet inspired by the triumphs and rivalries of the Empire and the Papacy. It was an age of cruelty and greed; and it was in protest against the prevailing habits of the time that the two great founders of the Friars, say a century and a half after the Norman conquest, headed a movement which, if it did not transform Christendom, made the ideals of Christ so cogent to artists and men of letters that in their following we find the century in which high achievement was most general and genius most fertile in response to Catholic religion. The return to nature is followed, and at times accompanied, by a directed effort of intelligence, comprehensive, subtle, and acute, by a discipline of science and a loyalty to the Classics which combine to inaugurate and to maintain a Renaissance in the Church of the glories of Greek and Roman genius.

The first of the two gifted saints to inspire and fascinate had a spirit so rich in poetry that his life is more significant to culture than his writings. He was charming firstly because he was himself, and the more simply so because his life was worship; and yet more because the beauty of his worship was holiness.

In the last quarter of the twelfth century a successful and apparently a rather corpulent merchant of Assisi, Pietro Bernardone, had prospered in trade with Provence, where he had found a bride. In 1181 or 1182 this bride bore him a son, who was christened Giovanni, but who became known, perhaps because of his father's French tastes, as Francesco. This son grew up into a handsome, high-spirited, and distinctly unconventional young man who loved amusement and entertaining, who was chivalrous, popular, and warm-hearted, but who was as innocent as he was extravagant.[1] He began by some soldiering, but fell ill, and when ill dreamed that he was in a great hall

lined with armoury, and on every breastplate a cross. "These", said a voice in the dream, "are for you and your warriors." When cured, he set out again to fight: but again in a dream at Spoleto he heard the same voice, and this time it commanded him to return to Assisi.

He went back over the rolling, purple country to his own hill town, and changed his ways. The passion he had had for gaiety was now transferred to solitude. Instead of carnival, he now affected pensiveness; his friends thought his mood, if not the wantonness of melancholy, the melancholy of love. To this teasing he replied that he was indeed considering marriage. "I am about to take a wife more noble, wealthy, and agreeable than any other," [2] he said: but the bride of which he spoke was his playful personification of poverty. And his passion for the Lady Poverty began to be bizarre. He not only poured out his purse at the Shrine of St. Peter: he sold his horse and clothes to give money to a church that was dilapidated: but he shocked his neighbours at another time by giving all he had to a leper whom he had embraced. It is not surprising that his portly father began to have misgivings, and decided not to leave property to a son who showed such scorn of it. The reply of Francis was to give the very clothes in which he stood up to a Bishop and leave his presence naked. He then entered a neighbouring monastery—not as a monk, but as a scullion.[3]

II

Ruskin has a vivid page in relation to this scene as painted by Giotto. There are, he says, two ways of viewing it: " the plain, common-sense, Protestant side", and he sums it up:

"One of St. Francis' three great virtues being obedience, he begins his spiritual life by quarrelling with his father. He, I suppose in modern terms I should say ' commercially invests ' some of his father's goods in charity. His father objects to that investment; on which St. Francis runs away, taking what he can find about the house along with him. His father follows to claim his property but finds it all gone, already; and that St. Francis has made friends with the Bishop of Assisi. His father flies into an indecent passion, and declares he will disinherit him, on which St. Francis then and there takes all his clothes off, throws them frantically in his father's face, and says he has nothing more to do with clothes or father. The good Bishop,

in tears of admiration, embraces St. Francis and covers him with his own mantle."

That, as Ruskin said, is one view of a famous episode depicted on a famous fresco; but he also suggests another: Faith depicts, he says, "the human race with all its wisdom and love, all its indignation and folly on one side—God alone on the other. You have to choose. . . . You must renounce your neighbour in his riches and pride, and remember him in his distress. That is St. Francis' disobedience." [4]

The Lady Poverty had few lovers so eager and so persistent. He had an instinct for dramatic appeals to the people, and for them he would spare nothing: so towards the end of his life he had himself drawn naked by a noose from the church at Assisi to the market-place; it was a cold sky, and he was weak from quartan fever: and then he announced that his ill-health had compelled him to relax the completeness of his Lenten fast.

"To poverty, as to death," wrote Dante, "none open the door in welcome. Bereft of her first husband, his spouse had been despised and neglected for eleven hundred years when a new bridegroom took her to be his bride, and afterwards from day to day he loved her more." [5]

The spirit of romance began to gain on the perversities and win the startling young man admirers. His personal attraction had been made more touching by the whole-heartedness of his self-sacrifice: men gathered round him; and with eleven of these he set out for Rome to ask the approval of the Pope himself: and, after some demur, the approval was given. About 1211, some six years after the surrender of Francis to the austere life of the spirit, his tiny following established themselves in some small huts on the plains below the city of Assisi; and from there they went forth to preach through the country around in the spirit of their founder; they were not without his power to win the hearts of men. Careless of the day, like happy children, they sang aloud for joy. For comfort they cared nothing: a church porch or a cave contented them; a hayloft was a luxury. Sometimes they joined the peasants in the field to earn a pittance: in cases of extreme want, they begged. Francis rejoiced in nature as he sported with nakedness. He had a love in special for birds and fishes. He felt himself made one in the qualities and powers of the elements, sun and wind and fire; and as brother to sister he spoke to water and the moon and death.[6] And so his playful fancy turned hardship

into a fairy-tale: and if he ever showed unkindness, it was only to his own flesh, for whom his name was Brother Ass.

But Brother Ass is apt to bray a word in answer from time to time. And perhaps it was this ill-treated brother who acted as a go-between when messages passed between his soul and that of a young heiress of eighteen, Clare of Assisi, who followed his example in founding a community and living with him in the joys of poverty and hardship. Between these, too, Clare and Francis, was shared a singular sympathy of ardours which gave their souls an intense communion of joy.[7]

III

A few years after the foundation of the Poor Clares, he founded an extension of his Order to enable those who had no vocation to live as friars to share something of his ideals. For his missionary journeys had become a triumph. His fervent, playful, poetic words were so exactly what the people loved that, as he passed in his brown robes, they crowded round him. His presence was magical: his hearers hung upon his words: enthusiasm flamed even before he had drawn near. The church bells welcomed him from afar, and as he came nearer he was met by processions of minstrelsy with the priests at their head. They brought him the sick to heal miraculously, as the Galileans had brought the sick to Jesus, and when he had passed, they kissed the ground his feet had touched.

Such was the enthusiasm he evoked in the provinces of Italy. But his ambitions flew outwards to the world of Islam. At the age of forty he travelled as a missionary to the sands and plains of Egypt, he saw the ancient river, the camels, the donkeys, and the palms: he went up into the hills of the Holy Land. In each alike he was walking in the footprints of his Saviour, and preaching to the Moslems. When he returned to Italy he found his Order enormously numerous, and corrupted with its growth. He tried to reform it. But his peculiar gift was obviously not for organization.[8] He was an artist who made the hardest truths more captivating than the fairy-tale in the guise of which his playful and original imagination tossed them forth. The charm of his mind would have burst like the beautiful bubbles of his fancy if he had been hard-headed. For him joy and prayer did the work of human prudence.

Early in August 1224 he retired to the mountain height of

THE BAPTISM OF CHRIST, BY GIOTTO. Men were freer to look on the world and one another because it showed them a subject for praise. [Photo by Alinari.

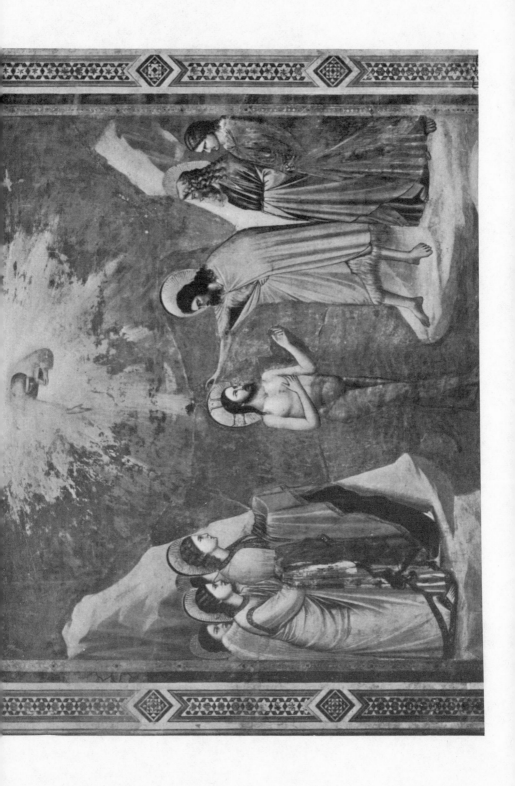

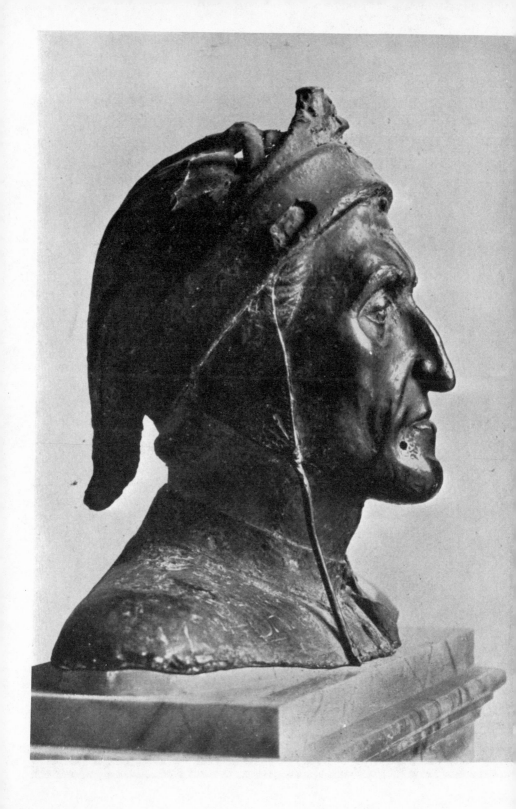

La Verna in the Apennines, above that upper valley of the Arno between Vallombrosa and Camaldoli which is known as the Casentino. There he began a forty days' fast, meditating on the sufferings of Christ. On September 14th, in a vision, a Seraph swam to him through his tears, and left his body with those marks of the Crucified which (long thought incredible) are now accepted as historical fact.[9] An open wound, as though made by a lance, appeared in his side: excrescences of flesh in the appearance of black nails, with the points turned backwards, appeared in his hands and feet. The unity of his soul with his Saviour's became manifest in the unity of his soul with his own body.

And now the genius of the Saint shone anew in his sufferings. His strength gave way; his eyes failed. He gave his last directions to his Order. In it he made a plain statement of his loyalty to the Church: he commanded his followers to abstain from vice and sin: to love hardship and obedience. "By Saint Gabriel, His archangel," wrote St. Francis, "the Most High Father announced to the holy and glorious Virgin Mary that His great, holy and glorious Word would come from Heaven: and from her womb He received the true flesh of our humanity and weakness. Although He was rich above all, He wished to choose poverty with His most blessed Mother." [10] Again the Saint visited the Lady Clare, with whom his heart and intuition gave him a closer communion than with any other being on earth, and in her garden he composed that Hymn to the Sun which expresses the intimacy of his loving relations with air and fire, whom he hailed as brothers, while he found sisters in water, in light, and in death. His sister death was drawing near to himself now, and no doubt he heard already the whispers of her heavenly secrets. He had been taken to Siena by his followers, and then back to the towered heights of Cortona, in the hope that high air might do him good: but there was no sign of a cure. So they thought it best that he should go to Assisi to die. It was known, however, that the Perugians would try to capture the little procession as it passed by, and taking his failing body into their splendid streets, enrich their city with a relic more priceless than their palaces.[11] And so he was brought by a long detour to his own hill city, and as he came to it he blessed it.

In 1226 his end came, with the golden leaves. The worn-out body, marked still in hands and feet and side as it had been at

DANTE: FROM THE MUSEO NAZIONALE AT NAPLES. *This layman has spoken of holiness in words more telling than the saints. He combined enquiry with religion and expressed both with an extreme poetical elegance and an imagination of unequalled intensity.*

La Verna, was lying, on the evening of October 3rd, in that thatched cell below the town where he had made a home some twelve years before with the followers that the Pope had blessed. Feeling the end at hand, with the last of those gestures which witnessed his passion for the Lady Poverty, the *poverello* stripped himself, and, naked once more, lay down in ashes: and so his ardent spirit left the harshly treated body, while innumerable larks alighted on the thatch, singing at nightfall, with full throats, the songs of the morning light.[12]

IV

Such is the story of the first and greatest of Christ's troubadours. It is itself a masterpiece of art. And it is also the inspiration of artists. St. Francis was firstly the subject of it. He was painted by Giotto; but the porcelains at Assisi and Florence, carved by Andrea della Robbia, are surely a truer likeness. They bring us back to the account given by Thomas of Celano in the *First Life*. Of less than middle height, and frail in stature, Francis had a long rather than a round face: his expression was joyous: he had dark brown hair and a thin beard: his voice rang with a vibrating sweetness: and his eyes were dark and brilliant. Grace added a finer distinction to the delicate form, grace and singleness of heart.[13] For "his dearest desire so long as he lived", said Celano, "was ever to seek among wise and simple the means to walk in the way of truth".

St. Francis had been conspicuous in his worldliest days for his moral purity; his generosity and his good temper met the faults of his age with an uncompromising loyalty to the literal commands of Christ, even at the points at which they transcend, or absolutely contradict, human standards of justice. One finds much in the Saint's life that is difficult to understand, but nothing which, when duly studied, is not explained by a passion for the highest standards of evangelical perfection. There is one point, certainly, where we cannot follow his example. The convictions of our age, and even the practice of that, agree with what he himself admitted, that his austerities were excessive. Modelled as they generally were on something in the Gospel, they yet went too far. This fact, however, must be balanced against another: that in spite of his severity with himself, St. Francis instituted a much milder system of discipline than had ever been known before. The castigations of

the rule of St. Columba were absolutely abolished.[14] Similarly, in spite of the Saint's passion for poverty, he could yet venerate men of rank and rich men. It was not power and authority which he condemned, but the abuse of them in the oppression or exploitation of the people.

His programme of politics was to give to men's hearts peace: the peace which passes all understanding; so alone could he look to freeing the world from war and faction. But what above all recommended his counsels was the persuasiveness of his own character. By temperament he was, in Dante's expression, "all seraphic in his ardour";[15] his ardour, as St. Bonaventura shows, was a continual joy that suffered even the tears of his penances.[16] This gaiety had, as we have seen, distinguished him before his perfect conversion to the spiritual life: it was still more manifest in the sufferings of his last illness. He wished the men and women of his Order to be messengers and harbingers of true joy to the whole world. "Christian joy, my brethren," once said Dean Inge, preaching to some young men at Cambridge, "is very different from the vapid hilarity of the theological seminary." St. Francis had anticipated the distinction: he meant by joy, not cosy emotion, nor physical exhilaration: he meant rather the soul's final possession of the object of its ultimate passion, showing itself in a pure tenderness of love for all that God had made; a general freedom, gaiety, and sympathy would be the natural attitude of those who had these gifts of joy and love. Knights, minstrels, troubadours, they too were to be seraphic in their ardour because, feeling with an exquisite tenderness the sorrows of the world, they were to accept them with a resignation so complete, and a peace so serene, that their suffering, even at its intensest, was to be a proof of their blessedness, and so to be translated into joy.

"Those who live much by their heart in their youth", wrote Meredith, "have sharp foretastes of the issues imaged for the soul." To those who live intensely by the heart, and yet live spiritually, joy and pain are so intimate, so near, that their finest raptures melt into a single glow.

V

The portrait of St. Francis awakens that poignancy of love for an unseen beauty which, as Plotinus showed, is a spur to creative impulse. An impressive body of witnesses, beginning

with Renan, proceeding through Thode and Bode, to John Addington Symonds, Crowe and Cavalcaselle, and finally to M. Louis Gillet, have recorded their conviction that St. Francis created a new epoch in Italian painting. "This sordid mendicant", wrote Renan, "is the father of Italian art." [17] Thode and Bode relate how as Assisi became the central school of painting in Italy, the career of St. Francis changed the history of painting.[18] Symonds speaks even more strongly.[19] Crowe and Cavalcaselle devote several pages to the career and influence of St. Francis.[20] And M. Gillet speaks enthusiastically of a new movement of spontaneity and fidelity to the record of the age.[21] For not only did St. Francis provide the artists with a subject, as we see in Giotto's frescoes at Assisi and his *Baptism of Christ* at Padua, but he always showed the way to a deeper sympathy with nature.

For, in the age of Giotto, pictures cease to be a convention, dependent mainly on the obviousness of the curve. Men were freer to look on the world and on one another, because it showed them a subject for praise: it showed them young members of the family in which heaven and earth are named. So religious art took direct cognizance of living men and women and animals, their moods and their needs; it was realizing the principle of Quintilian, that "true shapeliness is never to be found without regard for function".[22]

When Cimabue had himself been attracted to Assisi, and commenced to paint the life of St. Francis, he found portraits of the Saint already there. Giotto followed him thither, and worked out his freedom from the Byzantine convention. For him the line was not felt to be of more importance than the living model. "Giotto", says Vasari, "has indeed well merited to be called the disciple of nature rather than of other masters: having not only studiously cultivated his natural faculties, but being perpetually occupied in drawing fresh stores from nature, which was to him the never failing source of inspiration." [23]

This fidelity to nature was commended to the painters by the life of St. Francis. The romance of his story made his contemporaries feel that they need to look no farther than their own time and their own homes for the most inspiring truths. Artists therefore were free to look at life direct: and paint what they saw. The world rushed back on them as a reality: they could return to nature, and so we have at once the whole world of art living again. The thirteenth century was in every sense a

Renaissance. Nothing so important in the history of painting had occurred since the days of the Catacombs.[24] And St. Francis was the central creative power.

For the genius of Giotto, inspired by St. Francis, could paint the landscapes, the churches, the cities, the rooms, the worship, the people, the habits and customs he himself knew. It is true that many of his conventions remained archaic, and his style, in spite of a strength and earnestness which recall the massive sublimities of Isaiah, is often naïf. He had not gone far in the management of perspective. But his genius was revolutionary both in its range and in its freshness. He fills his picture with real people living on the solid earth; he opens up to the creative genius the world of men and women, and makes the human comedy one with the longing of the soul for things unseen. His scope, in short, is that of Dante. "He defines and explains; and exalts every sweet incident of human nature," says Ruskin, "and makes dear to daily life every mystic imagination of natures greater than our own. He reconciles, while he identifies, every virtue of domestic and monastic thought. He makes the simplest household duties sacred; and the highest religious passions serviceable and just." [25] Boccaccio says that he guided art forward into light.[26]

But Dante, however keen he might be on literature in the vernacular, was schooled in the Classics: and the return to nature direct was accompanied by a return to nature through the Classics—as we see most clearly in the sculptor Niccolò Pisano, and his contemporary workers in intarsio, the Cosmati.

While these showed the energy with which men were studying the Classic achievements, and the skill with which they were rivalling them, the universities offered fellowship and competition in learning and knowledge: [27] and the most enthusiastic followers of St. Francis developed their intuition into a spiritual philosophy, where mysticism and sympathy gave a new flight to intellectual subtleties. Duns Scotus was the subtlest of the Franciscan philosophers, but the most literary was St. Bonaventura, who was the friend of St. Thomas Aquinas, as St. Francis and St. Dominic had been friends before them. He was not so much a philosopher as a mystic: it is in love's rapture that he believes the final blessedness to lie, and not, like Aquinas and Dante, in vision. He identifies reason with intuition, and is more absorbed in bringing man into relation with the heavenly world than in

following up Aristotle's logical science with the same tranquillity as St. Thomas followed it. But his style is not so hard nor dry as that of St. Thomas. He breaks out into ecstasy, and, like Plato, turns philosophy into a poem.[28] So in turn Platonism kept pace with the revived Aristotelianism on which the Dominican leaders were the chief to expound: orison and logic were keeping pace with one another, and summing science and religion into a unity, as Aristotle had summed science and metaphysics; thus we find a sum of knowledge from the point of view of a man of letters in the work of Brunetto Latini of Florence, and another from the point of view of the preaching friar in the work of Thomas of Aquino, who completed the work of Albertus Magnus. When Andrea della Robbia portrayed St. Francis and St. Dominic together, he showed also how complementary were their Orders.

Thus in the culture of Southern Europe there were gathered together the masterpieces of Hellenistic philosophy, of Latin literature, of Christian theology, and Catholic mysticism, while at the same time there was a clear realization of the fact that "the novelizing spirit of man lives by variety and the new faces of things".[29] From this tension and wrestle genius became sinewy. "Antiquity envieth there should be new additions," so Bacon was to write some hundred years later, "and novelty cannot be content to add, but must deface. Surely the advice of the prophet is the true direction in the matter. *State super vias antiquas et videte quaenam sit via recta et bona et ambulate in ea.* Stand ye in the old ways, and see which is the good way, and walk therein. Antiquity observeth that reverence that men should make a stand thereupon and discover what is the best way; but when the discovery is well taken, then to make progression." [30]

<center>VI</center>

This warning, so necessary at the beginning of the seventeenth century, had been instinctively followed all through the thirteenth: the result was that, choosing the best from the archives of antiquity, and yet determined to assert values all their own, the age was suitable for the creation of the mightiest works, and works in which the might was dedicated to God's glory. The thirteenth century had come back to nature as it had come back to the Classics: as "the heir of all the ages",[31] it used its legacy to increase its power: and though it gave great energy

to contests for order, contests between cities, contests between the Church and civil power, it was content with nothing less than the order of a universal unity which should give a backward glance over the history of the world, which should take everything possible from, and give everything possible to, the world in which it lived, and which should so live that its society as a whole should have in its own experience a foretaste of life after death. It reached a success which for four hundred years kept the subjects and interests of the landmarks of genius Christian. In the North it contended with social factions, and with barbarism: and left the Gothic cathedrals. In Italy its novelty was a poem. Its prince was Dante.

<p style="text-align:center">CHAPTER VII</p>

[1] Fr. Cuthbert, *Life*, pp. 7, 8.
[2] Soc. 7, 13; I Celano, 7.
[3] The narrative follows Fr. Cuthbert's *Life*, Ch. III.
[4] Ruskin, *Mornings in Florence*, paragraphs 49, 50.
[5] *Paradiso*, XI, 59–62.
[6] *Writings of St. Francis*, pp. 152, 153.
[7] Fr. Cuthbert, *Life*, Ch. IV.
[8] Sabatier, *Vie*, pp. 327–332 (Ed. Rufin).
[9] Sabatier ceased to be sceptical about them before he published the second edition of his book, and researches of recent years have corroborated the evidence.
[10] Rule of 1221. See Sabatier, *Vie*, ch. XV.
[11] Mr. Basil de Selincourt put it thus: "His value as a relic might tempt jealous rivals to make away with him, and Assisi lose for all time the virtuous presence of his bones." *T.L.S.*, 1926, p. 637.
[12] St. Bonaventura, *Life*.
[13] See Celano, *First Life*, Ch. XXIX, §83.
[14] Felden, *Ideals*, p. 224.
[15] *Ibid.*, pp. 229–230.
[16] Dante, *Paradiso*, II, 37.
[17] Renan, *Essays in Religious History*, p. 169.
[18] W. von Bode, *Die Kunst der Frührenaissance*, pp. 9, 11; Thode, *Franz von Assisi*, passim.
[19] *Renaissance in Italy*, Vol. III, p. 195.
[20] *Painting in Italy*, Vol. II, pp. 12–21.
[21] L. Gillet, in *Catholic Encyclopædia*, Vol. VI, p. 565.
[22] Quintilian, *Or. Inst.*, VIII, 3.
[23] Vasari, *Lives of the Painters* : "Giotto".
[24] " The intense impression created by St. Francis, the historical nearness of his truly evangelical personality, and his likeness to Jesus Christ borne out by the miracle of the Stigmata, thenceforth influenced art to an incalculable degree. For the first time in centuries, painters until then limited to the repetition of consecrated themes, to an unvarying reproduction of hieratic patterns, were free to improvise and create. Painting was no longer an echo of tradition but rose at once to all the dignity of invention."—Louis Gillet, in *Catholic Encyclopædia*, Vol. VI, p. 565.
[25] Ruskin, *Mornings in Florence*, para. 37.
[26] Lord Crawford, *Dante as Artist*, p. 7.
[27] See Haskins, *The Renaissance of the Twelfth Century* (Cambridge, U.S.A., 1927); *The Rise of Universities* (New York, 1923).
[28] For an excellent account of this Saint, see Gilson, *St. Bonaventura*.
[29] Sir T. Browne, *Christian Morals*, p. 36.
[30] Bacon, *Advancement of Learning*.
[31] Tennyson, "Locksley Hall", I, v, 1.

I

Giotto, like Dante, whose portrait he painted, showed first a devotion to the Saints and a faith in the Church; he had also an intense interest in the world around him as offering the subject of an impassioned love which, when consecrated, could be one with the mysteries of the life of grace; lastly, he gave the keenest attention to the technique of his medium. It was the mingling and interplay of these three uses of genius which gave that age religious art: the combination of passionate feeling, of acute thought not only about the world, but about a man's particular business in the world, and so strong an interest in his own personal form of creation as to wish to raise it to a new excellence. Art has to become a scheme of all life and knowledge, and therefore the expression of eternal truth.

Aristotle had taught that art was an innate faculty which could be developed: this development of the inward faculties was talent, an habitual capacity for excellence, even though the physical apparatus should be inadequate to give it form. Dante believed, therefore, that art must aim at treating noble subjects, subjects sublime and beautiful, yet with a sense of man's place in the universe (for man shares intellect with the angels), and therefore with an instinctive craving for virtue: he shares a need of physical life and pleasure with the realm of sentient life, and therefore desires love; and in relation to the world of plants his instinct is for safety.[1] And therefore, however high his subject, it cannot help being combined with human interests and a close study of events and nature. Genius alone, said Dante, will not enable man to sing of the sublimest subjects in the sublimest style: those who attempted poetry without the effort of study would mount no higher than the goose, for geese their slovenliness and presumption showed them to be. He insisted that it is only by taking pains to acquire wit and knowledge that a man can expect to become creative in the sense of sublimity that marks the difference between the waddling goose and the eagle soaring to high skies.[2]

Aristotle, whose remorseless intellect gives him a place in the history of art hardly different from his function in the history of thought, had written at the beginning of his *Physics* that the

perfection of knowledge of every single thing is determined by
its ultimate elements. Just as it was necessary for a poet to
understand that man had a body, and an inner life that received
impressions through the body, so it was necessary for a poet to
analyse the arrangement of lines and rhymes and metre.

But apart from this, the poet must have a language that was
itself sufficiently elastic and sufficiently dignified. It must be,
said Dante, illustrious, cardinal, courtly, and curial. It was
illustrious when it was a means of illumination, receiving the
light of high examples and throwing it onward, when it was
exalted as a means of training and authority; it was cardinal
when dialects and local tastes of expression were seen to turn,
or hinge, on it; it was courtly when it was fitting for the
language of a central government; and it was curial, or as we
might say "nicely balanced", when it was suited to the precise
distinctions of the mind which could speak precisely in the
balancing of justice: for "whatever in our actions is well
balanced is called curial".[3]

II

And so, Italian as he found it, as he stamped it, and as it ever
since remains, Latin, made simpler, lighter, more elastic, more
liquid, more musical, is the language which Dante chose for the
highest theme to which a poet has addressed himself. Virgil had
pictured the heroes in the Elysian fields, Lucretius had set out
the Epicurean system, Goethe in time to come was to set out in
Faust his own philosophy of phenomena where he pictured life
as a rainbow rising from the turmoil of a waterfall, fixed only
in its changefulness:

Am farbigen Abglanz haben wir das Leben.[4]

Dante was not less ready to celebrate the iridescence of the
world, but for him its scenes and events were symbols to be
refined by imagination to convey a knowledge of the life of the
soul, which found in the world beyond the grave the fitting
counterpart of its choice of life on earth. For him the statement
in a phrase had four distinct meanings: there was the plain
meaning as record of events; there was the allegorical meaning
when it was treated as symbolic of the Christ; there was a moral
meaning when it conveyed a truth of the ethical life; and a
fourth, which he called anagogical meaning, where it conveyed

a truth about the life to come. "Israel went out of Egypt." That was historic fact. It signified Christ's redemption of the world from wretchedness to grace; a change in human nature from vice to virtue; and finally "the passing of the sanctified soul from the bondage of earthly corruption to the freedom of everlasting glory".[5] So, then, we may expect it to be with the *Divine Comedy*. It gave a background of real persons and human happenings. It explained the redemption of the world; it was a parable of the spiritual life of the Christian; it was a picture of life after death. These senses intermingle with one another, as the poem proceeds, so that though one may dominate at any given moment, the poem is wealthy with all four: it is a poem of history, of mysticism, and of philosophy: and the background of every episode, reference, or scene, has the momentousness of eternity.

III

As the Church felt assured of her power both over culture and over nature, she used a different standpoint in philosophy. At first her need was for Plato and the Alexandrian Platonists, whose gifts, partly poetical, partly mystical, and partly metaphysical, proclaimed the supremacy of the spiritual from a point of view that she could claim as philosophic. But Platonic idealism, which St. Augustine had developed into mystical theology, looked on the exterior world if not as a delusion, yet as a shadow. The Platonists did not see that it had in any way bettered the scheme of things. St. Augustine had gone farther: he saw that the things above are better than those below, but all together better than the things above by themselves. How could the Church fill out this truth so as to find a value for the good things of earth, and yet at the same time to relate them to the world of culture in which they now took the place of sovereign?

The answer was in the philosophy of Aristotle. Himself a Platonist, he believed in the supremacy of spirit: but he had shown, what Plato had failed to show, that the human mind learns all it knows through the senses, that it does not begin in abstract knowledge, or in intuitive communion, but that the hard work of close observation and of science are useful as well as the analytic ruthlessness of Socratic metaphysics. From the very quarter from which the worst storms had burst on Rome and Europe came also the response to the new need.

For it was the Saracens who had returned to Aristotle; among them were found the leading philosophers of the eighth and ninth centuries; their master was Averroes, or Ibn Rushd of Cordoba.

When St. Dominic, the contemporary of St. Francis, had, for his religious revival, established an order of intellectual preachers, it was from Cordoba that they brought their weapons. It was in Spain, where St. Dominic arose, that philosophy was most active and Aristotle best known. From the beginning the new order of preachers saw that they must argue their religion into the scheme of an intelligent world. Such was the work in which Albertus Magnus excelled. Such, above all, was St. Thomas of Aquino. For his achievement was immense. His philosophy comprehended all ranges of life and knowledge. Cosmology, metaphysics, ethics, psychology, politics, economics he combined with theology into a refined and ordered system. He worked out this sum of knowledge in less than fifty years. Born at the castle of Roccasecca in 1225, he was sent to the neighbouring height of Monte Cassino when only five years old to study with the Benedictines, and there, looking from the purple valerian on the walls to the snows of the Abruzzi, he asked the portentous question: *What is God?* He studied the liberal arts at Naples, and at the age of twenty went to the University of Paris. From there he followed Albertus Magnus to Cologne. And he divided the rest of his life between Paris, Naples, and the Lateran, sometimes as professor of philosophy, not seldom as the counsellor of Popes and Princes.

He extracts into a lucid and subtle synthesis the truths from all the philosophies which preceded him. His inspiration has survived through minds as different as those of Michelangelo, of Donne, of Sir Thomas Browne, and of Hegel to the present time, when Cardinal Mercier has been the leader of reunion in Northern Europe. Even Milton, though he mentions the favourite discourses of the Schoolmen as vain wisdom and false philosophy, and likens their discussions to the debates of the fallen angels, yet admits that there was something pleasing in their sorcery. With the medievals Milton shares also his concept of creation as the development of form from chaos and night. If Milton followed the Schoolmen, so did Dryden, and nowhere more than in his Anglican confession of faith. Pope went farther, and embodied many of their doctrines, though not without some striking deviations, in his *Essay on Man*.

But it is above all wherever we meet Dante that we are close to Aquinas. Once, in a famous essay, Dean Church wrote of Dante as the most original of thinkers. A great scholar has seldom erred so widely: for when did a supreme genius ever follow so closely as Dante in the train of a contemporary? The great Ghibelline did depart, it is true, from the political philosophy of *De Regimine Principum*; but in all other matters the doctrines he states are Thomistic; and through the centuries reflections, not only of his imagery, but of his thought flash down the avenues of literature, inviting us to study the system which was the coping-stone of his poetry.

IV

"How charming is divine philosophy!" The exclamation in *Comus* takes one to the very heart of the work of man's reason. Reason essays the task of solving the riddle of things. It looks not only on the world of sense, but in upon itself. It interprets its sensations and seeks to explain how it interprets and, in explaining this, to search not only into the reality of life, but into life's beginning and life's end. This is, indeed, something to charm the guardian of virtue. For reason is not bounded by itself, and still less by material things. It can insist that within the visible and temporal world, the world of sense, there are traces of something invisible and eternal, something more real than outward things, of some idea or form of good or truth or beauty, of some power of light or life or love, which is not so much akin to visible things, even the most beautiful, as it is to reason itself. And reason concentrated so asserts itself that this idea or form which it recognizes is the only reality, and that, whether or not the reality is purely abstract, from it we can trace not only what being really is, but its origin, and finally its end. Shelley, dreamily watching the reflection of the sun from the lake playing on the ivy and the yellow bees busy with its blooms, claimed that from them he could create a form immortal, a form more real than man.[6] So, the philosopher says, thought was ever creative, and drew the forms of all things out of abysmal void. In the beginning, said Aristotle, there was on the one side a Mind; beside it there was nothing; and yet this nothing was a raw material, a chaos out of which order could be evolved, a night which could be illumined.

Thought, then, when duly meditated, leads us to the two

incomprehensibles of God and nothing. God the absolute, the Mind, thinks only thought, and this thought is the only true reality. So Aristotle develops Plato's doctrine of ideas; he did not say that God is a thinker apart from what He thinks; but thought itself, illuminating the life of man, enables man to abstract from the things he knows by sense a contact with something indestructible, for thought is indestructible—something which, being unseen, and recognized by thought, not sight, is eternal. So likewise the things which are recognized by sight can claim no more reality than sense can give them, and are temporal. The senses recognize in things only the temporal or accidental appearance that they have; but their reality is something underlying this, substantial, which relates them to man's judgment; something they owe to their correspondence with informing thought, timeless thought, a thought which knows priority only as a logical relation; and recognizing so the scenes of nature which he loves, the philosopher may say, as Wordsworth said of his own youth among them—

> I held unconscious intercourse with beauty
> Old as creation.[7]

V

What, then, is the relation between man and the outward world? It is his knowledge of it: for that is an intense and close communion between the knower and the known. In the act of knowing, the mind meets, and becomes united to, what it perceives in a generative intercourse, the fruit of which remains as the witness of the identity which in knowing the knower established with the known. And this generation of concepts is the essential life of the mind. Until it meets with realities outside itself, and from its perception of them through the senses abstracts from them a knowledge of what they are, the human mind is itself formless, or uninformed.

This is the Aristotelian metaphysic, as St. Thomas brought it into the scheme of Catholic theology. He saw, as St. Augustine had written long before in *The City of God*, that a Light which was not nature, and which was not man, but which made them both, was the intellectual illustration which gave to all things their intelligible splendour. Belief in God he could deduce from the evidence of creation, for created things implied the cause which was their Creator and Sustainer and which would

be their consummation. But, until Hegel, no one, not even Anselm, conceived that philosophy could deduce the Christian revelation: it was claimed rather that philosophy could point to it as something which reached out to man in places where reason was inadequate. Christianity is harmonious to Aristotelianism, but it is something more.

For we are not all philosophers. A bond with perfection which enlists the loyalty of the will, which enlightens the mind, which thrills the heart; a personal relation with the light of life which is God: here is something both more general than the divinest philosophy of thoughtful men, and more dominant. It transcends the discursive intellect; for the imperious desires of a lover, when love is perfected in a love returned, give him with the beloved a union more immediate and more complete than that between the knower and the known. Love realizes the beloved presence as good in perpetual power and joy. The religion of Christians is a divine revelation of love so that man may have the life of grace which is a likeness with the Divine nature—a likeness given direct from God; it is therefore something other than, and more than, the sublime metaphysic of Aristotle. Aquinas accepted both. He welcomed philosophy as the continuous attempt of human thought to know more and more of life and truth in all their ranges, but he held, too, that there is a knowledge given by faith: logic cannot take one so far as the knowledge which is completed by the heart and will of the lover. Mysticism always reaches out beyond it ; and metaphysic is its continuous excursion into mysticism. For mysticism is the concentration of reason in feeling. It is the light of the mind so close to the inward life of man that it has the glow of a fire.

Furthermore, the Christian revelation, in the Thomist system, is the manifestation to the world as a whole of a truth of divine love which is yet more than metaphysic to the philosopher, or mysticism to the saint. In it, in terms the simplicity of which all can apprehend but the wealth of which none can exhaust, God is revealed as a unity of life and light and love. His knowledge of Himself—His thought of thought—lives, *lumen de lumine*, as an actual man. By being made manifest to men's senses, He wins them to love of His invisible excellence. Identifying Himself with what He has created, He completes both man's destiny and man's knowledge. But more, He captures men's hearts. He is, in the words, not of a theologian

but of Pierre Loti, *le maître des consolations inespérées et le prince des pardons infinis*.[8] His spirit of informing love dwells for ever, *lux beatissima*, in the society of His chosen.

By that light St. Thomas tested and perfected the doctrines of Aristotle. He established between religion and philosophy a harmony which invites the admiration not only of the Christian who recognizes the intrinsic merits of reason, but also of the philosopher who realizes that the excellence of reason points beyond itself to the insight of the lover and the mystic. *Credo ut intelligam.* As a Christian Aristotelian, St. Thomas could say of God that His being is His very act of thought. And this thought is the measure and the cause of every other being and every other mind. He Himself is His own being and thought. From whence it follows not only that the Truth is in Him, but He is Truth itself original and sovereign.[9]

How, then, would we outline the eminence of the supreme Christian Aristotelian, or count the worth of his contribution to the *philosophia perennis*? For he no more claimed to teach a final than an original philosophy. We would say instead that Thomism is a Christian humanism: it is not a combination of the Christian revelation with Greek philosophy, but it shows us rather that Christianity can comprehend humanism, and is in fact one and the same with humanism, which finds its natural completion in Christianity. To it Aristotle is necessary as well as St. Augustine. Reason's triumphs are recognized, and accepted; yet they are perfected by revelation: human nature is honoured as the supreme phenomenon of creation, and in spite of all men's failures essentially good. But it is by grace that man attains to the blessedness and perfection towards which he tends, and in which his longings will be stilled in joy and peace.

In St. Thomas, therefore, are united the two great influences to which the mind of Europe owes its knowledge of truth. He sums up all ages and philosophies which preceded him. "All thinking men", says Professor Tout, "must recognize his permanent place in history." His scholastic philosophy proved its hold over the creative imagination in Dante and Petrarch, Leonardo and Michelangelo, in our own Donne and Browne, Milton and Pope. It is, in fact, in harmony with the noble traditions of English literature. Having the vitality of truth, St. Thomas is still dynamic, still enlightening. After reading Professor Tout or Professor Taylor, M. Maritain or M. Gilson, M. Ghéon or Signor Olgiati, no one would, in Macaulay's

phrase, "sneer at Aquinas".[10] They celebrated his seven-hundredth birthday with not least *éclat* in the Universities of Naples and Paris, of which he was so distinguished an ornament. He commands the admiration of us all as one who, by combining original thought with profound study and genius with a holier inspiration, produced a synthesis which guided succeeding masters; and which still invites our minds to strengthen and refresh themselves by exploring farther the fact of their own lives, and, by revelling in hard exercise, to taste the charms of a philosophy which is indeed divine.

Here, therefore, was a fitting foundation for the thought of the Divine Poet. The light, life and love of God could be mirrored in the hearts created by the reason, imagination and passion of a supreme genius.

VI

Although Dante's poem is based upon and built up into the system of St. Thomas Aquinas, although it is starred with all the learning and mysticism of the thirteenth century, and although it reaches its height in a life which was wholly love and peace, it begins with an account of the eternal punishment of sin.

By tracing the close relation between the deed committed on earth and the reward it merits in the world of timeless being, by portraying the hideousness and filth of hell, its torments of fire and of frost, by associating its sufferings, through remembered temptations, with life on earth, by revealing the failure of ideals, and the survival of strife between men and women, or between political powers and factions, Dante attains to a profound assertion of justice and order in the universe, as well as of moral and philosophic truth. In this way he makes the picture of hell into the essence of great literature. For the secret of that is that it takes the experience of a few persons, or particular events, or even a simple scene pregnant with the grandeurs of life as a whole, and gives them the poignancy of love while at the same time suggesting eternity.[11] The more precise are our images about the tragic issues of sin, the better for poetic success; and therefore, says Dante:

> *Così scendemmo nella quarta lacca,*
> *Prendendo più della dolente ripa,*
> *Che 'l mal dell'universo tutto insacca.*

Ahi giustizia di Dio! tante chi stipa
Nuove travaglie e pene, quante io viddi?
E perche nostra colpa si ne scipa? [12]

It is true that the modern mind recoils from what Dante shares with Islam: an insistence on gross physical detail in the sufferings of the damned. The modern mind recoils from any idea of damnation at all; even to those who accept the dogmas of Dante's own Catholic Church on the subject, the change of emphasis is enormous. With Dante himself, as with the most modern mind, it is the loss of God, rather than the physical suffering, which is the essential of damnation: and even though the mention of pain has never been eliminated from the dogmatic statement, it is recognized that in the eternal state, which is not endless duration, but immediate unsuccessiveness, change is inconceivable; and the burning by fire must have a meaning too inward, too essential, for physical combustion to be other than a suggestion. Furthermore, we realize that we have the vaguest ideas as to how the place of utter godlessness is peopled: the last thing the Catholic is called upon to decide is who—if anyone—is there. And among Dante's condemned souls are those pagans of great virtue who, having had no opportunity of Christian redemption, could neither justly suffer nor be saved. They were in what Catholic theology defines as "limbo". "*Senza speme*", said Virgil, "*vivemo in desio.*" [13]

And yet it has often been noticed that the *Inferno* is the part of Dante's work which most people read. They read it not so much as a picture of literal truth, but for its high dramatic power, its highly flavoured memories of life and history, and for the corrosive force of the imagery which seems to cut out the hardest metal in sharp relief and then throw it up in high lights and flashing colour. For the *Inferno* is a play of lurid effects, like a stormy night lit up from the smoky flames of a furnace. This imagery, as Professor Asín y Palácios of Madrid has shown us, is shared with Islam, from the *Miraj* of Ibn Arabi of Murcia, just as the Aristotelianism of Dante had been developed through intermediaries from Ibn Rushd of Cordoba.

[12] *Inferno*, VII, 16–22:
 . . . We track
Still further that declivity of woe
Which doth our universal guilt ensack.
Justice divine! Can any there below
Heap up such penalties and travail now ?
And why doth guilt of ours consume us so?
The translations are from either Melville Best Anderson or Laurence Binyon.

But in the imagery the relation is far closer. The general architecture of the *Inferno* is but a copy of the Moslem hell; the architecture of Dante's *Paradiso* is identical with that of Islam. Ibn Arabi, like Dante, meets Adam and discusses with him the language spoken in Eden: the apotheoses in both ascensions are exactly alike: even the mystic doctrines of Dante had been anticipated by Ibn Arabi: and it was the Murcian mystic who preceded him in tracing the passion and idealism of a mystical communion in love, to which any sex experience was alien. In the tortures and rewards, in the development of dramatic action, in the episodes and incidents of the journey, in the rôle of the protagonist, and even in the parts taken by minor personages, the *Divine Comedy* finds a model in a legend of Islam.[14]

But although the episodes of the *Inferno* are often grotesque and abhorrent, not less to our judgment than to our taste, the poem has a moral quality which is at the same time æsthetic. It treats with great subtlety and precision of the effect of certain mortal sins in bringing to ruin even noble natures, and in its suggestion of an appropriate physical torment for each hideous sin, it satisfies reason's craving for order, a craving which is one of the instincts essential to the arts and literature. In the grim scenes of Dante's hell we find not only order, but also splendour, and even, in a certain sense, delight. For apart from the full, deep rhythm of his verse, apart from the appeal of its strong flavours, the poem contains many vivid pictures which take the eye of Italian children, even of to-day: the dog gnawing its bone, the flying doves, the fireflies in the summer nights, the boat putting out from shore, the prior in his habit walking along the street, the olive and the cypress below the white horizon and the luminous air; a Florentine still marks the villages of Trespiano and Galluzzo as the boundaries of his city north and south: he would not be unresponsive to the statement that Florence is the place best known of all in hell; nor that the people of Fiesole were evil people long ago; and that those of Genoa are in every way rascals.

But when we read poetry, especially if we are still young when we read it, we do not look only for concrete images, any more than we look for an answer to mysteries: we take much on trust, and repose in a dreamland of vaguely attractive pictures, suggested in a rhythm of musical words. The *terza rima* which subjugates the reader of English poetry in the *Ode to the West*

Wind and *The Triumph of Life* is associated in Italian with a majestic command over the music of a liquid language, a language in which the most melodious letters constantly recur. Dante had learnt from Virgil, his "master and author",[15] the secret of a sonorous style, as well as of a varied and effective narrative, and he can juggle with meaningless sound to express the converse of Paradise, or the babel of hell's greeting to Satan. And here he exhibits a power over sound which gives the whole poem a power of its own. "He who reads the opening of the *Inferno* for the first time", said Laurence Binyon, "is soon aware of a rhythmical power, the energy of which carries the poet on as by a force not his own, so profound and irresistible seems its impulse, through all the hundred cantos of the poem, and, never wholly subsiding even in the midst of harsh disquisition, leaves its full music in our memory at the *Paradiso's* ardent close. This rhythm is not only in the words and in the lines, there is an under-rhythm in the whole movement from canto to canto and even, we may say, in the sense as well as in the language. No lyric, however glorious, can so dilate our spirits or so enlarge for us the sense of the power of the faculties."[16]

VII

But the power of the *Inferno* is especially in certain telling episodes: above all, in those of Francesca da Rimini and of Ugolino della Gherardesca. And here the outstanding particular is sympathy.

> *O lasso,*
> *Quanti dolci pensier', quanto disio*
> *Meno costoro al doloroso passo!* [17]

It is the tears that start from Dante's eyes at the martyrdom of Francesca, it is her tale of the eagerness and insistency of mutual desire, it is the poignancy with which the lovers remember all that was most delightful of their life on earth, finding in this the torture of their souls. For to these lovers, always together, yet always whirled and lashed by the drear winds, the essential of misery is the memory of a kiss.

In the story of Ugolino, when otherwise the unmitigated

[17] *Inferno*, V, 112–115:

> . . . Ah me,
> How many tender thoughts, what longing drew
> These lovers to the pass of agony!

horror might leave us callous, it is the trustful devotion and dependence of the children which make their father's suffering cut us to the heart.

> *"E disser: 'Padre, assai ci fia men doglia,*
> *Se tu mangi di noi: tu ne vestisti*
> *Queste misere carni, e tu le spoglia.'*
> *Quetàmi allor, per non farli più tristi:*
> *Lo dì e l'altro stemmo tutti muti.*
> *Ahi dura terra, perchè non t'apristi?*
> *Posciache fummo al quarto dì venuti*
> *Gaddo mi si gittò disteso a' piedi,*
> *Dicendo: 'Padre mio, chè non m'aiuti?'*
> *Quivi morì. E come tu me vedi,*
> *Vid'io cascar li tre ad uno ad uno*
> *Tra il quinto dì e il sesto, ond'io mi diedi*
> *Già cieco a brancolar sopra ciascuno*
> *E due dì li chiamai, poiche fur morti:*
> *Poscia, più che il dolor, poteè il digiuno."* [18]

But in neither of these cases does the fullness of sympathy blunt the edge of theological ruthlessness; and perfect love is seen to be fulfilled in inexorable justice. Every detail of life matters: for it involves blessedness and eternity. Time, in changes and chances, is the means of deciding how a heart shall feel for ever.

It is not its depravity that matters: it is the confession of sin, and the desire for mercy.

"Horrible were my sins," cried Manfred,

> *"Orribil furon li peccati miei;*
> *Ma la bontà infinita ha sì gran braccia*
> *Che prende ciò che si rivolge a lei."* [19]

[18] *Inferno*, XXXIII, 61–76:
> "Father," they said, "our pain will be far less
> If thou wilt eat of us: thou hast begot
> This flesh; relieve us of its wretchedness."
> This made me calm, lest they be more distraught.
> That whole day and the next none made a sign.
> Ah, cruel earth! why didst thou open not?
> And after the fourth day began to shine,
> My Gaddo flung him down before my knee,
> Crying, "O why not help me, father mine?"
> And there he died, and there I saw the three
> As thou seest me, fall one by one all through
> The fifth and sixth days: whence he took me,
> Now blind, to groping on them, and for two
> Whole days called to them, after they were gone:
> Then hunger did what sorrow could not do.
> (Anderson)

[19] *Purgatorio*, III, 121–123:
> Horrible were my sins, but Infinite
> Goodness has arms of an embrace so wide
> That it receives whoever turns to it.
> (Anderson)

Manfred felt a sense of marvel at the thought of wickedness redeemed.

Readers of Shakespeare, for example, are given few opportunities to show that in his tragedies the repose of life is rare; attention is based on "carnal, bloody, and unnatural acts": for them life is most arresting when it is a chaos and uproar, or a night of storm so black that

> Man's nature cannot carry
> The affliction nor the fear.[20]

What to Shakespeare was the tragedy of madness and the grim mystery of life: this was to Dante part of an ordered scheme: for it was hell. He can fascinate the unredeemed man by his terrible theme: as he must always impress the believer by his vindication of eternal justice in the punishment of sin. Both alike will pay their tribute to a power compact of sympathy and ruthlessness, of force and of intensity.

VIII

And yet the *Purgatorio* is in every sense but that of acrid flavour a finer piece of work than the *Inferno*. It is true that the poet is still occupied with suitable punishments for sin, and these are still severe; but a kindly light lends beauty to the sinner's sufferings, and heavenly wisdom keeps opening on the holy souls, while the Divine Office of the Church pours its chaste melodies upon the listening ear. The *Purgatorio* is a poem of hope: the consciousness that even this punishment is one aspect of the fine virtue of justice. The longings and yearnings of the redeemed soul for the supernal life, the peaceful beauties of quiet earth and sunset sky, the consolations of hymns to the Madonna and other echoes from the Divine Office and the Psalter, memories of the Saints, pictures of the Arno flowing through the Casentino from Falterona, or of the Lavagna cutting its way through the hills behind Sestri and Chiavari: these are delightful and inspiring. And there are many other beautiful scenes in the *Purgatorio*: scenes especially in Tuscany; but the poet's eye passes over them to fix upon the secrets of the sky.

To Shelley, and Shelley alone, has he taught his peculiar skill in conveying in musical words the mysteries of light and air, giving us, with his impression of colour, the soul of colours

living within them. "Of all the poets," said Ruskin, "he is the most subtle in his sense of every kind of effect of light." [21] He, too, recognized the light as the queen of colours: and, in fact, to him the colours themselves were a rank of ordered powers. Each had for him a symbolic meaning, signifying some spiritual quality or energy.[22] It is in no idly decorative sense that he calls the blessed Virgin

> *il bel zaffiro*
> *Del quale il ciel più chiaro s'inzaffira.*[23]

For him each colour was radiant with light, and gave light a particular quality, as in the flash of a jewel, or the effulgence of a cloud. The translucence of sparkling light flashes into the earthly paradise which leads from the place of purification to Paradise. It was, he said, a *Living Light*, which opened its beauty to the air, as though drawing aside a veil to the harmony of heaven. It is in this illumination that the poet regains his sight of her whom he had loved long since, and whom his ideal fervour had gradually identified with the Gift of mystic vision

> *Io vidi già nel cominciar del giorno*
> *La parte oriental tutta rosata.*
> *E l'altrò ciel di bel sereno adorno,*
> *E la faccia del Sol nascere ombrata,*
> *Sì che, per temperanza de'vapori.*
> *L'occhio lo sostenea lunga fiata:*
> *Così dentro una nuvola di fiori*
> *Che dalle mani angeliche saliva,*
> *E ricadea in giù dentro e di fuori.*
> *Sopra candido vel cinta d'oliva*
> *Donna m'apparve, sotto verde manto*
> *Vestita di color di fiamma viva.*
> *E lo spirito mio, che gia cotanto*
> *Tempo era stato, ch'alla sua presenza*
> *Non era di stupor tremando affranto*
> *Senza degli occhi aver più conoscenza,*
> *Per occulta virtù che da lei mosse,*
> *D'antico amor sentì la gran potenza.*[24]

[23] *Paradiso*, XXIII, 102, 103.
 the sapphire beauteous
Which makes the clearest heaven all one sapphire.
[24] *Purgatorio*, XXX, 22–39:
 As I have often seen at break of day
 The eastern region of the sky all rose
 With the other heaven in limpid fair array
And the new Sun, shadowed with mist, disclose
 A face so temperate these eyes of ours
 Could long endure the radiance it throws.
So in the bosom of a cloud of flowers,

He can compare the appearance of the angels, with their spiritual bodies, to the splendour of a dawn in Tuscany, and yet another circling host to the gleamings of nightfall: his whole progress through Paradise becomes a gaze in the changing beauties, ever intenser, of light and flame, till in the Trinity he sees the rainbow turn to fire. The poet distinguishes again and again the real nature of the heavenly world from the imagery in which he had to convey his impressions of it; but a main fountain of his power is his control over the imagery of fire, light, and air so as to reveal the spiritual mysteries of the eternal life. And this he brilliantly mingles with his devotion to Beatrice: for the union of love which takes the life of sense into the life of spirit is in the magic of meeting glances. "Their eyes met and clung together", are the words of an American classic.[25] "Through her eyes, her soul was naked to him", are those of an English one.[26] In the *Paradiso* it is through the eyes of another that Dante sees into the supernal wonder:

> *Beatrice mi guardò con li occhi pieni*
> *Di faville d'amor cosi divini,*
> *Che, vinta, mia virtu diè le reni,*
> *E quasi mi perdei con li occhi chini.*[27]

And again:

> *. . . e quindi stupefatto fui;*
> *Che dentro agli occhi suoi ardeva un riso.*
> *Tal ch'io pensai co'miei toccar lo fondo*
> *Della mia grazia e del mio Paradiso.*[28]

Flung in the air and drifting to the ground
From the angelic hands in blossom showers,
In veil of white, with olive fillet crowned,
Appeared to me a Lady in mantle green
With colour of living flame invested round.
And to my spirit that so long had been
Out of her presence, which did even move
Me to stand trembling and abashed of mien,
Virtue descending through her from above
Attested, without witness of the eyes,
The great tenacity of earthly love.
(Anderson)

[27] *Paradiso*, IV, 139–142:
Beatrice looked on me with eyes of light
Filled so divinely with love's spark ablaze
That, vanquished, all my powers were put to flight
And I became as lost with downcast gaze.
(Binyon)

[28] *Ibid.*, XV, 33–36:
. . . Awe came over me,
For such a smile was glowing in her eyes
That with my own I seemed to touch the depths
Both of my grace and of my Paradise.
(Anderson)

Beatrice warned him:

> Not in my eyes alone is Paradise.[29]

It is through them that he is guided upwards, as Dante saw
him, into the realms of light, reflecting their beauty upon
adoring spirits where a beauty that was joy dwelt in the eyes of
all the holy throng. And Beatrice leaves him with St. Bernard,
who gathered beauty from the face of Mary as does the morning
star from the sun. And Mary leaves him before the blessed
Trinity, in whom alone men find the perfect beauty in a perfect
peace.

IX

If heavenliness were all—and certainly it is the highest
excellence of Dante's poetry—he would be less successful. The
fierce attacks and coarse imagery which break in upon these
passages of spiritual beauty accentuate their quality; through
the most ethereal of his lights and fires he leads us to his
heaviest attacks on simony, on the popes' preoccupations with
temporal power, and on their unhappy relations with the
French monarchy. It is, in fact, his loftiest raptures which are
followed by his heaviest invective. There was no negligence in
that discipline of long, varied, and intense effort: and naturally
it was in the tension of his ecstasies that he most bitterly
resented the sins and vices he found in the central organism of
the Church. He saw that the life of a Catholic was a constant
interaction of visible with invisible things. And just as he uses
the imagery of clouds and rainbows and wind and light and air
to suggest the winged raptures of the life which is hidden with
Christ in God, so he comes back from the visions which had
baffled even his unrivalled powers of description—or sugges-
tion—of a beauty which was joy, to declaim with all his strength
against the faults and scandals that both marred the perfectness
and sapped the strength of the Divine organism which had been
his unerring guide into the secrets of truth and love. His poem,
we insist, is the better for it: if we turn to Shelley's *Epipsy-
chidion*, we see how soon the unrelieved poetry of air and clouds,
of lightnings and idealism, begins to lack the power to bear us
upward. Dante gives beyond all others what Coleridge called
"a sense of wings uplifting": "his very words", said Shelley,
"are instinct with spirit; each is as a spark, a burning atom of

inextinguishable thought, and may yet be covered in the ashes of their birth, and pregnant with a lightning which has found no conductor." [30] He soars beyond the clouds: but he carries with him a load of dynamite which he can discharge with killing aim on spiritual wickedness in high places. As his eye ranges back over history, and round on his contemporaries, he brands, he ruins, he consoles, or he immortalizes. The range, the variety, and the precision of his interest in the world—these, we have said, are the sinews of his sublimity, and are the undertone of that natural flood of music in his mind which is, in Binyon's words, "imperious as the sea in volume and momentum".[31]

<p style="text-align:center">X</p>

But it is yet more interesting to trace in the *Paradiso* the elements of theme or treatment which are unique in their high excellence. For if the *Purgatorio* is the most general in the variety of its scenes and subjects, the *Paradiso* far outshines it in ethereal imagery, in philosophic subtlety, and in Catholic mysticism. Nowhere is the thought of the Church so elegantly, so persuasively spoken, nowhere does the theme so exalt poetry to those stainless peaks, which first catch and longest hold the sunlight. His personal passion is combined with an unrivalled control of the imagery of lights and fires, so that we feel rather than see the aerial brillance with which he invests the life of Paradise.

Even eternal hell could not mar the intelligible order of the universe. Justice was seen to be the motive of its Sublime Creator, who is not only divine power, but supreme wisdom and perfect love. But in heaven likewise justice proves itself divine by the very fact that it baffles us.

> *Però nella giustizia sempiterna*
> *La vista, che riceve il vostro mondo,*
> *Com'occhio per lo mare, entro s'interna;*
> *Chè, benchè dalla proda veggia il fondo,*
> *In pelago nol vede; e nondimeno*
> *E li ma cela lui l'esser profondo.*[32]

[32] *Paradiso*, XIX, 58–64 :
> The sight that your world liveth by
> Penetrates not the eternal justice more
> Than into the ocean penetrates the eye,
> For though it sees the bottom from the shore
> On the open sea it cannot: none the less
> It is there; but the depth conceals the floor.
> (Binyon)

Only the revelation of the infinite light can make clear the puzzles of the infinite order:

> *Lume non c'e si non vien dal sereno*
> *Che non si turba mai.*[33]

As the deprivation of God makes hell even on earth, so the blessedness of Paradise is the same acceptance of the Divine will which men pray may be done on earth:

> *Anzi è formale ad esto beato esse*
> *Tenersi dentro alla divina voglia,*
> *Per ch'una fansi nostre voglie stesse.*
> *Sì che, come noi sem di soglia in soglia*
> *Per questo regno, a tutto il regno piace,*
> *Com' allo re, che in suo voler ne invoglia.*
> *E'n la sua volontade è nostra pace.*[34]

The famous line is one of the coping-stones of the mysticism which is the unity of the heart and mind with God through acceptance of His will. It is a teaching essential to all Christian discipline and mysticism, and, before Dante's time, had been worked out with peculiar precision by St. Thomas and St. Bonaventura, two of the authors whom Dante most admired and most closely followed. And so in the third canto of the *Paradiso*, where Dante meets Piccarda, and "tell me", he asks her,

> *Ma dimmi: Voi che siete qui felici,*
> *Disiderate voi più alto loco*
> *Per più vedere, o per più farvi amici?* [35]

the answer was that in Paradise *love is fate*. It is both the stilling of desire and the answer to enquiry, because it means content in the acceptance of order, as giving to each the best as seen by the insight of love.

[33] *Ibid.*, XX, 65:
> There is no light but comes from that serene
> Which never can be troubled.

[34] *Ibid.*, III, 79-85:
> It is the essence of this blessed state
> To dwell within the Will Divine alone
> Whereby our wills with His participate,
> So that throughout the realm, from zone to zone,
> We pleasure the whole realm without surcease
> And please the King who inwills us with his own,
> And in this will is our eternal peace.
>
> (Anderson)

[35] *Ibid.*, III, 64-76:
> Tell me, ye who tarry here in bliss,
> Would ye not fain ascend to regions higher
> To win more friends, or to see more than this?
>
> (Anderson and Bickersteth)

Dryden was to write:

Thy throne is darkness in th' abyss of light,
A blaze of glory that forbids the sight,
O teach me to believe Thee thus concealed,
And seek no further than Thyself revealed.[36]

So Dante speaks with the same finality of predestination:

E voi, mortali, tenetevi stretti
A giudicar: chè noi, che Dio vedemo,
Non conosciamo ancor tutti li eletti.
Ed enne dolce così fatto scemo;
Perchè il ben nostro in questo ben s'affina,
Che quel che vole Iddio e noi volemo.[37]

This mystical quality of a faith which is both loving trust and trusting love is both the repose and the spur of the thinking.

Dante, as we saw, was a Christian Aristotelian, a keen follower in the steps of St. Thomas Aquinas. He saw the universe in all its subtlety arrayed as a hierarchy of act and potentiality, the motive of act, the essential act being thought. It is the pure intelligences, the disembodied intelligences, the intelligences which know intuitively, which are the most active beings in creation. Human intelligence, which is active, but which needs the food of a reality outside itself, must distinguish between the essential reality given by thought, and discernible by thought, and the palpable reality in the world of sense. And this, which is the groundwork of Christian Aristotelians, will be found in the *Paradiso*. It is the weakness of the system that Dante accepted from St. Thomas that the relation between thought and the world of sense, and their interdependence, as well as their modification of human intuition, are not explained, nor even defined. He built up his system into beauty in spite of vagueness there.

XI

And no doubt he was surer because as poet he was less logician than mystic. It is love that is for him the secret of

[37] *Paradiso*, XX, 133–138:
Judge then, ye mortals, with restraint: for we
To whom the sight of God is granted, still
Know not, how many the elect shall be;
And us the very lack with joy doth fill
Because we find our crowning good herein
That what is willed by God we also will.
(Anderson and Bickersteth)

creation, its central motive power. *Nè creatore nè creatura mai fu senza amore*,[38] he said. Love is the divine stamp upon creation.

> *In sua eternità, di tempo fuore,*
> *Fuor d'ogni altro comprender, come i piacque,*
> *S'aperse in nuovi amor l'eterno Amore.*[39]

Love, as we have seen, was at once a magnetic attraction and a power of intuition living in the eyes, and acting through them. It is the strongest and deepest movement of a being towards that which it intuitively recognizes to be its essential good, and so is what most enlarges and ennobles the nature of man: and whence is love enkindled but in the attraction of a presence which awakens a delighted admiration and which seems a vision of perfection? For such is beauty. It is the sense of this ardour for an elevated and entrancing excellence which raises the *Paradiso* above all other poems. Throughout the whole of the *Commedia* one may trace the conviction that love is the movement of the heart towards good, and that all evil comes from an error of sense or judgment as to what is really desirable. It is therefore by light and seeing that we are guided toward that which is truly good. It is love which guides us through all ranks of creatures to the central height, where the ardent soul attains that final and ineffable Worth which is at once the origin, the criterion, the sum, and the perfection of all the values in the Universe.

> *Nel suo profondo vidi che s'interna*
> *Legato con amore in un volume*
> *Ciò che per l'universo si squaderna.*[40]

It is typical of Dante's vigorous intellect that he should agree with St. Thomas in insisting that love follows on the contemplation of beauty. He says distinctly that the final blessedness consists in seeing rather than in loving. Yet with him vision, although his imagination surpasses that of all other poets in the distinctness which Keats held to be the excellence of poetic

[39] *Paradiso*, XXIX, 16–19:
> In his eternity where time is none
> Nor aught of limitation else, He chose
> That in new loves the Eternal Love be shown.
> (Binyon)

[40] *Ibid.*, XXXIII, 85–88:
> I saw in its abysmal light immersed
> Together in one volume bound with love
> What is throughout the universe dispersed.
> (Anderson)

workmanship, had so much intuition that it was itself an act of union, and so was also love. For it the power to see is united with a spiritual faculty when it becomes the power to behold beauty. For that is to admire, and to admire is to enjoy, to wonder, and to commune.

Dante is one of those spirits, both philosophical and mystical, in which the refined intellect transcended its own act of thought, and became contemplative, and, in its contemplation, was changed to a likeness of the glory it beheld. In him we can fill out the meaning of St. John's words that: "Now are we the children of God, and it doth not yet appear what we shall be: but we know that, when He shall appear, we shall be like Him; for we shall see Him as He is." [41] And as he insisted that love was the secret of creation, and that the universe was a series of magnetic attractions, so he was always guided up and inwards towards the supreme vision by his love for individual souls. There was first of all Beatrice, who drew his soul out into hers as he gazed into Paradise, meeting her eyes: Beatrice, who left the trace of her dear feet in hell for his redeeming. There are Matelda, and Piccarda, and Virgil, and the souls of many just men made perfect through the vocations of government or philosophy. But as he rises higher, he is more absorbed in the mystics and the Saints, till he loses himself in the contemplation of that perfect and inter-resplendent circle, the Trinity in Unity.

It would not have been surprising if the poem had become more chill, more austere, more difficult, as it rises into the ineffable, or been, like Shelley, content to leave us with an impression that "The loftiest star of unascended heaven" is pinnacled *dim* in the intense *inane*. But, on the contrary, the higher Dante rises towards the central bliss, the more fervently is his heart engaged; and he speaks of his ultimate visions in the Empyrean with more fervent glow and a more poignant tenderness than in any of the human relationships which had led souls into the depths of hell, or up into the perfumed air of the terrestrial paradise. As the poet rises into the exclusive society of the Saints, he catches from them that quality in their love which is peculiarly holy, the love which brings them to unite with the source and end of their love. And yet his imagination, always thorough, complete, intense, beyond those of other poets, is here still more eager than before.

XII

Such is the consummation of the plan of this unique poem: such is the end of his story: and the force of poetry could go no farther. To the believer this layman has spoken of the final end of holiness in words more telling than any of the Saints. But at every point he is apt to display this especial gift—the gift of combining intellectual enquiry with his religion, and uniting this enquiry with the spirit of prayer, and expressing both with an extreme poetical elegance and an imagination of unequalled vividness and intensity. An earlier—we need not say a better—Chateaubriand, he dispenses us from theological disquisition by winning us with a consideration so eloquent and so charming that it is irresistible. How many arguments can one hear for—or against—prayer for the dead! Dante does the work of them all in three lines:

> *Ben si dee loro aitar lavar le note,*
> *Che portar quinci, sì che mondi e lievi*
> *Possano uscire alle stellate rote.*[42]

The grace with which he can invest recognized truths or familiar forms throws its own personal charm over his paraphrasing of the *Pater noster*:

> *O Padre nostro, che ne' cieli stai,*
> *Non circoscritto, ma per più amore*
> *Ch'ai primi effectti di lassù tu hai;*
> *Laudato sia 'l tuo nome e 'l tuo valore*
> *Da ogni creatura, com' è degno*
> *Di render grazie al tuo dolce vapore,*
> *Vegna ver noi la pace del tuo regno;*
> *Chè noi ad essa non potém da noi,*
> *S'ella non vien, con tutto nostro ingegno.*
> *Come del suo voler gli angeli tuoi*
> *Fan sacrificio a te, cantando Osanna,*
> *Così facciano gli uomini de' suoi.*
> *Dà oggi a noi la cotidiana manna,*
> *Senza la qual per questo aspro diserto*
> *A retro va chi più di gir s'affanna.*
> *E come noi lo mal, ch'avém sofferto*
> *Perdoniamo a ciascuno, e tu perdona*
> *Benigno: e non guardare lo nostro merto.*

[42] *Purgatorio*, XI, 34:
> Surely we ought to give them aid to clear
> The stains they carried hence, that light and chaste
> They issue forth upon the starry sphere.
> (Anderson)

Nostra virtù, che di leggier s'adona
Non spermentar con l'antico avversaro
Ma libera da lui, che sì la sprona.[43]

Personal, melodious, ethereal, metaphysical, devotional, theological, mystical: such is the subtle tone which Dante's amplification gives to the familiar words. In him faith, hope, and love were so refined that they in their excellence intermingled with one another, and with the reflections of that beautiful country which mingles in such serene accord with its skies, with its lakes, and with the glittering sapphire of its seas around it; the poet called it *il tremolar della marina*.[44] Not for nothing was Dante a son of the Mediterranean. •

XIII

It is his universality of claim combined with a national inspiration which explains why the *Divina Commedia* arrests the attention, and holds the admiration, of the reader who has no interest in, and perhaps a profound antipathy to, his theological scheme. Such a reader can still admire the range of Dante's interests, the vigour of his style, the fullness of his rhythm, and the profundity of his thought. "Dante", as Shelley reminds us, "was the first awakener of entranced Europe; he created a language, in itself music and persuasion, out of a chaos of inharmonious barbarisms. He was the congregator of those great spirits who presided over the resurrection of learning." [45] He appeals to the most diverse tastes. And the workmanship

[43] *Ibid.*, XI, 1-20:
O our Father, who art in heaven above
Not as being circumscribed, but because toward
Thy first creation Thou hast greater love
Hallowed Thy name be, and Thy power adored
By every creature as is meet and right
To give thanks for the sweetness from Thee poured;
May upon us Thy kingdom's peace alight
For to it of ourselves we cannot rise
Unless it come itself, with all out wit.
As of their will Thine angel's companies
Make sacrifice, as they Hosanna sing,
So may men make of their will sacrifice.
This day to us our daily manna bring,
For in this desert rough, in utter dearth,
We backward go when most endeavouring.
As we forgive to everyone on earth
The wrongs we bore, so graciously do Thou
Forgive us, and look not upon our worth.
Put not to proof before our ancient foe
Our power of will, so easily undone,
But liberate from him who goads it so.
(Binyon and Anderson)

of his divine poem is as consummate as its theme. When a work of religious creation has these excellencies it can be admired in spite of being religious. "Reason", says Binyon, "may utterly reject it as a fact and from outside, yet who feels that it is false within?" [46]

But even to those who do reject it from outside, it is not merely a mantle of glittering tissue thrown over the skeleton of a decrepit invalid, or of a monstrosity. They cannot but recognize that style and scheme make one whole, and there is therefore in the scheme, at least as Dante understood it, a living symmetry of movement and meaning. To them love, justice, insight are qualities interesting in themselves, while possible to share with the Church. They can accept for the purposes of sympathetic appreciation the details of the faith as long as they are harmonious to their own ideals and tastes. They can say that to a mind so full and searching there was a profound knowledge of the heart and of its true values, as also Santayana did when he blamed Alfred de Musset for not recognizing that Paolo and Francesca were indeed in a damnable state because for them all was staked on an embrace; whereas true love is the constant, long, varied interaction of·lives joined in relation to work, to suffering, to events, to hopes, and, in short, to the world around. It was not merely that Dante's soul was in communion with a truth even more profound, more universal than his conceptions. The moral qualities each have their æsthetic value, being realities which, when contemplated, can delight us with their beauty. The appreciation of beauty is in itself a spiritual communion with something that appeals to the senses while it suggests a land that is very far off. And with their appreciation of the high seriousness of the life comes also a delight in the imaginative brilliance, the melody, and the precision of the style. "*Lo stile*", said Bonghi, "*è questa vita che prende in te il tuo concetto*".[47] Dante's style is a living intercourse with the world he knew and also with those who through the ages answer to his call. He himself claimed that "it was the attempt to express in symbols what an inspiring love had said within him." [48]

<div style="text-align:center">XIV</div>

To the Catholic the Divine poet is yet more. A believer finds the highest beauty only there when he is at peace with his own

NOTRE DAME DE PARIS: THE NORTHERN PORTAL. It was in the Seine valley that the new style came to its finest bloom and spread its thickest seed.

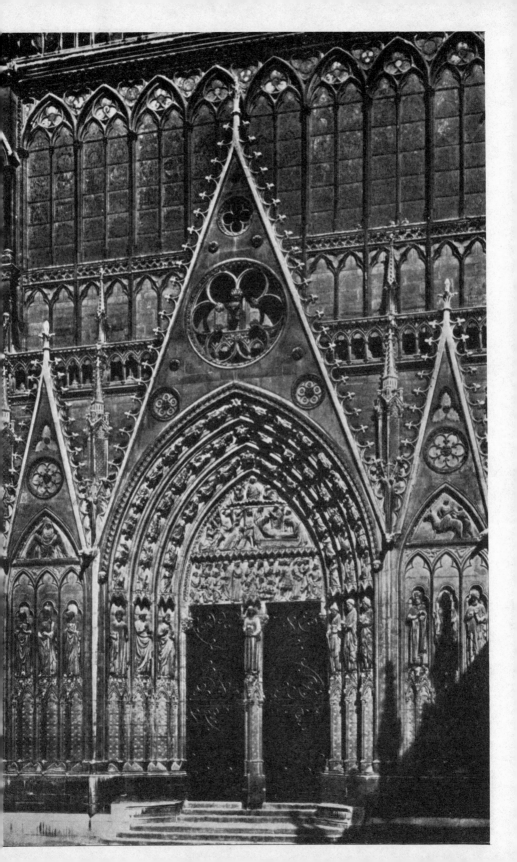

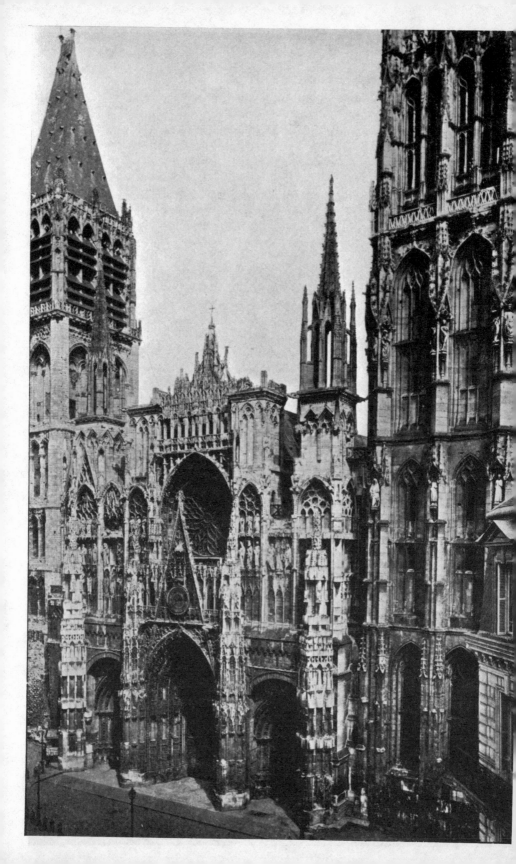

soul: he cannot deny the supremacy of the graces he has received, or the mystical experiences which have given him communion with the higher modes of being. For those who still believe what Dante held as faith, and who, as Catholics, have adored the King of the Universe which their faith set before them, the conviction of truth in his work is already the dearest thing in the life of their hearts: for them, therefore, the poem is an irradiation of pleasing images by an indwelling joy. For them this long poem is above all things a lesson in love, showing them how the delight of magnetic attractions and their enhancement of the values of life leads upward to that central attraction which is the perfect good, with whom they commune in adoration. That perfect good is indeed a mind, a mind so pure as to be spirit, a spirit so rich as to be life—the life which is eternal light. This light needs but to be seen to kindle love:[49] if some created thing be loved, it is loved only because lit from within by some ray of the uncreated light, like an alabaster vase, like a face living in its eyes, though in the shadow of mortality the ray may be falsely identified with the corruptible matter to which its shining lends a transient beauty. To see by the true light is for men the good of the intellect.[50] It should endow the soul with that true vision which few do, but all can cultivate; it should enable them to adore.

In adoration, therefore, comes the consummation of Dante's poem; in adoration he found the beauty that was joy, the joy which made him call his poem a comedy, the joy which echoes the *Gloria in Excelsis*, and which rings from the familiar words: "Hallowed be Thy Name". For although the poet insisted that words are poor and weak beyond expression to convey the glory by which all things live and move—as it is true that the miracle of the lily glittering on its stem is less august than the power which distilled its sap and arrayed its petals from the manure and darkness of the earth—yet there are words of power, words of eternal life, words which are the very light of the mind.

> Viewless power attends the motion of the shadowy winds
> Embodied in the mystery of words.
> There darkness makes abode and all the host
> Of shadowy things makes endless changes.[51]

XV

It is one of the functions of the highest spirituality not to disdain these words of power, but to find them. For the poet,

THE CATHEDRAL OF ROUEN. Familiar with the fire, the forest and the storm, the Gothic cathedral brings its affinities with these to serve the purposes and express the ideals of the Church. [Photo E.N.A.

like the artist, is a delegate of the revelation which is itself creation. This brings order where before the roughness of the raw material led back to the water and slime. It is a spirit of arrangement, a power of order, a generative love moving upon the waters. It is not, therefore, a clouding or diminution of God's hidden glory; it is rather a manifestation of it; it increases it where alone it can be increased, in the outward realms of reality, where beauty shines upon the outward eye, and yet calls to the spirit within to enjoy admiring, which is to thank God for His great glory, and to adore Him in the splendour of His truth.

Dante balances adoration with joy, and both with learning and enquiry, and all with tireless interest in the trifles of life around him, while his spirit, hearing the mightiest harmonies of wind and storm, took from them a tumult like their own.

If a poet has conceived this as his vocation—as Dante conceived it to be his; or if a reader can find this addition to the claim of poetry, which is in any case "at its normal best a kind of heavenly speech",[52] then it is plain that it will lead more directly to the sense of timeless being. For it will take the mystic there where he habitually finds it, and where faith has assured his mind is the essential truth. Dante insisted that the works of creative genius, like the phenomena of nature—and love itself—are essentially the splendour of the love consummated in the act of generation which is God's own secret:

> *Ciò che non muore e ciò che puo morire*
> *Non è se non splendor di Quella Idea*
> *Che partorisce, amando, il nostro Sire*
>
> *Chè quella luce che si mea*
> *Dal suo Lucente, che non si disuna*
> *Da lui, ne dal amor che a lor s'intrea.*[53]

No phrase could show more clearly the scope of art and of faith in their relation to one another and to all creation. For creative genius is never so much itself as when it is consecrated.

In this case, therefore, the consecrated theme will hasten the poetry upwards towards its end, setting reason, passion, and imagination to work together to attain it. Nevertheless it is by them together, and with an ever-certain energy and enjoyment of passion as "noble strength or fire",[54] and imagination as a creative and ordering faculty harmonizing in the fusion of its inventiveness, the images of sense with the soarings of the spirit, that it is poetry. The consecration must never allow the

poet the slightest relaxation from the most exacting and complex demands of poetry itself. It should, on the contrary, convince him that for the subject he has chosen, his work must be fine, his suggestions of life rich and changing. Other than the highest would be unworthy not merely of his faith but of the life of that faith, which, as in its own pure air, breathes in that art of words which is a fusion of music and beauty, with an addition of excitement and surprise.

CHAPTER VIII

[1] *De Vulgari Eloquentia*, I, 17.
[2] *Ibid.*, I, 18.
[3] *Ibid.*, I, 18.
[4] Goethe, *Faust*, Part II, Act 1, sc. i, l. 4727.—In the rainbow sheen we have a type of life.
[5] *Convivio*, II, i; cf. Epistola X to *Can Grande*. This develops an argument from the *Summa Theologica*. See pp. 16, 17.
[6] Shelley, *Prometheus Unbound*, Act I, Song of Fourth Spirit.
[7] Wordsworth, *Prelude*, I, 562.
[8] Pierre Loti, *Jerusalem*, final page.
[9] *Contra Gentiles*, I, 45; cf. Gilson, *La Philosophie de St. Thomas d'Aquin*, ch. XII.
[10] See *St. Thomas Aquinas* (Oxford, 1925); J. Maritain, *Reflexions sur l'Intelligence*; Etienne Gilson, *St. Bonaventura*; H. Gheón, *Le Triomphe de St. Thomas*; F. Olgiati, *L'Anima del Umanesimo.*
[11] Cf. J. A. Stewart, *Platonism in English Poetry*. See *English Literature and the Classics*, ed. G. S. Gordon, 1912.
[13] *Inferno*, IV, 42.
[14] Asín Palacios, *Islam and the Divine Comedy*, *passim*.
[15] *Inferno*, I, 85.
[16] Laurence Binyon, *Times Literary Supplement*, Sept. 15, 1921.
[20] *King Lear*, III, ii, 48, 49.
[21] Ruskin, *Mornings in Florence*, para. 53.
[22] For a sketch of the symbolic meaning of various colours and precious stones to the mystics, see Huysmans, *La Cathédrale*, pp. 179-181, 196-201 (1898 edn.).
[25] E. Wharton, *Ethan Frome*, p. 135 (London, 1911).
[26] Meredith, *Richard Feverel*, ch. XIX, concluding page.
[29] *Paradise*, XVIII, 21.
[30] *A Defence of Poesy.*
[31] *Times Literary Supplement*, Sept. 15, 1921.
[36] Dryden, *The Hind and the Panther*, I, 66-69.
[38] *Purgatorio*, XVII, 91 :
> Nor creature nor Creator ever lived
> But that they loved.

[41] I John III, 2.
[44] *Purgatorio*, I, 117.
[45] Shelley, *A Defence of Poesy.*
[46] Laurence Binyon, *loc. cit.*
[47] Ruggiero Bonghi, *Lettere Critiche*, 3rd edn., p. 82.
[48] *Purgatorio*, XXIV, 53, 4.
[49] *Paradiso*, V, 9; XXVI, 29.
[50] *Inferno*, III, 18.
[51] Wordsworth, *Prelude*, V, 595-600.
[52] A phrase used by Laurence Binyon in an unpublished lecture.
[53] That which dies not, that also which can die
> Is but the splendour of the Idea Supreme
> Which amorously our Sire conceives on high

> So that the living light which thence doth stream
> From His effulgence, from Him never strays,
> Nor from their trinal love's uniting gleam.

Dante : *Paradiso*, XIII, 52-58.

[54] Meredith, *Letters*, II, 535.

I

THE great Catholic achievements of the thirteenth century do not gain their full value for our own until we see how, while expressing the genius of their century as a treasury for centuries to follow—and for the twentieth especially—the Church yet seemed at the time to fail. For in the thirteenth century crime was still a common habit; travel was perilous, commerce difficult and slow; plagues would sweep through city and province; barbarism encroached on Christendom, not only in the north, but in the south; it left its influence on Dante even in his vision of Paradise; neither lust nor savagery was thought surprising, and, as in other times, the vices of men found a fresh outlet in every struggle they made to justify their virtues. But if the knowledge of our own worst—and that age never saw horrors on the scale on which we have seen them—can still allow us to be horrified by torture and violence, we must not omit to notice that our own material age falls far short of their ideals of spiritual unity.

We have to consider only the tension of thrust and balance in a great Gothic cathedral to see that that was an age of struggle between barbarism and order; it is not surprising that the Victorians, building up their sacramentalism on the one side, and their slums on the other, should go back to Gothic for a model for their churches. The Gothic cathedral shoots a spire into the clouds, and even within draws the eye upwards to the giddy height of its topmost stones; with its stained windows it finds its model for the House of God in a forest shooting flame. But it harbours the gargoyle and the obscene carving; it is at home with devils; and in its statuary, as in the figures in its glass, an elfin, a fanatic, or even a sullen mood, is commoner than serenity.[1]

Longfellow, in his magnificent sonnets on the *Divina Commedia*, has expressed almost to perfection this conflict in the medieval mnid when the thirteenth-century saints were all at war with the evil and ferocity around them. The same mind was in the great architect as in the great poet.

> How strange the sculptures that adorn these towers!
> This crowd of statues, in whose folded sleeves
> Birds build their nests; while canopied with leaves
> Parvis and portal bloom like trellised bowers,

And the vast minster seems a cross of flowers!
But fiends and dragons on the gargoyl'd eaves
Watch the dead Christ between the living thieves,
And, underneath, the traitor Judas lowers!
Ah, from what agonies of heart and brain,
What exultations trampling on despair,
What tenderness, what tears, what hate of wrong,
What passionate outcry of a soul in pain,
Uprose this poem of the earth and air,
This medieval miracle of song! [2]

It was to this conflict, that raged alike through society and in the heart, that the Church in her truths and mysteries offered a heavenly peace:

I lift mine eyes, and all the windows blaze
With forms of saints and holy men who died,
Here martyr'd and hereafter glorified:
And the great Rose upon its leaves displays
Christ's Triumph, and the angelic roundelays,
With splendour upon splendour multiplied!
And Beatrice again at Dante's side
No more rebukes, but smiles her words of praise.
And then the organ sounds, and unseen choirs
Sing the old Latin hymns of peace and love,
And benedictions of the Holy Ghost;
And the melodious bells among the spires
O'er all the house-tops and through heaven above
Proclaim the elevation of the Host! [3]

Worship dominating nature and impulse, a dedication of technique and design to a vast social purpose which by its high tension resolved conflict into maintaining an ideal of peace: these explain Gothic architecture as they do the poetry of Dante.

II

The Gothic cathedrals, remaining to the modern world associated with divided concepts of religion, remind us that we have twice been the victims of attempted delusions with regard to the Middle Ages. One school of historians was fond of saying of those active centuries that they were benighted by ignorance and superstition; another school arose—one saw an example of it in Wakeman—which persuaded itself and attempted to persuade others that life in Europe before the Reformation was a foretaste of the millennium. Each of these contentions exaggerates one set of facts, and ignores another. We will see how the cathedrals adjust their discrepancies, for a

church is not only, as Stevenson said, "a piece of history", it is one of history's living images. For a Gothic cathedral is hardly, as Coleridge said, "a petrifaction of our religion".[4]

Gothic was created by an age of contrasts. Between Catholicism's highest standards and the well-known practices of princes and of peoples there was tense conflict. It was when that tension and that conflict were most acute, in that age of dungeons and machicolated battlements, that the new architecture raised its high and gorgeous outlines: its very construction is an expression of the thrust and strain between one impulse and another in those ages of saint and scoundrel where, in a crowded succession of ingenious devices, men conquered the inertia of sloth by their eagerness to be predatory or to be constructive.

The Gothic cathedral, in other words, is the pitched battle of violent energies. At every angle of its complex vastness action meets reaction. Every column and buttress not only meets a thrust, but exerts one. At Stonehenge or Pæstum the support can stand alone and the transverse stones truly rest on the supports. In the round arch even more than in the pediment the powers of gravitation are adjusted in peaceful balance; in the medieval style of the North the adjustment is a balance of power like that which precedes a war between two federations of allied peoples, or like the play of muscles which sets a body in motion. And if the architecture does not move, it is only because it is buttressed by arches exterior to its mass which direct its attack into adjacent ground. While its combativeness knows little lassitude, none of its component parts but is dependent on another. That is the very principle of all domes, all vaulting. But in Gothic the contest of balance is sharper, and this sharpness finds its natural expression in the lines which run from the summit of the vaulting, sometimes semicircular, sometimes elliptical, frequently covering sexpartite surfaces, to the supporting walls or columns.

The Gothic style was not content alone to achieve this construction: it expressed it by its traceries and mouldings. These were apparent from the beginning, but at last they reached in England the most opulent elaboration, as in the gorgeous fan-tracery of the entrance to Christ Church Hall,[5] where a spacious roof is seen to rest upon a single column, and that a light one, or as in the cloisters of Gloucester, where the same rich traceries lead down a long arcade, and as yet again in the roofs of Exeter Cathedral and in the roof of Henry VII's

Chapel at Westminster. But everywhere the line traces the downward pressure from lofty vaults; it is they which give such dignity and such spiritual significance to the transepts of Amiens or Beauvais, or to the nave at Canterbury.

And just as these forces lead down from roof to pavement, so also they stretch outwards. We can trace the direction of their thrust in the flying arches which lead from the heights of the walls or apse of Notre-Dame-de-Paris, and still more from that of Le Mans, cut outwards with the sharpness of blades. It is their acuteness and competiton of weights and thrusts which raise the Gothic cathedral into awful height: just as in the age of its birth a saint could come to the eminence of St. Francis by the violence of his conflict with the baseness of the world around him. For the heroes of the Church are not created by the temper which dominates their world: they arise to a tournament with it, a tournament the more needful in the Middle Ages because of the reconstruction of society which came with the emancipation of industrial life.

But the conflict in Gothic architecture, like the spiritual and social conflicts which it expresses, is resolved into concord: its masses, its spaces, its lines, all cohere into unity, and by its heights it releases one of its tensions. Men have spoken of it as soaring, but the graceful swiftness of its ascent into the upper air is sharper than the flight of either bird or arrow. No finger points so sharply as its spire: no fountain rises so vertical as its mouldings. It distinguishes itself from everything else in nature and in art both by that directness and by the crossing ellipses of its arches. And these are the more interesting because not a few of us have taken it as our clearest *Sursum corda*. A phenomenon so extraordinary, yet to our northern culture so familiar, well displays the power of worship to elevate and inspire both architect and builder.

III

It was once claimed by John Bilson that the origin of the pointed arch belonged to England; Bilson claimed to prove it from the Cathedral of Durham.[6] Winchester, Peterborough, and Southwell, with the churches of Avening and Lindisfarne, all appeared to support the claim. Lasteyrie could not disprove it, but he weakens it. He argues that not only ogival vaulting, but the flying buttress and the pointed arch distinguish the new

style;[7] that there is no reason to think that even the vaulting was known in England before 1140, and that in any case it was in the Seine Valley that the new style came to its finest bloom and spread its thickest seed.[8]

In this district, and more especially in Paris, Gothic grew to swift perfection from the middle of the twelfth century.

Although the Saracens had used pointed arches in the ninth century in the mosque of Ibn Tulun in Cairo, St. Martin-des-Champs and St. Denis are at the beginning of this style: there the architects threw upon each pier two arches cutting crosswise, and on these arches they built their vault. Such a vault is easy to construct, for it weighs not upon the walls, but upon the arches; it is solid; it made churches higher, lighter in weight, and more luminous. The Cathedrals of Noyon, Laon, Mantes, and Lisieux quickly followed; and then came, as though—in the opinion of many—all trials had done their work, the building of the Cathedral of Paris. But in comparison with what Gothic was about to do, even Notre-Dame appears jejeune and chill. At the beginning of the new century cathedrals that were richer, loftier, more spacious, rose in a glorious circle; and we owe to that single period the simultaneous triumphs of Chartres, Rheims, Amiens, Bourges, and Le Mans. It was Pierre de Montereau who added light and colour by piercing the triforium. The new art spread in all directions, owing not a little to the building of the austere Cistercians of Burgundy. We see it evolving masterpieces at Ratisbon, Lübeck, Hildesheim, and Cologne; at Burgos, Barcelona, and Toledo, even as far as Seville. Italy adapted the style to her fanciful taste in marbles. England immediately added them to fine Norman work, as in the Cathedrals of Oxford or of Ely, or replaced the Norman altogether, as at Lincoln. The Gothic victory was complete.

Its dominance was maintained until the sixteenth century. Spain added to it the lantern, of which the best is at Burgos. England evolved her fan-tracery and her Perpendicular style. Germany excelled in carving. More and more gorgeous in its designs, Gothic arrived at the flamboyant style of ornamentation, and this excessive richness of effect marks the Cathedral of Rouen, the church of St. Maclou there, and the churches of Rue and Brou. The architects arrived at giving stone the elaboration of lace, and they succeeded in giving it at least to wood. "Under the carver's hand", said Ruskin at Amiens, "it seemed to cut like clay, to fold like silk, to grow like living

branches, to leap like living flame."[9] In the wooden reredoses and in the furniture of this period Gothic achieved some of its finest effects. It added to them a bold and happy use of colour, and above panels of azure and mouldings of scarlet a glittering fretwork ran up into gables and points of gold. This fretwork attained a peculiar excellence in Southern Germany, and has left some fine examples in the Frauenkirche in Munich, and in the Gothic churches of Prague.

Architecture and decoration alike owed to the Catholic religion an addition of riches, splendour and refinement.

IV

It can be seen from traces at Ely, Tewkesbury, and Wells that the decoration in Gothic churches was painted, and some think that the interiors were all unrelieved masses of colour, like the Sainte Chapelle, as we see it still to-day. The furniture, of which some superb examples are collected in the Musée de Cluny and at South Kensington, as well as in the Château de Langeais, produces much of this effect without the use of colour, though much of it was painted also.

As a style Gothic mastered all the arts of the period; and houses, halls, and castles exhibit both its austerity and its luxury. But its spirit has left the most striking and the most lasting monuments where the land is covered, in Michelet's phrase, with "the white robe of cathedrals". Their distinctive impression is summed up in Tennyson's apostrophe to a temple where Gothic compromises with the spirit of Italy:

> O Milan ! O the chanting choirs,
> The giant windows' blazoned fires,
> The height, the space, the gloom, the glory,
> A mount of marble, a hundred spires ! [10]

We have shown how the cathedrals expressed the social and spiritual tension of the life of the age. They were a new expression of corporate life, and this was especially the case in France. In England, as in Spain, the cathedrals arose at the command of powerful bishops and wealthy chapters, and some, therefore, are built in cities which had already lost their importance. This is true of Wells, of Ely, of Carlisle, and of Lichfield, where the grace of devotional *ensemble* is almost perfect.[11] And to this clerical independence is due the unique peace of our cathedral

closes, where trees so often enhance the charms of the architecture. But in France the cathedrals were more often the work of the Communes, who indulged a municipal ambition in this expression of their life, and raised it not infrequently above the market-place. All phases of their interest went into it; the detail was intricate enough to give play to their sense of humour as well as their taste for the grotesque: in the gargoyle their plain need of a water-spout gave them opportunities for playful modellings of hounds and cats as well as images of demons; and, like Dante and Fra Angelico, their sculptors found in religion an outlet for barbaric instinct in picturing the *dies iræ* and the tortures of hell with the vividness so dear to medieval preachers: a taste which, probably originating in the north, survived there almost to our own day. With this grotesqueness room also was found for malice, and even for obscenity. As Boccaccio and Langland both show, the clergy were the subject not only of criticism but of broad jest; and where the lines of the cathedral are austere, these do not express the mood of the age as a whole; Victor Hugo and Viollet-le-Duc were not wrong in pointing out the independence and laicism of the craftsmen. There has been far too much rhapsody over the figures of Gothic painting and sculpture; they were in general comparatively crude. A really noble face, such as St. Martin asleep, at Chartres, is rare; a full sense of beauty, either in draperies or in the human figure, is rarer still. It is not from Gothic sculptors that we shall learn what art owes to religion.

v

But it is unreasonable to ask for the excellences of humanism from the Gothic style. In it the spirit of man had found inspiration from other sources than the laws of its own reason, or the exquisite symmetry of the human body at its best. The Middle Ages had the fancifulness of a child; they loved legends, miracles, fairy-tales; their fancies played among flowers and animals, and they had, like many children, a certain irresponsible ferocity; all these they put into the Gothic cathedral. Mr. Pennell's drawings admirably enforce its imaginative sense. It was the invention of the north. It sought for harmonies with the subtle gradations of colouring in a cold, wet sky, and with the shapes of cloud and storm; it looks not least majestic when,

on windy nights of autumn, its precipitous blurs emerge into thorny sharpness beneath clouds when they are riven to show above it the unexpected stars,

> Hurrying and sparkling through the clear blue heaven.[12]

Daws and rooks are at home among its battlemented towers, and find perches on its crocketed finials. It learnt from the verdurous glooms of the forest how to people its aisles with pillars and—the work of a people for whom winter made life hard—its beauty expresses in harmony with the forms of the weather around it an aspiration for something unknown and far. But it took from nature another and a more curious form, a form, which becomes startlingly clear in the façade of La Trinité at Vendôme, and which reappears in the moulding of every decorated window as it had shone in the earliest of stained glass. This form is the form of fire. The Gothic cathedral is a furnace in stone. The flames of the forge when they are blown upwards take every line and shape which Gothic architecture fixes immovable, and the buildings seem to rise upward with the flames. Familiar with the fire, the forest and the storm, it brings its affinities with these to serve the purposes and express the ideals of the Church.

For in outlining these affinities of Gothic with what was naturally congenial to its builders, one must keep an equally clear sense of the august use for which its masterpieces were designed. No one has understood the great medieval cathedrals who has not assisted, with some sense of worship, at one of those imposing ceremonies where attention was centred on the altar, and where from the organ

> . . . a soft and solemn-breathing sound
> Rose like a stream of rich distilled perfumes,
> And stole upon the air,[13]

where plainsong and censer attuned the temper of a multitude to the forms arising in glory from the glooms around them, when ritual lights played upon the embroidered vestments, and, at the most solemn moments, there were few who did not believe that heaven had opened to their eyes. For this sacred drama the cathedral was designed, and it was adequate and significant just in so far as it was a fitting theatre for worship.

It is only extremists who see in Gothic alone the perfect temper of religious building. The enthusiasms of Pugin, of Abadie, of Ruskin, of Huysmans, or even of M. Mâle ignore

much ugliness and show a lack of understanding of that later period when Christian art, putting away childish things, came on to

> . . . that delightful time of growing youth
> When craving for the marvellous gives way
> To strengthening love of things which we have seen.[14]

The very name of Gothic, moreover, is a reminder that from the sixteenth century to the nineteenth that style was viewed as barbarism. It arose out of strife; it came from an age that, when it found this means of expressing an ideal in contrast with its vices, concentrated on it with all its might. Born of the forest and the flame, Gothic might well seem to the humanist both pagan and sinister. Where it most impresses, it appals.

There are, indeed, in Gothic elements which give some justification for its name: its glory, nevertheless, is a world far away from barbarism. Though its beauty was intended both to haunt and to startle, and its grandeur is to be still more strange than the natural phenomena among which it arose, its art is to turn this wild grandeur, or wild inventiveness, into the order of one cohering design, and the further it develops, the more intricate, conventional, and deliberate does that design become, till at times it merges into the Renaissance, with which it was at last admirably united in Laud's quadrangle at St. John's in Oxford and in the porch he added to St. Mary's. Of the Gothic church it was always true that there was a sense of spirit in the building of the stones.[15]

It soon developed something akin to the early humanism which found one impulse in Albertus Magnus and one expression in Niccolò Pisano. The sculptors of Bourges, and the English workers in stained glass who, in their wish for freedom of design, forced on the architect the transom which led to the perpendicular style, were preparing for the Renaissance triumphs just as were Brunelleschi and Masaccio. And in judging its effects we must remember that it arose from the buildings around it as a kindred and not, as now, an alien splendour. But when all this is said, we must admit that M. de Lasteyrie is right: it is too late now to change the name from Gothic. The word "ogival" is not sufficiently descriptive, and can be actually misleading. For though in its original form ogee meant support, it was later identified with the double curve of the arch. A name which might have been given is Parisian; but, so much can the connotation of a word change,

we doubt if that term would now be thought convenient, even by the Parisians themselves. The architecture is Gothic in all the most important languages of Europe, and Gothic it will remain. We English shall be content to find honour in words of opprobrium so long as any call themselves Whigs or Tories, or venerate the name of the Old Contemptibles.

VII

The chief vogue of Gothic architecture passed away with the Middle Ages, and their particular effort failed to adjust their life to its ideals. And on either side of the schism which followed it something has still been lacking besides a power to dispose of Pharisaism and conventionality. In other words, the problems which were contemporary with the Gothic masterpieces are occupying us still; but whether that style can be revived is another question. It is not easy to recapture its loftiness, its delicacy, its lightness, or its phantasy. And when, some seventy years ago, its vogue followed the medieval revivals in literature and religion, atrocities were perpetrated. But if Vienna and Cologne can quiet some of our misgivings, one remains which we have yet to discuss: except at Ratisbon, Bourges, Strassburg, and Milan, we do not find the typical cathedrals spacious. The fact that in England the choirs are so often cut off from the nave, and in Spain destroy it altogether, offers the suggestion that the relation of clergy to people was in those countries unsatisfactory. As we notice especially at Beauvais, also, where a flèche once shot high above that glorious choir, Gothic rose upwards regardless of breadth.

And in this connexion the final developments of Gothic came not from where it triumphed, but from the churches of Languedoc and Catalonia. In Amiens the breadth of the nave is a third of its height: in Toulouse breadth and height are equal. And when we contrast the Gothic cathedral of the north—its intricate complexity, its mysterious perspectives, with their subtle proportions of number, its contrasts of light and shadow, its forest of flying buttresses, its thousand statues, and its leap into the heavens—with the Gothic cathedral of Southern France or Catalonia, we find the latter disdainful of ornament, beautiful by its proportions alone, calm and self-complete. Churches like Santa Maria del Mar in Barcelona are those of a race attached to this world, a race which believes easily in the Incarnation as

logically involving the Papacy and the Mass. And M. Mâle, noticing this difference within the one style, called it "an amazing contrast which takes one's thoughts to those two great figures which Raphael has placed in the centre of his School of Athens, Plato who points towards the sky and Aristotle who with his open hand seems to take possession of the earth."[16]

But M. Mâle noticed more than this. His latest study makes an interesting discovery; he proves that of the French cathedrals from Clermont southwards, Limoges, Narbonne, Toulouse, and Rodez are (with Clermont itself) the work of Jean des Champs, who should therefore regain his place with Robert de Coucy, Jean de Chelles, Robert de Luarches, Thomas de Cormont, and Pierre de Montereau among the master-builders.[17] Born about 1218, he lived until at least 1287. To him are due the pierced mouldings, the suppression of the capital, and the employment of curve and counter-curve in the ogee—principles which reached their full expression two centuries later.

And with this revival of his devices there came the revival of another, a more practical and a more significant characteristic of Southern Gothic. For in the thirteenth century the churches of Southern France were built under the influence of the Dominicans in their struggle with the Albigenses. And the spirit of the Dominicans was, above all, the spirit of a reasoned religion. With Aquinas, they were Aristotelians. First they reasoned, then they preached their reasonings. Their view of life was broad, and broad must be their churches. These were to be built convenient for preaching, and so constructed that all might hear the sermon and see the altar. But in the sixteenth century the clergy had again endangered their church by their separation from their people. Once again Catholicism was dependent on the sermon. And St. Ignatius Loyola found in the churches of Catalonia, elaborated by the Dominicans three centuries earlier, the necessary architecture for the new crisis. The Southern Gothic thus joined its influence with the Classical style in Rome to create Baroque. The Jesuit Polenta insisted that the Gesù was to have one nave, and that a vaulted, as opposed to a flat, roof would not interfere with the preaching; Cardinal Alessandro Farnese endorses these requests in giving his directions to Vignola. And just as the Counter-Reformation revived the humanism and the energy of the thirteenth century, so we can trace the influence of the Gothic spirit through all the development of Baroque. That fact, not yet

sufficiently familiar, must, when recognized, dominate the relation of the medieval styles to our own time. Instead of looking to a revival, still less to an imitation, of Gothic, we hope for religion to accept an art and architecture which, governed by one informed æsthetic, will add the boldness of Gothic to the balance of Romanesque, where spiritual cravings will find a field on earth, where the developments will be reasoned and continuous, and where the sense of effort will be mellowed by majestic calm.

Gothic in assimilating humanism became Baroque. But in itself it witnesses the triumph of the Church over wild nature and human ferocity, and shows how much the Catholic religion could do to spiritualize, to order, to enrich and to glorify those who loved it in the north. As their spires pointed towards heaven, so their windows also spoke of glory.

<p style="text-align:center">VIII</p>

To soften the light with a pattern which made a story or a picture, to turn it from dazzling blankness into a diaper or mosaic of transparent colour as deep, as radiant, and as inexhaustible as that of precious stones—this was the ingenious device by which the workers in stained glass perfected architecture at the time of its transition from Romanesque to Gothic. So was added to cathedrals their most gorgeous ornament. But it was an ornament essential to their design. Since they were built as theatres of worship for those whose attention was centred on the altar, it was necessary to make its lights the highest point on which the eye could rest: and so, also, the detail of ritual, as of moulding and of sculpture, would be seen only if the pupils were allowed to dilate. Windows which let in all the light would simply have been blinding—to fulfil its real office, the light must be darkened. A portrait-painter fills his studio with the reflected luminance of northern sky. The makers of our most beautiful windows went farther—they took a lesson from the twilight. When the noonday whiteness is long past, when the sun compromises with the darkness and gives us light softened through the prism of vapours, he makes the sky into a radiant splendour and clothes earth with a lovelier garment. What light, then, did with tiny drops of moisture suspended in the air, it was for the glaziers to do with their own prismatic

medium. But art, which can never enter into open rivalry with nature, wins her victories by recognizing her feebleness. Art's imitations are personal devices—reasoned, honest, and elaborate. The artists of stained glass did not play with prisms: they made their glass already coloured, and arranged it to their fancy. Employing for detail the use of paint, they exaggerated into a fixed gorgeousness the light's own power to dissolve itself through refractions into varieties of hue. The painter's art was already being brought to a new perfection to turn walls into pictures; and the arrangement of fragments of enamel to the designs and patterns of mosaic told them almost all the story of what they might do with pieces of glass.

Mosaic is marked by its taste for glitter, and above all for gold. In the tenth and eleventh centuries it had been employed for the interior of San Marco at Venice, and, though the churches at Cefalù and Monreale were finished later, it was at that period that glass in the windows was found to have an effect still more brilliant than enamel on the walls: this discovery came like a revelation to those who lived in grey weather. For when glass was arranged as a mosaic, it was made so beautiful by the light behind that it seemed to burn with its own inward fire. Its beauty was as that of flaming jewellery, intense and brilliant.[18] It compensated the lack of coloured air by making the light into a stream of coruscations, like the river which Dante saw in Paradise. Thus pours down into cathedrals that fiery stream of colours which turns the light of consecrated buildings into a flame of ruby and sapphire, and which seems to set the whole of a cathedral burning.

For the architecture of the Gothic cathedral itself follows the forms of flame: it is, as it were, the blacksmith's furnace, solidified in stone, waiting only for a magic touch to give it back its warmth, movement, colour, and light. When, therefore, it reproduced fire's gorgeous lights of colour in tincturing its mouldings and carvings with blue and red and gold, when its rose-window became a wheel of fire, when it seemed itself to catch fire among the ardent seraphs and saints of its clerestory, it became a symbol of the virtue which will survive perfected when that which is in part is done away. For fire is a favourite image for the living heart. And to the Spirit's illumination of the mind of man Ruskin compared the light which gave gorgeousness to storied windows.

But we understand neither the cathedrals nor their best glass

A DOORWAY IN CHARTRES CATHEDRAL. It is not from Gothic sculpture that we shall best learn what art owes to religion.

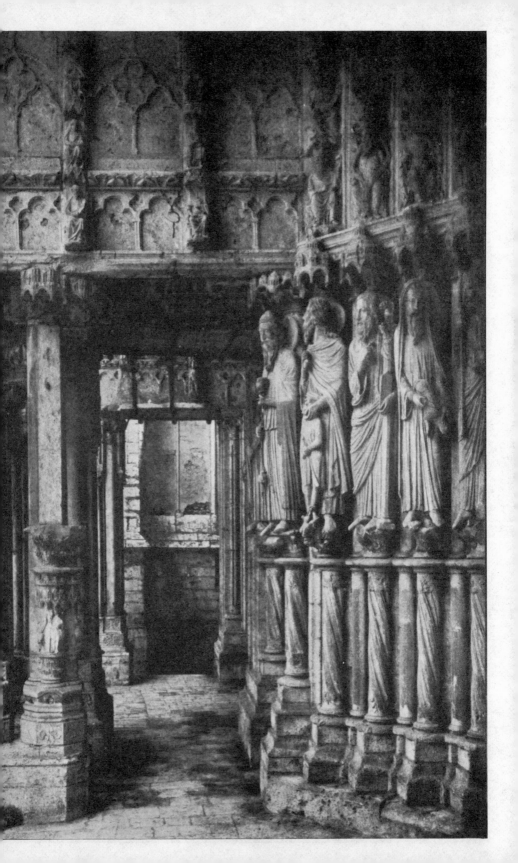

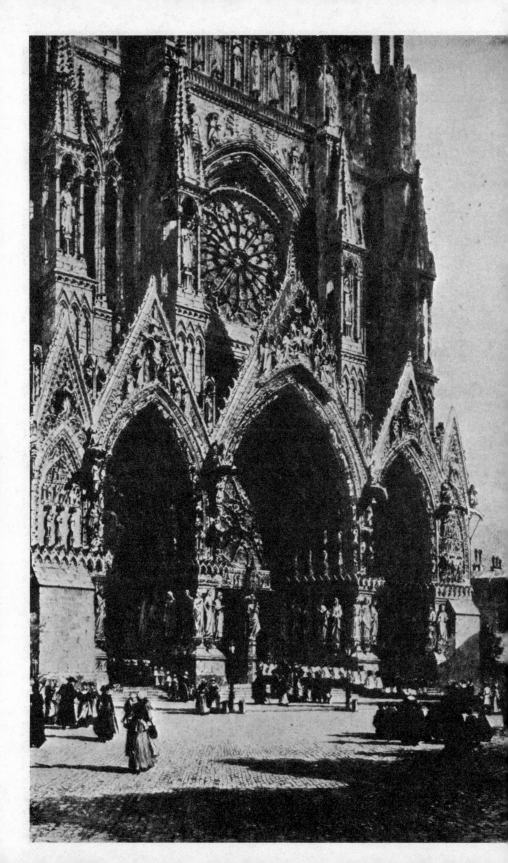

till we realize the barbaric element that mingled with the beauty of each and which was typical of the age. Even in the windows we see that the unity of society was the subject of incessant quarrels. Bourges—as well as the apse at Canterbury—makes it particularly easy for us to do so. Although the English spirit is far gentler than the French, we can see in either, though far more at Bourges, that, apart from the crudity of the conventional drawing and the bizarre taste for bright colours, which the glaziers, like many savage artists, worked into wonderful patterns, there was on the faces of the holy men depicted an expression that was often crafty, and sometimes really malign.

Though the windows may, when closely examined, show how, as we have seen, that age was indeed an age of faith in the stupendous Christian verities, the artists did not look direct at "Nature's living images", but saw them angular and awry; it saw human beings in shapes so conventional that, more than insipid, they were devilish. What happened was that faith itself was not so deep as the fountains of cruelty and pride which, pouring their venom into its stream, made it fanatical. And bigotry *is* devilish. The human mind can look at an image and yet in reproducing it express an ideal. These changed and conventionalized what they saw, but the details show that, in that process, often, far from idealizing, they corrupted. This fact must be weighed against the loftiness of the Beau Dieu at Amiens or the subtlety of the Gabriel at Rheims.

IX

But it is a glowing sense of devotion which at Chartres makes the interior into perfect harmony with the unrivalled windows. Pater pays a tribute to the cathedral's "unique power of impression". It is, above all, said Huysmans—its most eloquent evangelist—the cathedral with a soul.

Who can catalogue its gallery of illuminations? Something approaching 4000 figures have been counted in it. There the great prophets and many obscure, almost forgotten, saints appear among the central figures of Christianity. And just as the Incarnation is shown as the central fact of science and history—for thus it must always be to the orthodox Christian—so the prophets and evangelists, the confessors and the martyrs who gave their witness to the supremacy of the Redeemer are

THE CATHEDRAL OF RHEIMS (from an etching by Axel Haig). Each worker was free to express his fancy and his mood provided that he took pains enough, and that the fire of passion fused his strength with his imagination while he kept a clear view of how he could work with others to attain the mighty end in view.

shown forth as the world's wisest men and the heroes of history. Therefore St. Lawrence or St. Giles, St. Martin or St. George, St. Laumer or St. Symphorien, appear as giant figures gloriously apparelled, and a mitre seems as splendid as an imperial crown. Therefore, also, the Blessed Virgin assumes a supremacy incomparably more significant and more august than that of any other in creation.

Henry Adams, of Harvard, writing some years ago on the relation of Chartres to Mont St. Michel, developed this idea in another sense. He argued that the great cathedrals, generally bearing the name of Notre-Dame, came with a new veneration for woman: no longer the beast with tail and claws, as some perverted ascetics had depicted her, she was recognized as the sister of the Virgin. This idea was naturally acceptable to queens,[19] and Adams was doubtless shrewd in relating it to the window which Blanche of Castile gave to Chartres.

Yet since it is the Christian dogma itself, and not any rationalistic explanations of it, which was present to the Middle Ages, the Virgin, as the most highly favoured in creation, is seen again and again—first as a child with St. Anne, and, in attendance, Melchizedech, David, Solomon, and Aaron; but before long she had become a Mother, and shines down from height after height with her Baby on her knee. She fills a window of the nave, she is crowned with gold in the central window of the choir, and in the ambulatory she shines again more mystic and more beautiful as Notre-Dame de la Belle Verrière. Six-winged angels in green or scarlet, against a ground of blue, hold candles or swing censers, and between them the blessed Mother is defined with garments and a halo of azure against a background of crimson light which beats and glows like a heart. She holds in the centre of the picture a child with large dark eyes, whose face and cloak are a compound of russet and red, like the colours of an old carpet from Bokhara or of the woods of autumn when the leaves have felt the frost. Such is the greatest glory of all efforts in stained glass.

Another rare beauty appears at the end of the nave, where, beneath the rose, the windows, which depict the Redemption and the Passion and the Stem of Jesse, shine with an intense brilliant blue, which Huysmans compares to the flash of sparks and cornflowers,[20] to a knitting of blue fires, and yet again to the flames of *eau-de-vie*, of burning sulphur, and to the lightnings which flash from sapphires. In the rose window of the northern

transept that intense blue mingles with a limpid green in the figures of ardent seraphs.

The earlier centuries, when the colour seemed more important than the design, are the age when stained glass was most peculiarly successful. Its excellence, as Ruskin said, was that it made "intricate patterns in order to mingle hues beautifully with each other and make one perfect melody of them all".[21] But it was a bold, as we have seen, at times a barbaric, melody. Huysmans speaks of the clash as well as the marriage of the tones. He points out also how the whole effect was sharpened by the use of the leads which joined the mosaic of glass into a whole. "What concord and what skill," he said, "they showed in arranging the nets of leads to accentuate certain details, to punctuate, and to separate, as by lines marked out in ink, the flaming outlines of the fragments of glass!"[22]

X

St. Julien of Le Mans, a cathedral too little known to Englishmen, has a window in one respect superior to Chartres, in that it is earlier, though Augsburg has put in a rival claim. Authorities no longer dispute the fact that two lower panels in the *Vitrail de l'Ascension*, the second window on the right looking towards the altar, are the earliest of all remaining examples of painting on glass.

There is a greater art in the double row of windows in the choir, gorgeous everywhere, but best seen from the giddy height of the triforium gallery. These have been lately cleaned, and shine with a clearness forgotten for centuries. There are some who regret this, and think that a mellowing incrustation of dirt improved the colours of the glass: the original painters certainly never guessed at such an effect, and the cleaner the glass the nearer we are to the effect originally designed. These windows are full of figures of life size, or even greater. They represent, beside the saints of the Old and New Testaments, benefactors and donors. And so among them we see, as on certain windows at Chartres, the drapers, the furriers, the tavern-keepers, the bakers, and even the players, along with the ecclesiastics! This *esprit de corps* of a guild, or a *métier*, which makes it anxious to add something of its own to the great common treasury of beauty which was consecrated in their

churches, is one of the most delightful peculiarities of the medieval spirit. It is not too much to say that it shows that industrial society rose to conceive itself as a wonderful order, in which each had his function and dignity, consecrated and glorified by the succour of angels.

But if this encouraging thought comes to us at Le Mans, others, as we said, will alloy it at Bourges. That Bourges is one of the most stately, and the least visited, of French cathedrals hardly needs saying. Henry James delighted in its "tranquil largeness, a kind of infinitude".[23] And arranged upon its windows is the almost continuous history of four centuries of glass-painting. Nowhere is the glass of the greatest period so near to one as in the ambulatory of this spacious cathedral; nowhere are the peculiarities of its excellence so obvious. In the effect of its colour on the eye there is more than anywhere else the marriage and clash of tones, the arrangement of contrasts into serenity. There is about it all a fairy splendour; it is attuned to that mood which makes the world magical: the devotee raises his eyes to a scene where the colours of a supernal world, on the kaleidoscope of a medieval tournament, are enchanted into stillness. For besides flames, or jewels, or autumn leaves, those flashing lights might be compared to armour. In the early dawn Huysmans thought of the high windows in Chartres as the blades of broadswords and connected them with the crusades; Proust compared other glass to a decorated breastplate: those lights of blue and green and purple are like a brazen helmet, or a steel cuirass.

The sense of barbarism, which could be at times ferocity, is very strong as one looks down from beneath the Puy-de-Dome on the dark and sinister towers of volvic which Viollet Le Duc added to the cathedral of Clermont-Ferrand. That, too, has an admirable collection of thirteenth- and fourteenth-century windows; they owe their effect to the same choice of colours, and of conventional designs, such as diapers and trellises, which strike us in the Sainte Chapelle in Paris. But is it heavenly?

If the artists did not actually love the thought of hell, the unseen world, with its mighty powers of help and of hurt, was very real to them, and their religion shows their intimacy with both its possibilities. The range of these added, perhaps, to stained glass something of its barbaric beauty. It was a beauty of design rather than of imagery. It is especially suitable to the rose-window, and at Amiens, where the grace and splendour

of that are as great as anything at Chartres, the contrast is increased by a collection of those conventional patterns on a glass of greenish-grey which is so much admired in the chapter-house and north transept at York. We know it as *grisaille*.

<div align="center">XI</div>

It is a curious fact that in the fifteenth century, when, in France and England, the love of gorgeous pattern was giving way to a taste for turning windows into real pictures—such as we see clearly in the side chapels of the nave at Bourges, or in the church of St. Etienne at Beauvais—the old style of barbaric beauty in deep and glowing tones came to a new life in a city and in a country which had seldom bothered about stained glass at all. For the coloured windows at Florence in the Duomo, in Santa Croce, in the Or San Michele, and in Santa Maria Novella are all of the fifteenth century. The designs were prepared by artists who were themselves almost of the Renaissance. The windows in the Duomo are of lighter tones: turquoise, jade, and cerise. There are deeper shades in the circular lights of the dome; and in the transepts the lancets darkly burn, like the torches borne in the gathering twilight to a Tuscan interment: Andrea di Castagno, Paolo Uccello, and Ghiberti—who won the contest for the bronze doors of the baptistery over Jacopo della Quercia—designed them; the artists' own instinct for gorgeousness led them to the most beautiful period in designs. It was design rather than a picture at which they aimed, or, if not design, colour in all its magnificence. The finest in the church, certainly, are in the north transept, where the colours range from a rich caramel to plum colour and crimson.

In Or San Michele, as in the great rose-windows of the north, traceries and mouldings vary and heighten the effect. But there is no window in Florence so attractive as the great window behind the altar of Santa Maria Novella. The serene intensity of its mosaic of purples and blues dims the fading brocades of the famous frescoes around. Shocking to tell, this splendour of Florence is generally hidden by drab curtains. These find some excuse in the preservation of the frescoes, and they certainly help the window to be a source of income to the friars, who never draw the cords which let in light and glory to the house which is called a house of prayer, without some tribute

from the enthusiast. The masses, for whom the windows were meant, hardly ever see them.

To France, then, and to Florence we must go if we would see glass in its richest beauty. It is doubtful if England ever had anything to vie with it, and England's churches suffered first in the time of Thomas Cromwell, and then in that of his grand-nephew Oliver, and finally in the eighteenth century from the clergy themselves. At Salisbury, for example, a dean who could not appreciate the medieval glass had it hacked out and carted away as rubbish. Even at Chartres the clergy removed some of their priceless treasure so as to let in more light on Bridan's baroque *Assumption*. There is, however, good and interesting glass in the cathedrals of Canterbury and York, in Tewkesbury Abbey, at Fairford, at King's in Cambridge, and in a number of churches in and around Oxford, especially in Merton College Chapel. There is much also collected in the Victoria and Albert Museum at South Kensington. But when all this is said—when one has spoken with all possible warmth of the grisaille in the north transept and chapter-house at York, when one has looked with care on the unique series in the choir at Tewkesbury, and when one has admired to the full the combination of restoration work with original remains in the apse of Canterbury, one must admit that the best in this country are but shadows. It is not possible to make of them a collection of splendours such as might even be made at Clermont or at Florence. Bourges and Le Mans are each worth far more than all England's remains of medieval glass. Chartres is more glorious yet than these; between the prophet Jared or the Methusaleh at Canterbury and *Notre-Dame de la Belle Verrière* there cannot be comparison; and even in the beautiful windows of the apse at Canterbury, where the restorations are so admirably done, it is a feeling of calm and quiet that we enjoy, like the reflection of flowers in still waters : these windows suggest not fire, but river.

XII

Each worker, in fact, was free to express his fancy and mood, provided that he took pains enough, and that the fire of passion fused his strength with his imagination, while he kept a clear view of how they could work with others to attain the mighty end in view. The artisan must merge his individual skill or

personal fancy in the unity of the building and the needs of worship: and he must needs do so, for his spiritual life was something that made his soul and life one with those of his fellow-workers. To this combination of scientific study and technical skill, and of both with self-sacrifice, the workers added an inner strength when the spirit beyond the tension of its conflicts rose with the flames into the heights above them. One faith made the cities' discord into a harmony. The masons and workers in glass joined with the architects of Chartres to lose themselves in a work which, when completed, has as much a single individuality as the poem of the single, but scholarly, and therefore comprehensive mind of Dante.

In each alike, science, Aristotelianism, individual enterprise, and co-ordinated effort had given Europe a renaissance of humanism, which Christianity made its own then and through the centuries, for it first recognized and then consecrated the nature of man. Religion, by being social, by its conquest of barbarism, by its soaring aims, and by its eagerness to use the gifts of man for God's glory, gave the Gothic architects the inspiration to what is far their noblest work.

CHAPTER IX

[1] There are examples enough of these at Rouen, Amiens and Chartres.
[2] Longfellow, *Divina Commedia*.
[3] *Ibid.*
[4] *Literary Remains*, I, 69 (1836).
[5] This, which dates from 1643, is a revival rather than a direct elaboration of the Gothic style.
[6] Bilson made a special study of Kirkstall Abbey in this connexion. Cf. Francis Bond, *English Church Architecture*, I, 434 ff. Revoil, *L'Architecture du Midi*.
[7] One gladly discusses the precise and scholarly work of the late Count de Lasteyrie, which adds to the information that the Abbé Delaporte has attached to M. Houvet's superb reproductions of the windows of Chartres, as well as the informing essay of M. Mâle—and with these the popular book on French Cathedrals which Mr. Joseph Pennell enriched with his drawings.
[8] If it was not England where Gothic burgeoned, still less was it Germany. This Dehio and Bezold claimed in *Die Kirchliche Baukunst des Abendlandes* (Vol. II, p. 257), and it underlay the claim of Kraus that Strasburg Cathedral is "the fine flower of German mysticism". The soundest authorities, however, will agree with Lasteyrie that the style arose in and around Paris, in the Ile de France, or rather in the old Royal domain which stretched down as far as Chartres and round on one side to Sens, Epernay, and Rheims, on the other to Gournay, Beauvais, Amiens, Péronne, and St. Quentin.
[9] Ruskin, *Works*, XXXIII, 125 (Library Edn.).
[10] Tennyson, "The Daisy"; cf. Gray's "long-drawn aisle and fretted vault".
[11] Ely and Carlisle were built as abbeys.
[12] Wordsworth, *Miscellaneous Sonnets*, Part II, 23.
[13] Milton, *Comus*.
[14] Wordsworth, *Prelude*, Books 539–541.
[15] Wordsworth, *Sonnets*, Part III, 44:

> It was fashioned, and to God was vowed,
> By virtues that diffused in every part
> Spirit divine through forms of human art.

[16] Mâle, *Revue des Deux Mondes*, 1926, pp. 832, 840–3.
[17] Mâle, *op. cit.*, 1926, 840–843.
[18] "Serene, intense, brilliant, like flaming jewellery" (Ruskin, *Stones of Venice*, Vol. II App., 12). Mr. Read queries the word "serene": *English Stained, Glass*, p. 9.
[19] H. Adams, *Mont St. Michel and Chartres*, Ch. XI.
[20] Huysmans, *La Cathédrale*, p. 391 (edn. 1898).
[21] Ruskin, *Lectures on Art*, p. 180.
[22] Huysmans, *La Cathédrale*, p. 392 (1898).
[23] James, *A Little Tour in France*, p. 83.

I

THE achievements of the thirteenth century extended over wide domains. While Dante was writing his *Comedy*, *El Cid* was being composed in Spain; and shortly afterwards Simon de Montfort gave England a parliament, while a Franciscan Friar, Roger Bacon, was conducting curious scientific experiments, and Marco Polo was exploring Eastern Asia. Blanche of Castile and St. Louis of France changed the character of the civilization which centred in Paris.

It was a century which by its works of genius transformed European civilization. It crowned the intellectual activities which had been gradually arising while Europe was being made. In the succeeding centuries men lived in a new age, a Renaissance of classic learning, in a return to Nature, in a sense of wonderful powers uniting with their own gifts, and above all in a conviction of the unity of order, which remained unbroken through the centuries. Not alone the Gothic Cathedral nor even the *Divina Commedia* therefore duly shows the Catholic genius in its range of sublimity.

The century which followed neither rose to such heights of holiness nor created works of comparable grandeur. Its conflicts no longer needed giants. But it was remarkable for men who would not have been what they were if they were not believers. Petrarch ruled realms of culture at Florence and Avignon, urged the Pope to return to Rome, and wrote a noble hymn to the Madonna; Chaucer placed his collection of stories in the mouths of pilgrims to Canterbury, among whom nuns and their chaplain take a prominent place. St. Catherine of Siena was one of the great political figures of the century. Langland in *Piers Plowman* dreamed of a religious reformation of society, while the Medici gather together in Val d'Arno their company of painters, architects, merchants, and artisans.

With the beginning of the fifteenth century, the Renaissance, which had set the thirteenth century in a halo of starry light, flames forth in a new brightness. England, in spite of the distractions of wars with France and wars between rival houses, begins to build fine colleges, which still survive. Oxford becomes the most beautiful of University towns and a centre of advanced philosophy. Flanders becomes the centre of precise and masterly painting, centred as much as ever on religious

subjects. Germany decorates her cities with civic buildings, which in gable and spire shoot high over their elaborate woodwork. Cathedrals, as at Regensburg, widen into spaciousness. But it is in Florence that we see most clearly the wealth and variety of the genius of the age.

It was Nicholas V who summoned Fra Angelico to the Vatican, and with him the Florentine spirit captured Rome, and for another hundred years the spirit of those Middle Ages which began with the revivals of the twelfth century marched forward to triumphs of creative genius, of culture, and of learning which neither the rivalries of kingdoms nor the schisms of religion could lessen. The creative imagination founded on the direct experiences of a life cherished in every fibre of brain and heart proved itself superior to either. The world was seen to be a place where men could do God's will; a place which was worth recognizing, worth beautifying. The ferocity of the cathedral changes to something more spacious and more human. Everywhere, on the one hand, therefore, the long centuries of Renaissance became more fully and nobly Catholic: religion triumphed gloriously over the increasing wealth of life: yet at times it ceded to it, and in yet others men showed that they could be supremely great without paying more attention to the truths of Christianity than Æschylus or Sophocles had done.

II

It is in Florence, then, that we trace the full development of the Medieval Renaissance. On the hills to the north of the city rose the towered Cathedral of Fiesole, with its Romanesque pillars and arches between its rough brown stone; and among the cypresses and orchards of the hills which rise to the south stood a perfect example of elaborately finished work in patterned marble, in the Church of San Miniato. These had been there before the Gothic style invaded Florence, before Giotto had built his Campanile beside the marble octagon of San Giovanni, or Dante, who, as we have seen, loved both, had built his "fabric of the earth and air".[1] The city of Dante had remained central in the Renaissance, making not only Boccaccio and Petrarch, but Taddeo Gaddi, who built the Ponte Vecchio, Bernardo Daddi, Andrea Orcagna, Andrea Bonaiuti, Spinello Aretino, and finally Lorenzo Monaco. The frescoes of Bernardo Daddi are close to those of Giotto in Santa Croce, and so are

those of Agnolo Gaddi. But there is a brilliant advance in points of style in Andrea Bonaiuti's work in the Spanish Chapel of Santa Maria Novella.[2] His architectural background, his variety of costumes, his sense of individuality, his attention to anatomy, his balance and subtlety of colouring, and his power of elaborating composition show that the dominance of neither piety nor genius, as in the case of Giotto, could hold the eyes of men from absorption in life and its conceptions. And yet, brilliant as is the detail, and alert the attention of eye and mind to purely human things, and to mundane effects, the scene as a whole is a picture of life as the Dominican Friar envisaged it. If the ordinary contemporaries in the street were now recognized as possible subjects of attention, and therefore of portraiture, it was because they, too, even if they hardly realized it, were members of the Church Militant, part of a scheme of authority, of Pope and Kings and Bishops as consecrated authorities over it, where the friars, as watchdogs of the Lord, kept guard over the sheep of the true fold.[3]

This painting, done, as it appears, in 1365, forty years after the death of Dante, is a convincing example of the conception of religious creation which the Divine poet had consummated. He had been interested in everything, he completely understood "the daily world's true worldlings",[4] he knew how the fierceness of human passion, the inertia of indifference, the dull malice of ambition, avarice, and worldly jealousy, and the proud egoism of bigotry impede the holy influence of the spirit, and especially that generous and intelligent spirit of reform which marked St. Dominic and his Order. Dante knew it, and Andrea Bonaiuti suggests it, in his finely detailed painting, whether his subject is Christ preaching to the spirits of the departed, or the triumph of St. Thomas Aquinas, or the Pope supreme over the heterogeneous crowd of the Church Militant. The simple grandeurs of Giotto have gone for ever. The Spanish Chapel of Santa Maria Novella shows that in the middle of the fourteenth century religious art took cognizance of the world as it was. Men wanted to be strong by following the natural fact.

Such was the spirit of Florence when Petrarch, St. Brigit, and St. Catherine of Siena prevailed on the Pope to return from Avignon to Rome in 1377.

III

Their return coincided in Florence with a new burst of genius. Donatello, who was born nine years later, in 1386, gave art a closeness to the images of nature and an imaginative strength which could employ ugliness to its purpose. A year later Fra Angelico was born in the Mugello, and became a friar in the Convent of San Domenico di Fiesole, below the steep hill which led up to the old cathedral, and at the same time Brunelleschi and Michelozzo were busy building memorable edifices. Brunelleschi completed the Gothic Cathedral of Our Lady of Flowers with a tiled dome, while Michelozzo built a new convent for the Dominicans at San Marco.[5]

When we move across the Arno from the cloister of San Marco to the work of Masaccio in the Brancacci chapel of Santa Maria del Carmine, we leave this intense spirituality for a more massive and worldly appreciation of goodness. It is true that in the Saints of Masaccio one has the same Hebraic loftiness as in Isaiah or Giotto. Masolino adds to this a more vivid interest in the street scenes of Florence; there is a return to the interest of Bonaiuti, though the painting is neither so hard nor so conventional. The eyes of Masaccio could see a spiritual significance in nakedness, as those of Masolino saw the mundane charm of dress, and for the first time painting allows a return to the appeal of Greek sculpture to the passions, as working through the imagination.

The School of Florence sent emissaries to Padua, and then to Venice, and so at the same time we see the influence of Mantegna, who in his small religious pictures set up the arches and columns of Rome's imperial majesty. But when his influence touched Carpaccio and Giovanni Bellini, it freed them for a closer survey of the men and women around them and the way these lived. Everywhere alike humanism meant a return to nature; iris and columbine glistened in the ground, the varying lights of morning and evening lit up the skies: the saints had rounded contours and the individuality of men and women. Such was the rapid change which came over Europe in the fifteenth century. The work of Giotto and Dante was taking from one hundred to two hundred years to work out its effect through the eyes and hands of artists; and their rapid progress before and after 1453, when, as we saw, the Turkish Emperor captured Constantinople, coincided also with the election in

1450 of a great Florentine scholar and humanist to the Papal throne.

But the continuation of the Renaissance is best expressed in Fra Angelico and his younger contemporary Masaccio, born in 1401 at San Giovanni Val d'Arno, where the river turns westwards down to Florence after its gradual curve from the Casentino around the wooded heights of Vallombrosa. Fra Angelico had all the strength of delicacy. His pious spirit turned back towards Giotto, in whom he found a model for the noble countenances and simple characters of his Saints, as well as for the conventional folds of his draperies. And like the workers in mosaic, he loved to paint a background of gold. But his work was much finer than that of Giotto: he understood perspective better, and his drawing was much more precise. Besides this, he had a new and unique gift of fine and brilliant colour, as though flowers had offered him their petals to clothe his Saints. Refinement has become grandeur in the exquisiteness of this painter, to whom, as to Dante, colour was full of symbolic significance, and whence its aerial tints convey moods as angelic as the painter's name suggests. The pains of the waiting souls in Purgatory, the raptures of the Saints in Paradise—these are the theme of this decorative genius, who took such joy in lines, tints, architecture, and arrangement. He could exalt every interest into beauty: every painting is an elevation of his mind to heavenly things, an act of joy and love. "Fiesole", it is said, "prayed his pictures on to the walls."[6] He combined the refinement of piety with the most delicate appreciation of a beauty that was at once visible and invisible, that combined scene with atmosphere in the power of an exquisite imagination made livelier by a tender heart, which was itself warmed by the constant ardour of his soul's converse with God. "Art demands much quiet," he said. "He that would paint Christ must live in Christ."[7]

If we look at his *Deposition from the Cross* at San Marco in Florence, we see how the pure blues, greens, scarlets, and pinks of his tempera remain still brilliantly clear below a blaze of gold haloes ; all find their place within the gilt frame on which itself he paints episodes from the Resurrection ; nevertheless it is against a conventional Tuscan scene that the framed wood of the Cross stands out. And from this Cross is being taken down the dead Body. But in the scores of figures grouped there is every phase of piety, from the anguish of grief to the rapture

of adoration. There are very striking diversities of religious feeling in those depths of individual experience, but they all unite in the purity of the whole effect: an effect which we can best appreciate, perhaps, if we compare it with Van Eyck's treatment of the Sacrifice of the Altar and the Cross in his famous picture which celebrates the Lamb of God at Ghent. There not only the transports of Saints, nor the raptures of prelates and angels are centred on their Divine Redeemer. There are men and women of almost too solid flesh. Their features are heavy, their eyes dull; in their furs and velvet, they proceed with their horses and their servants, while behind them is the beauty of far scenery, and around them flowers among the grass. These are again the worldlings of our common human kind, living among the material comforts of the north. They all, it is true, offer their adoration, indirect or concentrated, to the mystic sacrifice; but none of them knows the refined, ascetic fervour of Fra Angelico of Fiesole. In his pictures the light of the sky has been transmuted into an idealization of human nature, and we can hardly see what the sun reveals without recalling that Christ is *Lumen de Lumine*.

IV

The unworldliness of this exquisite Friar was in tune with a Platonic revival in which scholars refined by idealism sat out in the loggia of the new villa which Lorenzo il Magnifico had built at Fiesole and there they renewed the spiritual significance of light and beauty.

Artist and Platonist alike in Florence had come back to the Alexandrian thought, that light, which unveils all brilliance, is itself sublime. It is itself a mystery, and we may not express it unblamed. We hail it as holy. So they taught that the light, which flashes upon the outward eye, though the least material of sensible things, is itself the outward form of the true light, which enlightens the mind and the soul: for, showing us the object of our love visibly, it persuades us to love the invisible till we worship that alone. "The flower of beauty", said Marsilio Ficino, the Florentine Platonist, "is oblivion of sense", and working out the relations of the visible to the invisible light, he unfolds to us the mystical nature of true beauty.[8] He reminds us that Plotinus placed the highest beauty visible in bodies in a certain incorporeal splendour; and he tells us that

the primal beauty is nothing other than the splendour of glory in the Father of Lights who emanates a triple order of beauty: first through the angelic intellects, secondly through rational souls, and thirdly through bodies wherever, being first shapely, they expressed a various splendour of colour, breaking up as it were the primal light into component colours, as it is broken through prismatic glass. By this we see the graces of beauty. Echoing Plato, he tells us that as we contemplate and consider beauty in bodies, it, being nothing else but the ultimate splendour revealed in various gradations, changes us in marvellous fashion into itself. For as we behold it with our eyes, it seizes us, and while we are enkindled by love of it, it transfuses us through that hidden heat. And beginning in a seeking for sensuous beauty through corporeal sight, love finally becomes what Pico della Mirandola called an "intellectual desire of ideal beauty", of those perfections which are each "the patterns of things in God as in their true fountain".

Those ideals, which we see by a certain divine light, are hinted in corporeal beauty shining in the light of day, or its reflection. For, as Ficino said, light is in all minds an exuberance of life; to it we owe the clearness of truth, and a certain fullness of joy. And, in bodies, it is an unfolding and effusion of divine life. So he taught that outward beauty is but its prismatic ray. It is the grace of form, and the stimulus of delight, because it declares the truth of things and of their author.[9]

But not all Florentines were as Platonic as Ficino and Fra Angelico. If we look for the Christian triumph of the Renaissance, we shall find it when the new excitement of beautiful conceptions in Florence was drawn out to that sense of universal empire which had occupied in turn, in their different ways, St. Augustine, Constantine, and Dante: we need to see how the continuity of development in Florence not merely was accompanied by rapid extension to precision and beauty in Germany and Flanders, in France and England, but how it met in a generative unity with the weighty traditions of Rome. At last Roman art, with all its massiveness, was to be impregnated with a subtlety not less than that of the proportions of the Parthenon, the low reliefs on Hellenic tombs, or the appreciation of nature in Anacreon or Moschus.

V

After the three centuries of humanism, which hurried forward to new kinds of triumph in Italy after the Popes' return from Avignon, there comes a new return to nature through the classics, a new revival of classic humanism, a new epoch of adventure. This time the struggle is not with barbarity (though that still was there), but with something secular in man's faculties, in his passions, and in his opportunities. The North separated from the Papacy as before the East had done. Western civilization is again inspired to great masterpieces. But this time there are no great cathedrals in the North, there is no Dante in Italy. This time it is the architecture of the South and the literature of the North which illustrate the crisis. In Rome the greatest, in a succession of geniuses, Raphael and Michaelangelo, come to the Vatican, and paint in the Vatican the triumphs of the Church; and the struggle of the ideals of Christian order with the grandeur of human life and passion finds its supreme expression in St. Peter's, as before it had found it in the *Divina Commedia*. In England the vast genius of Shakespeare expresses the spirit of the age in its sense of the grandeur of the human lot, but the sense is calamitously different from that of the great cathedrals. When, as in the great tragedies, the convulsions are most sublime, man compasses his own destruction; life leads nowhere and signifies nothing; it becomes at last a madman's tale of sound and fury, and men's reasons fail them because they are afraid;

> O this gloomy world,

they lament,

> In what a shadow, or deep pit of darkness,
> Doth womanish and fearful mankind live!

Shakespeare's greatest plays, it will be remembered, are studies of men driven to frenzy by their obsessions; even love has lost its bearings, and instead of making for order, instead of leading upward to Paradise, to the Madonna, and to the Blessed Trinity, the greatest force in the universe is seen to have escaped from control; it becomes the *grande passion*; the riches and beauty which it lends to human life are but a fragile splendour erected at the mouth of chaos; and from an earth which is terrible and sublime, the heart and mind of man are appalled at the gulfs of

THE DEAD CHRIST AT THE SEPULCHRE, BY FRA ANGELICO. He combined the refinement of piety with appreciation of a beauty both visible and invisible.
[Photo by Anderson.

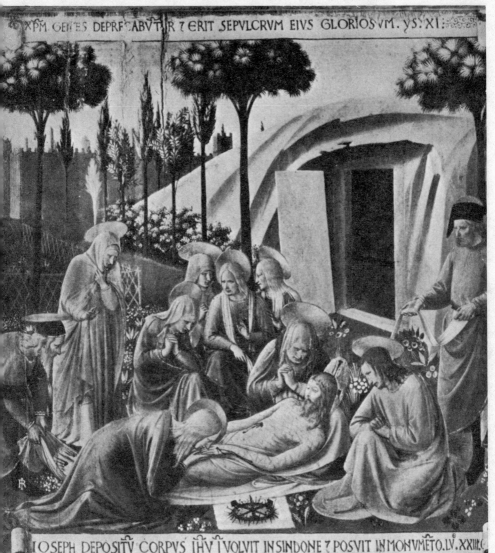

XPM̄ GENTES DEPRECABVTVR ⁊ ERIT SEPVLCRVM EIVS GLORIOSVM. YS: XI:

IOSEPH DEPOSITV CORPVS IHV INVOLVIT IN SINDONE ⁊ POSVIT IN MONVMĒTO. LV. XXIII. C

EFFVDAM SPM̄ MEVM SVP OMĒ·M CĀHĒ ⁊PPHTABVT FILII VR̄I. IOEL. II. C

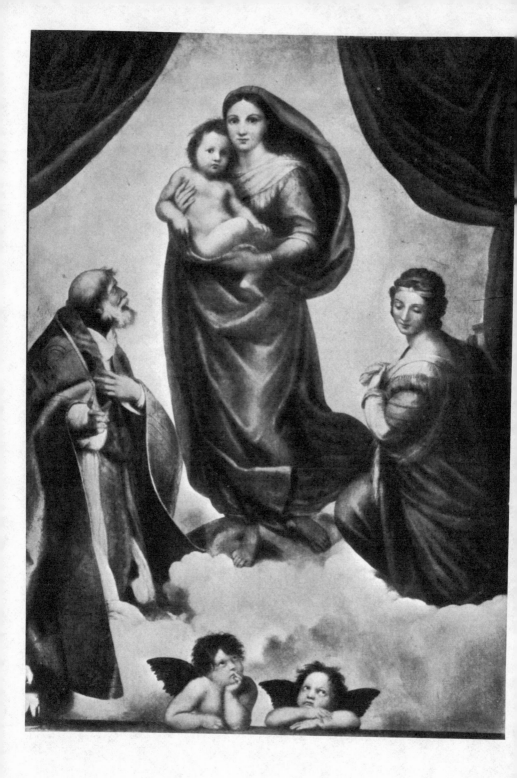

midnight towards which they are driven by the uproar within their own natures.

Greek tragedy had been grim; but what was it to the issues envisaged when the wild weather, the dark forests, and the brutal strength of the North invaded a conception of life enriched by three centuries of Christian humanism, and when the world offered to adventurers Indian and American riches, only to weaken the moral control over nations and to doubt whether, instead of a triumph of life, it was not death which, through all the "carnal, bloody, and unnatural acts" of men, was hunting a quarry to feast in its eternal cell? Death, even of the body, is not quiescence; it is the violent activity of forces of corruption.

It was, in fact, a stronger paganism with which at the close of the Middle Ages a purified but divided Christendom had to deal. While the Emperor now fought the King, and now sacked Rome, the outward world was a mirror of the havoc of ideas. Shakespearean paganism reached out to Roman origins as well as Northern ones.

Yet in her own realm the Church became more glorious. While St. Peter's, the Vatican, and the Council of Trent gave the Middle Ages their Catholic Crown, Lutheranism, Calvinism, and Anglicanism, even though cleft from the truth of unity and the unity of truth, still kept before men the ideas of God as Trinity in Unity, of the Divine Incarnation, of its continuance in sacramental mysteries, and of an inspired Bible which taught that the earth was good when it was made, and was still designed to prepare man for everlasting joy and felicity.

The roots even of the Reformed Churches were deep in Northern Medievalism. Again and again the ideas of Medieval Christendom were to show how strong was their hold upon the North and how far they stretched beyond Catholic unity. There was a change of interest to Augustinian Platonism from Thomistic Aristotelianism; but humanism survived through both, and genius became sublime not merely in Italy, but in England and Spain. Wherever religion was admitted, it added significance to gorgeousness, and where it was intense and mystical found expression in works of sublimity and beauty. The first sphere of its new triumph was in Spain, after it had given in Rome a new magnificence to the old tradition.

In the North the Renaissance came suddenly, and there was a schism in the Church. But if we look at the Mediterranean we

THE MADONNA DI SAN SISTO, BY RAPHAEL. This picture was the chief glory of Dresden before Allied bombers razed it to the ground.

see a very different phenomenon. So rich had been the enterprise of the fifteenth century, both in learning, in travel, and in the arts, that it still offered the richest promises of a continuous development. At the close of it, Western Europe was touched by the impulse of a universal spring. Once again, as in the thirteenth century, the gradual growth of decades opened into bloom, like Val d'Arno when April is changing to May. In thoughts, in holiness, in beauty, the spirit of man, active and fruitful as it had been in works of genius, advanced to gigantic things.

We do not understand the Middle Ages till we trace the Renaissance of the sixteenth century back to that of the thirteenth through Italy's unbroken succession of genius. This Second Renaissance, repeating the triumphs of three centuries before, is no more a revolt from Medievalism than the First had been. Wherever it is Christian—whether in the South or in the North—it is the final expression of the Middle Ages. Of this spirit, at once classical, medieval, traditional, and human, we have a superb example in Raphael.

CHAPTER X

[1] Longfellow, *Divina Commedia*.

[2] For further studies of the Spanish Chapel, see Ruskin, *Mornings in Florence*, VII.

[3] Tancred Borenius, *Florentine Frescoes*, pp. 36, 38.

[4] Wordsworth, *Sonnet on Personal Talk*.

[5] For a further account of the Florentine Renaissance, see my *Genius of the Vatican*, pp. 52-54. R. S.

[6] For an account of his piety, see Vasari, *Opere*, II, 519 (Florence, 1878).

[7] Hausenstein, *Fra Angelico*, p. 2, quoting Vasari, *Opere*, II, 520 (Florence, 1878).

[8] Ficino, *Proemium in libro de Sole*, Ch. XIV (Florence, 1483). Cf. F. Olgiati, *L'Anima del Umanesimo*, p. 598.

[9] *De Amore*, IX.

I

RAPHAEL's great painting in the Dresden Gallery is without doubt the most famous canvas in the world. No other picture is so widely known: no other picture has commanded high admiration from so many just appraisers over so long a range of time.

When it first appeared, Vasari, who had unusual opportunities among the painters, acclaimed it as unique: to-day his words are displayed below it in the Dresden Gallery, where it hangs alone: he names it *"questa cosa veramente rarissima e singolare"*. In 1593 Passeri wrote of it that it was "idyllic and beyond all praise". Cellini habitually referred to Raphael as the "mighty". When he died, Pico della Mirandola, writing to Isabella d'Este, prophesied that his fame would endure from age to age. And so it has done.

Perhaps Raphael's paintings were never more coveted than in the seventeenth century. But this, the finest masterpiece of all, still remained at Piacenza in the chapel for which it was painted. In 1745, however, King Augustus III of Saxony managed to buy it from the monks at Piacenza for 20,000 ducats: he had coveted it ever since, travelling to Lombardy as Crown Prince, he had seen it in 1711. When it came to Dresden, Winckelman was the arbiter of taste. He spread its fame through Germany as reproducing in its majestic calm the pose which the ancients, in attributing it to their divinities, had made the seal of excellence. It was praised alike by Schopenhauer and by Goethe. In the nineteenth century its reputation almost increased as first among the "dear Madonnas" of the prince of painters. Even now, when strength and roughness are placed so high as to win admiration for brutality, and when many cavil at the suavity of Raphael, it is better known than ever through countless reproductions. Each of these, no doubt, has retained something of the worth of the original. Yet each, as it departs from the colour, or from the completeness of composition, in the original insinuates an idea of weakness in it. And it is doubtful if even the best takes us beyond its aspect of serenity to that which dominates our impression after we have actually gone to Dresden, and have seen the picture itself; for what, above all, we take from the original is the sense of awe at its incomparable grandeur.

163

II

If we would explore the secret of its power, we must go far into the way we live and look at things. For always mind and soul are living through the senses, and it is through the senses that beauty passes into the soul and finds its entertainment there. The painter must express his genius through line and colour: he must combine high qualities of the spirit with technique in such a way as to please the eye and engage the intellect, melt all the excellences which delight or astonish to a whole, and yet give no impression of effort. "There will be", said Sir Joshua Reynolds, "necessarily an agreement in the imagination as in the senses of men", and he noticed that one of the first principles which the painter must share with architect and poet is the gift "of affecting the imagination by means of the association of ideas".[1] The creative genius must then, as Diderot and Ruskin agree, "be rich in great ideas".[2] Pictures depend for their greatness on their power of significance or suggestion through the completeness of their appeal to the imagination co-ordinating mind and sight as activities of one organism of life which not only apprehends, but feels and admires. The artist's own creative imagination depends, there-fore, on sensitive and searching vision, and with this he must combine that power over materials which will enable him to take advantage of the limitations they impose on him.

This implies a deftness with nerve and muscle. For, as Dante pointed out, a trembling hand may foil the artistic gift, even when that had been trained and developed. Without great art, we cannot have great religious art. The religious painter, like all painters, must possess much beyond ideas, much even beyond imagination. Power over the rhythmic patterns of colours and lines so that these will delight the senses by their clearness or brilliancy: truth to nature, so that, while keeping the conven-tions of art, nothing will conflict with our knowledge of the world itself: skill in producing an effect through true and grace-ful lines: a keen perception of the values of light and shadow: cunning brushwork to assist the effects of colours, lines, and lights: a sense of unity which will harmonize the skill shown in his work on the details of the picture and its individual excel-lences in one large, balanced beauty—all these must assist the artist in his expression of an ideal, or of a biased presentation

of life on a scale of permanent interest, so that the beauty of his concept increases as it finds its expression.

Beauty is the delightful resplendence of an intelligible perfection.[3] A work of art is the human presentation of it as conceived in a single image. It is a creative, while accurate, interpretation of nature, or of the life of man, an interpretation arranged by reason into a harmony, and having its own objective, energizing power. It shows its sublimity by the vigour with which it moulds great variety into the one unity which it informs; its mystery is a secret of harmonious and ennobled life, permeating a concentrated study of men and things, and combining these varied delights in a fine single new delightfulness, existing to be admired.

The admiration and delight inspired by them have a certain poignancy. It can never be final, never satisfy.

> Flowers, ruins, statues, music, words are weak,
> The beauty they transfuse with fitting truth to speak.[4]

It is with a picture as with a poem, its proof of excellence that it leaves us with a sense of longing rather than of satisfaction.

> Because all words, though culled with choicest art,
> Failing to give the bitter of the sweet,
> Wither against the palate—and the heart
> Faints, faded by its heat.[5]

It is the work of art that points us to that which is beyond, "the unreached paradise of men's despair". And no matter how radiantly a poet writes of love, does he not say at the end

> . . . only I discern
> Infinite passion, and the pain
> Of finite hearts that yearn?[6]

Intense admiration stretches our large discourse till it looks before and after. It is, as Longinus said, when a work of art startles our imagination that it wins our wonder.[7]

III

In the Madonna and Child the Catholic Church provides her painters with a theme peculiarly suitable to the high scope of art. Even if the mother and child were merely human, what broad and deep appeal, what precious ideas! The fruit of consummated love, the renewal of childhood, the generosity of

motherhood, the content of it, the bonded freedom of affection, the bloom of childhood and its promises, the rapturous sense of human love being framed in the scheme of Nature, feeling that

> Flowers are lovely, love is flower-like,
> Friendship is a sheltering tree,
> O the joys, that came down shower-like,
> Of friendship, love, and liberty
> When I was young! [8]

All these are present in the theme of child and mother. But how infinitely more if here is the Mother of God! A fruitful innocence, a lowliness raised to the heights, a blessed completeness in virginity because love's purest Spirit had overshadowed it: the sacrifice of redemption, the love of a Saviour leaning from realms of light to such a world as this, the majesty of a Child in whose hand are might and lordship over the kingdoms of the earth—these add ideas august and sublime to those which were grateful and wholesome: and the divine is the more wondrous because it touches on things low.

All that man honours in the virgin, all that he honours in the mother, all that he honours in the queen, all that he honours in the saint or angel, finds itself exalted to glory in the prerogatives of Mary: Dante, at the threshold of the ineffable, sums them in his ardent invocation:

> *Vergine Madre, figlia del tuo Figlio,*
> *Umile ed alta più che creatura,*
> *Termine fisso d'eterno consiglio,*
> *Tu se' colèi che l'umana natura*
> *Nobilitasti sì, che 'l suo Fattore*
> *Non disdegnò di farsi sua fattura.*
> *In te misericordia, in te pietate,*
> *In te magnificenza, in te s'aduna*
> *Quantunque in creatura è di bontate.*[9]

[9] *Paradiso*, XXXIII, 1-6, 19-22:
> Daughter of Thine own Son, thou Virgin Mother
> Of the eternal counsel issue fated,
> Lowlier and loftier than any other,
> To such nobility hast thou translated
> Man's nature that its Maker did not spurn
> To make Himself the thing that He created. . . .
> In thee is mercy, in thee is tenderness,
> In thee magnificence, in thee the sum
> Of all that in creation most can bless.

IV

We need not go back to trace from its remote origins the gradual clarification of the doctrines and devotions which had accompanied the interest of Byzantine artists in the theme, nor the concentration upon it of the genius of the Middle Ages. We have seen its place in the triumphs of Chartres. Venturi has traced the theme through the history of painting in an imposing volume. From Giotto and Cimabue, at the dawn of Italian painting, the theme had been developed with the most personal variety. Raphael had grown up in an age when it had been elaborated in more classic compositions, which had framed it in more and more extraneous detail.[10] From his earlier years he had worked it out in one study after another, gradually evolving a greater perfection from the study of his contemporaries and the improvement in his own workmanship. What an advance from the plump passivity of *La Belle Jardinière* in the Louvre to the refined, intellectual eagerness of the *Madonna with the Diadem*, with a background of shadowy distances of trees and of towered wall, all so eerie that they hint Leonardo da Vinci. At what precise date he painted the Sistine Madonna no record tells, and there is no final intrinsic evidence. In composition it much resembles his latest work, the *Transfiguration* in the Vatican, and the nearest approach to it in treatment is the *Madonna di Foligno*. It seems natural, then, to think that Raphael painted it after this picture, and after his final frescoes in the Vatican: probably in 1517. He was then thirty-four years old.

The influence of his contemporaries is expressed in the greatness of the picture as a whole. The figure of St. Sixtus recalls the *Eternal Father* as painted by Michelangelo in the Sistine Chapel: the harmony of the composition, as well as the arrangement of the figures, remind us of Fra Bartolommeo and his masterpiece in the gallery at Lucca. Something appears, too, to have been learnt from the depth of expression which Sebastian del Piombo put into his portraits: and it is not fanciful to recall in the posture of the Madonna on the clouds a memory of the wood-cuts of Dürer executed in 1510 or 1511: his *Grosse Passion* and his representation of the Trinity adored by a Pope kneeling on the clouds.

There can be little doubt, therefore, that Raphael painted the

Sistine Madonna after some years in Rome, where not only was his mind broadened by intercourse with the men of genius whom Leo X had gathered round him; there also his concepts of the Catholic religion had been inspired by those reminders of the continuous and universal life of the Church, of which Rome had made such an impressive collection and to which she was then daily adding. He himself had already found scope for his genius in painting frescoes in those great chambers of the Vatican which bear his name.

<p style="text-align:center">v</p>

As we look in the *Stanza of Heliodorus*, where the Miracle at Bolsena is set opposite to the Deliverance of St. Peter from Prison, and where the Arrest of Attila by Leo the Great faces the Expulsion of Heliodorus from the Temple, what we notice first is energy. In spite of the dignity and piety of the men of God, there is everywhere in the fresco an impression of power and violence, above all in the strong, free movement of the figures; this movement is carried right up into the vaulting. In the trail of Attila his barbarian hordes advance, more like devils than men, from a background of tempest and burning. The Pope and his Cardinals, riding out from the walls of Rome, arrest him with the Sign of the Cross, while far above the Pope are Peter and Paul, flying with drawn swords from the gleaming heavens. The same contest of piety and violence marks the Expulsion of Heliodorus. Here a bearded Pope sits venerable and calm, and beneath stately arches a prelate kneels at the altar, while the defenders of the temple (each of whom would make a picture) leap upon the despoiler.

In the adjoining chamber, or stanza, The School of Athens faces The Triumph of the Faith: in the one the lines of the composition lead up into high heaven: in the other Plato and Aristotle, the one gazing upwards to the unseen world, the other opening his hand as knowing "the proper tenure by which thou hast the earth",[11] are the centre of a group of wise men ranging in time from Heraclitus to the Renaissance. Behind them arch in arch fádes into the distance. It suggests the background of classic achievement, the noble rules which guided Greek or Roman. These men of thought are princely figures, like the Unknown Cardinal whose fine features arrest us in the Prado. In their gesture, and in the simple dignity of their

robes, they are not unworthy to face the group of Saints who adore the Trinity against a background of meadow and sky. For these have a joy and an intensity in their eyes and a brightness on their faces which reflect a purer light than any that shone in any human philosophy, even though the most necessary and true.[12] In the *Disputa*, the Virgin Mother is already in the clouds at the right hand of Christ her Son. In the *Madonna di Foligno* which was painted later than the *Disputa*, Raphael, advancing from the gracious human familiàrity of his earlier Madonnas, depicts St. Mary as the Queen of Heaven emerging from a cloud of cherubs and appearing from the clouds to a group of adorers on earth. In completing this picture the painter had prepared himself for the final expression of his ideal.

VI

In the new order given by the Benedictines of Piacenza, whose monastery was dedicated to a Pope of the third century, Saint Sixtus, the Saint was to be one of the leading human figures. With him is Saint Barbara, a maiden of Nicomedia, whom her father starved in prison. She looks down beneath the clouds as though summoning the adoration of the world: two cherubs look up, solemn and robust little creatures, too chubby to fly far on the feathered wings with which they have been provided. But they round the composition and provide a contrast to the central figure. Facing St. Barbara, the Pope, with raised hand, looks upwards towards Mother and Child to implore their mercy. His face, for all the roughness of the beard, is as sweet and holy as that of Barbara. The green curtains, which hang by rings from the sagging rod, are held back, revealing behind St. Barbara a tower, which is itself a symbol of her not unlike that monument to Hadrian which has become the Castle of St. Angelo. In this detail is a hint of all, either of invention or of imperialism, that is implied by Roman architecture. It alone stands out from the blaze of light behind the central figures, a blaze which, when we look at it more closely, we see to be an effulgence of baby faces.

The veil of Mary is blown out full, as by the swiftness of her approach, for no breeze disturbs the garment of Barbara or the cope of Sixtus: and this is suggested by the whole bearing of her figure. This reminds us of the Angel Gabriel in the An-

nunciation in San Pietro Ovile in Siena. For it is distinguished
from every other Madonna of Raphael by its majestic instancy.
Virginal and young, yet queenly and commanding, she knows
already of the sword that will pierce her heart. But though the
sorrows of the world have touched her, they have not aged her;
and there is something child-like in her tender features. Among
all created beings she is the purest. She is, as Wordsworth was
to write,

> . . . our tainted nature's solitary boast.[13]

The angels themselves have wondered at her beauty. Her
radiance is that of a sphere brighter than the serenest skies. Had
not Petrarch called her *"fenestra del ciel lucente"*, and Dante, as
we saw,

> . . . the lovely sapphire
> From which the heaven takes its clearest blue?

The Queen of Heaven has no need of crown, or jewels, or
shining raiment. Her bare feet, and her parted hair, might be
those of a peasant girl whose baby is her only treasure. Her
dignity is awful and her tenderness radiant because she is the
handmaid of the Lord. For she is not the centre of this picture.
She is the gateway for her Maker to come and raise our natures
to His own.

> The Word Divine became in yonder Rose
> Incarnate. Yonder are the lilies white
> Whose fragrance did the way of life disclose.[14]

The light which plays upon her face and shoulder is that which
pours forth from the golden nakedness of the Child she brings
from heaven. His face, although a baby's, is larger than her
own: His eyes are brighter and more solemn. Never before or
after was a young child painted as holding such authority, such
solicitude and wisdom. His aspect is not unworthy of the
emphasis which the artist has laid upon His figure.

VII

What is that emphasis? As we look more closely at the pic-
ture we can see how every line, like every colour, leads to the
Babe and His glory of saffron light. He was the Sun of
Righteousness. From Him pours the blaze, the exceeding
brightness, in which the faces of the cherubs grow dim: from

Him a glow of luminance pours upon the form of Barbara and lends a sheen to the golden cope of Sixtus. By Him the clouds are lightened. The curtains open upon Him. Sixtus and the cherubs look upwards towards Him; all the folds in the robes of Barbara and of the Madonna lead towards Him, and it is His form that completes the curve of His Mother's wind-blown veil. The green of the curtains and of the wings of the cherubs contrasts with the red on the robes of Mary and of Barbara so as to give it a brighter tone: the amber tones in the flesh of the Holy Child, which, as we have seen, dominate the lighting of the picture, are contrasted not directly with their complement of violet, but with varying shades of red and blue, between which those yellow tones would find their deepest contrast. The whole composition of the picture, so masterly in its arrangement of masses and spaces, and yet so immediate in its effect, so swift yet so subtle in its scheme of colour, so harmonious in its balance of light and shade, is centred upon the Divine Babe in His Mother's bosom. The picture dissolves into a perfect harmony in the lines in which the Child unites His form with hers. Such is the consummation of this picture: so it co-ordinates the devices and technique of art into a living image in which Nature is raised into the Divine. So the ideal dream comes true. The painter's art has been asked to essay the most sublime of ventures, and his genius has not failed.

VIII

With his contemporaries, Raphael had made a passionate endeavour to complete a monumental style. At times this aim seems almost to have enslaved him. His earlier Madonnas are too rounded, too sedate. But here he combines all that he owed to his contemporaries, and all that he gave as tribute to his habitual happy dignity of manner and mood, a last flawless, effortless completion. The astonishing ease and versatility with which he took over the temper, the devices, and the ideas of his contemporaries here enabled him to surpass them. For fifty years before and fifty years to come, one after another of the painters had broken in upon the tradition of their craft with the force, the fervour, or the idiosyncrasy of his genius. It had been true of Fra Angelico, Masaccio, Donatello, Mantegna, Pinturicchio, and Michelangelo: it was to be true for fifty years

to come of Titian, Giorgione, Veronese, Tintoretto, almost of Baroccio. But Raphael, with a suavity that had melted all, and a mastery that vanquished without apparent effort, combined all that there was to learn from culture and civilization. With the gentleness of his master Perugino, with the full humanity of Andrea del Sarto, with the rounded goodness of Fra Bartolommeo, he combined a strength and elevation less rugged than those of Michelangelo with an original enterprise which enabled him to combine the artistic nobility of his age in one full closing chord of Christian joy. It was that strong spiritual joy which Raphael gathered as the pure and rounded fruit of a golden age,

> *Die Frucht so hold und rein*
> *Vom Lebensbaum.*[15]

There is no temper of the mind more keen, more solicitous, more sympathetic, than that joy: none so cogent, so sane, so strong. For it is the blessedness of love in the attainment of its goal. In possession both of the ideal, and of a deep experience of life, it shows them in relation to one another. It tells us that in love, life is daily realizing radiant hopes, it is aware that

> Love's very pain is sweet,
> But its reward is in the world divine,
> Which if not here it builds beyond the grave; [16]

but it warns us of what Paracelsus learnt from Aprile of the human lot:

> Nor yet on thee shall burst the Future
> Like successive zones of several wonder
> Opening on some spirit, flying secure
> And glad from heaven to heaven,
> But thou shalt painfully attain to joy
> While hope and fear and love shall keep thee man.[17]

For this is the proper tenure by which we have the earth.

IX

There is, then, a spiritual reason for the expressiveness of Raphael. It is true that even among his contemporaries, Michelangelo painted with more passion and expressed more grimly and tumultuously the travail of life. Titian, and even

[15] Wagner, *Die Meistersinger*, Preislied.
> The fruit so fair, so pure
> From off the tree of life.

Fra Sebastian, had greater power of colour and chiaroscuro, both important spheres of success in painting. But neither they nor any of their successors excelled "the amplitude of Raphael's airy building, with its pillared arches, and an outlook, at the end of them, upon a country that is more fair and serene than ours".[18] The freedom and majesty of the frescoes in the Vatican are united with a homelier theme, more easily understood, in the supreme picture; it retains its hold over the masses while winning its tribute from the critic and the genius. To realize its relation to its rivals, we need only turn in the Zwinger itself to the great works near it; those of Correggio, Titian, Veronese, Holbein, or Velazquez. Let us not judge it till we have seen it so. None of them approaches it in power over the human countenance, or over the whole contour of the figures.

Each figure in this great picture is the revelation of a soul. The Virgin is a mystery of kindness and of calm; of grave yet radiant heavenliness, in spite of the apprehension in her eyes and the amazement in her lifted eyebrows. How much variance between the blissful mildness of Barbara and the fatherly love with which Sixtus, as intercessor, invites the mercy of Mother and Child to the world below. As for the two cherubs, who with their butterfly wings balance the lower extremity of the picture, one of them gazes upward with eager eye, his finger on his lips ready to throw a kiss; the other rests his wax-like chin on his little round arm, while his eyes are full of dreamy thoughtfulness as they reflect the veiled brilliancy of mother-of-pearl in the iridescent clouds. But most impressive of all is the power given to the undeveloped features of a young child; in spite of the babyish laxity of the body in the Mother's arms, which cradle it like a bird in the warmth of the nest, there is the might of resolution in the bare shoulders and the head: the dominance and vision in the round, dark, shining, eagle eyes declare that this Babe has already sat down at the right hand of God.

X

How did the painter attain this profound significance of effect? It is indeed strange that no legend has survived to tell us more. Let us not ignore what was required of the Benedictines who commanded this picture. Montgomery Carmichael told us in *Francia's Masterpiece* how much of the detail in a

picture may be dictated by theology.[19] This picture suited the dignified tradition of Benedictine culture: it answers their ideals of courtesy and peace. But we know no more of its secret than it tells itself. We can see in one of the cherubs a resemblance to that in the *Madonna di Foligno*: as for the Virgin herself, we can trace in the graciousness of her features a likeness to those in the *Madonna della Sedia* in the Pitti Gallery at Florence. In that same gallery is a portrait from which Raphael developed his ideal. She is known sometimes as *"La Fornarina"* and sometimes as the "Veiled Lady"; with a ripeness of womanly attraction, which she has deliberately enhanced by silks and jewels, she has in her dark eyes and sensuous lips, in her soft nostrils and lax bosom, nothing of the childlikeness, nor the chastity, nor the solicitude, nor the dignity of the Sistine Virgin. She looks more a Venus than a Mary. Who was she? The mistress, or the model of Raphael, or the woman to whom he was affianced? All that we know of her for certain is again what we see: that she fascinated him and inspired him. From her he rose to a higher ideal than that of any queen of love and beauty. An artist might have made her into Aphrodite. But by the inspiration of the Church, and at the command of the Benedictines, she was transformed into the Virgin Mother.

Such, says Venturi, was the method of Raphael. He brings men to their knees before the sweetness of his Madonnas: he delights us with flowers of grace. He translates the mystery of the birth of Christ into a vision of loveliness and of love; the beauty that he paints becomes godlike; he transfigures men and women; they rise to the sublime;[20] no worldly glory is so solemn as this holy dignity. In the School of Athens above the sciences and the liberal arts he expresses as a framing conception the immensity of space: "the gods and the great ancients go on their stately way, side by side with the princes of the Church, united in one majestic company".[21] In the life of art he was haunted by the vision of a grandeur beyond the limits of the human. Peaceful and free, his art attained that blue serene which, through all clouds and climates, is still the source of all our light. This blue serene is mirrored in the Sistine Madonna with a clearness that no painting has surpassed. That is why it guards its fame as a thing most truly rare and singular.

CHAPTER XI

[1] Reynolds, *Discourses on Painting*, XIII, p. 75 (1835 edn.).

[2] H. Gillot, *Denis Diderot*, pp. 179–186.

[3] See A. Conti, *Il Bello nel Vero*.

[4] Shelley, *Adonais*, LII.

[5] Tennyson, "A Dream of Fair Women".

[6] Browning, "Two on the Campagna".

[7] Longinus, *De Sublimitate*, 35.

[8] Coleridge, "Youth and Age".

[10] Venturi, *The Madonna in Art*.

[11] Browning, "Paracelsus", see *Poetical Works*, Vol. I, p. 71 (1896 edn.).

[12] For an excellent account of these *stanze*, see M. Creighton, *History of the Papacy*, Vol. V, pp. 201–202; Vol. VI, pp. 205–210.

[13] "Ecclesiastical Sonnets", II, 25.

[14] Dante, *Paradiso*, XXIII, 73–5.

[16] Shelley, "Julian and Maddolo", closing lines.

[17] Browning, "Paracelsus", *Poetical Works*, Vol. I, p. 71.

[18] Sir Charles Holmes, *Raphael*, p. 132.

[19] M. Carmichael, *Francias's Masterpiece*.

[20] Venturi, *Raffaello*, p. 210.

[21] Sir Charles Holmes, *Raphael*, p. 182.

I

RAPHAEL has left us no document of the ideas current in his lifetime. But we can trace them in the work of a versatile contemporary, the scope of whose gifts did not prevent him from being stupendous in the display of each. In the abundant century which witnessed the fullest outpouring of the Mediterranean genius, there was in Michelangelo a force of reason, passion, and imagination which came from no other source with so broad and strong a sweep. As a poet he was as absorbing and intimate as Donne; as a painter he glorified the Vatican with frescoes as fine as those of Raphael; as a sculptor he showed himself the rival of Pheidias and Scopas; as an architect he designed with faultless grace the sublimest temple ever offered to the Catholic religion, raising into the air with his engineering the mightiest feature in the outlines of Rome. And besides all this, he was a philosopher interpreting a traditional theory of beauty not alone into outward forms, but into phrases as powerful and haunting as the works of his chisel.

Those phrases demand the critic's long consideration. They connect the vigour of unforgettable images with Europe's strongest tradition of thought: here was one who, realizing that we must "think and feel if we would know", [1] made no compromises with those solaces which offer neither repose nor the kindlings of intellectual morning. Here was one whose life was at every turn fatiguing and poignant. The tasks demanded of him were cruel, and he was racked by inward throes both of human longing and religious contrition. The fires of passion scorched the delicate habitations of his Platonic idealism. Yet if he knew grief, he possessed also a calm congenial to intense thoughts. The reason is that he never allowed experience to paralyse him. Through all the tortures of pride and passion, and the complexity of thought to which they goaded or lured him, an inward grace lent to his mind and will a vigour which kept him in firm relation to the sublimest things that he had known. With the naked human body he was constantly occupied, and he knew how intimately the flesh was united with his love of beauty; psychologically the flesh met him everywhere. But though it fascinated, it did not satisfy. Indeed, wherever he met it, he met also mind. The proportions of beauty kept his com-

176

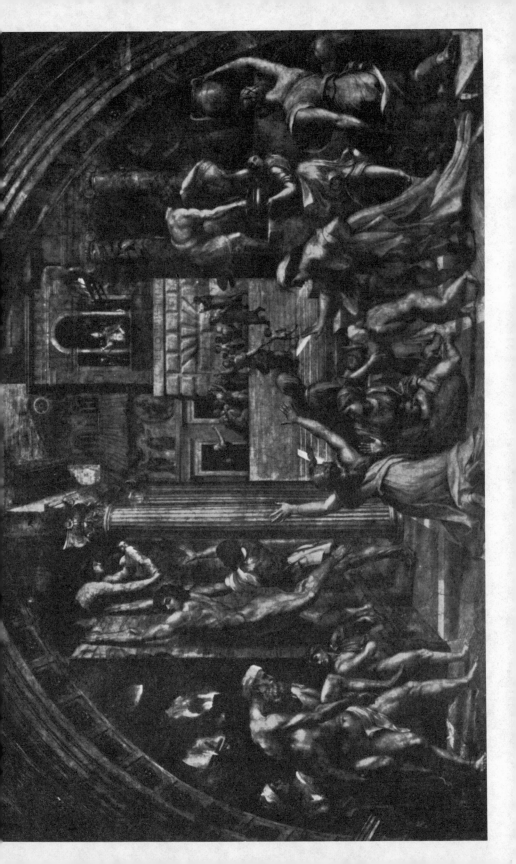

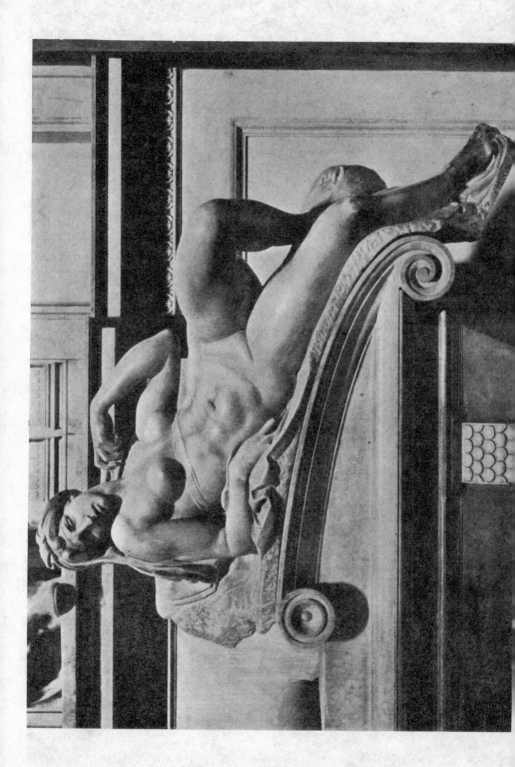

positions as finely cognizant of intellectual law as of human instinct. It was the wholeness, therefore, with which he gave himself to the study of the body which, through the body's unity with the mind, made him both the noblest of the architects of humanism and the poet who gives us the most arresting examples of Platonic thought in process of descent from Dante into the later Renaissance.

II

Eidos, or Form, said Plato, was the expression of the idea, and the Christian Aristotelians were always Platonists enough to insist also that form, whether in words or in tangible things, is that which expresses the power of reason over matter. Form, then, which is metaphysically an ultimate creative reality, is in the world of art and poetry what the artist's mind generates from his intercourse with his materials; the potential creative power realizes itself in the prospect of giving either order to ideas, or shape to inanimate material. Shape or outward form therefore distinguishes the individual creature from the raw material out of which it is created, just as it is the variety of nature which differentiates the created world from the night of chaos. It is therefore thè trained capacity to form a concept, what Aristotle called the habit, which makes a man into an artist, even though his technique may be unable to express it. For sometimes, as we saw, he, in Dante's phrase,

Ha l'abito dell'arte e man chi trema.[2]

And it is form which we recognize as *style* in the highest meaning we give the word. Style is not merely the man, nor yet, as Voltaire said, the thing. Neither Buffon nor Voltaire got as far as Vauvenargues, who said of eloquence: "*Elle donne la vie à tout—dans les sciences, dans les affaires, dans la conversation, dans la composition, dans la recherche même des plaisirs, rien ne peut réussir sans elle. Elle se joue des passions des hommes, les émeut, les calme, les determine à son gré. Tout cède à sa voix.*"[3]

And this may be compared with Newman's description of style as the expression of a completely defined thought.[4] It must be a thought which lives as a relation between the thinker, the thing thought of, and the means of expression: and the thing thought of as revealed to the thinker must be instinct with spiritual beauty.

[2] Has the habit of art and an unsteady hand. Dante, *Paradiso*, XIII, 78.

THE DAWN, BY MICHELANGELO, IN THE CAPPELLA MEDICI AT FLORENCE. It is through suffering that we attain the great massive power of fortitude which makes the heart true to love.

Beauty, indeed, had been defined by Plato as the splendour of the true. When Petrarch asks the question:

> *In qual parte del ciel, in quale idea*
> *Era l'esempio onde Natura tolse,*
> *Il bel viso leggiadro, in ch'ella volse*
> *Mostrar quaggiù quanto lassù potea?* [5]

he tells us that he was Platonist enough to regard man's creative acts as something made as it were in competition with nature. But Platonists as the medieval artists were, they were also Aristotelians. For the Dominicans, first Albertus Magnus, then Aquinas, had found in Aristotle the soundest philosopher to bring into relation with Christian revelation. To Aquinas beauty was the splendour of form. With the theory of poetry and of the arts he was, however, less occupied than with the proposition that human action and production depend on a right concept of what is to be done or made.[6] For the worker in raw material that concept could be foiled not only by lack of manual skill, but also by an intractable medium: Dante had recognized that:

> *Vero è che forma non s'accorda*
> *Molte fiate all'intenzion dell'arte*
> *Perche a risponder la materia è sorda.*[7]

Both difficulties are dealt with by Michelangelo in a famous sonnet:

> *Non ha l'ottimo artista alcun concetto*
> *Ch'un marmo solo in se non circonscriva*
> *Col suo soverchio, è solo a quello arriva*
> *La man che obbidisce all'intelletto.*[8]

The word *concetto* as the right concept which mirrored the eternal model in the human mind was used not only by Michelangelo at that time. Benedetto Varchi, the philosopher and critic, who pronounced the funeral oration of Michelangelo in Florence, comments on the word, identifying it with the Platonic *idea* and the Latin *exemplar*, and explaining it finally as

> In what idea, and in what zone of heaven
> Was the example unto Nature given
> From which her gay and beauteous face she gains
> To show to men how heavenly beauty reigns?

[7] Dante, *Paradiso*, I, 127–129.
[8] Sonnet XV:

> Nothing the greatest artist can conceive
> That every marble block doth not confine
> Within itself, and only its design
> The hand that follows intellect can achieve.

(Longfellow's translation.)

intuition.[9] This is almost an anticipation of both Schopenhauer and Signor Croce. A kindred thought to that of Varchi arises in the question of Galileo Gàlilei: *Quando sapresti levare il soverchio da un pezzo di marmo e scoprire si bella figura che vi era nascosta?* [10]

This thought suggests that the potentiality of the raw material was predestined to receive the informing act, which was modelled on the plan or intention of the Eternal Mind, being as Dante said the splendour of the Idea which the Eternal Sire conceives in his primal enthusiasm of love.

III

Such theories, linked, as we have seen, by Philo to Platonic Aristotelianism, are Christianity's contribution to the philosophy of art. They were integral both in the thought of the time and in the genius of Michelangelo. They do much to explain the monumental style of Raphael, which was a search to relate experience to an ideal type. And they apply with particular subtlety to poetry where the concept and its expression are linked in "the subtle knot which makes us man".[11] The word is in itself a unity with the thought that it expresses: it is a window to the mind, making the eternal light transparent to it, and giving the mind a detailed knowledge of the outward world. Let the mind live with this spiritual fullness, and the question of style is solved.

> *Rem tibi Socraticæ poterunt ostendere chartæ*
> *Verbaque provisam rem non invita sequentur.*[12]

So much Horace had already understood of the metaphysical tradition of Aristotelian Platonism. Words, so long as they exist, are stamped by the images of mind into a nature so near to mind; as Wordsworth said of passion, they are such adamantine holds of truth, as it is built "by highest reason in a Soul Sublime",[13] that through their transparency a light which Wordsworth was to call divine streams from that essential Life of Mind which is the light of men. This was a theory of art and style summed up by Ruggiero Bonghi in the memorable definition we have already quoted: *lo stile è questa vita che prende in te il tuo concetto e che tu comunichi nell'esprimerlo agli altri.*[14]

Art, in general, makes a picture of the ordinary in the

[12] Horace, *Ars Poetica*, 310-311.
 When Socrates has shown things as they are
 The words themselves will follow what is seen.

Divine Mirror of the Human Soul. But Michelangelo was much more precise than that. It was, he conceived, his vocation as the son of nature to immortalize in art the beautiful expression of an ideal which nature could borrow from the eternal world only for a season. He found, however, that art was not merely ideal, it was personal: that in painting, or carving, the portrait of one of nature's masterpieces, he expressed not only the mind of the original, but his own. And so through many years of labour the experienced artist arrives from one of nature's living images at the right concept:

> *Il saggio al buon concetto arriva*
> *D'un immagine viva.*[15]

Though he competes with nature, he can rival her. He himself has come from the eternal world, and reason unites him with its unseen beauties; and by an effort he can recapture them if nature gives him an image that will set his heart on fire. And so, as he watches one of his models preening himself in the mirror, he can say: "Not only does my face reflected make your reflection look fairer, but I can do better for you than that, I can make you a portrait more beautiful than you are". He returns to the same thought in his Sonnet to Vasari:

> *Se con lo stile coi colori avete*
> *Alla natura pareggiato l'arte,*
> *Anzi a quella scemato il piegio in parte*
> *Che bel di lei più bello a noi rendete.*[16]

He elaborates it still further in pointing out that in writing the *Lives of the Painters* Vasari gave another life to an age of art. Belief in God as the source of all reality, and therefore the origin of beauty, completes for the Catholic artists the implications of Plato's idealism.

IV

In the last hundred years writer after writer has returned to the life of this central and comprehensive man. As in Mr. Eliot's poem:

> In the room the women come and go
> Talking of Michelangelo.[17]

[15] The sage at the right concept does arrive
From one of Nature's images alive.

[16] *Rime* Sonnet No. 11 (translated by Symonds):
> With pencil and with palette hitherto
> You made your art high Nature's paragon;
> Nay more, from Nature her own prize you won
> Making what she made fair more fair to view.

And not only the women. He was made the subject of a Newdigate poem at Oxford; of monumental studies by Thode and Symonds; and a famous life by Romain Rolland. And we should remember also a long dramatic poem by Longfellow, never well known, and now almost forgotten. The great American had dedicated himself to the translation of the *Divina Commedia* as to a sacred task. His translation has been surpassed, but not, as a tribute to Dante, the sonnets he wrote on the divine poem. He made also a most careful study both of the Sonnets and of the Letters of Michelangelo, and understood the marvellous mind he studied. He sympathized both with its griefs and exultations, and in memorable passages reproduces the thoughts and theories which Michelangelo developed with his work in the imitative arts.

In the volumes of Fortunato Rizzi, Michelangelo's sonnets and madrigals, in all their tortuousness, in all their ingenious subtleties, in their mingling of scholastic mysticism with exalted human passion, are again before us. As we read once more their story of a being for whom human love provided a philosophy of religion, and faith and repentance vibrate with the intensest feelings of a tortured man to stimulate the workings of a quick and replete mind, we recall the poems of Donne. The two men have imprinted on their verse similar temperaments, similar interests. Both were passionate and learned; both were scholastic philosophers of rarest ingenuity; and both revelled in racing through labyrinths of condensed expression. More than once Michelangelo anticipated the actual ideas of Donne. Both were nourished in the same system of philosophy, and temperament may have inclined Donne to react to it as Michelangelo had done: but it is not impossible that the writer of the English sonnets and madrigals may have known something of the Italian who had employed the same form a hundred years earlier. The hypothesis is worth mentioning.

V

It is not the less so because of the sharp distinction between the poems of the two men. Their sources and study, it is true, were much the same.[18] But in spite of their affinities with and through scholasticism, their philosophies of love have very different tones. It is one of the fascinations of Donne that, though he said "love's mysteries in souls do grow",[19] he

insisted that the body is love's book. With a frankness, some-
times an outrageousness, that it would have been hard, but for
Villon and Ronsard, to parallel since the time of Ovid, Donne
develops his ideas in the closest conjunction with the intimacy
of his caresses.[20]

But though Michelangelo was not less passionate, his love,
in all its complexity, sought its satisfaction not in the senses, but
in the soul. It was, in fact, a passionate exaltation of his friend-
ship with men:

> *L'amor di quel ch'io parlo in alto spira;*
> *Donna è dissimil troppo, e mal conviensi*
> *Arder di quella al cor saggio e virile,*
> *L'un tira di cielo, e l'altro in terra tira;*
> *Nell'alma l'un, l'altro abita nei sensi.*
> *E l'arco tira a cose basse e vile.*[21]

That he made this sentiment the rule of his life is clearly
witnessed by Condivi: "Having long and intimately conversed
with Michelangelo," he wrote, "I never once heard issue from
that mouth words that were not of the truest honesty, and such
as had virtue to extinguish in the heart of youth any disordered
and uncrushed desire which might assail it. I am sure too that
no vile thoughts were born in him for this reason, that he loved
not only the beauty of beautiful beings, but in general all fair
things:—for example a beautiful horse, a beautiful dog, a
beautiful piece of country, a beautiful plant, a beautiful moun-
tain, a beautiful wood, and every site or thing in its kind fine
or rare, admiring them with marvellous affection. This was his
way: to choose what is beautiful from nature, as bees collect
the honey from flowers, and use it for this purpose in his
workings." [22] But his poems are so free from taint of coarseness
in the white heat of their fervour that they hardly need this
corroboration. Whether in his old age he is writing to Vittoria
Colonna, or whether he is addressing in the ardour of his
enthusiasm one of his younger friends, Bartolommeo Angelini,
Febo di Poggio, or Tommaso Cavalieri, he writes in the same
ideal, almost religious tone. He never uses an image or suggests
an idea that would justify us in believing anything but that

[21] *Life of Michelangelo,* Vol. II, p. 162 (Symonds' translation):

> The love of that whereof I speak ascends:
> Woman is different far; the love of her
> But ill befits a heart manly and wise.
> The one love soars, the other earthward tends:
> The soul lights this, while that the senses stir;
> And still lust's arrow at base quarry flies.

when, as the chief of sinners, he begged for mercy and grace from his Redeemer, he had the humility, with the purity, of the saints.[23]

He lived on the torture of intensity in these relationships:

I' piango i' ardo i' mi consumo e' l core
Di questo si nutriscie; [24]

but at the same time he insisted that experience proved them to be that which he evidently intended, one of the loftiest opportunities of spiritual life:

S'un casto amor, s'un pietà superna,
S'una fortuna infra due amanti equale,
S'un aspra sorte all'un dell'altro cale,
S'un spirto, s'un voler duo cor governa,
S'un anima in duo corpi è fatta eterna
Ambo levando al cielo e con pari ale,
S'amor d'un colpo e d'un dorato strale
Le viscier di duo petti arda e discierna,
S'amar l'un l'altro e nessun se medesmo
D'un gusto e d'un diletto a tal mercede,
Sc' a un fin voglia l'uno e l'altro porre;
Se mille e mill'altri non sarien centesmo
A tal nodo d'amore, a tanta fede—
Sol l'isdegnio il può rompere e sciorre? [25]

"If one single will governs two hearts, if one soul in two bodies has been made eternal, bearing both upward with equal wings to heaven." That is the living concept of the ideal personal relation which unified for Michelangelo his longing with his experience in certain ardent moments, too tense to last, and from which he returned to the grief and gloom of duty

[24] *Rime*, III, 52 (Altenburg, 1892).

> I weep, I am consumed, I burn with heat,
> And from all these my heart draws its strong meat.

[25] Sonnet XXXII (edn. Guasti):

> If love be chaste, if virtue conquer ill,
>> If fortune bind both lovers in one bond,
>> If either at the other's grief despond,
> If both be governed by one life, one will;
> If in two bodies one soul triumph still,
>> Raising the twain from earth to heaven beyond,
>> If love with one blow, and one golden wand,
> Have power with smitten beauty to pierce and thrill,
> If each the other love, himself forgoing
>> With such delight, such savour, and so well,
>> That both to one soul and their wills combine;
> If thousands of these thoughts, all thoughts outgoing,
>> Fail the least part of their firm love to tell:
>> Say, can mere angry spite this knot untwine?

> (Symonds' translation.)

carried out with intense effort in the teeth of exhaustion. It is in these struggles, and the calm in which they ended, that Michelangelo becomes the example of a sublime religious artist, that we see the perfect point of Ariosto's line:

Michel più che mortal, Angel Divino.

Whatever his genius touched bore the seal of that spiritual grandeur. Even with his poems, which are the least among the monuments of his greatness, no one who knows them, even in the translations of Longfellow or Symonds, could fall into the error of thinking them the mere sport of a man whose genius attained grandeur in other things; these poems are far from being what Petrarch might have called *nugellæ vulgares*. There is very little that Petrarch wrote, or Tasso, or Ariosto, stamped with such force and loftiness of conception: to find among the poets a greater spirit than his who wrote them we must go back past the *Canzónière* and the *Trionfi* to the *Divina Commedia* itself. That was his ideal. He had, writes Condivi, "a special admiration for Dante, delighting in the admirable genius of that man, almost all of whose works he knew by heart".[26]

<center>VI</center>

Michelangelo was familiar with the unity of two great traditions in Petrarch and Dante, whom the critics finally set in his proper place during Michelangelo's lifetime: these two traditions were those of Aristotelian Platonism and the Christian revelation. It is so we come to a final understanding of the view of art which is one with the quality of genius in this great creator. He viewed art as a great discipline of the mind: first, it was a discipline of his materials, for, as we have seen, he held that the business of the artist is so to conquer his medium as to lead its constraints to something more ordered, more passionate, and more illuminating than nature. It was, secondly, a discipline by his ideal, for it was to be so fine as to arouse a longing for what could be satisfied only in eternity. Thirdly, the double discipline was perfected by the unity of those two great traditions of thought and faith which had governed European genius for already three hundred years. For just as the metaphysical system, first committed to writing by St. Paul, being one with the story of Jesus, has a range of appeal, a power to touch and pierce the heart, and a mystical

clearness and finality which, when all is said, go to heights and depths that neither Plato nor Aristotle ever knew, so it was the completion of religion in its unity with the mind's own conclusions as to ethics, as to social and political theory, and as to the final nature of the universe, that has enabled the faith to reign as queen of the arts because queen of the sciences.

This is the view which explains what we find unique in the sculpture, the drawings, the paintings, and the buildings which are known as the work of Michelangelo.

<div align="center">VII</div>

When we hear of him, we think of him first, perhaps, as a sculptor. Bringing to a height surpassing the successes of Pheidias and Polycleitos the Renaissance commenced so long before by Giovanni and Niccolò Pisano, continued in Ghiberti and Donatello, this remarkable end was attained by Michelangelo in his earlier twenties. But neither he nor his contemporaries were content to take the grace and symmetry of a trunk and limbs as a fit representation of the gods. It was an age in which the body's own attraction was admitted; in the frescoes of Masaccio and Signorelli it had been restored to its throne over the imaginations of men. Apart from many legends, there are signs enough that Michelangelo loved it: but he never carved it so as to suggest that he yielded to its attraction, or admitted that to be enough for his aims. Where did he carve a nude without showing either in face or muscle some trace of his own inward torture which subordinated the grace of human shapes to colossal muscular strength, or tragic expression? In each of them there is this troubled ferocity. It appals us in the hard features and expression of the horned head, with its heavy curly hair, in the Moses of San Piétro in Vincoli. And we notice this the more because it is set against the architectural shapes of classic calm.

The same disturbed, indignant expression is mingled in his athletic David with a sensuous self-questioning. It is the study of a young man whose athletic success helps him to charm in the magnetism of another kind of physical attraction, but who is puzzled that all this completeness of natural living does not bring joy to his heart. Neither sport nor self-indulgence can bring a flash to his eyes, or the pleasures of his satisfaction to either features or muscles: we are conscious, as we look at him,

of the cloud that envelops us when we fail to give scope to the soul, and because we share this experience with him, there is nothing petty in his sullenness: on the other hand, it is instinct with an unattained grandeur.

We feel this latent grandeur more in the Slave in the Louvre. The style is more conventionalized, for from henceforward the sculptor sought a nobler effect in a compromise with his material. He wraps the fate and the feelings of his men in a sublime and stony impassiveness; but even in this he is spiritual; it suggests that passion is spent, that even in the travail of life the sufferer is prepared

> . . . in peace of heart,
> In calm of mind and soul to mingle
> With Eternity.[27]

This acquiescence in an infinite scheme never meant the surrender of individual dependence to interfering people nor to tyrants: in fact, the mood and dignity stamped on the Brutus in the Bargello, throw a new atmosphere over the young Apollo in the same collection. For though his body is as voluptuously rounded as that of any youth in the age of Pericles, there is independence, almost authority, both in his pose and features. But most memorable of all is the seal of grandeur on the human lot in the figures of Dark and Light, of Evening and Dawn, which are carved on the tombs of Giuliano and Lorenzo de Medici in Florence. Those figures were carved at a time when the German invasion and the sack of Rome had added a national horror to the weight of suffering which temperament and genius had laid upon the sculptor's heart. While he was at work on them he received a letter from Sebastian del Piombo which gave utterance to his own sense of will, steady even in the experience of outrage: "Now, friend, that we've passed through fire and water, and supported unimaginable things, let us thank God, and spend the little life that remains to us, as much as possible, in rest." [28] It is through suffering that we attain the great massive power of fortitude which makes the heart true to love. "The fullness of pleasure," wrote Michelangelo, " since it extinguishes desire, is less joy to lovers than misery which is full of hope."

> . . . Degli amanti è men felice stato
> Quello ove'l gran desir gran copia affrena
> Ch'una miseria di speranza piena.[29]

[29] *Rime*, CIX, 48.

These figures are grim with the peace that follows the rack of passion: but here, as everywhere, there is a sense of better life being somewhere true to beauty in the gracious shape and proportions of the design in the background. In his admiration of the figure of Night, Giovanni Strozzi composed a famous stanza, saying she was "by an angel carved, and since she sleeps, she lives". As with each of those four figures of darkness and light, Night's gloom is too vital for despair. But there is all the tragedy of the soul of Michelangelo in his touching answer:

> Caro m'è 'l sonno e più l'esser di sasso
> Mentre che 'l danno e la vergogna dura:
> Non veder, non sentir m'è gran ventura;
> Però non mi destar, deh! parla basso.[30]

VIII

Even of human love, the sculptor had argued, from the grief it brought on earth, that earth was not enough for it: not merely was misery full of hope, it was a pledge of eternal life which would vindicate final justice:

> Se 'l cielo è degli amanti
> Amico e il mondo ingrato
> Amando, a che son nato? [31]

Therefore he could find a place for suffering, almost for stony grief, when he asked marble to speak of Christian things. He is all delicacy and sympathy with the suffering Mother of Christ and her Son when she leans in sorrow over His dead body in St. Peter's: he makes her gentle and resigned in seeing the peace of His inert and slender form. But it is a woman who has pondered many things in her heart, and who is still scrutinizing the enigma of human life, that we see in the Holy Family in the Bargello, as she holds the book open for a Babe, who, though less solemn than He of San Sisto, has an equal character and power in His large head: and he has given to the Madonna at Bruges still more of the stubbornness with which he confronted

[30] *Rime*, CIX, 16, 17:

> Dear is my sleep, but more to be mere stone,
> So long as ruin and dishonour reign.
> To hear naught, naught to feel, to me is gain.
> Ah! wake me not: speak in thy softest tone.

[31] *Rime*:

> If to each lover heaven is a friend,
> And the world hates him,
> And I'm a lover too, then where's my end?

misery. All these witness the conflict which a man greatly tried must endure before he can attain to hope or peace.

IX

Sculptor as he was, Michelangelo has in the frescoes of the Sistine Chapel bequeathed to posterity something greater than his marbles. It is true that, like the picture of the Madonna in the Uffizi, they are the paintings of a sculptor: the same interest in the architecture of the human form, the same knowledge of the mechanical function of flesh, leads in a similar way to a similar revelation of the intimacy of flesh with passion, and of both with the striving spirit of man.

For in the design of the roof of the chapel the scheme of redemption is made not only to commence with the creation of man according to the Christian interpretation of the Bible, but the salvation which was foretold by Daniel or Isaiah is the answer to every oracle, to

<div align="center">every heat
Of pale-mouthed prophet dreaming.[32]</div>

It is a completion, therefore, to the sybils of Libya, Delphi, or Cumæ. As, in the School of Athens, Raphael had grouped together all the great thinkers of the Mediterranean, not omitting the Moslem Averroes, so here the comprehensiveness of Michelangelo's conceptions as a Catholic of the Renaissance gathered many types and names out of the variety of experience and history, figures of athletes as well as historic or symbolic scenes. His' scheme of redemption was built up of a great variety of noble forms, all instinct with passion and strength, and each combining with the other to bring significance and honour to the Gospel and the Church.

Here was no sudden flight into the serenity of the blue above the clouds. Here, to compass the might of the Lord, we ride out upon the storm of life, and see His work in its great deeps. Here we survey primeval issues, the struggles of darkness and light, and find them echoed first in the intensity of human lips, human eyes, and human flesh, and then in the tormented aspects of the men who sought to declare the ways of God.

It was to the Church that Michelangelo owed the overwhelming scale of these ideas, the scope for such a tumultuous harmony of inspiring types, and the reason for portraying them

in the order of a single masterpiece. It was from his Church and his Bible that he gained the power to raise to such lofty heights of purpose and design his fine natural experience of men's open nakedness: so that he could write:

> Nè Dio sua grazia mi si mostra altrove
> Più che 'n alcun leggiadro e mortal velo,
> E quel sol'amo perchè 'n quel si specchia.[33]

These children of Adam are gathered together because their only hope is in the advent of their Redeemer: and in His judgment they will know the final assessment of their worth.

X

But the mind of this overwhelming man generated a yet greater conception than any of his sculptures or his frescoes. He was sublimest when his attention was occupied simply with the arrangement of masses and lines. His mind less disturbed with the inevitable struggle for balance involved in subduing his interest in naked men to an ideal purpose, his taste became more austere. The subtlety of significance in the human form was still with him in architecture. "He who hath not mastered, or who doth not master the human figure, and in especial its anatomy," he wrote, "may never comprehend it." [34] It enabled him to imagine for buildings a beauty so mysteriously graceful and dignified that he conveys a longing for paradise through travertine and marble. We have lost the colossal bronze for the façade of San Petronio in Bologna: but we are still indebted to him for the Piccolomini altar in Siena Cathedral, for the Medici Chapel in San Lorenzo in Florence, and in Rome for the Farnese Palace and the Campidoglio. He restored the Baths of Diocletian, transposing them into the basilica of Our Lady Queen of Angels. But neither this nor the Campidoglio is his masterpiece. Master-builder of St. Peter's from 1547 to his death in 1564, he projected for the great basilica a design in which classic simplicity should combine with a new and original daring in effect to endue with majesty the shrine of St. Peter, and make it a fitting environment for the most stately functions of the sovereign who claimed as his successor a dominion

[33] Sonnet LVI:

> God hath not deigned to show His grace more clear
> Than in the joy of some fine mortal form;
> And since it mirrors Him, I hold it dear.

unique on earth. The later architects (not without genius) changed those proportions for something more massive, and, to use Hawthorne's words, more "cheerfully sublime".[35] In a fresco in the Vatican, however, we can still see the design of Michelangelo: it is that design realized that we admire as we pass the transepts of St. Peter's and see them surmounted by that Dome which, from far up the Tiber and far over the folds of the Campagna, shows us the Eternal City, and which tells us all that we need to know of it:[36] that it alone surpasses all the remaining beauties of the world, and that its builder and maker is God.

"Gigantic elegance" is an expression that Byron applied to St. Peter's,[37] and in what the basilica owes to Michelangelo we see how the sense of awe which we connect with Gothic cathedrals can be awakened by happiness of proportion. For this serenity and grace mirror the calm of a soul which, in spite of all its throes, its wildness, its agonies, its pride, its tumultuousness, and its gloom, retained its belief in grace and its hope of heaven.

The dome was the sublimest achievement of a consecrated genius. Yet it gains its final significance from a sonnet. At last, when the building—like the drawing, the painting, and the hewing of stone—of this mighty man were done, the art of words in the most touching of his verses signs art's abdication of her reign as the idol and monarch of his heart. Dedicated to religion as much of that art had been, there was yet a taint of corruption in it all. Redeeming love with open arms upon the Cross was to Michelangelo the only concept by which the human soul could finally recover its full communion with the eternal: at the last the passionate idealist turns to the embracing arms of the one lover who, after all his research of flesh and fancy, could satisfy his soul. In that final gesture of a nature so individual and so stormy we see the significance of his images; without that thirst for consecration, why, when he was compassed too often with dull pain, or sometimes consuming torment, should he have sought to strike again and yet again into his wondrous track of dreams, and make them real in enginery and stone?

CONCLUSION TO PART II

Such, then, is the second period of Christian art. It is the story of a long Renaissance continuing unbroken from the thirteenth to the sixteenth century. It had been occupied almost

continuously with both the classics and with nature. The simple, seraphic love of St. Francis for such things as water and birds had been making the heart of man purer at the same time as St. Dominic prepared the intellectual enterprise of his Order by which Albert the Great and Aquinas give the support of more scientific reason to faith. The whole range open to the eye and mind was explored by the adventurous eye of Dante and set by his disciplined and intense mind into a scheme of the Universe which opened to the human imagination pictures of Paradise so ethereal, yet at the same time so mystical, and with both so ordered by reason, that, combined as they were with the highest technical gifts, the Church had already her poetic masterpiece. He added also to the Catholic philosophy of beauty. A similar intensity of scientific effort was combined with a similar impressiveness of scale in the engineering of the Gothic cathedral. But whereas this effort of the architects seemed temporarily to exhaust the Christian genius of France, England, and Germany, there was no break of the development in Italy, for even during the absence of the Popes at Avignon, Petrarch was busy, and their return coincides with the extraordinary combination of sculpture, painting, and architecture fostered at Florence by Lorenzo il Magnifico and in Venice by the Doges. So that one sees that, through all these centuries, Italians were strengthening their genius by less distrust of Nature and more interest in facts.[38]

Neither reason nor passion, however, went beyond the control of faith. On the contrary, their imagination was inspired to greater service to the Church by a serenity which kept the majesty of Rome as a model, allowed them to use their eyes to attain a more perfect technique and adapt it to express warmer and more human feeling. So it is that in the world of architecture, Donatello and Bramante lead on to Michelangelo, and while among painters, Ghirlandaio, Masaccio, and Perugino prepare the way for Raphael. Together they express in their devotion to the Church the consummation of centuries of humanism, both in struggle and in triumph. In his Madonnas Raphael shows more of what the Incarnation added to Christian art. Nothing in human nature was alien to either; both had a triumphant sense of its grandeur, but the genius of the one was as serene as the other was stormy.

Michelangelo, however, even where he owed most to his Christian inspiration, showed that—in this age of enterprise, of adventure, of economic revolution and new wealth, of

exuberance, pride, and gorgeousness—faith could not triumph without a struggle. For the culmination of the Renaissance was no more religious than its exordium. The world was becoming secularized. New schism disturbed the Christian Church, and in the centuries to come the faith was no longer to dominate inspiration. Where it produced the supreme masterpiece, it would be either sustained by intense personal fervour or show the compromise which was troubling and dividing civilization. Nevertheless it elaborated for art Philo's idea of the creative concept, and for another century and a half the highest grandeur was yet within the reach of consecrated genius.

<div style="text-align:center">CHAPTER XII</div>

[1] Wordsworth, *Memorials of a Tour on the Continent*, XV.

[3] Vauvenargues, *Du langage et de l'éloquence*.

[4] Newman, *Discourses on University Education*, pp. 218–220 (1852).

[6] In translating the famous expression of the Nicomachean Ethics into *recta ratio*, they gave rise to a misconception which has survived till the present day. Is not concept a better equivalent than plan or deduction?
Through the ages scholars have debated the meaning of Plato and Aristotle: and not least of the expression of ὀρθὸς λόγος. Mr. Cook Wilson (*Classical Review*, 1913, No. 4, pp. 113–116) has insisted that it is always applied to reasoning or one of its modes. But Professor Stocks (*Journal of Philology*, 1914, XXXIII, No. 66, pp. 182–194) has shown that it is also applied to perception. It is the essence of Christian interpretation to find in Greek philosophy, as in the Old Testament, more and more wealth and growth of meaning. And since it loved life, and love and life were so strong within it, it found an elucidation of this expression, which such an Aristotelian scholar as Sir W. D. Ross (cf. W. D. Ross, *Aristotle*, p. 174) is able to accept. For as thinking implies a thought, so the word λόγος applies to the whole life of the mind, and it is in such a translation as the word concept that a Christian artist clarifies and improves on the changing and uncertain thought of Plato and Aristotle. For it is a part of his function to give this newness of life to classic words, and to claim authority for his own interpretation.

[9] These comments are reproduced in *A Selection of the Poems of Fortunato Rizzi* (1923).

[10] When did you begin to raise the cover from
 A piece of marble, and reveal the
 So lovely form which had been hidden there?

[11] Donne, *The Extasy*.

[13] Wordsworth, "Prelude", V, 39–42.

[14] R. Bonghi, *Lettere Critiche*, p. 82 (3rd ed., Milan, 1873). For translation, see p. 238.

[17] T. S. Eliot, *Prufrock*.

[18] See Professor Grierson's edition of Donne's poems and Signor Rizzi's of those of Michelangelo.

[19] *The Extasy*.

[20] See R. Sencourt, *Outflying Philosophy*, pp. 40–46.

[22] Condivi, *Vita di Michelangelo Buonarroti*, LXIV, pp. 79–81 (Pisa, 1823).

[23] The most searching discussions of the moral character of Michelangelo are in Symonds' *Life*, Vol. III, Ch. XII; Ludwig von Scheffler, *Michelangelo: Eine Renaissance*.

[26] Condivi, *op. cit.*, LXIV.

[27] Wordsworth, "The River Duddon", XXXIII.

[28] Quoted in *Life* by R. Rolland, p. 28 (Eng. trans.).

[32] Keats, "Ode to Psyche".

[34] Quoted by Geoffrey Scott, *The Architecture of Humanism*, p. 22.

[35] Hawthorne, *The Marble Fawn*, Vol. III, Ch. V, p. 77 (1866 edn.).

[36] "Omnes excellas una pulchritudines", *Brev. Rom.*, 29.

[37] Byron, "Childe Harold's Pilgrimage", Canto IV, Stanza 150.

[38] See my "Mediæval Rome", *Times Literary Supplement*, June, 1926; *Genius of the Vatican*, pp. 52–56.

THE MASTERPIECE OF MICHELANGELO: THE DOME OF ST. PETER'S FROM THE POPE'S GARDEN. *The dome was the sublimest achievement of a consecrated genius. The sense of awe can be awakened by happiness of proportion.*
[*Photo by Dorien Leigh.*]

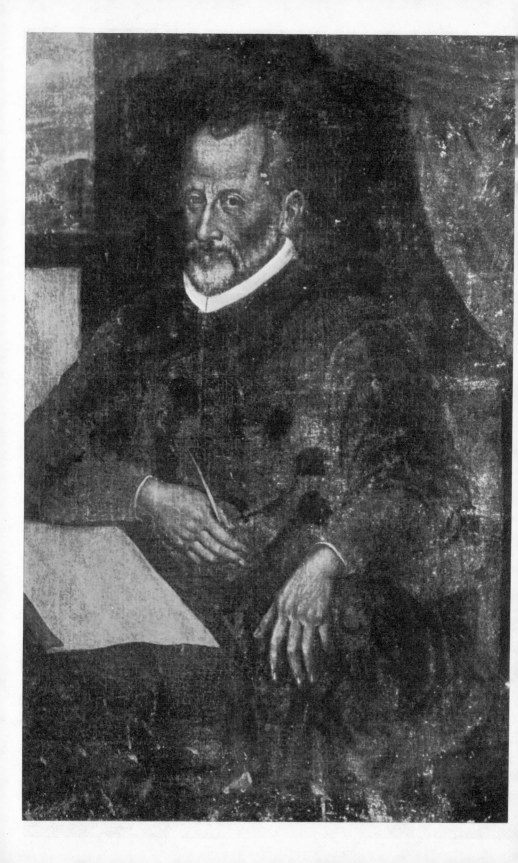

PART III

THE SPLENDOURS AND DANGERS OF THE BAROQUE

CHAPTER XIII TWO PASSIONATE POETS: SPENSER AND
ST. JOHN OF THE CROSS

I

As we look at the struggle of genius against passion in the imagination, we can well appraise the effects of religion upon it if we think of two poets of the sixteenth century, each of unquestioned eminence in the literary history of his country, each prodigal in temperament and fancy; these two are Spenser in England, and in Spain St. John of the Cross.

Spenser's poetic genius was recognized at once: his contemporaries counted him as the greatest since Chaucer. This immediate recognition has been supported by a line of poets. Shakespeare said, "This deep conceit was such as passing all conceit needed no defence". Milton confided to Dryden that Spenser was his original, and honoured him as "sage and serious".[1] Dryden said that his verses were so numerous, so various and harmonious that only Virgil, whom he frequently imitated, had surpassed him among the Romans, and only Waller among the English.[2] Pope paid his tribute likewise. Thomson and Shenstone revived his stanza. Even Wordsworth used it in "Resolution" and "Independence", as Keats did in "The Eve of St. Agnes". Wordsworth put the "Faerie Queene" with "Othello" as "pre-eminently dear",[3] and wrote of Spenser moving through the poet's sky

> With the moon's beauty and the moon's soft pace.[4]

"Childe Harold's Pilgrimage", says Mr. E. C. Davis, "is simply Byron masquerading in Spenserian dress."[5] In Spenser's successors his influence pervades. Shelley copied him much. In short, he is known as "the poets' poet".

193

PALESTRINA, FROM A PORTRAIT IN THE ORATORY OF SAN FILIPPO
NERI AT ROME. Palestrina endowed his musical themes with colour, complexity
and feeling, while keeping intact the simplicity he inherited. [Photo by Giraudon.

II

He was secure in the patronage of the powerful: his mind centres on Queen Elizabeth: in him, as for many of his contemporaries, patriotism and the Puritan movement combined to provide the English ideal.

In what way did his religion affect his genius? To tell the truth, its inspiration is obscure and indirect. Although the "Faerie Queene" begins with a red cross knight, who symbolizes holiness, there is hardly any trace of personal devotion in that long allegory, nor has it any overmastering scheme of inspired thought, such as controls the *Divina Commedia*. The ideas and temper of Spenser are those of the Renaissance rather than of the Protestant believer. He read Du Bellay, Du Bartas, and Giordano Bruno. His scheme of virtues is taken from Aristotle,[6] his idealism is Platonic, and his hymns on beauty almost paraphrase the Symposium. Nevertheless, we can see that on the one side religion provides a purer and more elevated standard for his luxurious imagination. It enables him to contrast better things with his Bower of Bliss: it gives a chaster charm to his temple of Venus and his delight in amorous attraction. When in his best poem, the "Epithalamion", he accompanies the bride through her wedding-day, from her donning her wedding-dress in the morning to the blissful night when she receives the embrace of her bridegroom, it keeps the whole poem in perfect taste. "I do not know any other nuptial song, ancient or modern, of equal beauty," said in fact Hallam. "It is an intoxication of ecstasy, ardent, noble, and pure."[7] Here the poet expressly mentions the rites of religion:

> With trembling steps and humble reverence
> She cometh in before the Almighty's view;
> Of her, ye virgins, learn obedience
> When so ye come into those holy places
> To humble your proud faces,
> Bring her up to th' high altar, that she may
> The sacred ceremonies there partake,
> The which do endlesse matrimony make.
> And let the roring organs loudly play
> The praises of the Lord, in lively notes;
> The whiles with hollow throates
> The choristers the joyous Anthems sing,
> That all the woods may answer, and their eccho ring.

This it is which purifies the poet's fancy as he contemplates

the bridal couch; and so his raptures are as delicate as they are playful:

> An hundred little winged loves
> Like divers feathered doves
> Shall fly and flutter round about the bed
> And in secret dark that none reproves
> Their pretty stealthes shall work, and shall all spread
> To filch away sweet snatches of delight
> Conceal'd through covert night.

And thus in him is prepared the tribute to the bride's inward and spiritual beauty.

> There dwells sweet love, and constant chastity,
> Unspotted fayth, and comely womanhood,
> Regard of honour, and mild modesty.
> There virtue raynes as Queen in royal throne,
> And giveth lawes alone.

This is the theme which Spenser takes up again in his hymn in honour of love: it is a very vivid picture of the course of passion in the hearts of lovers till their "full joyance of their gentle game", before treating of beauty as the Platonic semblance of the unseen ideal.

But from these "lewd layes in praise of that mad fit which fooles call love", he rose finally to Hymns of heavenly love and heavenly beauty. Here he treats directly the Christian revelation: the Blessed Trinity, the design of creation, of redemption, and man's elevation to grace and to heaven.

III

He treats of these high themes with a rapture not less than that he had given to earthly love; but his nobler theme gives his verse sublime and spiritual images. As he pictures the bliss of the angels and their fall, and man made in his Maker's image, though only in turn to fall, his poem becomes moving and powerful. Of the Redemption of Christ the poet writes:

> He downe descended, like a most demisse
> And abject thrall, in fleshes frail attire,
> That he for him might pay sinnes deadly hyre,
> And them restore into that happier state
> In which he stood before his hapless fate.

With tenderness he portrays the life of the Redeemer:

> . . . Reade in the story of his life
> His humble carriage, his unfaulty ways,
> His cancred foes, his fights, his toil, his strife,
> His paines, his poverty, his sharpe assayes
> Through which he past his miserable days,
> Offending none, and doing good to all
> Yet being malist both by great and small.

When Spenser touches on these, the lasting themes of the Christian faith, we see among the luxuries and prodigalities of his Renaissance taste the picture of something tenderer, nobler, purer. Such is the combination of qualities which, as we noticed in St. Paul, came to the genius of Europe with the Church; this gives a purer and more wholesome view of the whole dispensation of nature and its magnetisms.

IV

So much, then, we may learn from Spenser of what Christian faith does for poetry; but if we wish to see the yearning and anguish of the human heart meeting God in His immediacy, let us go to two poets who were Spenser's contemporaries in Castile.

One was that Luis de León who was among the first to argue that the Song of Songs, whatever its allegory, had within it a drama of the heart, the other was his pupil, known to the world long since as St. John of the Cross. In both of these we see in the sphere of prayer the most poignant language of feeling, and from them we learn that mysticism, far from lulling, or even escaping, human experience, gives the man of genius not only his most sublime experiences, but applies a more urgent impulsion to the heart of flesh. Luis de León pictures in his most famous lyric his desires for paradise as something far more satisfying than earth: it is the keen stars as they sparkle out over the plateaux and sierras of Castile which stab his spirit broad awake to the bliss beyond.

And so eager is he to be worthy of grace that he cries aloud from torment:

> *Mostrad vuestras entrañas amorosas*
> *En recibirme ahora y perdonarme*
> *Pues es benigno Dios, tan propio vuestro*
> *Tener piedad de todas vuestras cosas.*
> *Yi si os place, Señor, de castigarme*

> *No me entregueis al enemigo nuestro;*
> *A diestro y a siniestro*
> *Tomad vos, la venganza*
> *Herid en mi con fuego azote y lanza*
> *Cortad, quemad, romped, sin duelo alguno.*
> *A tormentad mis miembros de uno a uno*
> *Con que, despues de aqueste tal castigo*
> *Volvais a ser, mi Dios, mi buen amigo.*[8]

To his Catholic mind, this torment of adversity finds in the Blessed Virgin a hope of release, and from the dungeon of the Inquisition he directs a cry which, while recalling the peril of the sailor, shows how much the contrast of heaven added to the poignancy of misery, while its standards made the heart more sensitive.

> *Virgen que al alto ruego*
> *Lo más humilde sí diste que honesto*
> *En quien los cielos contemplar desean*
> *Como terrero puesto*
> *Los brazos presos, de los ojos ciego*
> *A cien flechas estoy que me rodean*
> *Que en herirme se emplean :*
> *Siento el dolor, mas no veo la mano*
> *Ni puedo huir ni me es dado escudar me.*
> *Quiera tu soberano*
> *Hijo, Madre de amor, por ti liberar me*
> *Virgen, lucero amado*
> *En mar tempestuoso clara guia.*
> *A cuyo santo rayo calla el viento*
> *Mil olas á porfia*
> *Hunden en el abismo un des armado*
> *Leño de vela y remo, que sin tiento*
> *El humédo elemento*
> *Corre; la noche carga, el aire truena*
> *Ya por el cielo va, ya el suelo toca,*
> *Gime la rota antena;*
> *Socorro antes que embista en dura roca.*[9]

[8] Luis de León, Del Conocimiento de se mismo. The following translations are by Dr. Raby.

> Show to me now thy heart's most dear compassion
> In taking back and quite forgiving me,
> For 'tis thy nature, gracious Lord of light,
> To pity everything Thy hands did fashion;
> Oh, give me not unto mine enemy!
> If 'tis Thy will to smite,
> On left hand or on right,
> Vengeance be in Thy hand:
> Wound my hard heart with whip or spear or brand;
> Cleave without pity and consume and break,
> And all my limbs one living torment make—
> All this if only when Thy wrath shall end
> Thou wilt return, my God, to be my friend.

[9] Luis de Léon, A Nuestra Signora.

> Maid who at that high call
> With truth that matched thine own humility

V

It is, however, in St. John of the Cross that we find the most subtle exposition of the riches that the graces of communion with the Divine add to those of genius. St. John of the Cross was a nature quite as prodigally endowed as Spenser with sensitiveness, imagination, passion, fervour, and memory; to these he added intellectual subtlety, and the gift of verse. All were fully developed in Salamanca at a time when the University there was as active as any in the world; its best minds then far exceeded those of any other period of its history, or of any other in Spain in any period. The theologians who guided the Council of Trent had established its tradition: the navigators' stories, and the opportunities of the West Indies and the Americas provided novelties, wealth, and excitement. Into this period came two additional influences: an abundance of mystical writers, and a finesse in love poetry. These streams of inventiveness combined in the genius of Luis de León,[10] who was the Professor of Theology when St. John of the Cross came as a student to Salamanca. They enriched the faculties of the younger and yet more brilliant poet.

Sometimes all thought, sometimes all feeling,[11] he was absorbed in the task of getting beyond either. His aim was to flee from desires, passions, and sensations, flee also from the distracting travail of the reasoning mind, in order that, in the intuitive communion of mysticism, he should converse heart to heart with the very source and fount of life; he

Didst speak the "yes" the heavens would contemplate.
Fix'd like a post am I,
My arms imprisoned, blind my eyes, and all
Helpless I am; a hundred arrows wait
To compass me with hate.
The wound I feel, the hand that smites is hid.
I cannot shield myself, I may not flee.
Mother of love, I bid
Thee pray thy sovran son to set me free.

Maiden! blest Star, whose light
Is a clear haven on the troubled deep,
Lulling the loud winds till they quiet be,
A thousand billows heap
Their waters o'er a bark disarmed quite
Of sail and oar, which drives unceasingly
Over the restless sea.
The wind is roaring, and the night is vast;
Now high, now low, as smites the tempest shock,
Shudders the riven mast;
Help, ere we break upon the cruel rock.

would drink of the essence of God. He therefore deprived himself of all—he desired to have nothing, to feel nothing, to know nothing, that his whole nature might be free for exclusive consciousness of God. God should be all in all: he and his Father one.[12]

Nor did he fail to receive the power or, as he would—more precisely—say, the grace, to attain to this communion. He sought for unity with God to enjoy all the blessings and perfections of Divine love: "I wish for Thee wholly, and they are unable and know not how to speak to me of Thee wholly; for naught on earth or in heaven can give the soul the knowledge which she desires to have of Thee, and thus they cannot tell me what I wish. In place of these messages, therefore, be Thou Thyself both messenger and message".[13]

In his chief poem, "The Song of the Spirit", this memorable Carmelite tells, in stanzas modelled on the Song of Songs, of the longing of his soul for God: as this poem is one of the very finest Castilian lyrics, and is accompanied by a mystical exposition, we learn through it much what mystical communion does for genius. A final stanza tells of

> The zephyr's breath and balm,
> The darkling nightingale's enchanted singing,
> The woodland's fondest charm,
> The starry night and calm,
> With flames that burn my flesh, no torment bringing.[14]

Expounding this, St. John of the Cross writes:
"Even as all the trees and plants have their roots in the woodland, so the creatures, those both of heaven and of earth, have their root and their life in God. Thus then the soul says that she will show herself there to God inasmuch as He is life and being to all the creatures, for she knows that in Him they have their beginning and the time and mode set for their existence: for without Him naught is given to the soul, nor does the soul believe it can know them with the spiritual sense. The soul also greatly desires to see the beauty of the woodland: this is the grace and wisdom and beauty which not only does each created thing have from God, but which is found among themselves, both the higher creatures and the lower, in the wisdom and order in which they are ordained one with another: and when one has this sense of creation, it is a mystical sense and a great joy, for it is knowledge of the things of God." [15]

It is in fact the gift of the spiritual man not only to find God

in the traces of Himself He has left in creation; but furthermore the human spirit enjoys in ecstasy a direct communion with the Divine as the root and source of created beings. If a prince's palace were thrown open, one could see from outside both the prince himself, and what he was doing as work, or in relation to the treasures he owned:[16] so it is with certain mystical experience. It sees God and in Him what He has created.

Dante at the vision of the Trinity said:

> I saw in its abysmal deep immersed
> Together in one volume bound with love
> What is throughout the universe dispersed.[17]

So St. John of the Cross says, "When by essential love the soul is commingled with the Ineffable and so awakens to glory, although it is true that the soul is now able to see that these things are distinct from God, inasmuch as they have a created being, it sees them in Him with their force, root and strength, and it knows equally that God, in His own Being, is all these things in an infinite and pre-eminent way to such a point that it understands them better in His Being than in themselves. And this is the great delight of this awakening." [18]

Such, then, is the direct, intuitive experience by which the man of religion enforces the insight and exhilaration of the creative artist. He cultivates a direct intercourse with Him who created and sustains all in the round earth, and in the mind of man.

VI

Not only does the spiritual man see clearer the higher values of the Christian character, and of the spirit, but he has a clearer insight into what Coleridge called "the one life within us and abroad"—that sustaining power without which, as St. John of the Cross reminds us, nothing could exist; for God is in all things by His truth and by His power to give them their being: and it is this presence which the mystic knows by the intuition he owes to love. It is for the Christian thinker to relate this intuition to revelation by the philosophy and theology of Catholic mysticism.

Here St. John of the Cross speaks with eminent authority. He had both the experience and the psychological gift which enabled him to discuss it, and he had the passion, the imagina-

tion, and the technique of the poet: he tells us at the beginning
of his dissertation on the Song of the Spirit that when the soul
has arrived at union with God, He gives it at its apex such an
abundance of life and glory that from this abundance it pours a
gushing stream into the human faculties, which have been
developed by intercourse with the exterior world. For in
advanced souls the faculties of the imagination and perception
are so purified, so spiritualized, that the soul, with its natural
faculties and powers, is in a state of calm quiescence. They,
after their manner, partake and enjoy the grandeurs which God
has communicated to the spirit; and the psalmist was right to
say, "My *heart* and my *flesh* rejoice in the living God".[19] In the
mystic's consummation of union, it is not merely the soul, but
the whole being of the lover who rejoices with the Beloved to
attain to perfection in the blessings of love.[20]

From that full chime of being, the mystic's whole nature is
steeped in tides of colour and glory: and it is from these the
artist, in his rapture, conceives beauty, the composer music, and
the poet words which convey in measured sound the rapture of
his sense of order and perfection. Each has gone into a realm
transcending logic. Yet it is given to the sense of composition
to hint the excellence which the adorers contemplate. As St.
John says: "By means of figures, comparisons and similitudes,
mystics allow something of that which they feel to overflow,
and utter secret mysteries from the abundance of their spirits." [21]

VII

Such is the secret of all genius. Such is the intermingling
power of reason, passion, and imagination; but since all reach
their height in man's highest faculty of spirit, it is from the
spirit that they receive their intensest power.

Reason, passion and imagination—wherever they are found—
have their grandeur. Man is noble in his faculties and infinite in
apprehension; but religious poetry discloses the secret of poetry's
highest seriousness. For as man rises from the noble and
sublime in nature to participation through grace and love in
the Spirit which is Divine, his patterns and images of excellence
reveal that Eternal Love in its union with the Eternal Word
Who is the express image of glory and the model of all excellence
of words. There we see also how poetry takes its origin: for

loves inflames and fuses the faculties; it gives them a generative
unity with their objects, and therefore, as Wordsworth said in
their blended might, they accomplish a new creation.

So when we come back to St. John of the Cross, we see not
only magnificent passages of baroque prose as sumptuous as
the jewelled and brocaded vestments of the time, but we have
also love poetry of unsurpassed ardour. Arthur Symons spoke
of it having a "directness and intensity of spiritual longing
which exceeds that of the love poets of all ages".[22] In the
words of another critic, "it fuses intensest passion with perfect
purity".[23] "More fervent in its passion than any profane
poetry," said Menéndez y Pelayo, "its form is as elegant and
exquisite as any of the finest works of the Renaissance." [24]
When did a lover speak with more force than this?—

> Descubre tu presencia
> Y máte me tu vista y hermosura;
> Mira que la dolencia
> De amor, que no se cura
> Sino con la presencia y la figura.[25]

From this desperate intensity, the poem passes to an enchanting
playfulness, more rapturous still than the "Epithalamion" of
Spenser.

> De flores y esmeraldas
> En las fresca mañanas escogidas
> Haremos las guirnaldas
> En tu amor florecidas
> Y en un cabello mio entretijidas.[26]

If, then, the voice of love is tender and ardent, if poetry is
simple, sensuous, and passionate to a supreme degree in this
Castilian, it is because he is heroically spiritual. All that he owes
to his love of God, he sums up in one stanza on love's living
flame:

> Oh lámparas de fuego,
> En cujos resplandores
> Las mas profundas cavernas del sentido,
> Que estaba obscuro y ciego

25 Ah bring thy presence nigher
And kill me with thy aspect and thy grace!
Love is ordeal by fire,
Torment too fierce and dire
To cure but by thy presence and thy grace.

26 Of greenest emeralds and of flowers
Gathered in freshest morning hours,
 We'll make our garlands rare,
That with the glint of brightest gems
Enmeshed, your love will find his petalled stems
 Inwoven with my hair.

> Con extraños primores
> Calor y luz dan junto a su querido.[27]

We need only recall the stanzas of Spenser to see how much more the direct and uncompromising surrender of the spiritual life added to a poetic gift for the themes of love and beauty. The mystical ardour of the Carmelite gives his poems a fervour that exceeds that of Spenser, as later the surprise and magic of Gerard Manley Hopkins outdistance the chaste and fine art of Robert Bridges. The poems of St. John of the Cross in their intense concentration show up also the defects in Spenser, which his admirer, Church, lamented: prolixity, the elaboration of distasteful themes, and the absurdity which made him flatter an able, ageing and hectoring royalty into thinking she was a fairy queen.[28]

CHAPTER XIII

[1] *Areopagitica.*
[2] *Essays,* Vol. II, p. 29 (1926).
[3] Third Sonnet, on Personal Talk.
[4] Wordsworth.
[5] E. C. Davis.
[6] Prologue to the "Faerie Queene".
[7] Quoted in *Chambers's Encyclopædia of English Literature,* Vol. I, p. 296.
[10] See Aubrey Bell: *Luis de León*; Sainz Rodríguez, *Introducción a la Litteratura Mística.*
[11] Llama de amor viva.
[12] Cf. Coleridge, *Religious Musings.*
[13] *Cántico Espiritual,* VI, 6.
[14] *Ibid.,* XXXIX:

> El aspirar del aire,
> El canto de la dulce Filomena
> El soto y su donaire
> En la noche serena
> Con llama que consume y no da pena.

[15] *Cántico,* XXXVIII, Peers, *Works,* Vol. II, p. 179.
[16] *Cántico,* IV, 5.
[17] *Il Paradiso:*

> Nel suo profonda vidi che s'interna
> Legato con amore in un volume
> Cio che per l'universo si squaderna.

Cf. Luis de León, "A Felipe Ruiz", *Oxford Book of Spanish Verse,* No. 79.
[18] *Cántico,* IV, 5.
[19] *Cántico,* final paragraphs.
[20] Cf. R. Sencourt, *Carmelite and Poet,* p. 133; Conti, *Il Bello nel Véro,* Ch. V, par. 16 Crisógono, *San Juan de la Cruz,* Vol. II, pp. 43–45.
[21] *Cántico,* Prologue.
[22] Symons, *Cities, Sea Coasts and Islands,* pp. 66, 67.
[23] E. I. Watkin, *The Philosophy of Mysticism,* p. 398.
[24] Quoted by Peers, *Works,* Vol. I, p. 48. Cf. Damaso Alonso. *La Poesia de San Juan de la Cruz,* 241. "He is a marvellous literary artist and the finest of Spanish poets".

[27]
> Resplendent lamps of blazing fire
> The darkest caverns of desire
> Where human senses go.
> Caves deep, peculiar, obscure,
> Thou fillest with piercing gleamings pure,
> Outstreaming heat and glow.

[28] R. W. Church, *Spenser,* pp. 176–179.

I

W E shall the better understand what the mystical theology of St. John of the Cross did for his temperament and genius if we consider his greatest contemporaries in the realm of music. What are we to say of music in its relation to religion? The sphere of its influence is both subtle and powerful. In its origin it was recognized that the vibrations of its notes were arranged in mathematical proportions, and men thought of it as an application of arithmetic, though Chateaubriand says: *Le chant nous vient d'anges, et la source du concert est dans le ciel.*[1] Yet in the early history of the Church, music was under suspicion; it was restricted by Gregory the Great not only to the human voice, but to a small range of notes which five hundred years later Guido d'Arezzo extended. Only on feast days was an alternative allowed to the simplicity of its structure. Let us see why. Its power to charm, to restore, and to subdue could not be ignored, but while it took more than a thousand years for the architecture, art, or poetry of the Church to move freely in relation to nature, so it was yet nearly five hundred years more before ecclesiastics who cut themselves off from family life to practise celibacy found in the Church an opportunity to give play to the influence of music or to the emotions it involved, and the most outstanding genius to do so was a married man.

II

Neither merely sensuous nor purely spiritual is the domain of music: it rules over a psychic territory all its own, a realm indeed of emotion, but also one of mystery, one which is at the springs of both desire, of knowledge, and of life. It touches, more than any other art, *las mas profundas cavernas del sentido,* those mysterious depths of experience out of which the will is moved to love, and determination joins with instinct in the deepest movements of the heart towards its end.

There are within us sensitivenesses of feeling which storm and overpower the conscious work of reason; the enquiring spirit has impulses of yearning, and feelings of contentment, of which nerves and mind are but indirectly aware; no art can clearly express them, for their kinship with sensation is at once too profound and too elusive. Nor can we define what is

moving in music. Under its influence all that is peculiar to the
work of soul, or of spirit, or of passion acts so mysteriously on
the other that joy and pain, be they ever so acute, establish be-
tween sense and soul a sympathy and mutual operation; then
contemplation becomes creative: it demands expression in
the realm of the senses.

It does not matter how purely spiritual our natures or our
particular experience may be, yet music touches so intimately
the subtle knot that makes us man that the sensuous being feels
the thrill of excitement, which becomes an urge towards
expression. Nor is this only something which fuses soul and
sense into their interacting work of human life: but it joins
heart with heart, and becomes a thrill of sympathy in pain or
joy; it takes its colouring and tone from the relations of
separate beings. How subtly in this way scents work upon us!
but yet more powerfully works sound. A vibration passes with
such evocative power that one life calls to another in the depths;
and long afterwards the pathos of a heart is recreated as the
expression of it echoes over space and years.

This applies not only to emotion, but to thought, to char-
acter, to energy, to spirit. Here is the highest excellence of an
impressionable man, that not only the things of sense affect
him, but perceptions of mysterious things afar. Whether we
consider them morally, philosophically, or in the range of
human experience, such perceptions, says Gervinus, are the
noblest that we receive.[2] "If therefore," he continues, "we in
the sensitiveness of our soul feel ourselves warmly akin to the
highest strivings of man's reason or imagination or with
power after that which the being of man provides towards
things enduring; if in longing we draw near to knowing the
immortal, the true, the beautiful, the good, in the creative
power of some image; if deeply moved we return from some
great building made for the worship of God; if we linger before
a noble work of art, and feel the consolation of its harmony; if
in the chain of scientific truths we find the companionship of a
new one that surprises us into joy and wonder; if a noble deed
is done that awakens both in him that does it and him for whom
it is done, and in him who knows it is done, strange feelings of
encouragement—if we have such experiences as these, we
breathe a purer air of which self and sense reck little." [3] It is in
this purer air that sound speaks most powerfully. And here we
enter the interior castle of religious music.

"How sorely I wept", wrote St. Augustine, "at those hymns and songs, how often was I melted by the moving thunders of the Church. Into mine ears poured those voices; and the truth shone warm into my heart, and kindled in it the flame of adoration. My tears flowed, and upon me blessings poured." [4]

III

Palestrina well expressed this power. He wrote in 1589 to Cardinal Ippolito d'Este, "Music exercises great influence over the minds of men not merely by cheering but also guiding them. Those men deserve great censure who use such a gift of God for frivolous or unworthy purposes, exciting to immorality men who are by nature so prone to evil. For my own part, from my youth upwards, I have ever held the misuse of music in horror, and most anxiously have I striven that nothing should proceed from my pen which should make any man more wicked or profane. I am not far from being an old man and at my mature age it befits me to direct my mind all the more assiduously to those sublime and serious matters which alone are worth a Christian's regard."

The case of Palestrina admirably shows what the Christian faith has added to the genius of musicians.

Born in 1526 at the village Horace knew as Praeneste, a village standing on one of the lower declivities of the wild Sabine Hills, he had come as a boy to Rome and studied music. Marrying in 1547, he was appointed in 1551 Choirmaster of the Cappella Giulia, which when the Sistine Chapel was completed became the Sistine choir. He immediately began the composition of Masses, but he first made his name in the touching music to which he set the reproaches sung during the Adoration of the Cross on Good Friday, which Goethe found among the most beautiful of Church services.[5] His chief work was to enrich religious music at the same time as he kept it severely suited to its solemn themes: and in him we can survey better than in any other case what the tradition and formulas of the Church have done for musical genius. As Gervinus noted, the drama and the oratorio provide a field for manifold situations in which human impulses and sensations are entwined with, and lose themselves among, spiritual and moral interests, and so become more intimate, deeper, and nobler. The intellectual ideas such

as sung words provide, when associated with a piece of music, add unmeasured ranges to the significance of what the music in itself suggests—just as, in turn, the addition of music warms, colours, and deepens the power of the words.

IV

That there is in the surge of music an intrinsic power which either religion or something quite different from religion can seize for its purpose is well expressed when we consider how well the music which Haydn composed as the Austrian national anthem has served other purposes. Originally, of course, a hymn for the preservation of the Austrian Emperor and his house, it was adopted by the countrymen of Bismarck to the words "*Deutschland, Deutschland, über Alles*". While the English use it for two hymns:

> Praise the Lord, ye heavens adore him.

and

> Glorious things of thee are spoken,
> Zion, city of our God.

A distinguished English musician [6] has in fact conducted at the same time Austrian, German, and English choirs, each singing it to the words they knew. This might almost suggest that our ideas of what marks religious music are vague. What it really shows is that in the realm of a national anthem there is an exalted surge of feeling which is at once both national and religious: that with this the purely national feeling can borrow a majesty not its own, and the language of praise and devotion can give the majesty a still higher consecration than it originally had.

At the same time it reminds us how easily on the one side music and its power transcend intellectual conceptions, and how easily, on the other hand, it mingles the most exalted themes with surges of impulse which are not religious.

Inwardly, therefore, men think they can associate sentimental and even playful tunes with religious words. Masses based on the music of popular tunes were composed in the sixteenth century. In the nineteenth century Wesley was generally approved for the playful music he introduces in one of his most famous anthems, "Ascribe unto the Lord"; and Mendelssohn

for his sentimental charm and pathos in "Oh for the wings of a dove".

A problem of a similar kind did present itself to Palestrina. "Too many poets", he wrote in his preface to the Song of Solomon, "have composed songs, the words of which treat of love that is estranged from the Christian faith, and mine. Yet musicians have not cast aside these poems, but many of them have spent their art and diligence to adapt them to music. And by such compositions they have made for themselves a name, though to cultivated and serious men they have by their choice of bad material given great offence. It makes me blush and fills me with grief that I too did once belong to this class." So far he went in age with the regrets that pierced the heart of Michelangelo—and yet how could he treat such a poem as the Song of Songs without realizing that the words, even if mystically interpreted, were the words of natural love? Try as he would to stop his ears, the tones of natural attraction could not but make themselves heard. In that poem which meant so much from century to century for the mystics, which at that time was affecting so powerfully Luis de León and St. John of the Cross, he shows that even in a genius so chaste as his, nature mingles delicately with grace to inspire and shape the work of art. "Now," wrote Palestrina, "I have selected those that extol the love of Christ for his bride—the Song of Solomon. I have written this in a tone that is more animated than is my wont in music for the Church, but my subject seemed to require this." In fact the thought of the wife he had loved mingles with his mystic ardour, as in the words of the Song itself.[7]

v

Palestrina stands at the doorway of that new baroque age which in recognizing the sublimity of passion, felt its allurements, and in the strife of the heart subdued it to the order of the universe. Behind him was the severe tradition of the Church and the Orders vowed to resist the lust of the flesh, the lust of the eyes, and the pride of life, with the rules of poverty, chastity, and obedience. The Church had felt that simplicity, centring the mind on worship, was the first thing necessary for religious music. If emotions were aroused, they might bear men and

THE PRESENTATION OF THE VIRGIN IN THE TEMPLE, BY TITIAN, FROM THE ACADEMIA DI VENEZIA. Rich imagery and vital sympathies combine in a beauty which is dazzling and which conveys great numbers of great ideas.
[Photo by Anderson.

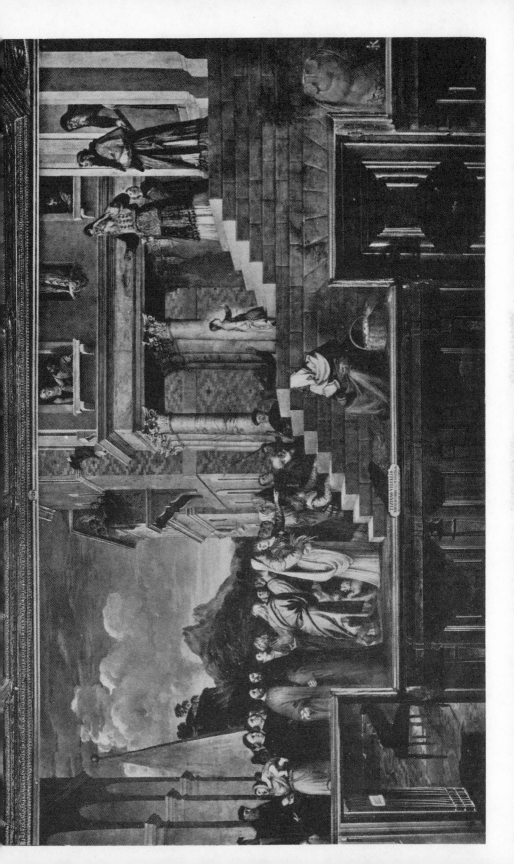

women out of the safe harbour of their rule to the waves and
storms which engulfed Abélard and Héloïse.

Gregory the Great, taking over this tradition, had enriched
and enforced it, presenting to the Church a norm which survived
down the ages, and which had been nobly interpreted by Alcuin
at the court of Charlemagne. But all through the Middle Ages,
from the time of Guido d'Arezzo to that of Josquin and
Goudimel, Church music preferred always to err on the side of
simplicity; only in the sixteenth century did it allow the
development of counterpoint and so added a whole new wealth
to Church music.

Chaste and severe in its forms, allowing for beauty and
developing melodies to combine in the structure of composi-
tions taken as a whole, music then entered on a golden age. Of
this, ranging among such men as in Italy Orlando di Lasso
and Felice Anerio, in England Tallis, Taverner, Morley, and
Byrd, in Spain between Morales and Victoria, the prince was
Pierluigi da Palestrina.

In the age in which passion preoccupied the poet, the
sculptor, the painter, it joined with harmony and discord to
give new ranges to music; what would the tradition of the
Church do for it in return?

Developing all the resources of technique, the contempor-
aries of Palestrina certainly infused religious music with passion.
His first masterpiece, as we saw, was the music of the Re-
proaches. Finding them chanted to plainsong, he set them to a
faux bourdon, or plain harmonization, which, as the result of his
instinct, combines an apparent simplicity of construction with
an effect of complexity in emotional, haunting, and sublime
effect, which made the heart melt at the spectacle of the Cruci-
fixion. "Let the tune or melody", said St. Nicetus, "be sub-
servient to holy religion, not that which bursts out into
theatrical display but that which shows forth in us their Chris-
tianity; not that which savours of the stage but that which
produces compunction in sinners." To aid this compunction
by an appeal to feeling and imagination was what Palestrina
achieved in his music for Good Friday, not alone in the
Reproaches, but in the Lamentations sung at *Tenebræ*, when
each word of the Hebrew alphabet is made into an appeal as
elaborate in passion and fancy as the most gorgeous illumination
in the initial letters of a medieval Book of Hours.

The next great work was a book of motets, dedicated to

THE FEAST IN THE HOUSE OF LEVI, BY VERONESE, IN THE ACADEMIA
DI VENEZIA. *Here secular genius, almost in spite of itself, produces a religious
masterpiece.*

Cardinal Ridolfo Pio. These motets had some resemblance to the madrigal, and, without dramatizing the words, did add to them an overtone of feeling which, while ingenuous, was fervent.

When, in verses of a famous Mass, he treats the words *O admirabile Commercium*, the voices pause on the O as if transfixed by wonder and awe, and in the alleluia which follows there is a breathless ecstasy of ejaculation which fills the air with the accent of excited joy. Palestrina always retained his apparent simplicity, and his effects are always restrained by tradition and piety: but in intervals of feeling and subtlety of effect, he shows how great was his originality of enterprise and his mastery of technique.

VI

So did he prepare for his best-known masterpiece, the *Mass of Pope Marcellus*. Even in our days—when so much has followed it—that composition remains profoundly significant. "Its most striking features are its perfect proportions, architectural in design, its remote atmosphere, and its remarkable dignity, at times almost approaching austerity." [8] It came in its own day as a revelation. It is written for the most part in the hypolydian mode. There is in the opening phrase a sense of peace which is itself a gift of blessing. And though the composition is ingenious, it seems at each turn so natural as to be inevitable; the simplicity is both striking and satisfying. Only when one turns to the score does one see how much art has been used to disguise the subtlety of the effect. "There is a pure unbroken flow of sound and the sense of a calm, sweet ordered progress only interrupted as the voices rest on the allotted point of repose." [9] As we follow this order through the whole Mass we find a logical scheme, "artistic effect being achieved by the use of a more restrained type of decoration in the counterpoints, by the balancing of the latter, in combination and in contrast, giving each point equal importance and independence (instead of centring them all round a *canto fermo*), and by the more skilful and subtle use of vocal colour." [10]

The solemn restraint of the *Kyrie Eleison* melts gradually into the full majesty of the *Gloria*; when we reach the *Credo* a special expressiveness is attached to the musical annotation of each

phrase. In the *Sursum Corda* the composer of course keeps the plainsong prescribed through the ages of the Church: but this melts gradually at the *Sanctus, Sanctus, Sanctus Dominus Deus Sabaoth* to a harmony that still more exalts the words of adoration.

Among these the composer sets scale passages which recall those choirs of angels, *"Più di mille angeli festanti"*,[11] as Dante called them, who shoot between the stars, rejoicing while they adore. Thus he leads us to the culminating moment, when, as the music dies away and heads are bowed, they hear the bell that announces the Consecration,

> And the melodious bells among the spires
> O'er all the housetops and through heaven above
> Proclaim the Elevation of the Host.[12]

That is the moment to which he has been leading in superber music than ever yet was given to the supreme act of worship. Now, in an atmosphere of peace, the welcome to the present Christ is sung in four-part voices. *Benedictus qui venit in nomine Domini*. It seems as though a procession rises up, as on Palm Sunday, to move towards the approaching Christ in thankfulness and praise.

The Church then begins the immediate liturgical preparation for the communion, with the festal *Pater noster* which had come down from Gregory the Great. No sooner does this end in the prayer *Libera nos a malo*: than the *Pax Domini sit semper vobiscum* is followed by the moving phrase : *Et cum spiritu tuo*. Then the composer completes the balance of his composition in the *Agnus Dei*. Because here the words are few, this, like the *Sanctus* and the *Benedictus*, which have preceded it, give the composer more scope for the pure harmonies and mysteries of sound than the more elaborate words of the *Gloria* and the *Credo*. So he leads up to the final consummation of the Mass, where, in imploring peace from the Lamb of God who takes away the sins of the world, the soul receives His body and blood in the holiest communion offered to the soul of man.

> And there harmony divine
> So smooths her charming tones that God's own ear
> Listens delighted.[13]

VII

Such was the theme which the supreme worship of the Church offered to Palestrina. That the Mass offered the musician a unique opportunity who could deny? "My zeal and toil and energy have I given to ennoble with new devices that which in the Christian religion is most worthy of veneration and most divine, the Holy Sacrifice of the Mass." [14] So Palestrina wrote in the dedication of this Mass to Philip II of Spain.

Here in one act of sacrifice was summed the whole history of the human soul, its fall, its redemption, and its sanctification; here the purpose of creation was both manifested and accomplished, for here the fruits of earth were not only offered to the Creator, but accepted by Him into His own nature, in the Person of the incarnate Christ; here the Divine Love, with its enterprise of help, its readiness to give, and its endurance of the extreme of suffering are linked with the glorious Resurrection and Ascension which vindicate the God incarnate, as He, Who, having assumed the nature of man stained by sin, takes that nature upward in triumph to the central height; in His mysteries He not only is with us always, but in His presence cogently applies the travail of His Redemption; since His Redemption culminates in the Spirit's hallowing our souls to unity with the wholeness and the immediacy of Christ. Such is the Mass.

Thus it offers the composer an opportunity which the greatest genius of Europe has accepted again and again, even when it is, as in the cases of Bach and Beethoven, outside the Catholic Church. But if we think of the triumphs here attained by Bach, or Beethoven, or Mozart, we must not the less acclaim the enterprise and genius of Palestrina, who endowed the themes with colour, complexity, and feeling at the same time as he kept intact the simplicity which he inherited.

VIII

Improving on his predecessor, Josquin, Palestrina gave the meaning of words that musical elaboration which some musicians call word painting; [15] the web-work of counterpoint,

when he employed it, impeded him, however, in doing this. Both are employed, as occasion offers, in the *Missa Papae Marcelli*. He had fully studied his predecessors, and in deference to them refrained from introducing inverted fugue. He kept his harmonies simple. The Church taught him to keep the music in close relation to the meaning and intelligibility of the words.[16] The problem of Palestrina was to do this while keeping the musical effect unimpaired and the interest of the musician fully sustained. He employed two devices: first, in employing note against note, he gives a marked preference for the upper voice, allowing it to emphasize the melody: secondly, he lets groups of voices succeed one another in reciting the text, thus bringing in new and subtle additions of musical interest. The result was not a colourless experiment, but a composition of magnificent proportions with a clear intellectual significance, while the feeling was impelled to touch the heights and depths.[17] He thus improved on great contemporaries; though no doubt excellent forms of contrapuntal melody—and many of these combinations—were already found in Rome, his melody was more fluent, his harmony more polished.[18] He applied to them "a work of taste, of judgment, and of insight";[19] this, while retaining their dignity, immensely added to their power over the heart. The result was the most ideally perfect music that could be conceived, pure and serene, free from agitation or excitement, though rising at times to a high exaltation in the expression of praise.[20] There was no sentimentality in it, and, when he was at his best, no strain. The means he used were the very simplest, for he used few discords, and of those which he did he lessened the harshness.

IX

So far had the art of music recently advanced that in its charm and power it was in danger of ousting the severe Gregorian tradition; and what was required was a style of music of equal power and beauty, but at the same time spiritual and pure. Profane music could stir the heart with gladness, or melt it in sympathy; the new music of the Church also could compass these effects even while it raised men above the world to things divine. Not only could the composer sway the feelings, but by the stateliness of his melodies, and the nobleness of his inter-

woven harmonies, he exalted the feelings he had aroused to a sphere heavenly, holy, and blessed.

What Raphael did in the Sistine Madonna, what Michelangelo did in his Pietà, that Palestrina did for singing. But his was a still purer spirit. Bäumker calls him the Fra Angelico of music.[21] He made its new ranges worthy of the sanctuary and the altar. His majestic and full mind, his sensitive heart, his bright fancy gave his compositions an endless variety: while all were alike full of nature, charm, and life, each in its own form expressed the beauty of religion.[22] He gave to music pathos, solemnity, and grandeur.[23] Then might one apply the words of Dante:

> Render voce a voce in tempra
> Ed in dolcézza ch'esser non può nota
> Se non colà dove gióia s'insempra.[24]

This consummation was one with the fervour of the musician's religion. Just as in Dante was combined the art of the poet with the soul of the mystic and the lofty wisdom of the theologian, so also in Palestrina the consummation was won by a religion as powerful and as intense as the musician's genius. This religion did not create his technique; it gave his pathos and exaltation a nobler scope. It added to sensitiveness and passion mystery, holiness and awe. In the Mass it presented him with the immediate presence of his Redeemer; and finally it set before the worshipper's mind the most exquisite portrait redemption could paint—the Virgin Mother. Such was the influence of faith in exalting this man of genius. It rendered his emotions chaste and pure: it extended and it exalted his themes. It did for him what it had done for St. Augustine.

X

Nor should we fail to note his connection with a movement in religion which was new, a new society.

In the early days of the Church, the music of Gregory the Great had expressed the magisterial spirit of the Benedictine Order; its wish to withdraw from the world in order to give men more fully the dignity of beauty and the Bible. The centre

[24] *Paradiso*, X, 146-148:
> They render voice to voice in modulation
> And a sweetness that cannot be comprehended
> Excepting there where joy is made eternal.

of that life was the worship of the Choir in psalm and liturgy. This was the inspiration of Benedictine culture and Benedictine mysticism.

From the time of St. Francis of Assisi, the new closeness to science, to the classics, to nature—the new scientific enterprise of thought and engineering, the new impulse of spontaneous love for nature which led Italy through four hundred years of her continuous Renaissance—was assisted at every turn by the work done for the Church in the more elastic rule of the Friars.

For here were religious Orders who came from the cloister into the world, even while they kept the model of the Liturgy as a community in choir. In these centuries music was extended from the Gregorian chant to a fuller range. But now, taking to herself that converted officer Ignatius of Loyola, the Church needed Orders emancipated from any attendance in choir; as civilization again completed the Renaissance in newer learning, in wider voyages, in economic changes, and not least in the welcome which Literature gave to the *grande passion*, mysticism gained upon the Church while music became a vibrance of mighty harmonies; the Church offered it a fuller freedom in her new Orders, the Jesuits, the Theatines, the Visitandines, the Oratorians, the Mission of St. Vincent de Paul.

St. Philip Neri, the founder of the Oratorians, was himself a musician. He admitted into his congregation Francisco Soto di Langa to direct its music. He greatly influenced the Florentine musician Giovanni Animuccia, and taught him that the effect of sound should be kept in close connection with the meaning of the words of the Liturgy, so that the words, instead of being lost in the fancies of the musician, should be both heard and understood. For, as Animuccia noted in the preface to his first volume of Masses: "In many compositions the words are not so much embellished with song as lost in the maze of runs and returns and repetitions of the voices. And therefore I, being thereto urged by the judgment and counsel of these persons, have striven to adorn these prayers and praises of God with such singing as may not hinder the hearers from understanding the words, while at the same time they lack not such artistic beauty as may delight the ear." [25]

So it was that Palestrina found that his way had been prepared by the enterprise of the new religious societies.

XI

He stands at the threshold of the Baroque age not only, as his tombstone attests, the prince of music, but as a lighthouse on a rocky coast. He had himself done all that was required to keep the tone of worship supreme in the music of churches: he had refused to allow sound to become independent of sense ; he had shown what faith and worship could do to extend, to chasten, and to exalt the genius of a composer: he had subdued the new excitability of melody and the new richness of polyphonic composition to the austere and sublime tradition of the Church; and at the same time he had brought into music the sense of the *grande passion*, and the pain of finite hearts that yearn.

But for how long could this high tension be maintained? What music shows in Monteverde is shown by painting, as we watch what is happening to painting in Venice, and the influence that Venice took to Spain.

CHAPTER XIV

1 *Le Génie du Christianisme*, Livre V, Ch. 1.
2 Gervinus, *Handel und Shakespeare*, p. 223.
3 Gervinus, *op. cit.*, p. 291.
4 *Confessions*, IX, 6.
5 Goethe, *Italienische Reise*, Brief V, 22 Marz, 1788.
6 I refer to Dr. Thomas Armstrong.
7 C. von Winterfeld, *Palestrina* (Breslau, 1832).
8 Henry Coates, *Palestrina*, p. 110.
9 Z. K. Pyne, *Palestrina*, pp. 5-7.
10 Coates, *loc. cit.*
11 *Paradiso*, XXXI, 131.
12 Longfellow, *Divina Commedia*.
13 Milton, *Paradise Lost*, V, 525-527.
14 Quoted in Baümker, *Palestrina*, p. 36.
15 Cf. Praetorius, *Syntagma musici* (1619), III, 150. His predecessors thought *"allein auf die Fugen und Noten und nich auf die Effektus und Gliechförmigkeit der Wörter"*.
16 S. Weinmann, *Das Konzil von Trient und die Kirchen Musik*, p. 4 (1919).
17 K. Jeffesen, *Palestrina and the Dissonance*, pp. 40, 41.
18 Grove, *Dictionary of Music*, Vol. II, p. 162.
19 H. E. Wooldridge, *Oxford History of Music*, Vol. II, p. 232.
20 Sir Hubert Parry, *Studies of Great Composers*, pp. 15, 16.
21 Baümker, *Palestrina*, p. 58.
22 Capocelatro, *Life of St. Philip Neri*, Vol. II, pp. 95, 96.
23 G. Baini, *Palestrina*, Vol. II, p. 8.
25 Joannis Animucciæ Magistri Cappellæ Basilicæ Vaticanæ Missarum, Lib. III. Cf. Baini, *Palestrina*, Vol. I, pp. 360-365.

I

WHILE St. John of the Cross was completing in Spain his profound studies of the relation of mysticism to poetic genius, while Palestrina was enriching the music of Rome, great painters in Venice were busy with equally outstanding works almost devoid of mystic consciousness.

This presents another problem. Through the sixteenth century, into the seventeenth century, worldly success remained with the Venetians, and since certain of their finest masterpieces still treat religious themes, they invite us to consider how far in such subjects genius was consecrated, how far a religious ideal was enslaved to a profane effect. It is, indeed, a most important aspect of the question of the ideal in art. Many Venetian painters owe their greatness to their preoccupation with the world: hardening in their pride, they gloried in it. They have such imaginative grandeur, such abundant interests, such power of effect, and so little inward vision in their pictures of the Church's themes, that they present an exact analogy to their Baroque successor in England, Milton.

With them religion did not master genius, as much as genius burdened its subject. To men who, like Titian, or, like Tintoretto and Veronese, had God's plenty in their interests, faith was an ingredient of life rather than the sum of it. It is present, and it is central, but there is much that is oblivious of it. Rich imagery and vital sympathies combine in a beauty which is dazzling, and which conveys great numbers of great ideas.

In Titian's "Presentation of the Virgin", nature, architecture, and a group of some forty figures are combined to give a masterly picture of a world of beauty, and to make the picture the frame of a sacred scene. In the farthest background is the bright hue of the evening sky and the Dolomites of Pieve di Cadore, the home of the painter's boyhood. In the middle distance is a slender pyramid with a ball at its apex, taking us back into the earliest phase of art. On either side are palaces of marble, on the left with pillars and arches, on the right resting like a balcony on a quadruple row of marble columns, and at the extreme right squared pillars at the head of a flight of steps give entrance to a temple which escapes from the scene into mystery.

217

Below these an old woman with marked Jewish features turns, half in menace, half in impatience, to the scene which interrupts her selling her basket of eggs and her fowls. At the left of the picture a woman with her body half naked turns to take an alms from an old gentleman; a number of Venetians of assured position and marked features turn their eyes from the subject in which the rest are absorbed, the picture of a little girl emanating light against a row of marble pillars as she lifts her dress to step up a last flight of marble stairs to the high priest, who awaits her at the summit with two priestly attendants. Although the painter has given full scope to his skill in portraiture and landscape, although he revels in stately architectural design, in trees, villages, mountain-side, smoke and sunset sky, and in the study of Venetian character, not as producing saints or mystics, but handsome, well-dressed people of position, and people of not less strong character in the humbler class, he has made these normally worldly people into a tribute to the Church by arranging them, whether they give attention to her or not, as accessories to the figure of the little girl in her shimmering blue dress, who realizes to the full what it is to meet the high priest and enter the temple, and who, in doing so, shows herself to be living on a scale immeasurably more august than can be found in those good citizens of Venice, in the taste or ambition which has raised their palaces in classic beauty, or than the fair scene of Alpine beauty of which the snowy heights reminded them, as they looked over the opalescent water towards the sunset sky.

Such a picture is not the revelation of a marked religious temperament. It was, indeed, customary for Titian to place a normal, well-dressed, well-fleshed Venetian type in the pictures to which he gave sacred names. Only perhaps in the warm golden light of the Transfiguration in San Salvatore does he anticipate the fervent faith of Murillo: but not the less this picture is a monument of something not to be ignored in the history of religious art: the sense of an ennobling of life by a dedication to the Church, and the acknowledgment that however interesting secular life might be, it was the soul which was supreme, and which even to people absorbed in the world or in themselves might throw a sudden flash which would alter all the values of their lives.

So it was with Titian; so it was with Milton; so it was with Veronese.

Let us therefore consider another picture in the Academia at Venice, "The Feast in the House of Levi" by Veronese.

Colour and composition, architectural design, animated figures richly robed, exquisite tints in marble and sky, and a prodigal opulence of effect make a dazzling entourage to the simple figure of the Saviour. Beneath a gold cornice, three immense marble arches, among which the feast is being served, rise in majesty; in the curves of the arch, robed female figures with wings glitter in the light with bronze tints of glittering dark marble: faint lights of the same hue as the petals of that rose which is known as cloth-of-gold play over the evening sky behind sea-green clouds which lighten and melt into the sunset glow. With the pale green of the sky, marble pinnacles of still paler green, faintly contrasting with the tint of the figures of the arches, rise above column and pediment. The golden rose of the sky spreads something of its own colour over the cool green marbles. The buildings assist the marbles to draw one's whole attention to the centre of the picture, There the figure of Christ, independent of all splendour but its halo, turns away from the banquet to converse with a youth in scarlet wearing a green velvet mantle. In these two figures, with their abstracted yet ardent glances, placed as they are against the evening sky, within the central arch, the picture finds justification for its religious title.

But religion once confessed as central, the painter gives the rest of his attention to things secular. Nowhere else in the picture is there a suggestion of anything but a rather luxurious feast in circumstances of almost riotous splendour. But for the attendants on the right and two dwarfs at the left of the central arch, the figures are all men, and almost all gross. But the animation of their attitude is accentuated by a quite unequalled power of perspective, due to their being outlined by shadow, so that they stand out in the most life-like relief both against one another and the background, whether they are sitting at the feast, passing between the balustrades, or lifting down plates and flagons beneath the scarlet baldachino at the left. Scarlet, luminous green and pale primrose, with here and there a touch of peacock blue, are artfully arranged among the robes worn so as to heighten the almost wanton luxury of the whole effect. Yet, like the dog sitting on its haunches on the marble pavement, even the most gorgeous of them, the fat man who wears a striped tunic over his round figure before the column on the

right, and that other who is Veronese himself in green velvet lined with silk, by the left column, and the Cardinal seated behind him, and indeed the ensemble, with its almost excessive fidelity to the contemporary taste for feasting, inevitably cede the first claim upon attention to the humbler figures in the centre of the composition, the figures who alone express devotion. Here, then, secular genius almost in spite of itself produces a religious masterpiece.

It was in the Italy of these painters that Milton, after devoted friendship with an Italian boy, travelled to ripen his imagination and perfect his culture. It was to this kind of realm, as we shall see, that he was to belong. But that the painters could show so much interest in technique, such power of effect, such wealth of interest, and yet dedicate all these to a religious theme, as they do in these two pictures, is a proof that Catholicism could still provide a background, if not a home, for genius: that, even if men are far from being saints, and their interest is in the world, yet they know they have souls whose keeping is in the Church.

Such an art is a normal and a healthy one, at which one has no right to cavil. An artist, like any other man, can be a believer without being a contemplative: and in fact such are most believers. They neither deny their faith, nor are they absorbed in it. They acknowledge its supremacy, attempt to maintain its law, but are indifferent to its theology, its mysticism and its passion for self-sacrifice.[1]

In the Prado we have a singularly happy opportunity of tracing this temper, which was at once both Catholic and secular, to a sphere where personal piety was expressed with Baroque effects. It offers to the admirers of art a lesson not all have learnt: it leads us from a collection of Venetian masterpieces to the Spanish splendours of the seventeenth century. It therefore shows us, better than any other gallery can do, how Renaissance art inevitably becomes Baroque; and the Baroque in painting as in architecture, as Ojetti once reminded us, is neither the decadence nor the contradiction of the Renaissance, but rather its logical conclusion.

As we follow on from an altar-piece of Fra Angelico to Mantegna's "Death of the Virgin", and a Madonna of Andrea del Sarto to Raphael's "Unknown Cardinal" or his "Holy Family"; as we trace the Venetians from Bellini and Giorgione to Titian and then on again to Van Dyck and Rubens, we have every opportunity to assess the spirit of the age: we see how the

classic sense of order and restraint was changed, not to disorder, but to a sense of the fullness, and, often, the pride of life. For with the fullness of life streamed in a materialism which could become paganism, just as the worship of beauty could also. Even when it remained spiritual, the temper of the age underwent a similar change. The traditional ideals of beauty, truth, and goodness were transformed by a more abundant energy, and the new ideals took from the mystic the qualities of light, life, and love. Without an intense absorption in spiritual things, such as that of St. John of the Cross, creative genius could not remain Christian: and even so it was elaborate and sumptuous. In decorative magnificence the age, whether in one country or another, whether in prose or painting, satisfied its demands for both audacity and calm. Henceforth neither the natural nor the supernatural could ever be thought of as still. Life was physical, organic, strong; its sensuousness and passion were adopted into religion. The Baroque style everywhere suggests something which appeared afterwards in the philosophy of Hegel, the idea of an ultimate *Werden*. Movement not in harmonious curve and balanced line, but wild and swift, often crosswise.

Mo sù, mo giù, e mo ricirculando,[2]

like Dante's glance in Paradise, gives its own atmosphere to every composition. The serenity of Raphael can survive; but, whether in the Baroque Italians, or in Murillo and Alonzo Cano, it is seen only in the raptures of virgins or priestly saints. The chiaroscuro of Leonardo is developed into the boldest contrasts of shadow and luminance; light becomes not an attempt to paint in paler tones, but the soul of colours living within them. The brush-work of Titian and Veronese had given a new immediacy to painting, bringing the sense of light nearer to a consciousness of touch: and nature develops into objectivity, as in each canvas of Velazquez. On his tombstone, renown is claimed for him as *El Pintor de la Verdad*.

II

And why is he a painter of truth? Because at that time men recognized with a new enthusiasm what the Platonic doctrines had implied long before: that there is truth in what appears to

the senses, and that nature competes with the abstract to reveal it. "*Nos habemus oculos eruditos*", Cicero himself had said, and the sentence carries us far. In the opinion of two distinguished Spanish writers of our own time it is the secret of the Mediterranean attitude towards life: "The Mediterranean peoples have a strong tendency to think with their eyes", said the Catalan, Eugeni d'Ors; and Señor Ortega y Gasset elaborates the suggestion: "Everything concerned with the vision which belongs to the pure impression is incomparably more energetic in the Mediterranean peoples than in other races," he said in his first book, "the Mediterranean is a perpetual and ardent justification . . . of the fugitive impressions things leave on our excited nerves." [3]

What is said of the Mediterranean is particularly true of the greatest of great Spaniards. Life as he found it was to Velazquez —as to Shakespeare—theme enough and wonder enough. In his pictures the senses regained their equilibrium with reason, and in doing so they became themselves a means of realizing the ideal. The body, in fact, is both more intimate and more sacred than either the pagan or the Renaissance artists had ever quite admitted. But for Rubens, nudes are therefore rare in the Prado, and have an intense significance when in that age the Southerners painted them, as one sees in Reni's pictures at Bologna and Naples. The age recognized that the life of sensation and emotion can be satisfied only in something supersensual. The objects, with which our natural vitality communes at its fullest,

All seem to know what is for heaven alone.[4]

This it is, then, which explains the objectivity of Velazquez and the modernness of his treatment. As Señor Rodríguez Sádia insists, in his study of Velazquez,[5] with a force of passion and sympathy rare in critics, he was the most human of all artists; he knew, therefore, that reason has with the objects of sense a relation much more complex than one generally recognizes; the mind, in its intercourse with objects, relates them to a type by its old experience of an instinctive standard; and as Leonardo and Sir Joshua have both reminded us, it is the painter's business to relate what he depicts to an imagined perfection, picking out the more excellent parts of the object before him. The observer, then, in his love of beauty, generates an ideal concept by his intercourse with nature; and this

generative act is the reality of perception, a reality which when fixed in a word or image exists apart and of itself.

The relation of Velazquez to his subject depends not so much upon a separate imagined ideality as upon a reasoned selection of his memories. As Rodríguez Sádia subtly shows, sensation, desire for expression, and sense of form were all so full in him that his great aptitudes gave him new combinations, so as to make him both more original and more natural. He was a painter of truth because beauty was compared immediately with nature as he knew her. There was in his mind, as there was in Sargent's or Meredith's, such a closeness to human life as had its own distinction; and Velazquez added to his relentlessness with an effete royalty the freshness of the high Sierras. He knew just how to fill his canvas, and our age asks no further function of his imagination. It is truer to say that he was a master of composition than to say he was either an impressionist or a realist.

He loved nature; but it was not therefore to some profound and invariable reality in her to which his imagination referred him. He found himself satisfied rather in the unity which a single moment offered him as the light of it opened to his eyes a fine and keen effect: that light of air which nature herself interposes between the eye and what it sees, and interposes with such peculiar attractiveness on the mountains rising from the plateaux of old and new Castile. That is why we ourselves are satisfied with his pictures of "Prince Balthasar Carlos on Horseback", or his portrait of Philip IV. He makes the wildness of nature his servant, just as Titian does. He followed Titian closely, but his essential aim was to bring painting far more under the mastery of the eye than Titian brought it.

III

Although Velazquez occasionally painted a religious picture, his triumphs are interesting because they are not the triumphs of religious genius. His religious paintings illustrate Newman's warning, for they are indeed profane. The very lack of spirituality added assurance to his gifts, and left it to other painters to strain at effects which he had abandoned. Yet without an idea of how he surpassed, how can we estimate their successes?

The most arresting of them had preceded him. Domenico

Theotocopuli had been born in Crete, and had first studied Byzantine art, of which the seriousness and formality always haunted him: he had arrived at Venice when Titian was the master of her painters. He went on from there to Rome, and was finally attracted by Philip II to work at the Escorial and Toledo. His paintings can be seen in Paris, in London, in certain American and German collections: but, except for the Royal Collection at Bucarest,[6] all his masterpieces are in Spain. We cannot know him till we have been to the Prado, to the Escorial and to Toledo. We see then that he is not merely a painter of skies, of soot, of clouds like icebergs, of mournful lights and morbid ecstasies, of elongated limbs and features, or of tip-tilted noses in holy women. The Prado shows him a painter of stately portraits: he has given them the quality of his own attitude towards life by outlining their heads with a thin, faint line of light. Just as Veronese often gives vividness to his subjects by outlining them with a faint shadow, this outline of light gives an elusive hint of a halo, so that each appears to emerge from an atmosphere of spiritual brightness. El Greco belonged to an age which both discerned holiness and studied earth.

His two most famous pictures are the "St. Maurice" in the Escorial, and the "Burial of the Conde de Orgaz" at Santo Thomé in Toledo. The "St. Maurice" has already left far away the Venetian influences which are so marked in "The Purification of the Temple" at Richmond [7] or "The Annunciation" in the Prado. The tones have become chill and sombre as a wintry night: the movement of storm is in the air: winged women appear on clouds that are like suspended rocks, and a fierce light throws an astonishing emphasis on the thighs, the knees or the calves of the men in the foreground, a light which almost distracts our eye either from the quiet melancholy of the faces, or the striking nudes in the massacre scene to the left. In all these paintings of the naked human figure there is a sharpness which suggests an interest or a longing that cuts like a blade, ripping off their garments as it were, even when they were clothed; in this intimacy the painter lifted his impressions of them into a sphere of spirit: they are "lit by wild lightnings from the heaven of pain".[8] The steely tones of the flesh contrast with the curious dulled shades of blue and yellow which the warrior wears. And this picture tells a story: St. Maurice and his Theban legion were Christians, but had sworn fealty to a

ST. MAURICE, BY EL GRECO: IN THE ESCORIAL. In these naked human figures there is a sharpness which suggests a longing that cuts like a blade, yet they are raised into a sphere of spirit.

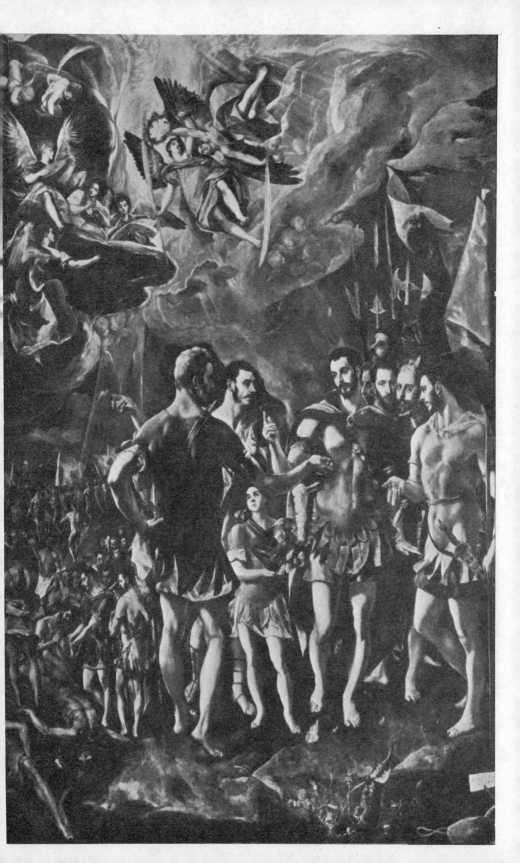

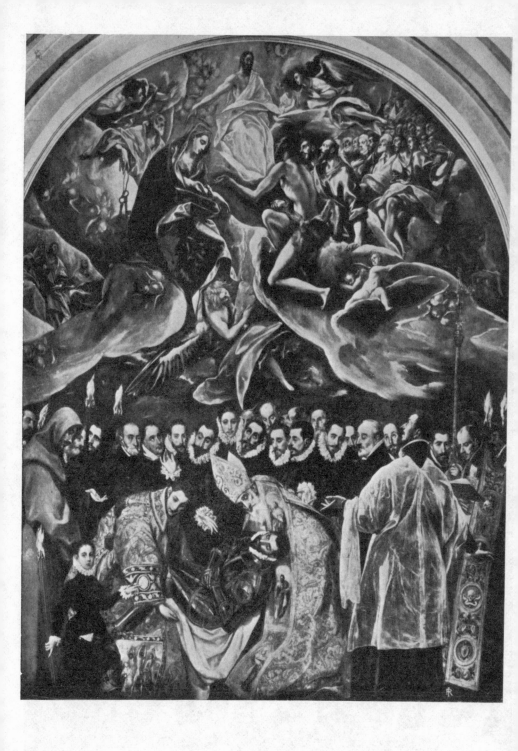

Pagan Emperor who commanded the worship of the gods. Unable to forfeit either their allegiance or their faith, their only prospect was death: but death was a gateway to the skies, and the martyr's banner is roseate like the hues of dawn.

This was El Greco's preparation for his masterpiece, the famous "Burial of the Conde de Orgaz": a Spanish nobleman who had left as a perpetual charge on his estates the provision of certain charities for the poor. When his relations disputed the will and lost their case, El Greco was commanded to paint. Going back to the example of Raphael, he again showed on one canvas scenes of both heaven and earth. The clouds are as unsuccessful as ever; they seem like wind-blown sheets, but their lines give powerful aid to the composition, at the summit of which the Redeemer, clothed in fine linen white and clean, beams austerely over the Virgin and the Baptist, and a shining company of the heavenly host, while below two figures, one a Bishop, one a deacon, lift the dead body into its tomb before a company of friars and hidalgos. The Bishop was held to be St. Augustine, the deacon St. Stephen.

In this composition we see the soul of Spain: we see types characteristic of a people, solemn, serene and noble, looking into the very grave and gate of death, and seeing in it the end and purpose of their lives. Death invests daily life with religion, and frames it in eternity. This picture of a burial arrests us like the tones of the trumpet blown among the sepulchres to drive before the judge's throne. For though the scene on earth is full of peace, and the peace is itself illumined with a silent joy, as at the arrival of a beloved companion in the place of prayer, the *Gloria*, as we call the heavenly vision above it, is restless and disquieting.

The "Burial of the Conde de Orgaz", says Don Manuel Cossío, is indeed one of the truest pages of the history of Spain. "I hold it very difficult", he writes, "to picture to oneself the soul and body of the society of Castile in the last years of the reign of Philip II in other guise, or with more authentic accuracy than is seen here. The true dignity of a miracle in Spain, a solemn office for the dead, an austere company of highly strung and well-born men in mourning between priests on one side and friars on the other, and each of these not simply chosen for the design but faithful portraits: forms rooted up out of the ground of actual experience, and more alive than when they breathed; they are edged instruments which

THE BURIAL OF THE CONDE DE ORGAZ, BY EL GRECO, IN TOLEDO.
We see types characteristic of a people, solemn, serene and noble, looking into the very grave and gate of death, and seeing in it the end and purpose of their lives.
[Photo by Anderson.

engrave deep in our souls the melancholy impression of those
last miserable days of the sixteenth century in Spain, when the
Sovereign, who was the most genuine representative of his
people, was dying in his room at the Escorial",[9] meditating on
the mysteries of the life beyond the grave, the sacred truths of
faith, and the glory of the Mass. Here is a picture of a nation's
soul "more real than living man"; it is instinct with that imme-
diacy which made Aristotle say poetry is truer than history.
It has what Goethe saw was the essential of a work of art when
he wrote that they "should live in our fancy". They are as
intimate to a Spaniard as his own soul.

For out of the arid plains and rocky sierras of his country,
out of its bracing air, its blaze of sun, its piercing winds, he has
drawn austerity of manners and opulence of taste: he lives by
contrasts. Courteous in general, he makes the fiercest of
enemies; patient in repose, his impulses of fury are as torrential
as his streams: his moods vary between mildness, whether in
melancholy or fun, and a fierce excitement of blood and brain.
His eyes shine with the lights of life and death.

In a country of this character, El Greco was at home. He
understood it, not in its fierceness, but in its mysticism, not in
its blandishments, but in its suffering. Interpreting Spain in
repose, he bathes every personage in the contemplative concen-
tration of St. John of the Cross. Each has passed through the
dark night of the soul to the living flame of love: each dwells
in an interior castle and finds his entertainment there. Not all
have suffered: some may have eaten too much: for the Spaniards
are fed on heavy dishes, and many of the children are already
victims of an overloaded stomach. But whether fed or fasting,
they are gentlemen; they know how to bear themselves on
all occasions: though touched, they are not abashed at the
sudden appearance of Saints. On the contrary, their demeanour
is as sensitive as it is calm. Those eyes, so dark and tender, have
long since learned to weep with them that weep. Those hands,
so slender and nervous, delineate natures and moods more
truly than any face.

It was said of El Greco by Palomino that "what he did well
none did better: what he did badly none did worse".[10] The
saying has been thought to receive complete illustration
in this one picture. Few could cavil at the portraits: but it
needs a taste, or a wisdom, of a peculiarly excellent kind to
enjoy the *Gloria*, and Madrazo could not attain to it: he said

that the man who painted it was mad. Yet it is exactly these qualities, so special, so typical and—must we not add?—so eccentric, that now make his admirers most enthusiastic. If we could know El Greco, as Señor Cossío knew him, the peculiarities take their inevitable place in our understanding of the painter, and show him nearer to common men than he seems.

He was, like Michelangelo, very highly strung: he had strong affinities to the religious temperament: he was scarcely normal. He had no fear, nor need to fear

> . . . lest love should ride the wind
> With Spain's dark-glancing daughters." [11]

In fact, his was a temperament with many resemblances to that of Michelangelo.[12] The great Florentine habitually gave to his representations of the saints the weight of his own suffering, El Greco likewise stamped his saints with his own temper: in the contemplation of a certain elevated type of congenial men his nerves were calm, his appreciation exalted, his fervour strong, though all his own: but if he let his imagination loose, either amid the muscles of men, the personalities of women, or the life beyond the grave, he could not remain serious. The fine features coarsen, the shining eyes fade, the lips thicken, the point of the nose turns upward, and the expression becomes pert, vulgar, rather fatuous; and nothing illustrates more clearly both the passion and exaltation of his temper than his "Sacred and Profane Love".

These rather idiotic stares or ecstasies upon the face go with an extreme sensuousness, sometimes delicate, sometimes coarse, in the naked forms below. Once the balance of his tense nature was disturbed, a morbidity, that some confuse with madness, caused him to veer between genius and ineptitude. It is because he strains, in all sincerity, at an effect beyond his gifts that he, like Cézanne, is felt to be so touching and even great. Cézanne, said M. Maurice Denys, reminds us of El Greco, and "tel est le desarroi de notre temps qu'il semble nous ouvrir une renaissance classique en nous proposant un idéal voisin de la décadence de Venise".[13]

Shall we admire El Greco, then, for what he aspired and was not? Perhaps the extravagances that come very near being silly are the proof of genius. Señor Cossío traces a further complication, purely technical. It was an attempt at sincerity in the treatment of colours: an effort to escape from a splendid but

inapplicable convention to paint lights and hues that up to then had escaped the artist. He sought in the very clouds something congenial to those human bodies which gave him sharp longings for he knew not what: for something which appealed intensely to his heart and which he felt only the unseen life could satisfy. His pictures transcend his aims, and base their most powerful appeal not on his genius, but on the weakness of his temperament. "Such", says Cossío, "is the condition of the work of art, and perhaps of every human work. It is executed deliberately as though the spirit made it: and yet in it there is something more and sometimes very different from what the artist desired to give it, elements which traversed his intention for which alone he is responsible, elements which arise without him suspecting it from the great subconsciousness in which the mind moves, and which can come to light by the slow, undisturbed assimilation and the propitious point of vantage which come with time." [14] Perhaps we can discern now something of what puzzled earlier ages: the man had the most acute sense of spirituality as shown in character, and yet could find assurance neither in sacred history nor in visions of a life beyond shared with the Saviour and His saints. He understood the mystics without sharing their faith.

Such a master is profoundly significant, especially to an age like our own. But he must warn us not to expect from his country a vigorous growth in religious work.

IV

Castile is a different world from Andalusia, and but for what they have inherited from the Moors, we find little in common between Toledo and Seville. For Seville is not severe. It is opulent and enervating: yet a great inspiration came to it with the wealth of the Indies pouring through it, and the body of Columbus finds its right resting-place in the great temple where in Holy Week ladies, even in our own day, have moved before the altar in a rhythmic dance. Velazquez illustrates the strong material life of Seville: but Seville in its greatest age was opulent not alone in the wealth of the Indies. There, Byron once wrote, all in turns is love or prayer, [15] or, he might have added, fury. The Alcázar and Giralda gain a fresh significance from the memorials of Catholic faith set up beneath them in the

seventeenth century. San Telmo and the Tobacco Factory are buildings as captivating as the Salas Capitulares. Spain owes still more precious examples of them to Murillo and Montañés. In each of them the sense of dignity and race has been transmuted into an expression of the saintliness, to which, especially in that century, Spain has loved to dedicate her vitality. Her excesses were still her excellences. That could not have been said even of Velazquez which Cézanne said of Monet: *"il n'a qu'un œil"*.

But it was still less true of Murillo. His soul lived in his heart, and united sense with reason to show yet another variety of the excellences which flash on the one organism of eye and mind, which in our most human moments turn us home to infinitude by one of vitality's own surprises. The religion of Murillo attained to ecstasies without a taste of wormwood. His saints are neither wan nor mournful: they come eating and drinking; they are bright with

a spirit of pleasure and youth's golden gleam.[16]

But they are not less typical of the Baroque age. His was the painter's enthusiasm for life which impels both senses and affection beyond the limits of earth. He, too, had that sense of infinity which in the opinion of Benedetto Croce accounts for both the strength and the weakness of the great style of the seventeenth century. It can lose all sense of form in a delirium of excess. It aims at both exciting and stupefying, and often succeeds in both. The outrageous subtleties of Donne, the sonorous and erudite magic of "Hydriotaphia", the noise of *Tamburlaine the Great*, are admired by those who smile at that preamble of the rococo "Euphues". And Bunyan is secure. But if Bunyan, why not Murillo? What Bunyan wrote for English nonconformists, Murillo painted for the Catholics of Andalusia. He knew and loved the poor, and spoke to them of the joys of heaven in a language that moved and touched them. He gave the sordidness of Seville a dower of lights and fires, and pictured saints in a guise that endeared their elevation to the people, because his Madonna had drunk milk and been *"in pratis studiosa florum"*.[17]

V

The reason that he is loved in Andalusia is the same for which he has been despised elsewhere. Concentrating on atmosphere,

he had little interest in strong drawing and can be easily copied. He compromised too far with current ideas of piety when he gave an expression of such luscious and self-conscious ecstasy to "Our Lady of the Immaculate Conception". These Madonnas are human in their heaviness, but some of them have an expression that those who take the religious life seriously never tolerate, a singularity which is definitely theatrical. In their enjoyment of their prayers, they are obsessed with the sense of self. It is true that words so extreme are unfair to many of these Madonnas, though not to that in the Church of the Capuchins at Cadiz. But it is true of all, as it is true of the healthy, and often holy, children who figure in so many of his pictures that, though they have "the fruitful bloom of coming ripeness", their expression is cloying to a robust taste. They are pretty, not eloquent. They satisfy a people who knew that in 1617 the Spanish Church had declared the Virgin Mother to have herself been born free from the taint of original sin. Rejoicing in this faith, the Sevillians made, and still make, their devotion to her the nourishment of what is human in their hearts.

Yet there is in all these figures of Murillo a note of a personality peculiarly strong, a glow of affection from eyes as bright with inward fires as any ever painted by Goya or El Greco. In his communion with Spaniards Murillo anticipated the triumphs of Goya: he gives us glimpses of vivacious personality and eyes which show sympathy with joy and pain. He painted a people who have breathed the perfumes of orange blossom and to whom the sun is a friend.

Yet this is the man whom Ruskin described as being fascinated by filth.[18] Other detractors say that he was a society photographer of the saints, or, in a generous mood, concede that he once painted a sheep rather freshly; if that is all they can say, they show poor knowledge of his technique. He solved the difficulty of painting his figures against a background of brilliance; he was able to make his flesh tones reflect light; his gradings of chiaroscuro and his foreshortenings are both adroit; and no one who has seen in Lord Lansdowne's collection at Bowood his portrait of Don Justino Neve y Yevenes or that of Don Andres de Andrade in Lord Northbrook's can deny his power to paint a portrait. He had, in fact, sufficient skill to be impressive. But religion, even though at times he showed its weaker side as it showed up his own, gave him a quality that far surpasses in power and interest all that he con-

trived of grip and boldness in his studies of secular subjects.
In his St. Thomas of Villanueva at Seville, in his St. Elizabeth
in the Prado, and in the two pictures there dedicated to the
Roman basilica of Santa Maria Maggiore, he showed magni-
ficent powers of conception, of composition and of workman-
ship: he could combine the triumphs of man with those of the
saints in one comprehensive grandeur. Far from losing his
poise like El Greco when he looked into the secrets of heaven,
he found that he had learnt from light and air, from cloud and
mist what Dante learned; he could make them tell of something
of which our most ethereal experiences are but a hint or
symbol, but which, nevertheless, points us on into a region
where all is spirit. His St. Thomas of Villanueva deserves
comparison with the St. Augustine of El Greco at Toledo, and
no Spaniard ever represented finer studies of more individual
figures as saints than Murillo's Isidore and Leander in the
Cathedral at Seville.

VI

These masterpieces of the School of Seville are not the city's
only claim on our attention in that century. They were pre-
ceded by works more interesting and more powerful in the
unexpected medium of polychrome statuary. The master in
this kind was Montañés Martínez, who was born in 1568 and
died in 1640. He is the Bernini of Spain. His medium allowed
a directness of approach which would ambush any genius but
the grandest. To carve wood in life-like figures and paint them
with shining surfaces of colour till they looked like enamel or
wax—this would make them like dolls if a talent was insipid,
like barbaric idols if it was subject to any temperamental
idiosyncracy. Montañés is never near either. His statues,
which were sometimes painted by Pacheco, have an impressive-
ness which shows him to be as great as any artist then living.
His finest works are the statues of the Saints, Ignatius Loyola,
and Francis Borgia, in the University Chapel at Seville; his
"Immaculate Conception" and his "Crucifixion" in the Cathe-
dral, and not least his "Adoration of the Shepherds" in San
Isidro del Campo at Santiponce; and with the "Jesus of Great
Power," *el Jesus de Gran Poder*, in the Church of San Lorenzo
and San Salvador, we see a superb example of his power in his
"St. Bruno".

These works are all on the supreme scale. Never did pictorial art come so near to life, and yet maintain its full essential of suggesting the reaches of spiritual experience. The "Adoration" is a bold and complex composition.[19] Like the horns of oxen, the wings of angels curve upward like flames of fire. Their fingers are like sticks kindled from the burning glow within their hearts, but they have a subtle rhythm with the weaving of the basketwork in the cradle. The clouds and open country are behind them, yet they frame the genial folds of the garments worn by the four figures which lean to adore the Holy Child, and there is a subtle rhythm between these and those which cover the cradle. But all these are subordinate to strong, fine features and the individuality of temperament shown in glowing reverence and faith as the four human faces centre their interest on the Babe, whose solemnity recalls Him resting in the arms of the Madonna di San Sisto. He has rent the heavens that He might come down, and the mountains have quaked at His presence as brushwood . before a kindling fire; but He seems as troubled as those around Him are happy.

> *El llanto del hombre en Dios*
> *Y en el hombre la alegria*
> *Lo cual del uno y del otro*
> *Tan ajeno ser solia.*[20]

He is already the "Jesus of Great Power" whom we see crowned with thorns in the Church of San Lorenzo, or, in the Cathedral, hanging from the Cross.[21] There His sufferings have, however, given Him the maturity of His strength. The spirit of wisdom and understanding has made Him tender to pain and sorrow; He has borne the sins of many and made intercession for the transgressors; the chastisement of our peace is upon Him; and yet His humiliation has a power that, as we look at the lips opened in a strong cry, at the blood that trickles down forehead and neck, and is sprinkled upon His garments, at His tense hands, at the skin stretched over bone and muscle with such delicacy of texture that we can realize how the nerves within it tingled in comfort or quivered in torment, at those

[20] St. John of the Cross, *Poesías*, Romance XI:

> Man was full of joy and gladness,
> God was weeping, weak and prone;
> Ne'er before, throughout the ages,
> Had so strange a thing been known.

(Adapted from Professor Allison Peers' translation, II, 465).

pierced feet which have trodden the winepress alone—we see
that here is a Man at whose word the stormy wind arises and
who has divided His spoil with the strong. No figure in Greek
sculpture can compare with this.

This, then, is the art which we must set against the pictu-
resqueness of Velazquez, the weirdness of El Greco, and the
fervours of Murillo if we wish to understand what the seven-
teenth century in Spain has to tell us of the scope of religious
art. An art inspired by faith was already adding something
further to powers of technique shown in strong studies of the
unconsecrated world: but at the same time it was holding in
reserve for different temperaments a power of appeal which
produced the most diverse results. It could ennoble, it could
individualize, it could soften, it could kindle, it could fortify
and appal.

In Seville a great venture had taken men's ambitions beyond
their orange-groves, their horses, or their bulls to give to more
than a continent the faith, the hope and the charity of Spanish
Catholicism. An exaltation arose in those who profited by the
fruits, treasures and precious metals which their ships carried
into their river-port and through it into Spain. Both thank-
fulness and effort pointed to the need of consecration. Murillo
answered it by his love of the Holy Family, his enthusiasm for
the prerogatives of Mary. Montañés, a more virile and com-
manding genius, connected it with the two Spanish noblemen
who had become saints, and with the resolute courage and
enterprise which gave the quality of steel to the exercises which
the Society of Jesus offered to Him whose name they bore.

VII

Though the work of Montañés is saner and stronger than
the painting of El Greco, though one marvels at the triumph
which appeals to the soul through a medium which offers to
eye and touch alike an almost slavish imitation of flesh, and
though this work was nobly maintained by Alonso Cano and
Roldán, there was yet both in them and in Murillo a certain
softening of fibre, which shows that even in Seville, neither
painter, nor architect, nor sculptor could adapt either the tradi-
tions of Islam, the opportunities of the New World, or the
intensity of their own mysticism, into works of such grandeur

as those which had come in what was alike for court, colonists, and Church, Spain's golden age. As a comparison between Murillo and Bunyan suggested that what was happening in Spain was happening also in England, we shall understand the importance of these Spanish painters better when we have considered the case of Milton, Milton's own relation to his age, and compared Milton also with Bunyan.

CHAPTER XIV

[1] Newman (*University Education*, p. 113 (1857)), however, speaks of painting treating religion as a servant, which "in its long galleries and stately chambers, adorable figures and sacred histories, did but mingle amid the train of earthly, not to say unseemly, forms".

[2] *Paradiso*, XXXI, 48.

[3] *Meditaciones del Quijote*, p. 89.

[4] Meredith, *Love in the Valley*.

[5] Madrid, 1924, p. 31.

[6] For an excellent account of these, see Al. Buswioceanu, *Les Tableaux de Greco dans la Collection Royale de Roumanie* (Brussels, 1937).

[7] Sir Herbert Cook's Collection.

[8] Edith Wharton, *Artemis to Actæon*, p. 52.

[9] Translated from M. B. Cossío, *El Entierro del Conde de Orgaz*, p. 23.

[10] Cossío, *El Greco*, II, 478.

[11] *Childe Harold's Pilgrimage*, I, lix.

[12] See W. Somerset Maugham's, *Don Fernando*, pp. 213–216.

[13] Cézanne, *L'Act Sacré* (numéro special, 1936).

[14] Cossío, *El Entierro*, p. 91; translated by V. Suarez (Madrid, 1914).

[15] *Childe Harold's Pilgrimage*, canto I, stanza 67: "Love and prayer unite, or rather rule by turns".

[16] Wordsworth, *Prelude*, XII, 266.

[17] Horace, *Carmina*, IV, 27, 29 : "on the meadows eager for the flowers."

[18] Ruskin says of the foot of a beggar-boy in Murillo's painting in the Dulwich gallery: "Do not call this the painting of nature: it is mere delight in foulness" (*Stones of Venice*, III, §61).

[19] For illustration, see M. Dieulafoy, *Statuaire Polychrome en Espagne*, Plate LXV; for description, pp. 660–661.

[21] See M. Dieulafoy, *op. cit.*, pp. 166–167, Plate LXVIII.

I

THE age in which Milton lived was one in which tradition met and mingled with new ideas of science and new theories as to the nature of the world. The questioning habits of Erasmus and More had become so general that Milton was naturally intimate with revolutionary knowledge and theory. But while they believed, there was scarcely more than a cultured scepticism in the mind of Montaigne, though he was too deep in the sense of life and order to wish to cut himself away from the traditions of a Church which carried in its system not merely theology, but government, learning, and the fine arts. Some believers sought to give their religion an elasticity which would enable it to breathe freely in the atmosphere of the Renaissance and adapt itself, where necessary, to either enquiry, knowledge, or new theories: while others, frankly discarding the whole system of Trinity and Incarnation, built up a new metaphysics where they could accept and enjoy a measure of spiritual reality without involving the conceptions that had grown up around the New Testament. They believed, in other words, in what the Church would call a natural law and religion, but not in that supernatural order which she believes to have been revealed.

It was in this unweeded garden that the temperament of Milton flowered out to genius. His early works are full of the subtle atmosphere of a conversion from Catholicism, the atmosphere in which the deep habits of mind and character remain while observances and conceptions have changed; the new ones, in fact, are weapons to be fiercely handled against the old. It is true that, though the Puritan conceptions of worship and faith were in sharp contrast to the ancient ones, they still held the Bible to be inspired; they still held the Christ to be the Second Person of the Trinity in Unity. Although faith did not necessarily demand the complement of works, the laws of property and conduct were, of course, as strict for Anglican and Puritan as for the Catholic. Yet though as strict in their rules and much stricter in their views, the Protestants urged a new confidence in individual judgment, which could allow a logical and religious Puritan like Milton to advocate polygamy, and argue against what his fellows believed of the Divinity of

Christ. While he was so far a sceptic, his highly cultivated tastes and passionate temperament linked him with the culture and learning of the Catholic Renaissance. With it he shared not only the Bible and the classic heritage: for he knew Italian well, and he had a special predilection for what Italy's cities and landscapes offered him of beauty.

<center>II</center>

Majesty, a Roman majesty, was one of the special attributes of his Virgilian genius, and gives volume to the music of his rhythm. His gifts stopped abruptly short of any of that luminance which his contemporary Sir Thomas Browne shared with the poet of the *Paradiso*: yet he loved nature, he loved virtue, he loved the classic tradition. And from these loves he proceeded to the wedding of exuberance with order, of mighty movement and profuse effect with the classic rules that mark the spirit of Baroque. He was, in fact, one of the greatest of those Baroque artists who accepted a background of Christian religion while preoccupied by the gorgeousness of the world which their senses knew or their minds explored.

There is no genius so like him as the towering Neapolitan sculptor who was his exact contemporary.[1] As with Bernini, a recurring dalliance with luxury steeps Milton's spirit in amorous suggestions: as with Bernini, the sense of power is stronger than any of these; as with Bernini, the clouds become solid, and bear up thrones of gold; as with Bernini, the luxuriance of the tropics challenges, its subservience enhances, the plainer majesty which humanism gave to building; as with Bernini, the figures of the saints and angels stand massive over the most lavish scenes of earth, set up above the majesty of mortals; as with Bernini, the grotesque at times invades the columns and arches of a stately architecture; as with Bernini, the whole effect waits for the tones of music to attune our spirits to its grandeur; as with Bernini, the shadow of man's primal disobedience falls upon an earth which is yet the theatre of redemption. The hope of Christ's advent changes the memory of lost Eden to an eager desire to mount on the wings of some rare ecstasy into the Empyrean!—as with Bernini, one comes back to where one began, saying that this ecstasy implies a human passion which is a perpetual fountain streaming forth

fancies and joy. While Bernini follows on the worldliness of the Renaissance and consecrates in Rome the magnificence which had been fascinated by the wealth of Venice, Milton is also divergent from the genius of Titian and Veronese. In those two masterpieces in the Academia at Venice, which we have already surveyed—Titian's "Presentation of the Virgin" and the "Feast in the House of Levi" by Veronese—we see in pictures just where imagination stood, when he was born, in the Italy he loved; as he grew up to his majority he found its wealth his own. For in his case also the religious names he employed are subordinate to enjoyment of magnificence.

By then it was a whole century since, in the art of Raphael and Michelangelo, religion had found an artistic expression because it had a power to enthral their genius. They had had the gifts and leisure, as we have seen, to study artistic principles, to cultivate taste and to develop technique; and having thus the gifts of artists, they lived in a world where its order reigned over high passions and the range of thought; their experience had been full, sensitive, and wide; their religion was enthroned amidst gorgeousness, massively designed. It was strong, therefore, in its love of noble things: it accepted the images of nature: and it has such a deep sense of the harmony of life that it welcomed what the body offered to the spirit. Their flesh gave them its full and impassioned impulse. And in their style, which was a power over materials, they showed that power of their combination of rhythm or composition with precision and force as the architects had at Santa Sophia a thousand years before. But, during the seventeenth century, as we have seen, faith, even when it ennobled art, was apt to become a secondary interest.

III

The child of reason and passion, the sister of painting and sculpture, literature expresses the relation of a high and vital spirit to his age. It is a voice of the social reason. Our criticisms therefore even of books must pass beyond books to the imitative arts. If criticism must relate and estimate, it must first know life, and then trace life through each of its patterned expressions. We cannot write becomingly of literature till we view it in relation to its own world of culture. We cannot

understand an age till by a comparison of one art with another we find its spirit. We have been seeing how necessary is this process from age to age: but it is above all in the seventeenth century that we need to make these searching comparisons. The relation of Poussin to Racine, of Rubens to Wren, of Van Dyck to Sir Thomas Browne, of Tintoretto and Veronese to Bernini, and of each to Milton, all combine with the peculiarity of the Baroque age. Through its monumental classicism it felt the impulse of the senses so strongly that it was pushed by them into an excess which at once demanded the magisterial and classic control of reason, and yet led them to a rapture which, although supersensual, yet satisfied their passions. The opulence of their world awoke their enthusiasm, but it led finally to a sense of its own insufficiency. And so we find our great writers of the time both Puritans and High Churchmen; so in France there were both Jesuits and Jansenists: so St. Margaret Mary Alacoque melts into devotion to the Sacred Heart of her Redeemer, while Molinos and Madame Guyon advocated the extreme of the prayer of quiet; so in one Milton we have both Humanist and Roundhead, both sensuousness of imagination and austerity of worship. Such are the complications and reactions which the spirits of an age leave in the expression of their concepts. For all, the words of Ruggiero Bonghi are equally true: "Style is the life which our concepts take within one, and which one communicates to others by expressing it". Milton's genius was peculiarly typical of that Baroque age.

IV

His imagination went with a conception of a love genially marital,[2] and yet free from the expense of spirit in sensuality; already as a young poet he had held in his hands the key that opens the doorway of the palace of eternity. He had asked the spirit of Plato

> to unfold
> What worlds, or what vast regions hold
> The immortal mind;[3]

he had dreamed of the mansions

> where those immortal shapes
> Of bright aerial spirits live insphered
> In regions mild of calm and serene air,[4]

the air which Veronese painted, and Dante made into the
realms of spirits, the air which he had learnt to love in Italian
day. Having said of poetry that it should be "simple, sensuous
and passionate," [5] he had made it so, investing his lines in an
atmosphere of rich but indistinct beauty, a beauty not of clear
images but cultured suggestions, combined with the melody of
his profuse but patterned words. Remote names known only to
the scholar, frequent personifications, an embroidery of
flowers and plants, a conventionality as fresh as it was exquisite,
and among them the recurring theme of "vermeil tinctured
lips", "love darting eyes" and "tresses like the morn";[6] these
had been made more alluring on the one hand by the baits and
guileful spells of loose gestures and unchaste looks—but they
were set over against the deeper joys of contemplation or the
moments when to an accompaniment of an organ the choir sang
anthems which, he wrote:

> through mine ear
> Dissolve me into ecstasies,
> And bring all heaven before mine eyes." [7]

He felt that there was a charm in the *philosophia perennis*; but his
imagination could not do what Dante's did in making imagery
reveal the secrets of faith or mysticism to philosophy.

Neither to Milton nor to Veronese was the imagination the
servant of faith: it was an end in itself: to him beauty was so
wholly truth that it hardly mattered whether or not truth was in
itself beautiful.[8] Sometimes it would flash on him that the
essential paradise, like the essential hell, was a state rather than
a place, or that love was an intuitive commingling; his Raphael
could say to Adam, "Without love, no happiness!" and explain
that

> Easier than air with air, if spirits embrace
> Total they mix, union of pure with pure
> Desiring.[9]

But for the most part his moral conceptions were as downright
as those of Isaiah, one might almost say of Moses. What
Hellenic idealism had prepared for the Church counted with
him for almost nothing. But Milton had hardly any interest
in this ascent of metaphysics into mysticism which had
triumphed in the thirteenth century. Damascus was a name to
him, a name, like many other names, with an array of fine
associations. He had caught but fleeting glimpses of that

mystical Damascus where body delights spirit with the apricot and rose. Milton's mind, like those of the Puritans about him, made this faith as definite as human laws; they stated it as categorical, because inspired; they applied it therefore with·all the precision of an act of parliament. This in itself, with a very small aperture for mystical idealism to shine within them, was roomy enough for their practical mind, or their stored imagination, to be busy even in gigantic creations of genius. Milton teaches us almost nothing, but he ennobles our conceptions with a loftiness and majesty whose music and imagination call on far historical memories, on names, as loaded with the romance of distance as they are sonorous in their marches. Thus he leads us to admire the earth and the planetary scheme as far as mind, accepting moral law, could contemplate it:

Solicit not thy thought with matters hid:

such is his word through Raphael:

Leave them to God above; him serve and fear.
Of other creatures as him pleases best,
Wherever placed, let him dispose; joy thou
In what he gives to thee, this Paradise
And thy fair Eve; Heaven is for thee too high
To know what passes there. . . .
Dream not of other worlds.[10]

But if his Paradise was to be very distinctly a terrestrial paradise like that where Eve could prepare a menu for an angel, or greedily swallow her apples, if the empyrean was stocked with battlements and artillery, if, in short, the realm of the unseen in no way restrained his imagination, and gave it an amplitude of never-ending variety over earth and water, over rich soil, wild forest, boiling mud or blistered sand and stone, if it was bright with gems, and its air heavy with spices or ointments, if splendid palaces and battlements of crystal rose out of its vague but gorgeous landscapes, it suited his Baroque spirit to perfection.

v

The result is that Milton has ennobled and delighted our imaginations ever since. But we can understand at the same time how he comes at the end, as Dante came at the beginning, of five centuries of Christian achievement on the supreme scale.

SACRED AND PROFANE LOVE. Showing where El Greco succeeds and where he fails.

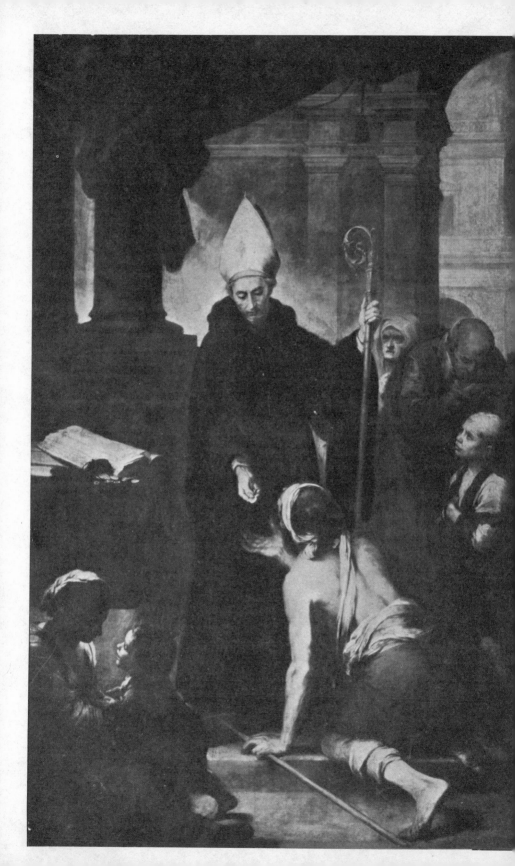

Dante had summed all the types of human mind and spirit then touching the Church. Milton, though the most genial of humanists and scholars, retired from the frontiers of mystery. Personally he was a violently independent spirit; but in his work he dissimulated his independence. Therefore tradition, though he ostensibly deferred to it and glorified it, was being secretly weakened. The result is that he gives us something which at last began to look more like a fable than like the truth.

Paradise Lost and *Paradise Regained* are a creation of high genius: their beauty is superb, but in spite of all they owe to their august theme, they tend (to borrow a phrase from Newman) to be "a sort of pagan mythology in the guise of sacred names".[11]

We have seen many resemblances in the genius of Milton and Bernini. The distinctions between them are also obvious, almost too obvious for mention: the artist knew the lives of the saints while the poet studied the Talmud and Kabbala.[12] One celebrated the sublimity of the Pope: the other praised the worship of Puritan or Anglican. To one the centre of interest was St. Peter: to the other, Satan.

It is perhaps too much to say with Shelley that in *Paradise Lost* Satan is the hero.[13] But that he is the central figure has been felt by poets as different as Dryden and Goethe, by professors as various as Masson and Raleigh, by a man of taste as distinct from any of these as Lord Chesterfield.[14] The story of Milton's Satan in the world of imagination is, after the *Paradiso*, literature's greatest debt to religion. His career means a revolution in heaven and on earth. It involves the fate of worlds. It is the struggle of a being elevated and depraved beyond all others, who seeks to ruin, and succeeds in ruining, the first and noblest of men and women. Its theatre is heaven, Eden, hell; and the fate of mankind is its result.[15]

Without religion, obviously, none of this. For just as man in spite of Adam's disobedience is the most august creature in the world, so the fallen archangel yet keeps about him so much of the original brightness, that made him the most magnificent creature in the upper world, as to add appeal and pathos to his withering. His scope was higher far than Adam's: at times he could revisit the Heaven of Heavens; much more often he was busy going to and fro in the world, and wandering up and down in it. And in raising men to heights of noblest temper he was playing a part both necessary and high in the inscrutable de-

ST. THOMAS OF VILLANUEVA, MUSEO PROVINCIAL DE SEVILLA, SHOWING THE GRANDEUR OF MURILLO. Religion gave him a power and interest surpassing the grip and boldness of his secular subjects.

[Photo by Anderson.]

signs of the Power who had become his enemy, while remaining his Master; he enjoyed, therefore,

> Large liberty to roam this globe of Earth
> Or range the air.

He is

> Co-partner in the regions of the world,
> If not disposer.

He speaks to men by

> oracles, portents and dreams
> Whereby they may direct their future life.

He concludes

> Though I have lost
> Much lustre of my native brightness, lost
> To be beloved of God, I have not lost
> To love, at least contemplate and admire
> What I see excellent in good or fair
> Or virtuous.[16]

He reigns as King on a throne of barbaric state over those regions of dismay, those tracts of sombre deluge and hardly less sombre fire which gradually solidify into a ground bearing gems and metal, but which always remain a place of sorrow

> where peace
> And rest can never dwell, hope never comes
> That comes to all.

"I know not", wrote Landor, "what interest Milton could have had in making Satan so august a creature, and so ready to share the dangers and sorrows of the angels he had seduced." [17]

Many, as we have seen, go farther; and indeed it is usual to speak as though Milton's Satan was an heretical conception, alien to the central tradition of Christian art and culture. It was not so. What was peculiar to Milton was firstly the place which he allowed to Satan in the composition, and secondly the fact that Paradise is regained not by the redeeming life, the Passion, the Cross, and the Resurrection of Christ, but by the single episode of the temptation on the Mount.

This conception is crude enough to go with the sturdy bumptiousness of his *Treatise on Christian Doctrine*. It is not only implied in the title of the second Epic: it is expressly stated in the opening lines of the poem:

> I who erewhile the happy Garden sung,
> By one man's disobedience lost, now sing

> Recovered Paradise to all mankind,
> By one man's firm obedience fully tried
> Through all temptation, and the Tempter foiled
> In all his wiles, defeated and repulsed,
> And Eden raised in the waste Wilderness.

It might be possible to interpret these lines into the orthodox scheme: but there is no evading the meaning of certain lines at the end of the poem where the angels sing hymns to Christ as though His answers to the thief of Paradise had requited all:

> Now thou hast avenged
> Supplanted Adam, and by vanquishing
> Temptation hast regained lost Paradise,
> And frustrated the conquest fraudulent.
> He never more henceforth will dare set foot
> In Paradise, to tempt; his snares are broke.
> For, though that seat of earthly bliss be failed,
> A fairer Paradise is founded now.[18]

It is worth remembering that this statement (although it is afterwards slightly qualified)[19] founds man's happiness on an episode which is one of the most difficult in the Gospel narrative and which modern critics would hesitate to accept at all: so that Milton's conception is as remote from them in this as in his view of Eden: it is still more remote from the orthodox theology of every denomination.

These observations are strengthened by the length of verse given to the exploits of Christ. *Paradise Regained* is as a whole several hundred lines shorter than the ninth and tenth Books of *Paradise Lost*. The later Epic admittedly fails to maintain the "gigantic loftiness" which Johnson counted as the natural port of Milton. And though there are many fine passages in the poem, such as the picture of Athens, the comparisons of Antæus and the Sphinx, and the fall of the fiend from the pinnacle of the temple to the pit, yet far the most telling passage is Satan's plea for himself. That passage, as I have said, is in perfect harmony with the view that any orthodox believer would share with the writer of *Job*. It becomes disquieting only when compared with the comparative colourlessness of Christ. And even that is involved with the sinner's natural resentment of model men. Tennyson had the same difficulty in giving Arthur the glamour and individuality of Lancelot.

Not only does Milton see Paradise regained without the Cross and Passion of the Saviour, but his Christ prefers classic learning to the service of the poor.[20]

VI

But there was another reason—and a more profound one—why Milton gave a peculiar personal appeal to the views which the Church had held as to the splendid qualities of the fallen Archangel. The poet's epic power was strongly mixed with the dramatic. He believed that tragedy was a grave, a moral, and a profitable exercisè of genius.[21] And he threw so much heart into it that at the end, as even so guarded a critic as Raleigh asserts, the words of his Samson can hardly be distinguished from his own.

But if the situation of the blind and luckless Samson could arouse such a personal force of sympathy from Milton, we must also face the fact that his fate and his habits of mind had much in common with the rebel chief

> of many throned powers
> Who led the embattled seraphim to war.[22]

He had on the one side an extremely lofty conception of Government. If he does not arrive as far as Burke's conviction that Government is one of the greatest blessings that God has given to man, yet Government was a divine economy for the governance of men that they might live in concord. "Discipline", he wrote, "is not only the removal of disorder, if any visible shape can be given to divine things, the very visible shape and image of virtue whereby she is not only seen in the regular postures and motions of her heavenly graces as she walks, but she makes the harmony of her voice audible to mortal ears." [23] To him the law of government was "that invariable planet of joy and felicity" by which the happiness of many could "orb itself into a thousand vagancies of glory and delight".[23] A rich variety, and differences well defined, were to be welcomed, as he argued in *Areopagitica*, because they gave more significance to the government which enabled them to work together, as in Baroque architecture divergencies of ornament, or of style itself, could be harmonized in one powerful design: "out of many moderate varieties and brotherly dissimilitudes that are not vastly disproportional", so he wrote in his argument for freedom in printing books, "arises the good and graceful symmetry that commends the whole pile and structure".[24]

Yet against his convictions about the sacredness of authority, Milton found himself from early in his career at war. He

attacked the sacramental institution of marriage, advocating polygamy, and, what was to him more extreme, divorce. He was strong on the side of regicide, and flung his mud against those who defended loyalty to the King; from a republican he had become definitely a rebel at the Protectorate, and even if he believed that republicanism was right morally, he had to confess that it was outlawed: that he acquiesced in the laws of his country, and the choice of his fellow-men. For a republican would have found it difficult to refuse More's theory that Parliament was omni-competent. Lastly, as the treatise on Christian doctrine shows, even in the ultimate things he flew in the face of the article of faith on which Catholics always and everywhere, Churchmen since the Reformation as before, and Puritans with Calvinists all insisted. All alike held it essential to salvation to believe that the Three Persons of the Trinity were One Lord and One Incomprehensible, their glory equal, their majesty coeternal.

In the views, then, of the great majority of his countrymen for most of the time he was writing *Paradise Lost*, he was himself a rebel. In fact, if his secret conjectures were to be known, his Puritans would believe he was to go at the last, with all his splendid genius, his learning and his love of beauty, to keep company with Moloch and Belial in the bottomless pit. He may have held to his view with all the strength of his individualism and his powers, but it was impossible when he considered the Archangel in revolt not to lend a sympathy—more desperate, no doubt because unconscious—to the rebel's statement of his case.[25]

And this the more because in the first case his poem was not unorthodox, and because to the fullest force of Satan's arguments came the answering words of Michael or the Christ, or the clamour of the deep-domed empyrean as it

Rang to the roar of an angel onslaught,[26]

Satan's downfall, as related, is complete: it is when we leave narrative for the deeper world of poetic sense and sympathies that we find he has become the centre of appeal; and had not Milton in his heart of hearts invested Satan, in Satan's hold over all that is highest in men's gifts and learning, with something which Milton had not given without reserve to his Redeemer? Milton had preserved his individualism, which was his pride, at all costs. His genius served the purposes of the Most High,

but it is improbable that among all the subtle frauds of vanity, of isolation or of pharisaism, his heart had been—few hearts are—entirely proof to the insinuations of the Tempter. His life, in this case, becomes the complement of the work. To those who share with the traditions of faith the interest in magnificence, the magnificence even of a ruined archangel is turned to an increase of God's glory: but to those who compromise or doubt, the religious significance fades away, and the fragile splendour of the imagination's design is like that of a dress which holds the infection of the plague in its folds of brocaded satin.

<center>VII</center>

What does this moral contagion imply in the history of art? It means that we are approaching the end of the long mastery maintained by the genius of Christendom over man's inventions of beauty. Milton had succeeded in what had not before been attempted. His sublime project has every glory poetry can gain: all its modulations of variety, its wealth of detail and its dignity; born, as Johnson said, for whatever is arduous, he worked it out with an amplitude not less than it required. Landor might say, forgetting Dante, "nor any modern nor any ancient author has attained to that summit on which the sacred ark of Milton strikes and rests".[27]

Yet, for all its sublime workmanship, his poem lacks the quality of prayer. The tenderness, which rejoices with those that do rejoice and weeps with them that weep, comes hardly more to Eve than to Satan. There is no hint either of common kindness or hallowed peace. It is not merely that the harassed woman does not go to Milton for consolation, nor the heavily laden for refreshment, but unless for the Nativity Ode, the most cultured mind cannot learn Christian piety from him.

We find the purest beauty

> Not where the wheeling systems darken,
> And our benumbed conceiving soars.[28]

It was a finer idea that men contemplated when they thought of the lowliness of the Family of Nazareth; and there is a loftiness in the Cathedrals of Canterbury and of York which neither Milton nor Bernini has expressed.

When the great Cathedrals were built (and they, too, are

among the religious masterpieces of England), the task of spirituality had been to master culture and technique. But now culture was escaping from faith, imagination was growing more interested in itself than in worship, and religion was becoming the means of salvation for the few rather than the order of unity for all.

VIII

We have understood Milton better by comparing him with great contemporaries in Venice and in Spain. Let us now compare him with a real English Christian—a writer like himself.

CHAPTER XV

1 This comparison with Bernini was written before I saw the same idea expressed in Sir Eric Maclagan's study of Bernini, *Italian Sculpture of the Renaissance*, pp. 270, 271: "Are there not many points of resemblance between Bernini and his contemporary Milton?" he asks. "Both represent the interaction of religion with the spirit of the later Renaissance. . . . Both began with what we might call mythological subject-matter; both consecrated the longer and later portions of their lives in the main to religious art; both were unequalled before or after their own day in the perfection of their technical achievement. . . . Both showed a frankly sensuous appreciation of human beauty and expressed it with slight reserve."

2 So much so that in this particular C. Patmore alone has followed him, and it gives him a certain connection with both Villon and Ronsard.

3 *Il Penseroso*, 89–91. 4 *Comus*, 2–4.

5 Preface to *Samson Agonistes*. 6 *Comus*.

7 *Il Penseroso*, 164–166.

8 Cf. Keats's letters. "What the imagination seizes as beauty must be truth."

9 *Paradise Lost*, Book VIII, 627, 628. True as this passage is to an important tradition in Catholic mysticism, especially exemplified in Richard of St. Victor and Ruysbroeck, it also comes into violent collision with the technicalities of scholastic philosophy where each angel is a distinct species.

10 *Paradise Lost*, VIII, 169.

11 Newman, *University Education*, p. 113 (1852).

12 Saurat, *Milton: the Man*, pp. 281–300.

13 Introduction to *Prometheus Unbound*. 15 Cf. Johnson's *Life of Milton*.

14 Raleigh, *Milton*, p. 147.

16 These four citations are from *Paradise Regained*, Satan's speech, 358–404.

17 Landor, *Imaginary Conversations*, quoted Raleigh, *Milton*, p. 137. Cf., however, *Imaginary Conversations*, VII, 240: Satan is after all a thing "to be thrown out of the way"; and 237: "It is Adam who acts and suffers most".

To set the temptation of Christ over against the temptation of Adam was a natural contrast: but it should not have beguiled him into such an error as confusing the results.

18 *Paradise Regained*, IV, 607–613.

19 See *Paradise Regained*, IV, 628–630.

20 His classical education and contempt for the people (he calls them a herd confus'd, a miscellaneous rabble) do not sit well on the carpenter's son who had compassion on the multitude. Christ in fact is partly an allegorical figure, partly Milton himself imagined perfect. Christ's description of his own childhood has often been considered a part of covert autobiography:

> When I was yet a child, no childish play
> To me was pleasing, all my mind was set
> Serious to learn and know, and thence to do
> What might be publick good.
> (*Paradise Regained*, I, 201–204.) Tillyard, *Milton*, 305–306.

[21] Preface to *Samson Agonistes*.

[22] *Paradise Lost*, I, 128, 129.

[23] *Church Government*, I, 1.

[24] *Areopagitica. Prose Works* (Bohn), II, 93.

[25] *Quiconque a quelque critique et un bon sense pour l'histoire pourra reconnaître que Milton a fait entier dans le caractère de son Satan les perversités de ces hommes qui vers le commencement du dixhuitième siècle couvrirent l'Angleterre de deuil : on y sent la même obstination, le même enthousiasme, le même orgueil, le même esprit de rebellion et d'indépendance ; on retrouve dans le monarque infernal ces fameux niveleurs, qui, se séparant de la réligion de leur pays, avaient secoué le joug de tout gouvernement légitime, et s'étaient revoltés à la fois contre Dieu et contre les hommes. Milton lui-même avait partagé cet esprit de perdition.*

(Chateaubriand, *Le Génie du Christianisme*, Book IV, Ch. 9, final paragraph.)

[26] Tennyson, *Milton*.

[27] *Imaginary Conversations* (Welby), V, 236.

[28] Francis Thompson: "O world invisible . . .".

I

"IF all the adulterers and fornicators in England were to be hanged by the neck till they are dead, John Bunyan, the object of their envy, would still be alive and well." [1] These hot and homely words carry us far into Bunyan's life. He wrote them himself towards the close of that brilliant essay in autobiography which he called *Grace Abounding to the Chief of Sinners*: the sinner was himself. But not because, like Saint Augustine, he had once lived lasciviously: not because there was any sort of moral accusation that could justly be brought against him; but because, like the saints, he set himself a standard of absolute holiness. Beside the life inspired by motives so pure, working in faculties so purified, that the saint mirrored and became an aspect of Christ, beside this, a mere righteousness was filthy rags.

When a Christian sets up for himself a higher spiritual standard than that of his neighbours, they feel a certain resentment at the implied criticism of his example; they vent their difference in attacking him. Was it not said in the Gospel: When men shall revile you, rejoice? Bunyan knew it; he gloried in their slander. He described it as knavish lies and slanders cast upon him by the devil and his seed. "Should I be not thus dealt with wickedly by the world," he said, "I should want one sign of the saint and child of God." [2] He had never had any fancy for love-making. "It is a rare thing," he said, "to see me carry it pleasant towards a woman": [3] now certain good men of his acquaintance were wont to give that greeting of a kiss for which they found a warrant in Holy Scripture, but Bunyan misdoubted it. "I have asked these men why they did salute the most handsome, and let the ill-favoured go?" [4] Bunyan's one wife had been the first and last woman he had ever approached; he was accused nevertheless of having mistresses, of being the father of bastards, of keeping two wives at once; we will not ask of what vice beside.

He knew everything they said: he was no fool: the shrewdness of his judgment, his common sense, and his thorough knowledge of England stamp one after another of his pages. He had the zest in life which strong sense is apt to spread among the masses of the people. And as the years went on his ex-

perience increased. When he was green in judgment, he had tried to put the fear of hell into his hearers. "Oh, my friends," he would begin, "there are hot days a-coming . . .",[5] and the old threats would be heaped one upon another: even then, when he was a young man, the sentences were telling, the words simple and strong.

<div style="text-align:center">II</div>

But with his age came the wisdom of a better taste. You can catch more flies, had said St. Francis de Sales, with a spoonful of honey than a barrel of vinegar. And so as he approached his fortieth year Bunyan wrote his confessions in *Grace Abounding*. This story of his own struggle from his own innocent but unredeemed life to that intense spirituality where mystical experience governed his choice, and provided his unexpected joys, had a deeper influence on his hearers than threat or adjuration.

In later years, when imprisonment restrained him from his preaching, it showed him a still more excellent way. He remembered the pleasure he had taken as a boy in reading of the adventures of Guy of Warwick and Sir Bevis of Southampton. The stories of their adventures took him straight back to the Chronicles of the Middle Ages. The fairy-tales had left their echo in his memory. And he gave back to England in a series of allegorical narratives the pleasure that it had once taken in the Morality plays. Religion then had occupied itself most with scene and song; now the principal object was a book. So, to grip the habits and tastes of the time, books were given to it by Bunyan: and books which owed their beauty and strength to being built up out of that sacred Book which was itself a collection of books covering the wisdom and experience of thousands of years: the Bible of the Church, on which, from the beginning, the spirit of Christendom had been nourished.

Its culture was in itself wide enough; it was starred with poetry, as the winds were starred with the coloured light of flowers: it touched the very depths of the heart; to it Bunyan went in every turn, whether he was narrating incident or revealing character. It gave him his note; he evolved from the remains of medieval England, its clear faith in Christ, and its constant recurrence to the stories, the lessons and the phrases

of the Bible, a new allegory, made more exquisite by the style of the Authorized Version.

He gave religion the glamour, the homeliness, the vividness which the holy story has in an illuminated book of hours in the fourteenth century. He returned to the model first set out for European literature by Guillaume de Guileville of the Abbaye de Chaliz in *Le Pèlerinage de l'Homme*, of which Caxton printed in 1483 a translation called "The Pilgrimage of the Sowle".[6] In this, two hundred years before the *Pilgrim's Progress* was published, the English reader had already followed a pilgrimage where a pilgrim caught sight of a city in the heavens, passed a wicket-gate, was received into the house of Divine Grace, and was equipped with armour in an armoury. There is of course no sign of direct copying; Bunyan can hardly have known of John Bromyard, the Dominican Friar, who wrote the *Summa Praedicantium*; but his genius ran in the path Bromyard had suggested. He gave back to a people, who had lost touch with scene and song, words so picturesque and melodious that, in the amusement of their imaginations, they drank in wisdom. His speech was so simple, yet so vivid, that it made reparation to them for their having nothing more than speech; it won them and it haunted them. "Read my fancies," wrote Bunyan of the *Pilgrim's Progress*, "they will stick like burrs."[7]

III

Another link between Bunyan and the medieval plays and preachers was one of those books which to a people still naïf gave the ancient legends in a printed book. This was the *Seven Champions of Christendom*, published in 1607 by Richard Johnson: Sir Charles Firth believes it was to the life of St. George in this that Bunyan referred as "George on Horseback".[8] But we do not know how many of such books there were that Bunyan fancied before he concentrated on the Bible: he speaks of his love for ballads, for news-books, for books that teach curious facts and tell of old fables. He was fed early on meat that developed his imagination: he had a natural taste for romance: he loved legends and marvels: and at the same time he had a healthy taste for sport and fun: he specially enjoyed the music of bell-ringing, and above all he loved a dance; we

cannot doubt that, like Much-afraid, he "answered to the music handsomely".

In the England in which he was brought up none of these things were inconsistent with religion: his healthy love of pleasure, his exuberant vitality, were the marks of one of those rich natures who alone can give us the best things of either religion or genius. His youth was in the same tradition as that of St. Augustine, or St. Francis: but he insisted, as we have seen, that it was not, like St. Augustine's, scandalous; it was innocent, like that of St. Francis. He talks of the prevailing of the lusts and fruits of the flesh "in this poor soul of mine", but restraint and reverence for religion were never lacking. Strange fits of terror, however, would break in on his normal attitude: as with many of the mystics before him, imagination would body forth the forms of things unknown: he would hear voices: he would see visions. He would thus receive within him the beginnings of the fuller life of grace with which even innocent pleasures were inconsistent. For it was while playing the harmless game of tip-cat that he heard the inner voice calling him. "Wilt thou leave thy sins and go to heaven: or have thy sins and go to hell?" [9]

Such a question was the echo of the awful uncompromising-ness of Christ as it had been set down in the Gospels: human nature was unable to respond to it: he could only cry for mercy: and so he entered on that long process of purification or morti-fication in which the soul gains strength by moving from the natural impulses, which are right for normal men, to that surrender of instinct to grace which is the special vocation of the more supernatural man. The effort of deliberate self-sacrifice, as we saw in the case of St. John of the Cross, is not the hardest thing that this change of impulsion demands: a harder trial comes in the sufferings of the mind, in what St. John of the Cross had called the dark night of the spirit, in the sense of dryness, of loneliness, of sin, of being cast out by God.

Bunyan gives his own record of this: and in his allegories he relates it to the inclination to return to what most people perforce consider a more common-sense view of religion, to the shrewd and extremely general advice of Mr. Worldly Wiseman. But even here visions of delight would shine before him, the first signs that he was entering on the illuminative way. As his purgation was drawing to a close, he heard an intensely mystical sermon on one of those verses of the *Song of Songs* on

which saints have recurrently lived: *Behold thou art fair, my love; behold thou art fair.* Here, said the preacher, the unseen Lover is drawing nigh to the loveless, and offering them Himself from first to last: here the dark night was illumined by the day-spring from on high. "Poor tempted soul," said the preacher in words that went to the depths of his hearer's heart, "when thou art assaulted and afflicted with temptations, and the hidings of God's face, yet think on these two words MY LOVE still".[10]

As Bunyan thought of them, they returned warmer and stronger, incessantly. His mind rang with the words, "Thou art my love, thou art my dove", till fear had given place to comfort and hope; on through trial to peace, he came at last to say with St. Paul: *To me to live is Christ.*[11] Christ not merely as a teacher, nor a crucified Saviour, nor risen and ascended, but all together, summing time and operation, whole Christ. "Christ!" he wrote, "there was nothing but Christ that was before my eyes." Then, comparing his gifts and graces with the coin in a rich man's pocket while his wealth is locked up in his safe: "O!" cried Bunyan, "I saw my gold was in my trunk at home: in Christ, my Lord and Saviour. Now Christ was all: all of Wisdom, all of Righteousness, all of Sanctification, all of Redemption. Further the Lord did also lead me into the mystery of union with the Son of God that I was joined to Him, that I was flesh of His flesh and bone of His bone . . . now could I see myself in Heaven and Earth at once." [12]

IV

It was from this vantage ground of mystical union that he returned to his use of homely phrase, to his turns of wit, to his love of romance, to his shrewd knowledge of the world, to his strong fund of natural joy, and to his leaping imagination: to all that, in a word, made him a writer. And he turned it all to the single end of edification. Here was no phantasy of the unconscious, as in *Alice in Wonderland*: if this was a dream, in its magical exchange of one image or reflection for another, yet, for all its surprise, it was a reasoned dream. It attained the end of preaching better because it insinuated its lessons among men by keeping them diverted.

> It seems a novelty and yet contains
> Nothing but sound and honest gospel strains.[13]

Those gospel strains were the fairy story, the chap-book of Christian mysticism, told by one who, though he once had loved the ceremonies of the Church, had reached the heights where his worship had thrown off all other forms but the very Bible's words. He renewed the religious imaginations of the Middle Ages in sharply, and at last fiercely, dividing itself from every other form that the Church had created as the vehicle and background of her prayer. Pascal had thought out a Catholic religion of the heart in his intense revolt against the compromises and formalism which revolted him in certain circles guided by the Jesuits. Bunyan, in an equally violent revolt against not merely Jesuits, not only Catholicism, but every form of Church worship, erected a work which in massive strength and sense rose like the nave at Gloucester, to insist that, except for what words did for the imagination, men would be damned if they made any compromise with Christ's counsels of perfection.

Nevertheless, when genius made religion at once so different and so severe, it was losing touch with the mastery of subtle intermixtures in motive and knowledge which had enabled the Church to keep culture Christian. Dante's aim had been to search, to arrange, to comprehend. He aimed at mastering every human excellence. Bunyan's tendency had been to exclude. For plain minds to see through worldly wisdom, and the infinite variety of men's half-measures, to evangelical mysticism, a great art of words was left. But the tragedy was that other sciences, other grandeurs, other mysticisms could all dart past it.

Bunyan and Murillo, the Bedford brasier and the Sevillan painter, how much alike indeed they are! In each imagination glowed, in each there was a mystical fervour, each knew the common people, each brought them into sight of the glories of the heavenly city; but there is no place for the Blessed Virgin among the allegories of Bunyan: and Murillo painted her with a luxury of sentimentality of expression that will bear no comparison with the strong sense of his own Saint Anne in the "Holy Family" in the Louvre; and how far that pious softness is from the hardy strength which alike in *Grace Abounding*, and in the four allegorical narratives, showed how strong must be the grip of the Christian on his plough if he was to cut a straight furrow for good grain!

But if Bunyan is stronger, we must not forget that he is also

cruder. He had the greatest command of homely words, of words that tuned well with the Authorized Version, but were habitually much simpler and shorter. "Had I had a thousand gallons of blood within my veins, I could freely then have spilt it all at the command and feet of this my Lord and Saviour." [14] That is an effective, simple, strong expression— but it is not good enough for a great literary masterpiece. We have the excellence of such a mind without the fault, a shock attack that is all subtlety in the question: "Do you think I am such a fool as to think God can see no farther than I?" [15] And this is put into the mouth of Ignorance!

V

But Bunyan was making too easy an appeal in his account of the Jury who tried and condemned Faithful: we all know their names: Mr. Blind-man, Mr. No-good, Mr. Malice, Mr. Love-lust, Mr. Live-loose, Mr. Heady, Mr. High-mind, Mr. Enmity, Mr. Liar, Mr. Cruelty, Mr. Hate-light, and Mr. Implacable. They are an unforgettable list; they hint at recurrent motives and attitudes of men hostile to zealous Christianity. Leading on, however, as they do to the execution of Faithful, and going back to Foxe's *Book of Martyrs*, are they not a little too naïf? But they prepare us for Mrs. Lechery, who had such a well-bred appearance, and Madam Bubble, who speaks very smoothly, giving you a smile at the end of the sentence,[16] and for Madam Wanton, who contrasts so well with the young woman whose name was Dull. And how entirely successful is the account of the city of Fair-speech, and the discussion with Mr. By-ends, who explained, "I am a gentleman of good quality, yet my great-grandfather was but a waterman, looking one way and rowing another, and I got most of my estate by the same occupation."

"Are you a married man?" asked Christian.

"Yes," answered By-ends, "and my wife is a very virtuous woman, the daughter of a virtuous woman; she was my Lady Feigning's daughter, therefore she came of a very honourable family, and is arrived to such a pitch of breeding that she knows how to carry it to all, even to Prince and peasant. 'Tis true, we somewhat differ in religion from those of the stricter sort, yet but in two small points. First we never strive against wind and tide. Secondly we are always most zealous when religion

goes in his silver slippers; we love much to walk with him in the street: if the sun shines and the people applaud him." [17]

To which comes, after a little while, the great conclusion which sums up all that is sublime in the writer's mind.

"If you will go with us, you must go against wind and tide . . . you must also own religion in his rags, as well as in his silver slippers, and stand by him too when bound in irons, as well as when he walketh the street with applause." [18]

There is no denomination, no religion in which those great words are not true. But in Bunyan's history they not only marked the choice between self-sacrifice and selfishness: they marked in his mind and experience a difference between nonconformity and tradition. There was never a century when there was no lukewarmness, no need for reform. But after the religious struggles of a century, the principle of corporate Christianity had been forgotten, the order of unity and the unity of order had ceased to control either civilization or culture; these shrewd hits were aimed at strengthening essential religion against the inherent weakness of the nature of its adherents: in the Middle Ages they might have stopped at that; but when they also implied an inferiority of one denomination to another, they menaced the hold of religion over culture and a man's sanity.[19]

The study of Christian genius cannot refuse to take cognizance of schisms in the Christian religion. This is one reason, and not the least, why European culture changed its course. In the first excitement of the Renaissance, the Middle Ages, as we have noticed, reached the consummation of their religious interpretation of Nature. And then followed some fifty years of exhaustion before, at the end of the seventeenth century, the spirit of Bernini mastered men of genius in England, in France and Spain, and we see the weakened tradition burst forth once more into a splendour, a serenity and an exuberance which lift the homeliness of Bunyan to classic heights.

Meanwhile, the *Pilgrim's Progress* elevated and pleased the taste of every reader whom it exercised by "a multitude of curious analogies, which interested his feelings for human beings, frail like himself, and struggling with temptations from within and from without, which every moment drew a smile from him by some stroke of quaint yet simple pleasantry and nevertheless left on his mind a sentiment of reverence for God." [20]

JESUS CRUCIFIED, BY MONTAÑÉS, IN THE CATHEDRAL DE SEVILLA.
His medium allowed a directness of approach that would ambush any genius but the greatest. [Photo by Anderson.

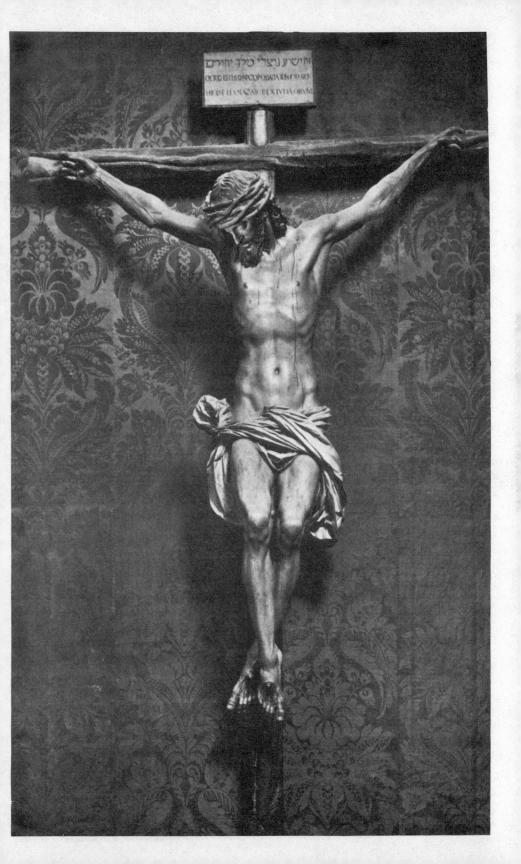

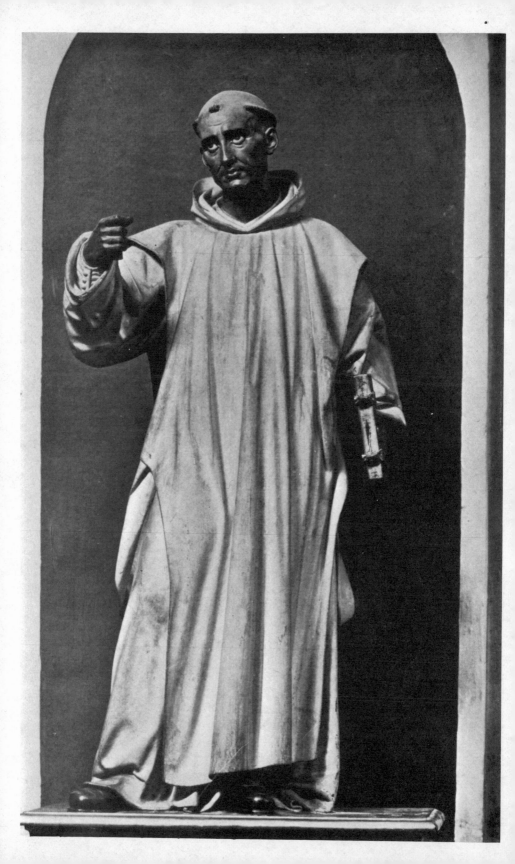

VI

Holiness and humour walk freely together because they are agreed. Those who see clearest the truth of God's greatness are content that comedy should bring home to man the truth of his littleness, should show him the incongruities between his pretensions and his behaviour. Why do we laugh to see a fat man slip? Why is an ingredient of reference to sex apt to make a story funnier? It is because it is a salutary thing for man to remember that he is a creature of flesh and blood. The comedies of the Restoration were well aware of that.

But the pleasantries of Bunyan are such as fit well with his constant citation of the Bible. He showed how one can raise a smile without being coarse. His humorous touches are subtler, shrewder, nicer. He recognized the existence of Mrs. Lechery and Madam Wanton, and amuses us by doing so. But that was enough. He does not coarsen his book by too close a cognizance of their ways. A smile is always lurking at the corners of his mouth, but he is too fine to invite us often to a roar of laughter. And almost all his wit is meant to remind us of that saying of his that "the soul of religion is the practick part".[21] For what he said of the moral value of his imagery is true of moral life in general:

None throws away the apple for the core.[22]

In fact, one great reason why the *Pilgrim's Progress* is such good literature is because it is so practical in its Christian teaching. It is not an attack on those unfortunates whom the law punishes. It appeals to the infinite numbers who are decent but not unselfish: or who maintain standards of righteousness and yet refuse the sacrifice which Christ invites. "The whole allegory", Bernard Shaw said shrewdly, with that dart at paradox in which his mischievous soul delights, "is a consistent attack on morality and respectability without a word that we can remember against vice and crime." [23] Is not this true of the discourses of Christ? Does it not apply to the New Testament as a whole? It is among the scribes and Pharisees that we find that obvious, but obviously insufficient, righteousness which corrupts the mass of us into sinners more hopeless than the felon. For Bunyan, as for Pascal, as for all great masters of the spiritual life, the great thing is to push those who call themselves Christians off the cushion of complacency.

SAN BRUNO, BY MONTAÑÉS, IN THE MUSEO PROVINCIAL DE SEVILLA.
His statues have an impressiveness which showed him to be as great an artist as any then
living. *[Photo by Anderson.*

None of us can forget those pages which end the first part of the *Pilgrim's Progress*: they arrange widely separate texts of the Bible together into one exquisite crown of jewels. The style is perfect. It has the glamour of a dream about it, and yet a shining clearness: and the style, like that of the masterpieces of the saints, has the power to lift us by its own wings into the heavenly life, into that intense life into which the prayer of quiet leads us while it stills our busy thought. How describe this better than to say that "It is the nature of the grapes of these vineyards to go down so sweetly as to cause the lips of them that are asleep to speak"?[24] This is an exquisite picture of the mystic's thankfulness after receiving Holy Communion.

All, we say, know the beautiful story of how the Pilgrims, passing the enchanted ground, came into the land of Beulah, addressed themselves to go up to the City, passed through the deep river, and went with the shining ones till they were met by a company with ten thousand welcomes, so that it seemed to them as if heaven itself had come down to meet them: all know how the two men went in at the gate, and, as they entered, they were transfigured and were robed in raiment that shone like gold; how they were given harps to praise withal and crowns in token of honour; how all the bells of the City rang for joy, as it was said unto them, *Enter ye into the joy of our Lord.*

All will remember this: some will not forget that there is a way to hell even from the gates of heaven: but how many now realize that the wondrous beauty of the picture was maintained by the nine explanations of how men become unworthy of the promises of Christ? In Dante the exordium to the vision of the Trinity was the denunciation of vice. With Bunyan also the final picture owes its strength to the nine ways that the shame that attends religion, and the efforts required to practise it, push men back into indifference. They are a striking example of Bunyan's power as an observer of men:

1. "They draw off their thoughts all that they may from the remembrance of God, Death and judgment to come.

2. Then they cast off by degrees private duties, as closet-prayer, curbing their lusts, watching, sorrow for sin, and the like.

3. Then they shun the company of lively and warm Christians.

4. After that they grow cold to publick duty, as Hearing, Reading, Godly Conference, and the like.

5. Then they begin to pick holes, as we say, in the coats of some of the godly, and that devilishly, that they may have a seeming colour to throw religion (for the sake of some infirmity they have spied in them) behind their backs.

6. Then they begin to adhere to, and associate themselves with carnal, loose and wanton men.

7. Then they give way to carnal and wanton discourse in secret; and glad are they if they can see such things in any that are counted honest, that they may the more boldly do it through their example.

8. After this, they begin to play with little sins openly.

9. And then being hardened, they shew themselves as they are. Thus being launched again into the gulf of misery, unless a miracle of grace prevent it, they everlastingly perish in their own deceivings." [25]

It was when this slackening tendency passed on from worship to imagination that Europe's culture grew too faint for the nobler flights. The whole process is summed up in Meredith's famous aphorism: "For this reason so many fall from God who have attained to Him—that they cling to Him with their weakness, not with their strength".[26]

That truth is not more significant for ordinary practical life than for high creative genius. It applies to the power of comprehensiveness of type, as well as to the need for zeal and mysticism. How much these could still do when combined we can estimate from Bunyan's contemporary, Wren.

CHAPTER XVI

[1] *Grace Abounding*, p. 315.
[2] *Ibid.*, p. 310.
[3] *Ibid.*, p. 316.
[4] *Ibid.*, p. 316.
[5] *Some Gospel Truths Opened*, quoted in *Times Literary Supplement*, p. 917, 1928.
[6] See John Brown, *John Bunyan*, pp. 272–275. This in turn was said to be modelled on the *Romaunt of the Rose*.
[7] Author's Apology.
[8] Sir C. Firth, *Pilgrim's Progress*, Introduction, p. xxxii (1898).
[9] *Grace Abounding*, p. 22.
[10] *Ibid.*, p. 91.
[11] Philemon I, 21.
[12] *Grace Abounding*, pp. 233, 234; cf. Ephesians V, 30.
[13] *Pilgrim's Progress*, Author's Apology.

[14] *Grace Abounding*, p. 193. Repeated, in a slightly different form, in *Pilgrim's Progress* (edn. 1936), p. 141; there are many such clauses from *Grace Abounding* in *Pilgrim's Progress*.

[15] *Pilgrim's Progress*, p. 144.

[16] *Ibid.* (edn. 1926), p. 322.

[17] *Ibid.*, pp. 104, 105.

[18] *Ibid.*, p. 106.

[19] For further studies of this, see E. G. Selwyn, *The Approach to Theology*, pp. 49 ff; J. B. Pratt, *The Religious Consciousness*, pp. 145–150.

[20] Macaulay, Essay on Bunyan in *Encyclopædia Britannica*.

[21] *Pilgrim's Progress*, p. 86.

[22] Author's Apology.

[23] Introduction to *Man and Superman*.

[24] This is taken from the Authorized Version: wine for my beloved that goeth down so sweetly, causing the lips of those that are asleep to speak: Song of Songs VII, 9. It is in this very verse, as we saw, that M. Guitton, taking a better translation, found the culmination of the drama he traces.

[25] Reprint of original edition (London, 1926), p. 152.

[26] George Meredith, *Richard Feverel*, Ch. XXII, p. 206 (1896).

I

Born in 1632, Christopher Wren was happy in his lot. When he was four years old, his father was appointed Dean of Windsor, and Chaplain of the Order of the Garter. His uncle Matthew had already in 1634 been elected Bishop of Hereford, being afterwards translated to Norwich, and finally to Ely. When the boy was nine he was sent to school at Westminster under a staunch royalist who, though rather ruthless with lazy or contumacious boys, was a man nobly zealous for piety and learning. Wren stayed at Westminster till he was fourteen, when he acted as assistant and demonstrator to an anatomist. Going up to Oxford when seventeen or eighteen, he matriculated at Wadham, and immediately made a brilliant name among contemporary scientists. In 1653 he became a Fellow of All Souls, where he continued his scientific studies and experiments. In 1657 he was appointed Professor of Astronomy at Gresham College in London; four years later he returned as astronomer to Oxford, to take up the Savilian Professorship. It was doubted, when he was thirty years of age, "whether he was most to be commended for the divine felicity of his genius or for the sweet humanity of his disposition; formerly as a boy a prodigy, now as a man a miracle".[1] It was Evelyn who, when he was twelve, had called him a miracle of a youth. He had both a mechanical hand and a philosophic mind; and with a natural reverence for all that was most dignified in tradition, he had a genius in the highest degree inventive and original. In his youth he had known suffering from delicate health and from the hardships of political attacks on his family. His home at Windsor was ransacked by Roundheads, his father removed from the Deanery, and his uncle the Bishop thrown into prison.

Though himself an ardent royalist and churchman, Wren was himself too urbane a savant to make no friends amongst the men of the other side: his career under the Commonwealth had been already brilliant when Evelyn brought him to the notice of Charles II. Wren was accustomed to circumstances of dignity and charm, happy in his friends, and victorious in his genius; his scientific knowledge, whether of the involutions of the brain, of the play of muscles, or of the courses of the stars,

was united with a gift of taste. But it was in 1665, when at the age of thirty-three he went to Paris, that intercourse with men of genius brought him to the fruition of his own powers.

II

"In the year 1665," says his first biographer, "Mr. Wren took a journey to Paris, where at that time all Arts flourished in a higher degree than had ever before been known in France; and where was a general Congress of the most celebrated Masters in every profession, encouraged by royal munificence, and the influence of the great Cardinal Mazarin." [2] Taking a recommendation to the British Ambassador, the Earl of St. Albans, he found that everything was made easy for him to pursue the study of architecture, which by now had displaced his interest in either the human body or the stars.

As an architect he had given his whole genius to the Renaissance tradition which had been established in England by Inigo Jones.[2] It was by now almost a hundred years since the genius of Palladio had made general in Western Europe the homage that some eminent stylists were paying to the Roman architect Vitruvius, whose rules of proportion seemed to tell the whole secret of how buildings could be made beautiful, or why they had been made ugly. Eight years before Wren's birth, Sir Henry Wotton had published in his *Elements of Architecture* his own exposition of Vitruvius. Palladio himself, however, had seen that if buildings were to be magnificent, the designer must show that he had in himself something more than obedience to rules. Swiftly the Classic tradition had developed into Baroque, that style which revelled in bold effects of light and shade, of mass and space and line, which was an architecture of passion, above all of passion for infinity, and which was apt to change from suave majesty to a surprise that shocked like an explosion. It was more than even the architecture of humanism: its humanism appealed to the nerves, it spoke what one of the modern classics of criticism has called "the language of the human body";[4] ancient architecture had satisfied a body exercised in discipline and rhythm, the new architecture was subtler: it recognized that the body felt also the pulse of passion, and how could passion be finally satisfied except by the striving

of the soul? Such is the theme of that remarkable study of the Baroque, *The Architecture of Humanism*.

Geoffrey Scott has shown us there how the finest masters of the Renaissance accepted the order which Vitruvius and Palladio had imposed on them: they could say with Wotton: "Well building hath three conditions: Commodity, Firmness and Delight", but their special delight had been in freedom. They were for ever bursting out into an expression of their own feelings: their individual impulses were wild and high: they were, even more than the ancients, at home in the world. Feeling that, more than its masters, they were the very reason of its existence, they were free to build in it an architecture all their own. This was not, like Gothic, an obeisance before the power of storm or fire: it was not haunted by the mystery of the trees. "Theirs", says Geoffrey Scott, "is an architecture which by Mass, Space and Line responds to human physical delight, and by Coherence answers to our thought. These means sufficed them. Given these, they could dispense at will with sculpture and with colour, with academic precedents and poetic fancies, with the strict logic of construction or of use. All those also they could employ: but by none of them were they bound. Architecture based on humanism became an independent art." [5]

III

But when Renaissance architecture was acclimatized at the Court of Louis XIV, its assertions of power had to compromise with a new element: the influence of women. From the time of Ronsard, the love of women had been recognized, and it has ever since remained, one of the most refining elements in the genius of France. If a Frenchman built a château, it must be a home where women could receive court. To Doctor Wren, though he was no misogynist, this femininity of taste seemed questionable. "The women," he wrote, "as they make here the language and the fashions, and meddle with politics and philosophy, so they sway also in architecture." It was not for these engaging trivialities that he had come to France. He had come to make the acquaintance of Bernini and Mansard; [6] he had come because he believed with them that "building ought to have the attribute of eternal"; [7] he had come because the work then being done in the Louvre made it, in his opinion, the best

school of architecture in Europe. But he did not stop at archi-
tecture: building, he said, without the imitative arts would be
lame. "Painting and scuplture", he quoted from Monsieur de
Cambray, "are the politest and noblest of ancient arts, true,
ingenious, and charming, the resemblance of life, the emulation
of all beauties, the fairest records of all appearances whether
celestial or sublunary, whether angelical, divine or human."

The master of the creative arts had just arrived in France.

Born at Naples in 1598, Bernini was now an old man who for
almost a generation had ruled in Rome as the master-builder of
St. Peter's. He had completed the terrace and the Colonnade:
he had peopled it with statues of the saints: he had set his
baldachino above the tomb of the Apostle; he had built the
Palazzo Odescalchi; he had designed the fountain of the
Piazza Navona; within the bronze doors of the Vatican he had
built in the Scala Regia the world's superbest staircase: he had
set up in St. Peter's the Papal throne on clouds of black and
gold, and the shining marble tombs of the Popes Urban VIII
and Alexander VI; he had painted striking nudes and portraits;
and his statues of St. Teresa and Innocent X witnessed the
intensely spiritual life he could convey to stone. Everywhere
alike his spirit transferred to travertin and marble a sense of
violence overcome by calm, of individuality in homage to
tradition, of exuberance adding a surprise to weight and
grandeur, of the momentum of an immense shock throwing a
mass into a more vital stability. The calm of his effects was
made more impressive by a sense of movement surviving
through them. He was, said Venturi, "a giant among dwarfs".

When Wren went to Paris Bernini's consummation at the
Vatican aroused the greatest admiration.[8] He had been received
by the Grand Monarque with signal honour. And when he
showed the visiting Englishman his designs for the Louvre,
though only for a few minutes, Wren's every faculty was
strained to grasp it and remember it. It was something, he
wrote, "I would have given my skin for". The secret of Wren
is his admiration for Bernini: beyond Bernini he looked back
to the Dome of St. Peter's, which mastered his imagination as it
towers above the monuments of Rome. From the Villa of
Hadrian, across the Campagna, or from far up the valley of the
Tiber, its curves and its completeness are seen when all else is
hidden. To give something of the significance of that symbol to
England's imperial capital, such was to become the mastering

end and passion of Bernini's new admirer. "St. Paul's", says a great English architect, "would not have been what it is without St. Peter's." [9]

Paris, though we have no record that Wren said so, offered him already in 1665 some fine examples of the influence of St. Peter's Dome. It is, of course, impossible that he could have seen even a model of the *Dome des Invalides*. But already Mansart had set up a cupola over his Church of Ste. Marie in the Rue St. Antoine. In that very year Mansard completed his beautiful domed church in the *Val de Grace*, perhaps the finest example of a Baroque church in all Paris; and there were three other domes in course of construction—that of *La Salpétrière*, that of the Theatine Church of Guarrini, and the cupola of what is now called *le palais de l'Institut*.[10] This building Wren particularly admired for its "masculine furniture",[11] and it is remarkable that the *Château of Vaux-le-Vicomte*, which with that of *Maison Laffitte* he designates as "incomparable", has like Longleat and other Elizabethan houses, a dome inserted into its roof; and it is crowned, as St. Paul's was to be, by a lantern. After studying all these, he himself made a dome more graceful than any of them for St. Stephen's, Walbrook. "I had only time to copy it in my fancy and memory," wrote Wren of Bernini's design of the Louvre, but in his study of other buildings his memory received assistance from his hand. It was to feed on many a detail of the Louvre before his masterpiece was finished, and from the first he was fascinated by watching the thousand builders of the King's Palace at work: some in laying mighty foundations, some in raising the stories, columns and entablatures with vast stones by great and useful engines; others in carving and inlaying of marbles, plastering, painting, gilding.

IV

The age of the Grand Monarque was one in which men's faculties consummated one another. Mysticism inspired formality. True feelings could survive the elaborate convention of a Court which, when all was said, was not ideal. The intimacy, the individuality, the delicacy, of the most refined women, could combine, as in Racine, with the most intense passion, or in Molière with the most vigorous humour. But

there is little of this in its painting: in Le Brun, Philippe de Champagne, or even in the luminous skies, stretching landscapes, and Roman architecture of Poussin. Courtly graces, imperial statecraft, victorious captains, and women magnificently arrayed, combined in a pageant of homage to a sovereign who from the age of five had reigned with increasing successes. It was for such a capital as this that Wren found his builders making great homes, or palaces, or churches. They did not want anything quaint or simple or naïf. "By the combination of largely conceived extremes, bold lines and masses, gorgeous colour, choice material and consummate craftmanship"[12] they achieved effects which were superb. The pomp in which the central authority moved: that mastered their imaginations, but though it was generally graceful, it was gradually to be overdone. And Wren was to work in England, while Louis XIV lived on into his decline, and shadows began to fall on "*le siècle le plus éclairé qui fût jamais*".

V

We cannot doubt that Wren returned to London an enthusiastic follower of the Baroque tradition which Bernini had consummated. When his library was sold, with that of his son, in 1748, there were eight prints of the cupola of St. Peter's, as well as a collection of designs by Inigo Jones, there were Perrault's translation of Vitruvius and Fontana's *Templo Vaticano*, as well as a book on Perrault himself by James, there were Leoni's *Palladio*, and a French edition of Vignola.[13]

The great Baroque tradition is the material out of which the original English genius of Wren built up through thirty to forty years the gradual design of St. Paul's Cathedral as we know it. And no doubt Wren was the more attracted by it because alone among English architects he had first become famous as a watcher of the skies. In his first building, the Sheldonian, he built a little dome above the lantern which lets in light from the roof. He had been attuned to a design expressing the coherence of thought when the heavens had set before him a Roman model while he surveyed the stars. And it must not be forgotten that many Tudor buildings had already had their little domes as Gothic mingled with Baroque in the outlines of Segovia.

VI

Such was the spirit in which Wren approached his task. The great commission seemed to come to him with the same inevitableness as rain descends upon earth and sea. Evelyn had presented him to Charles II; already, with an ease as swift as it is mysterious, the astronomer has become an architect. At Oxford he had built his theatre for Archbishop Sheldon and advised on the design for the Chapel for Trinity College.[14] Then, under the title of Surveyor-General, he had become responsible to the Sovereign for the maintenance of the great Gothic Cathedral of the City of London, which already, like the Church of St. Mary the Virgin at Oxford, had been dignified and enriched by a Renaissance portico. In place of the Gothic steeple Wren was to build a dome.

"He had a mind to build it with a noble cupola, a form of Church building not as yet known in England but of wonderful grace." So wrote Evelyn on August 27, 1666. The week was not out when a fire, breaking out in Fish Street and leaping from house to house, and from street to street, with noise and cracking and thunder of the impetuous flames, had come to Ludgate Hill and burst like a bombardment on the Gothic Cathedral. Flames devoured the architecture. Numerous masses of masonry melted in the heat. The stones, said Evelyn, flew like grenados, the portico was cut in pieces, columns, friezes, capitals, and projections of massive Portland stone flew off, and at last, after a scene which men thought not to see again until the globe itself is consumed in general burning, the goodly church lay as a charred ruin in a city of ashes.

Wren's task was to rebuild it.

He was to keep the ancient ground-plan. Old St. Paul's had been the longest church in Christendom, and long therefore the new church was to remain. But Wren made no compromise with the fierceness of the old style, or with what was called the "crinkle-crankle" of its ornament. Fresh from his encounter with Bernini, vibrating to the inspiration of the Parisian Renaissance, he went back direct to Bramante and Michelangelo, and planned to build in London what St. Peter's might have been. A single order of classic majesty, a massive portico, a dome with lantern and ball and cross such as crowned the Escorial: this was to be the monument of the age in the centre of

London. A temple more touching in its majesty has seldom been conceived. It would have given to the central shrine of England the calm, the faultlessness, the grace, the might of the noblest temples of Athens or of Rome. Its power is inherent in the Propylæa or the Parthenon. We bow before a kindred grandeur as we pass around the transepts of St. Peter's and see the Dome above.

The concept exceeded the appreciation of Restoration England. Whether because of the influence of the Court, or from the lack of education among the clergy, the masterpiece was rejected. They would have neither dome nor coherence. The glorious unity of space, of mass, of line was changed, and a royal warrant was signed for another design which was a nightmare of ungainliness; its central feature was an immense curve of steeples like nothing so much as a dragon's tail frantically erected in the air.

It is yet another of the mysteries of Wren's life how this design was changed into what we see. Rapidly the monstrous steeple was abandoned, the reigning dome returned, with its full elegance of curve. The original design in its Roman simplicity of column and pediment had changed to another: a design elaborate, Parisian and novel: a doubling of columns which found a model in Perrault's design for the façade of the Louvre was adapted with great originality and with the addition of a pediment for the façade, supported, as at the Louvre, by pairs of light columns. It never worried Wren that the columns of the façade support nothing; that the fine proportions of the design have no relation to the needs or nature of the church inside.[15] He wanted his effect, and to complete it built on either side of the façade a campanile, faintly reminiscent of St. Peter's, but developing through one or two stages into the unique design which combines with the façade into the picture so impressively distinct as to greet us with a style we all recognize at once, like the timbre of a voice familiar in childhood: crowning all, above a lantern as generous in streams of England's light as the windows of Santa Sophia, rose dome, lantern, orb, to the final cross of gold. The design had grown into the mind of the architect as the stones rose one upon another, and in spite of its evolution, it kept an unbroken unity. Before a single generation of Londoners, all busy in rebuilding,

> Out of the earth a fabric huge
> Rose like an exhalation;[16]

this was their central temple, undisturbed, astonishing, complete.

St. Peter's had been the work of a hundred and thirty years. One master of the Renaissance after another had stamped upon it in alternating moods the calm or turbulence of his invention. There "style succeeds to style in the effort to satisfy the workings of an imagination too swift and restless to abide the fulfilment of its own creations." [17] Bramante, Raphael, Sangallo, Michelangelo, Peruzzi, Fontana, Maderna, had all preceded Bernini: what they had modified in succession, Wren now accomplished alone. He began to build it on the younger side of his middle-age. He saw it finished before his power began to fail.

In the Vatican Basilica, within and without, one object had blended in a deafening symphony the clangour of changing composers. In the full inundation of Renaissance excess their orchestra of building lauded "in glorious and lofty hymns the throne and equipage of God's almightinesse".[18] It had been designed for those moments when the Vice-gerent of the Most High is carried in triumph amidst acclaiming crowds to show his state as the ruler of kings and princes. Wren could envisage no such ceremony in the Londoners' Anglican Cathedral. He expected them to come to it not to admire a procession, but rather to hear a sermon. But in its central need his temple must accord with the great tradition. It must be the background of worship at the Altar. Beyond prayer and preaching his mind could hardly go. Yet, since his Cathedral is so reminiscent of St. Peter's, its interior is perfect only when we see it as the environment of some great act of national consecration or national thanksgiving. So one saw it in 1935, in the thanksgiving for the royal jubilee, and so—on a stretching canvas—in the Academy of 1936 Mr. Salisbury exhibited it. The interior has not much changed from the aspect in which Wren left it. He planned to build the vault with mosaics, and mosaics, of a kind, have since been set there: the High Altar has been completed in a sort of Baroque design that might have appealed to that rather opulent taste which we can trace alike in his early writings and in the design for a royal tomb which we can see in the Wren collection at All Souls'. Only in the windows is there any change to the spirit of his design. For mosaic and stained-glass windows go ill together even if both are good. And in this case neither is.

Wren was perfectly conscious when he built this basilica that

it was a return to the Mediterranean. And it is with a sense that we are still "leaguing with old Rome" [19] that we watch the curve and glitter of its outlines rise to share height and colour with the clouds. Whether it looms like Mont Blanc out of the narrow gorge of Paternoster Row, or whether—a link between Westminster and the Tower—we see it from across the River as the mother and mistress of London, it is both a monument of England's Christian heritage from Pope and Cæsar, and a prophecy of that ministry of peace which, both within the Empire and among other nations, has been the vocation which the Sovereign's conciliatory administrators have tried, not always vainly, to answer. In the heterogeneousness and soot of London, St. Paul's maintains alone the sense of order which is given us by the whole design of Paris, and which impresses us in every architectural monument of either Pagan or Renaissance Rome: those who heard England's liturgy in Wren's basilica were raising their hearts to the throne of heavenly grace on a paraphrase of Latin collects: so in England they could yet be citizens *"di quella Roma onde Christo è Romano"*.[20]

VII

Although he leaned so hard on classic memories, Wren was not less an Englishman for that. Without what has been brought to it from "lands of palm and southern pine",[21] how would Wren's island have played its part? What would its ideas have been, what would be its language, what its blood? By strengthening the Latin component in the amalgam of the British Isles, the great architect gave London a metropolitan temple which patriots have rejoiced to vindicate as more excellent because more English. And it is true that St. Paul's shows, alike in position as in design, the compromise that was wrung from Wren. He was not allowed around it an approach in a rebuilt city of which it would be the queenly ornament: he was not allowed to build around it a colonnade such as Michelangelo designed for St. Peter's, or as Bernini developed into an approach. He was not allowed to place above its High Altar an adaptation of those contorted columns and that baldachino which break into the interior of St. Peter's with such bizarre surprise. He could not even place the façade to confront Ludgate Hill direct. It slants aside, and from the oval of shops and

warehouses of what we call the Churchyard its only defence is a meagre space of grass and a few elms. These are all that is left in London of that enshrining and wide quietness which enhances the sacred dignity of Canterbury, of Salisbury, or of Lichfield. St. Paul's is the compromise with one man's patience.

That patience is one with the intrinsic mildness of our island life. Like the Cathedral, the beauty of his churches, St. Stephen's Walbrook, or St. Lawrence Jewry (with its unrivalled vestry), fits it and breathes it. It is born to us with climate and the scene. Here neither snowy crag nor gorge nor precipice disturbs the curve of hill or moor or down; and ocean current softens for us the winters which freeze our closest neighbours; even if it is disappointing weather, the rain drops so gently as to suggest to our dramatist the quality of mercy, and breezes from a silver sea temper the rare offensiveness of a sun on whom we press our invitations. This tempering nearness of the ocean mingles with clouds of smoke to soften light and colour. And even when England is not covered with a canopy of vapours, tones of grey recur in the clearness of the sky. There can be sultriness or murk over the profusion of lush green shades which mingle lawn and field with lime or sycamore, with beech or walnut; but none can complain that tones or outlines are too definite. St. Paul's is part of this English scheme. The island story has been similar to the island temper. Compromise has engendered continuity. Respect has not been wanting in a society so respectable, and voters still defer to those from whom they extract the taxes. The absence of disturbance has encouraged an aptitude for commerce and thoroughness: and in the midst of successful business, Wren raised St. Paul's with the King's help of a tax on coal. His thoroughness he showed in the way he dug down for the foundations, in the strength with which he arranged and built his piers to take any thrust from walls and roof, and in the triple dome: for between what is seen within and what is seen without rises a cone of brick to support the higher lantern. In architecture, mathematics must be applied with a love of line and shape. Many a curious and recondite device in building shows that Wren as an artist was not more a genius than as an engineer.

VIII

Incontestably the graceful outlines he evolved have given both his façade and the emergence of his dome a grace which cannot be justly claimed for the inexorable *baldanza* óf St. Peter's. But few can contemplate the *interior* without a sense of question. The grand simplicity of towering piers and arches, the long, open vista, the heights of frescoed dome, and then, as the eye turns towards the Altar, the rich workmanship of Grinling Gibbons in the choir stalls, the consummate ironwork of Tijou in the grills, what is there here which recalls the great Apostle as St. Peter's primacy is suggested in the Vatican basilica? For whom could these stones say: "To me, to live is Christ"? It is true that in this organ-music of building there is again a reminder that the Church is corporate: "the whole body fitly joined together and compacted of that which every joint supplieth, according to the effectual working in the measure of every part, maketh increase of the body unto the building up of itself"; that mutual architecture of unity is the spirit of Christ, and so, by a natural exchange of illustration, the Apostle explains how the building fitly framed together grows into a holy temple. That central teaching of St. Paul's was here magnificently exemplified. And yet is it not hard to realize that in this house one is a partaker with the saints in light? Is there not in these gigantic and most noble forms a sense of something lacking to the true conception of baroque? Do not the spaciousness and unity of the style seem blank in an interior unless it is made gorgeous by coloured ornament and polished marbles? Can one truly say that in this temple "everything saith glory"? [22]

Wren at the end had many disappointments; it is true that he brought Tijou from Paris to make the grills of wrought iron: it is true that in Grinling Gibbons he made the choir as beautiful as it could be made, for Gibbons, as Horace Walpole said, "gave to wood the loose and airy lightness of flowers, and chained them together in a fine disorder natural to each species". [23] But Wren dreamed of an opulence of shine and colour, such as an unexpected revival of Baroque was to give long afterwards to the interiors of Newman's spacious oratories at Brompton and Edgbaston. But the new scientific spirit, which grew up with the Royal Society, in the inception of which he and his

FROM GOTHIC TO BAROQUE ARCHITECTURE: THE CATHEDRAL OF SEGOVIA (from a painting by Axel Haig). Southern Gothic joined its influence with the classic style to create Baroque, which was an architecture of passion, above all of passion for infinity, and was apt to change from majesty to explosion, as in the outlines of Segovia.

friend Bishop Sprat had been active, was no longer incorporated into the conceptions of the faith. Before Wren died, the most alert minds were ceasing to be Christian: living to be over ninety, and surviving in England two revolutions, he must have learnt before the end how much the times had changed.

Nevertheless, within as without, his metropolitan temple bears witness to the fact that Christianity could still engender sublime conceptions: and St. Paul's is not complete till it is peopled with worshippers, till the pure notes of his contemporaries, Purcell, or Bach, or of Byrd and Tallis, his Elizabethan predecessors recall to them the blessed hour

> When such music sweet
> Their hearts and ears did greet
> As never was by mortal finger strook;
> Divinely warbled voice
> Answering the stringed noise
> As all their souls in blissful rapture took.[24]

It is when people fill with music and colour the void spaciousness of his interior that then also the design of vault, piers, cornice, arches, and entablature coheres into a whole as true as that which unites the portico, the lantern, the walls, the windows, and the steeples with that Dome which has been well called the Dome of London.

CHAPTER XVII

[1] *Dictionary of National Biography*, Vol. XXI, p. 995.
[2] *Parentalia*, p. 261.
[3] See Loftie, *Inigo Jones and Christopher Wren*, pp. 98–101.
[4] Geoffrey Scott, *The Architecture of Humanism*, p. 216 (2nd edn.).
[5] G. Scott, *op. cit.*, p. 240.
[6] Loftie, *op. cit.*, p. 258.
[7] *Parentalia*, p. 261.
[8] *Ibid.*, p. 287.
[9] *Sir Christopher Wren, Memorial Volume* (1923), p. 214.
[10] *Ibid.* (1932), p. 206.
[11] *Parentalia*, p. 261.
[12] W. H. Ward, *Architecture of the Renaissance in France*, Vol. II, p. 356.
[13] See Catalogue of Wren's Library in the Bodleian.
[14] He built the chapel of Pembroke, Cambridge, but not, as is so often said, that of Trinity, Oxford.
[15] See Lena Milman, *Wren*; H. Goodhart Rendel, *Vitruvian Nights*, p. 10.
[16] *Paradise Lost*, I, 710, 711.
[17] Scott, *The Architecture of Humanism*, pp. 17, 18.
[18] Milton, *Church Government*.
[19] Herbert Trench, *The Vine*.
[20] *Purgatorio*, XXXII, 103.
[21] Tennyson, "The Daisy".
[22] Psalm XXIX, 9 (A.V.).
[23] H. Walpole, *Anecdotes of Painting* Vol. II, p. 552 (edn. 1849).
[24] Milton, *Ode on Christ's Nativity*.

THE CHIEF WORKS OF WREN. The great Baroque tradition is the material out of which the English genius of Wren built up through thirty to forty years the gradual design of St. Paul's Cathedral, as we know it. [By courtesy of "Country Life," Ltd.

I

As Wren found his chief architectural inspiration from Bernini in Paris, naturally there is very little in the spirit or temper of Wren that could not be paralleled at the same time in Paris.

The first sign of genius losing direction in the order of unity was shown in the spirit of France, and it first became apparent in the philosopher whom the Jesuits trained as a defender of the faith. Descartes seemed to be going to the root of the matter when he based his system on the pure reality of thought; and Corneille seemed true to the Christian tradition when he made noble ideals the guiding principles of his heroic compositions. But in each case logic was invading the realm of the spirit. Order, instead of a universal complexity dominated by the final unity which was evolving the lower natures out of chaos, was taken to be a plan, comprehensible by one man's mind.

The Jesuits had evidently not given Descartes sufficient warning against the error of thinking that the Divine plan could, if attentively studied, be wholly understood. They had taught him the supremacy of mind over matter without convincing him that the outward world of nature was man's appointed home, was not only chief nourisher of the body but moulder of the mind: he had not, in fact, grasped that man was created neither heavenly nor earthly, but as an interreaction through some subtle agency of nerves and blood between the soul and sense.

In the system of Descartes, the mystery of knowledge, and the power it has of establishing a communion between the man seeing and the thing seen, became an act of immediate, individual apprehension. "Each individual", he wrote in a famous sentence, "can mentally have intuition of that fact that he exists and that he thinks", and then he advanced with a single bound to a statement that a man can have an intuition that a triangle is a figure bounded by three straight lines.[1] If such statements as these are made the basis of one's philosophy, the hope of a religious art will be strangled. In the first place, the outward world, being a shadow of thought, and not an essential factor in the life of its concepts, will cease

both to inspire the heart, and to sustain the imagination. In the second, the word intuition will lose its nobler meaning of a power to know through loving communion a truth of life hidden from the outward eye; it will become merely, as Descartes describes it, the conception which an unclouded and attentive mind gives so readily and distinctly that we are wholly freed from doubt as to that which we understand;[2] in the third place, the outward world will become a system independent of the mind surveying it:[3] philosophy and science will be so far apart that they can hardly recognize each other's cogency. The heavens, as Professor Whitehead says, will lose the glory of God: the Saint, he might have added, will have no reason for trying to remodel the world upon the heavens or make it a theatre for the designs of Wisdom. And thus we come to the fourth result of this philosophy: it loses that sense of the unity of order in the Universe[4] which enables the creative artist to convey through imagery a sense of timeless being, or to express a vision which makes eternity dear to the heart.

How without this can one learn from imagination that the beauty of holiness, as contemplated and known to worship, brings us to the true significance of those poignant hints and longings for eternal things which give something of holiness to our love of every image of beauty?

So much can be urged against the Cartesian system: so much was sensed instinctively already by Bossuet,[5] and though it would fail to do justice to the real element of truth in Descartes' own intuitions, it is not untrue in relation to the modes of thought among which his philosophy finally became current. For he was himself not the cause, but the index of a civilization which was losing that sense of ordered unity in the world which is the aim and the ideal of the Catholic Church. It was not merely schism in the West: in Catholic France and Protestant England alike, the process of disintegration was remarkable. In England Lord Herbert of Cherbury had set forth a system in which a vague religious sense could be accepted as the background of philosophy without involving Christianity. Hobbes had insisted that the State was the supreme master of the instincts of man. Locke had based his philosophy upon the immediate data of the senses. In France the absolutism of Louis XIV gave the impulse of a concrete example to reinforce the tendencies of Hobbes: and out of his France rose the quarrels

of the Jesuits, first with Jansenism, and then with Quietism, as there arose also the critical philosophy of Bayle; it was felt that truth instead of being the special prerogative of Christianity was scattered indiscriminately.[6]

The "most Christian King" was a supporter neither of the Papacy as a centre of unity, nor of the unity of Catholic countries among themselves. Completing the designs of Richelieu, he combined with the Protestant Powers to thwart his Catholic rivals; and while he disrupted Europe in the Wars of the Spanish Succession, he succeeded in throttling the Spanish genius when he placed a Bourbon upon the Spanish throne.

In Spain itself creative genius was showing signs of weakening. Much of its richest blood was passing to the Americas, where it set up memorable masses of Baroque architecture as monuments of the Church over the most luxuriant ranges of the New World.

For the Spaniard, likewise, the earth was growing dim in a mist of unreality, and in spite of the wealth of his towns, and the virility of his peasantry, he began to say with Calderon that

> Our treasures trifles seem,
> And all our life is dreaming,
> And the dreams themselves are dream.[7]

The knightliness of the heroic Society of Jesus, which had made of the Portuguese Colony of Goa a Rome in Malabar, and civilized the Indies of Columbus for Jesus and Mary, could not in Spain itself add the strength of imagination to the intensity of fervour. In Italy, the death of Bernini closed an epoch. Guido Reni failed to indue the sorrows of his Redeemer with the passion and energy of his Atalanta. Rome itself was forced to repudiate the latest fashion in piety which Molinos popularized in Spain, and Madame Guyon at the Court of the Grand Monarque. Prayer itself, even in the mansions of its secrecy, had apparently taken on a taint.[8]

And yet in the works of creative imagination the grandest traditions of humanism stood firm against the new activities of the scientific mind. These, like hordes of worms and insects, performed their necessary function of transmutation by eating away the raw material of which man's imagination had constructed its outstanding monuments. Milton had pillaged the world for images of things august; Rembrandt, by concentrating

golden lights among rich auburn shadows, gave Dutch Jews and merchants an atmosphere which made them august, beautiful and vague: and for the Holy Family he could do little more; Rubens had assembled in a blaze of light the strength of wild animals in the chase, the glitter of courts, the fertility of handiwork and fancy employed in the dresses of rich women, and—as the consummation of sumptuousness— the rolls and cushions of flesh in the bodies themselves of these well-fed women. Racine had expressed the passions of love and jealousy with the finish he had learnt from classic models for the Court of a Sovereign round whom not only France, but even Europe, circulated as planets round a sun.

II

Here, in this central Paris, France began to abandon its dear Gothic disorder and exchange it for an Italian regularity; this was made yet more elegant by an indefinable but undeniable suggestion of the preciousness of women. Here, in this Paris of Colbert, Racine, and Mansard, lived at the same time two men who left in their writings and their lives new monuments, unarguably great, of the genius of Christendom. On the one side Pascal, as the opponent of the Jesuits, left a record of religious experience meeting with, and surviving in its intensity, its conflict with the rationalist temper within himself; on the other, tradition rose to new heights of imaginative grandeur in the style of the great Catholic preachers who, affronting the powers of disintegration, maintained the power of the spirit which had been the master of European genius for half a thousand years.

Among the preachers were Fléchier, Mascaron, Bourdaloue, and Massillon: but the greatest by far was Bossuet—greatest not only by the height of his eloquence, by his position at the Court of Versailles, by his historic arguments with Leibniz and Fénelon, and by his prestige in Christendom as a whole. His genius was like Dante's in its comprehension of history, of theology, and of affairs of state: and, like Dante's also, it found its final rest in imaginative soarings to regions of consecrated beauty, which, having within themselves the mingling and reacting mights of sky and ocean, lift us from formalities to the sublime. They give a higher significance to the common things

of earth, as the perfect host gives to all his hospitality the
delicacy and solicitousness which others cannot extend beyond
their rarer affections.

Both Pascal and Bossuet were, in their ways, representa-
tive of the age. Both were steeped in the influence of St.
Augustine: but one completed tradition in the splendour of
the faith, while the other fascinates us by his *naïveté*, by his
simplicity, by a personal acumen which owed very little to
learning, and much to the new temper of science which has
since gone far towards guiding our habits of thought.

III

Pascal therefore is not an elaborator of Platonic theories:
for him beauty is not so much an ultimate reality as the result of
man's pleasure and choice. *Se moquer de la philosophie*, he wrote,
c'est vraiment philosopher.[9] And though he admitted the necessity
of rules, he could not approve formality. His view of eloquence
was that it was an adaptation of thought and expression to the
mind and heart of the person addressed. "We must put our-
selves", he said, "in the place of those who hear us, and be as
natural as possible . . . for it is not enough that a thing should
be beautiful: it must be proper to its subject, with nothing
lacking and nothing in excess."[10]

There is, he continued, a certain model of pleasantness and
beauty which consists in a certain agreement between our
nature, such as it is, in its strength and weakness, and the thing
we like. In a word, Pascal was conversational and content that
things should be in good taste. Imagination in its grander sense
he did not understand. He used the word for the faculties which
divorce us from real life, which make sport of the reasoning
intelligence, and replace it with false and morbid instincts.
By him the noblest part of man's nature was named the heart,
and the heart was an instinct of love.

It was here that Pascal joined with the Platonist tradition.
"We are born", he wrote, "with the characters of love written
in our hearts, characters which grow clearer as the mind grows
finer. They incline us to love what seems beautiful to us
without anyone ever defining what that is. Who then can think
we are in the world for any other reason than love? Really
one cannot disguise from oneself the fact, that one is always in

love. Even in the things when one seems to act apart from it, it can be discerned hiding and ·in secret. Man cannot live a moment without it." [11]

Man must love an object not less noble than himself: there must be a kinship and resemblance, such as one finds defined and limited in the other sex. Each carries within himself (or herself) an original idea of beauty, of which he seeks the copy in the world. For it is not in nakedness that one loves beauty: one demands from it a thousand graces which depend on one's mood, and it gives fresh impulses to every faculty of one's mind. Certainly it is a mystery, as Corneille had guessed, saying in *Médée*:

> *Souvent je ne sais quoi qu'on ne peut exprimer*
> *Nous surprend, nous emporte, et nous force d'aimer;* [12]

and again in *Rodogune* he said that lovers

> *S'attachent l'un à l'autre et se laissent joigner*
> *Par ces je ne sais quoi qu'on ne peut expliquer.* [13]

The cause, said Pascal, is a *je ne sais quoi*, and the effects are terrible. A highly strung invalid, he indeed knew what it was to live in a state of tension which takes reactions of mind and emotion on one another strained to the last degree.

The peculiarity of his philosophy is the supreme preciousness of experience. Sensitive and sincere, he carries us forward by his shrewdness and insight. His style is definite and incisive, even when he writes of mysteries. His sentences are short and alert, even when he is dealing with the most complicated subjects. The impatience of his eager intellect made his habit of expression almost explosive.[14] Wit, sarcasm, feeling, fashion he knew and employed as a finished Parisian: and he could combine all into eloquence when he spoke for the Jansenists against the Jesuits. "Bien penser, bien sentir et bien rendre"[15]— he did all together in a flash of lightning.

His importance in the history of criticism is as significant as his place in religion. He fascinates us by his sincerity. A single-hearted acceptance of religion is always worthy of reverence, and is often combined with charity, but it is not only for natures who have the gift of love with the fervour of a pure heart that the Church exists: they could almost do without her; and we could not make up the world itself of them alone. The Jansenists of Port Royal, whom Pascal loved and imitated

and where his sister Jacqueline was a nun, were a holy company: they had broken with the world; they lived in the fear of God; their habits were austere. They believed that certain souls were predestined to heavenly joy, and to them the grace of God was all in all.

The Jesuits had other types in view. They saw that there was much of good in human nature, and sought to make the most of it; they recognized that the Church must keep in touch with men and women of the world, enlist their aid, offer them help, and make at certain times a compromise with worldly wisdom, even though that, in the ultimate resort, should be foolishness with God, for an absolute dependence on Divine Grace would soon lead to a fatal laxity of fibre and will in the less religious types.

But Pascal saw the danger of this attitude. He knew that the Jesuits' compromise with worldliness could encourage formalism and laxity; he therefore vindicated with all the force of his intense, impatient, spiritual unworldliness the need of an austerer life. In his *Lettres Provinciales* he pleaded for a more entire dependence upon Divine Grace with a force and fire which make them, in spite of their theological preoccupation, a landmark in literature. Much of his energy was absorbed in a theological subtlety: in considering, and arguing against, the distinction between sufficing and efficacious grace, between the grace which gives us an original participation in the Divine nature, and the additional grace which gives us the power to translate this original state into an active life. This distinction had been worked out by Aquinas centuries before the Society of Jesus was ever thought of, and came definitely closer to grappling with the problem of reconciling man's free will with his entire dependence on the generosity of the Almighty.[16] But to Pascal it was a stumbling-block: one finds a touching picture of his mind in an adjuration to the Dominicans in the second of the *Provincial Letters*:

> "This victorious grace, awaited by the Patriarchs, foretold by the prophets, brought into the world by Christ, preached by St. Paul, explained by St. Augustine, the greatest of the Fathers, embraced by those who followed him, confirmed by St. Bernard, the last of the Fathers, sustained by St. Thomas, the angel of the Schools, by him transmitted to your Order, maintained by so many

of your fathers, and so gloriously defended by your Order under Popes Clement and Paul: this efficacious grace, which had been entrusted to your hands so that in a holy Order unfailing for ever there should be preachers who should publish it to the world unto the end of time— this grace is now found abandoned for the most unworthy interests. The time has come for others to take up arms for its sake: it is time that God should raise up courageous disciples of the doctors of grace who ignoring the engagements of the world should serve God for His sake alone. There may be no more Dominicans to defend grace, but it will never lack defenders, for it will form them by its almighty power. It asks for hearts pure and unentangled. Itself it purifies them and disentangles them from those worldly interests which are incompatible with the truths of the Evangel. Think well of this, Reverend Father, and take care that God does not remove this torch from its place, and that He does not leave you in darkness, and without a crown, to punish your coldness for a cause so important to His Church." [17]

Touching and effective as this passage is, it is not less interesting because Pascal had missed the point that grace is given to natures less pure and devout than his.

<center>IV</center>

The significance of Pascal is not only intrinsic, but prophetic. He has attained a greater importance than his actual quality of work would urge, because his individual piety and his insistence on a life so pure and holy that it will lead to eternal joy, were not only a reaction from a tainted and compromising temper in the Church; they were precursors to an age when the faith grew rare and dim, and most men were preoccupied with the world. For Pascal's individual reaction against lukewarmness, his inclination towards Jansenism, meant on the one side that the religious tradition was too ashy to hold a light before the cultured mind. Christendom, being divided and uncertain of itself, offered individual opportunities in Church and sect; but it no longer provided the medium in which genius displayed for the masses its conceptions of grandeur and beauty. The Christian revelation had lost its prestige. The intensest minds

studied other mysteries, and benefited the world by other discoveries.

The French Church, however, had still within it one of the most gorgeous minds of Christendom; it was yet to build up a monument as impressive in its classic order and its sumptuousness as the Churches which the preceding century had built in Rome or Venice. This Palladian genius was Bossuet. He exemplified the dictum of Pascal that religious truth must exceed clear definition; "*outre nos idées claires et distinctes,*" wrote also Bossuet himself, "*il y en a de confuses et de générales qui ne laissent pas d'enfermer des vérités si essentielles qu'on renverserait tout en les niant.*" [18]

Bossuet's theory of art was an elaboration, and to some extent an adaptation of the theories of St. Augustine, and they in turn had been adapted by Aquinas and Dante.

"Certainly there is within us", he said, "a heavenly brightness. The light of Thy countenance, O Lord, is imprinted upon us. And it is there", he continued, "that as in a luminous globe, we discover an immortal complaisance in virtue and right conduct. It is the original Reason which by its images within our conscience, within our sense of law and of order, makes clear to us a picture of itself. It is the Truth itself which speaks within and which should show us clearly that in our natures there is something undying": for we prefer sacrifice to comfort, and courage to life itself. The moral order is thus founded on the same principle as our enjoyment of a preciser order in works of art. Everywhere alike, in spite of his languor, his weaknesses—must we not add his coarseness?—man has an instinct for high, even for eternal things. "Our shameful weaknesses cannot hide our natural dignity." We are ever renewing our effort to find this dignity: we hardly know what we mean by the word spirit : our imaginations, unable to conceive of pure spirits, are always diluting the idea of them with some notion or feeling of a body: but after the imagination has made its last effort to subtilize and unloose these spirits from the notion of something material, does one not feel at the same time, rising from the depths of the soul, a heavenly light which puts to flight these phantasms, even though they were the most delicate and ethereal that we could conceive, and points us to some secret energy and power, some hidden spring, which, even though its action is constrained and intermittent, shows us that, somewhere in the veriest recesses of the soul, there is another principle of life? [19]

This is the argument in which, after the lapse of many centuries, the learning and inventiveness of Bossuet apply themselves to that which was left unsaid in the *Enneads* of Plotinus. And it led him to a preciser view of Christian art. God was still the original Artist, the prime Inventor. And to Bossuet, as to Philo, the secret of art was best understood when one had conceived of the likeness between God's creativeness and man's.[20] *Nous ne pouvons égaler nos propres idées*, he said, *tant celui qui nous a formés a pris soin d'y marquer son infinité*. Taking up, as Sir Thomas Browne had done before him, the thought of St. Thomas Aquinas that nature is the art of God, he founds his theory of art on his belief in God as the Creator alike of man and of the world. Man, he argued, has changed the face of the world: he has tamed the animals which far surpass him in strength, training their rough temper and their intractable freedom to his service: by his skill he has bent the stubbornness of inanimate masses and metals; the very earth has been forced to give him the most delicate repasts, plants have corrected in his favour the rough or sharp tastes of their unnurtured growth, the very poisons have been transmuted for love of him into medicines. He has become master of the elements: for are not fire and water his domestic servants? And, mounting to the heavens of space, he has taught the stars to guide him in his travels, and the sun to give account of all his steps. How could so weak a creature, a creature physically vulnerable by any of the others, assume such an ascendency over them, if there were not within his spirit a power superior to that of all visible nature, an inbreathing of the immortal from the Holy Spirit, a ray of His aspect, a feature of His likeness? No, no, said Bossuet, it could not but be so. And so we arrive at an understanding of the nature and scope of art.

"If an excellent workman has invented some engine, no one else can make use of it unless the workman has explained it. God has invented the world like a great engine which only His wisdom could devise, only His power construct." "O man, He has established thee to use it, He has, so to speak, put in thy hands all nature to apply it to thy services: He has even granted thee to elaborate and beautify it by thy art; *for what is art but the beautifying of nature?* Thou canst add certain colours to elaborate this admirable picture: but how couldst thou even in the

slightest move a machine so powerful, and so nicely adjusted: or how couldst thou add even one suitable feature to so superb a picture unless there were not in thyself, and in some portion of thy being, some art derived from the original art, some secondary ideas drawn from those original ideas, in a word, some resemblance, some overflow or emanation, some partaking of that constructive Spirit which has made the world?" [21]

V

In these eloquent questions, where argument and conviction intermingle in harmonies of word and thought, Bossuet, completing the speculations of Philo, Plotinus, and St. Augustine, has left at the last height of five centuries of consecrated genius the final statement of its *raison d'être*. For St. Augustine was to him master and guide. And he was the link between the African Platonists and Shaftesbury, and through Shaftesbury with Goethe. What Velazquez had done on canvas at Madrid for the Court of Philip IV, Bossuet did at Paris and Versailles for the Court of Louis XIV, in the series of portraits he painted in words in his *Oraisons Funèbres*. They both took princes and princesses whose outward semblance was scarcely beautiful, and by throwing on them unexpected lights, and putting them in well-arranged settings, they made each portrait into a work of art, and a joy for ever. But whereas the background Velazquez found was the plateau, the sierra, and the snow, the very setting of Bossuet was still the Court; but instead of the Guadarrama, and its icy winds, the background of his portraits is the eternity which opens upon the faith. Velazquez had told little of religion, or of death. To Bossuet these gave a splendour of canvas which surpassed both the Byzantine impressiveness of El Greco and the harmonious hazes of Murillo.

For to Bossuet death was not ghastly, nor did the heavens open to show a human eye some halo, some vapour or emanation from an etheric or astral plane throwing the emphasis of sanctity on the figure he depicted. His object was to show his prince, or princess, moving certainly in the dignity of a Court, but enduing its formalities with a spiritual interest pregnant with infinite joys and sorrows, because each vicissitude of life offered a means of grace and bore within itself a hope of glory.

Men's days in the palaces of Paris and Versailles, as at White-
hall or Hampton Court, involved a universal issue common to
humble people, especially when they drew near to death.
Grace, faith, and death were realities so towering that before
them the differences between the prince and the poor man
hardly mattered, "as the rivers so highly vaunted remain
without name or glory lost in the ocean with the streams that
were most unknown." [22]

<div align="center">VI</div>

Look at men and women with intense care for them; see
them in the true light which exchanges judgment for charity,
which replaces what is obvious to the mere human eye by the
knowledge that man was made in the image of perfection and
meant to know the secrets of the abyss, meant to know The
True Being, Being Timeless and Unmeasured, Being unre-
strained by matter or passion, so that man by intuitive contem-
plation could share in the "central peace subsisting at the heart
of endless agitation".[23] See man able to live on this scale—even
though he could not rise to it without a wrench from low-
thoughted cares, from staleness, from sordidness, from vul-
garity, from wranglings, from lusts—and you will see what
raised the learning and imagination of Bossuet to the mightiest
harmonies of French prose: you will see how he beautified an
occasion or a character, because his heart was full of sympathy,
and, in its love for men, saw glory shining through them. Take
Henrietta Maria, the Queen of our Charles I, the Queen we
know in the portraits of Van Dyck, as a melancholy but pleasing
person, ennobled afterwards by tragedy, earlier by a crown.
English history has told us little of this lady but that she
brought her Papist worship to the Court. But a single para-
graph of Bossuet turns her into a mistress of romance.

> *Vous verrez dans une seule vie toutes les extrémités des
> choses humaines: la felicité sans bornes, aussi bien que les
> misères: une longue et paisible jouissance d'une des plus nobles
> couronnes de l'univers: tout ce que peuvent donner des plus
> glorieux la naissance et la grandeur, accumulée sur une tête qui
> ensuite est exposée à tous les outrages de la fortune: la bonne
> cause suivie de tous succès, et, depuis, des retours soudains, des
> changements inouïs; la rebellion longtemps retenue, à la fin tout-à-
> fait maîtresse; nul frein à la license; les lois abolies, la majesté*

violée par des attentats jusques alors inconnus; l'usurpation et la tyrannie sous le nom de liberté; une reine fugitive qui ne trouve aucune retraite dans trois royaumes et à qui sa propre patrie n'est qu'un triste lieu d'exil; neuf voyages sur mer entrepris par une princesse, malgré les tempêtes; l'Océan étonné de se voir traversé tant de fois en des appareils si divers et pour des causes si différentes: un trône indignement renversé et miraculeusement rétabli. Voilà les enseignements que Dieu donne aux rois.[24]

It was but a year after he had painted the portrait of the mother that he was called to speak of the sudden death of her daughter, of this second Henriette who had married the brother of the great King. Hers was a character less tried, but sweeter and more charming:

"Do you recall, gentlemen," asked the preacher, "the admiration which the English Princess awoke in the whole Court. Your memory will paint it better in the features of its incomparable gentleness than all my words could ever do. She grew up amidst the blessings of all ranks: and the years ceased not to adorn her with new graces." But above all he praised her for her reticence. "Under a smiling face, under a look of youth which seemed to promise only play, she hid a prudence and wisdom which filled with surprise those who had to do with her.

"Far from responsibility for business and social ties, souls who lack both strength and faith are unable to restrain their indiscreet tongues: they lie, says the Wise King, like a city without walls, open on every side, and which becomes the prey of the first comer. How high above this weakness was Madame! Neither surprise, nor the hope of advantage, nor vanity, nor the soothing of delicate flattery, nor sympathetic conversations which often, as they move the heart, incline it to pour forth its secret—these could not make her reveal hers; and the fixity which one found in this princess, which her mental gifts made so congenial to high affairs of state, persuaded one to entrust her with the weightiest."

The greatest masters of French prose have seldom found a subtler analysis, a juster expression than this: *ni l'appât d'une flatterie délicate ou d'une douce conversation qui souvent épanchant le cœur en fait échapper le secret n'était capable de lui faire découvrir le sien.*[25]

VII

These fine insights, where the grace of his praise for his princess conveys a lesson and a warning for us all, were accompanied not only by great warmth of heart, not only by the courtier's tact and experience, but by a poetic gift for the beautiful and the sublime which put his references to history and politics on a level with those of Burke: neither logic, nor learning, nor theory, ever stood alone. His reason, at every point, received instruction from his feelings;—it rose with his imagination as on the wings of an eagle: it ran and did not weary: it walked and did not faint. For it was not in vain that Bossuet waited upon the Lord. "In the rank of writers", wrote Paul Valery, "I know of none above Bossuet." And here Valery was but echoing the classic judgment of Vauvenargues. *"Connaissez vous,"* asked *"la majesté et la magnificence de Bossuet? Croyez vous qu'il n'ait pas surpassé au moins en imagination, en grandeur et en sublimité, tous les Romains et les Grecs?"*—And he singles out for special praise the *Oraisons Funèbres*, where, he says, Bossuet had "equalled perhaps the greatest poets both by the singular enthusiasm which fills them and by that imagination ever coming to a new birth, with which no one was as endowed as he, and again by the deep emotion he can arouse, and finally by the boldness of his transitions which, more natural than those in our great lyric pieces, seem equally astonishing and more sublime." [26]

And the last effort of his eloquence—which again Burke was to echo—is not the least touching; in the Christian death of the Grand Condé, the preacher saw the general more triumphant than at Fribourg or Rocroi. "Charmed with so fine a triumph," said the preacher, "I shall repeat in thanksgiving the beautiful words of the beloved disciple: This is the victory which overcometh the world—our faith. Enjoy this victory, Prince; enjoy it for ever by the undying virtue of this sacrifice. Accept these last efforts of a voice you knew. It will be the last of all my utterances. Instead of mourning the death of others, great Prince, I wish henceforth to learn from you how to render my own death holy; happy if accepting from my white hairs a warning of the account that I must give of my stewardship, I keep for the flock which I have to nourish with the word of life all that is left of a voice which is failing and a fire which is

dying away." [27] "At this last effort of human eloquence" wrote Chateaubriand, "our eyes were wet with tears of admiration, and the book dropped from our hands." [28]

VIII

Bossuet had a genius both of choice and of arrangement: he mingled the personal with the universal: in the poetic phrases of the Bible he was always finding a novelty to freshen, to adorn, to point, and to deepen his thought. Bunyan's genius was not more built out of the Bible than was his. To his tact and knowledge of the world he added an instinct for affairs. And his own affinities with beauty showed him beauty where another would have seen only boredom—or bareness. A good little girl goes to a convent: let us see what Bossuet makes of it: "In the solitude of Sainte Fare, as far removed from secular ways as its happy situation separates it from the traffic of the world, in this holy hill which God had chosen for his own a thousand years before, where the brides of Christ had given back to life the beauty of ancient days: where the joys of earth were unknown; where the steps of worldly, inquisitive, restless wanderers came not; under the guidance of the holy abbess who knew how to give milk to babes as well as bread to the strong, Princess Anne's beginning was happy. The mysteries were revealed to her; the Bible became familiar to her; she learnt Latin because it was the Church's language: and the Divine Office was her delight." [29]

Bossuet's style was the image of a mind, rich, elevated, and wise. The secret of his life was his passion for the fullness of peace in society, for the order which that implied, and for the beauty this order of life meant in every phase, but, above all, in the style which expressed the life which his concepts took within him. He traced and completed the laws by which inward and outward things were related to one another; like St. Augustine, he traced a divine plan in the history of the world; like St. Augustine, he was haunted by the ideal of a perfect society, and aimed at conciliating all so that they could enjoy the benefit of the conviction which made him thankful: the conviction that life is at its noblest when the order of its unity is continuous. "Rising from peak to peak till he reaches the heavenly mansions," says M. Hazard, "he comes at last to

that sublime state where prayer and poetry can no longer be distinguished, and where his speech breathes of naught•else but the whole movement of his soul towards the truth and beauty which are to last for ever." [30]

Whether he wrote on Universal History, on the Polities of Holy Scripture, on the knowledge of God and of oneself, or on the relation of the Catholic Church to the variations of Christianity around it, whether he preached, or talked, or wrote a letter to a friend, he was always the central figure of Christendom. "You are like another St. Paul," Lord Perth wrote to him on 12th November, 1685, "your words are not confined to a single nation, to a single realm: your works at the present time speak in most of the languages of Europe, and your proselytes publish your triumphs in tongues you do not understand." [31] A theological philosopher, a royal chaplain and tutor, and finally, a Bishop, he was above all a master of persuasion. His thought was deep; he was convinced by observation and by logic that faith was the best foundation for each. For what was the alternative? It was to exchange the paradoxes of the spirit for the superficiality of the sceptic. *"Les absurdités où ils tombent en niant la religion deviennent plus insoutenables que les verités dont la hauteur les étonne; et, pour ne vouloir pas croire des mystères incompréhensibles, ils suivaient l'une après l'autre d'incompréhensibles erreurs."* [32]

Left, then, as we are in a choice of ingenuities between a view of the universe which stuns reason by its absurdity, and shocks the heart by its vileness, and one which invites reason to step into a winged machine and reconnoitre from the air, Bossuet preferred the flight to the bombardment. By a combination of reason and sympathy, by a glowing, genial view of life as a social whole, and by a faultless taste, he ranged over mountain heights. Yet he was ever ready to come down to earth to observe the most delicate tissue of rare flowers, to enjoy the quiet meadows, the shade of pine-woods, and to drink from the shouting cascade. The air he breathes is always high and pure, and he is never beyond earshot of either running waters or tinkling bells, though at times the roars of storm and avalanche sound loud as battle.

IX

Ste. Beuve in his famous essay said of Bossuet that he was
"l'âme la plus calme et la moins combattue qui nous apparaisse".[33]
Rigaud in a famous picture has painted him as one inspired and
breathing in a sovereign majesty the words of power and glory.
But that was only one aspect of the great preacher.[34] Far from
being a mere angel of the Church Triumphant, he was deeply and
sympathetically conscious of those who felt forced to abandon
it; he knew that the sceptics were gaining on the world, whether
they kept some of the Christian religion or held the super-
natural to be an exploded delusion. Bossuet was therefore not
unacquainted with distress. It was not only that he could weep
with those who weep: it was not only that he understood the
changes and chances which are apt to bring dismay to the rich
and great as well as to the humble. But he knew himself that
the tide in the habits of men's minds had turned against him,
and that all that he valued was being menaced; he may have
realized that at the end of a sequence of centuries he was the
last of the great masters of Catholic genius. And it is deeply
significant that, like the contemporary Spaniards, he was so
often beside the grave, so often busy with the monument on
the tomb.

For it was death that in that epoch of disintegration both
affronted, and consoled, the men of faith. This world was
fading from them for a long 'season, and though they might
rise again, it would only be after a deep intimacy with cor-
ruption. But, though the vileness might be swept away that
another being should be prepared instead of it, yet the supernal
world was opening its promises to the eye of faith; saints were
recognized as stars. So in his rapture, Luis de León looked up
from the brief point of earthly life to the grand promises of
death which he saw in the "immense, clear, star-sown vault"
which canopied the plains of old Castile.

To Vaughan death had been beauteous, the jewel of the just.
It led him to an air of glory whose light trampled on his dull
glimmering days. To the clear mind of Sir Thomas Browne,
which took a more gamesome pleasure than Bossuet in the
paradoxes of faith, the man of God had a diuturnity more
assured than his tomb could pledge for him: on obelisk and
pyramid he looked as the irregularities of vainglory, for he had

learnt in his ingression into the divine shadow the ecstasy of everlastingness. It was that satisfaction, that completion, that surrender which shone on the dead face of the Count of Orgaz on the canvas at Toledo, as it shines in stone at Ravenna on the marble features of Guidarello Guidarelli.

Il ben nostro in questo ben s'affina
Che quel che vuole Iddio e noi volemo.[27]

Such, as we saw, had been the account of their joy which the angels in Paradise had given to him who questioned God's justice. The consummation of peace is in the final acceptance of the Divine Will as the end of all lessons of adjustment.

It was the sense of this which, in the seventeenth century, painter, sculptor, poet could give to their image of a dead face. The soul's hallowing of the body attained its most perfect beauty not in the glow of love's delightful dawn, nor in the raptures of its union, but after dissolution, when, taking flight, the soul had caught a glimpse of the life which was the perfect whole of peace and joy. That peace was a resignation so touching, so deep in gratitude for mercy, so sweet in blessedness, that it shone from the dead face, transfusing into itself the pity and tenderness on the faces of Saint and friend. Hope had seen through trouble and anguish; it had said even in the gate of death: "call to mind that which heretofore you have received of His goodness and live upon Him in your distresses".[36]

Such was the consummation, such the insight that marked the Baroque finale of that Renaissance which had come as sunrise after gradual dawn to St. Dominic and St. Francis, to Giotto and Dante, and which had gone onward in its long procession of shades and colours to this grave gorgeousness of twilight. It had called men to glorify themselves with a grace beyond their own attainment; now, when fewer cared for that, it still called the elect to eternity. And anticipating the line of Tennyson that all things will change, nothing will die; anticipating the play that Shelley was to make with the merry worm that feasted on the poet's buried flesh, it saw in the truth that flowers grow from earth, grow therefore out of graves, one aspect of the universal process: the new attitude of knowledge neither philosophy nor theology had been able to reduce to subservience. Theology no longer reigned as queen of the

[27] Dante, *Paradiso*, XX, 137–8:
And herein do we find the crowning good
That what is willed of God we also will.

sciences. All she could claim to rule was her own walled city. But looking out from it on a universe of vicissitude, and finally at death, she saw, with Bossuet, in death a hint of resurrection to a changed, but not a less precious life. And even in this world, though her sovereign state was no longer seen in the streets, she yet invited loyal followers to enjoy their former privileges in her diminished court.

CHAPTER XVIII

[1] *Discours sur la Méthode*, Part IV.

[2] *Principes*, I, 45.

[3] For a clear account of this, see *Enciclopædia Italiana*, Vol. XII, p. 662.

[4] Hazard, *Crise*, Vol I, pp. 174, 175.

[5] "*Je vois un grand combat se préparer contre l'Eglise sous le nom de philosophie Cartésienne.*" (Bossuet à Huet, 18 mai, 1669.)

[6] For a fuller discussion of this subject, see P. Hazard, *Crise de la Conscience Européenne*.

[7]
> El mayor bien es pequeño
> Y toda la vida es sueño,
> Y los sueños sueños son,
> La vida es sueño.
>
> *Jornada*, Scene xix, ll. 1200,1202.

[8] For the best account of this see Bremond, *Histoire du Sentiment Religieux*, Vol. III.

[9] *Pensées*, I, 4.

[10] Pascal, *Pensées*, 989; *Œuvres*, Vol. III, p. 123 (edn. Braunschweig).

[11] *Idem, Les Passions de l'Amour.*

[12] Act II, sc. vi.

[13] Act I, sc. v.

[14] Charles du Bos, *Approximations*, 2nd series, p. 82.

[15] So Buffon defines the need for style, *loc. cit.*

[16] Cf. Janvier, *La Grâce*.

[17] *Œuvres*, pp. 172–174 (Braunschweig edn., 1914).

[18] *Lettre a un disciple de Malebranche*, 21 Mai, 1687, quoted Hazard: *Crise*, L. 285.

[19] Bossuet, *Sermon sur la Mort*, 2me point.

[20] *Idem, Discours à l'Académie : Œuvres*, I, 742 (1841).

[21] *Sermon sur la Mort*, 2me point.

[22] *Oraison Funèbre du Grand Conde.*

[23] Wordsworth, *The Excursion*, IV, 1153–4.

[24] *Oraison Funèbre de Henriette Marie.*

[25] *Oraison Funèbre de Henriette d'Angleterre.*

[26] Vauvenargues, *Pascal et Fenélon, Œuvres*, III, 30 (1929).

[28] Dante, *Divina Commedia.* Chateaubriand, *Génie du Christianisme.*

[29] *Oraison Funèbre d'Anne de Gonzagne.*

[30] Hazard, *Crise*, Vol. II.

[31] Quoted in Hazard, *Crise*, Vol. II.

[32] Bossuet, "The absurdities into which they fall in denying religion become more difficult to believe than the truths, the loftiness of which confounds them, and through refusing to believe incomprehensible mysteries, they fell one after another into incomprehensible mistakes."

[33] *Causeries de Lundi*, X, 158 (edn. 1852).

[34] For an elaboration of this point, see Hazard, *Crise* Vol. I, p. 266.

[35] *Paradiso*, XX, 137, 138.

[36] Bunyan, *Pilgrim's Progress*, p. 157 (1926).

I

How far can we now set out our conclusion? Alike in words, in music, in rhythmic movement, in sculpture, in painting, and in architecture, the creative artist seeks to find in the harmony and order of his patterned design a simplification of experience which would at first suggest, and to some extent console, his longing for something afar from the sphere of his sorrow; for his observation was ripened by meditation until it was made so personal that, with all the spontaneity of passion, it could in ardour generate a new birth.

This fervency for an ideal, this power to satisfy hope out of experience, this way of looking before and after, this willingness to accept the strain and hurt of passion, is itself a spiritual vocation. It is so most of all when the artist, resolute in flight into the world beyond, faces the thunders and lightnings of the universe, and fights in the empyrean with affliction and with fear which his heart has carried there from grim acquaintance with the crimes, the waste, or the vileness to be found in the lives of men; and this distress of men is felt more sharply when outlined on a background of miserable circumstance. Where there is no cognizance of evil, no experience of suffering, there is a lack of mastery. The artist who is unwilling to strengthen his imagination or his faith by the sight of what is to be borne will forfeit heroism. For it is only the tender heart which has endurance. The strength of its sympathy gives it insight, and insight gives it knowledge of a value hidden to less searching eyes.

II

So it is that we attain to style. "The art of style", wrote Herbert Trench, "is to add to beauty and precision of expression the impression that reality lies behind his words, and the spirit of beauty in turn behind that reality." [1] The vivid experience of sense must be so closely personal in its touch upon the feelings of the heart that a communion with spiritual reality is opened from it. It is so that style attains its elusiveness and its distinction. Every artist is therefore an ambassador from Parnassus: *Dona Deum Musae*. The most moving works of

music and beauty carry us far towards mystical experience. And it was natural for Ronsard to say:

> *Dieu est en nous et par nous fait miracle*
> *Si que les vers d'un poete escrivant*
> *Ce sont des dieux les secrets et oracles*
> *Que par sa bouche ils poussent en avant.*[2]

Just as the fullest experiences of the religious mystic are more than a sense of silent communion, and illumine the whole scheme of life with convincing significance, so the mere concentration on outward objects keeps leading from them to a state of mind which Coleridge identified with religious devotion. In both these exercises joy enables us to see into the life of things: the outward beauty keeps mingling with life and life's own secret joy, and when the light of sense goes out, it is with a flash that has revealed the invisible world. It is in that moment when

> The heart and soul and sense in concert move [3]

that we find the exhilaration which leads us to artistic beauty of the highest order.

That exhilaration has a power to define. It turns back to a medium, whether stone, or colour, or words, and takes advantage of their limitations to stamp the order and unity of reason upon the form of its expression. It simplifies life by expressing it in terms of a single artistic purpose. At this point the purpose becomes an integral part of the concept: and alike in literature and in the arts, that purpose is to give a delightful sense of an intelligible perfection. The perfection involves too great a fullness of life easily to accept definition as moral, or even as religious. Art can enhance any ethical, any theological scheme: though more at home in one than in another, it reaches towards them all. The mind, when realizing its highest powers, sees nature, sees the whole universe, bound together in love and united in harmony with its own perceiving power.

III

For such is the effect of the Platonic temper on which it is founded. To the Platonic mood, as Professor Stewart once said, the endless variety of the sensible world and its beauties are the counterpart of an invisible or eternal, an ideal world which is

behind or within the sensible world, and maintains both it and the mind which perceives it.[4] And to this mood, which is the mood of one who knows by loving, the mind is lifted up by its curiosity about things seen, and its fine sense of their beauty and truth, into life in an invisible, eternal, ideal world which is still more true than the temporal or palpable world. So that each thing becomes, or rather is, the specific form of an idea which is a power or virtue of the one beauty of the Universe :

> Fresh births of beauty wake
> Fresh homage, every grade of love is past
> With every mode of loveliness, then cast
> Inferior idols off their borrowed crown
> Before a coming glory; up and down
> Runs arrowy fire, while earthly forms combine
> To throb the secret forth: a touch divine
> And the sealed eyeball owns the mystic rod:
> Visibly through his garden walketh God.[5]

The creative artist unites that sacred exhilaration with a scene or event; he reproduces but modifies his experience in a new communion with his medium. And so:

> "The poet is a winged being, as Plato said. It is not the action of visible and individual things which engenders his creation: he escapes their grasp and soars above them, receiving his inspiration from on high. But if the idea is born as it were of an immaculate conception, still, on the other hand, it is inconceivable that in its effort after development and expression the idea should disdain what the materal world already offers. No thought can come to full and real existence unless it becomes incarnate in a form, an image, a symbol." [6]

IV

A sense of exaltation marks the highest creative work, but it is not that which differentiates it as art. All that a man makes stamps the design of reason on raw materials to change them to what—if we may return to Stevenson—is called "a work of human art", and its form should be determined by a reasonable concept of rightness. Use is no poor criterion of words—or of saucepans.

But to art we have added another significance, the meaning of fine arts, the scheme of making things *per fine di bellezza*. Fine

art is distinguished from technical work by its delightfulness, by its pattern or arrangement, and by its endeavour for perfection; and finally, above all, by the spontaneous effect of the indissoluble and natural union of all these in the ripened and perfected concept which the experienced mind has generated by its intercourse with material in an act of which the work of art is the monument, having its own objective and energizing power. And material, far from debasing the ideal, gives energy and fineness to the mind's instinct for form. To make the exterior world the scene of his triumphs is a creator's inspiring privilege. In searching for fresh harmonies and elegances in his verse, Victor Hugo found that his thought itself became stronger, simpler, and truer.

Schiller and Plato agreed that art is a game. Plato, however, feared that it misled those who sought truth, because it was merely a representation of outward things which were themselves but the shadow of the true. But the art which creates beauty is very different from the shadow of a shadow. The mind's work of realizing its own potentialities and a material's is an act which brings us nearer to the final truth, which is itself a thought. The ideal world is not a gallery of inanimate forms, but the activity of a perfect mind seeing by intuition the truths which the mystic knows more deeply, but which come to us generally in the fullness of reason and discourse. Not inaptly did Johnson give the name of "invention" to the creative imagination.

It is because art is all this that it merges itself at its highest in the life of faith: it is an exercise not merely congenial but necessary to the full life of the faculties. "All great art", said Ruskin, "is praise." [7] It prepares the joint exercise of a believer's reason, his passion, and his imagination for the high ventures which the faith will demand of them, and without which it will be tenuous and vague. A Christian must be creative: firstly, in communion and fellowship with God as a single being, and secondly, through admiration of others, as a fellow-citizen of the saints, he must find the means of praise.

The Church and her faith brought men a clearer and more far-reaching light, a fuller and intenser living. St. Paul could well claim that this was a mystery hidden from the beginning of the world, that it was unsearchable riches, that it was indeed "the glorious gospel of the Blessed God". And since grace transformed character, at the same time as it pro-

vided an answer to the riddles of the universe, and gave to life the inner light of a hope of glory, since it came as a power of peace and joy, it brought men new qualities of living which permeated their lives even when they were unconscious of it. This in turn affected their creative genius, for the supreme qualities of life reflect themselves in art, just as, in turn, artistic grandeur has a quality that, affecting all our faculties, cannot but elevate the moral and spiritual life.

The Christian revelation gloriously completed the speculations of the Greek metaphysicians: it fulfilled the law and the prophets of Israel. In doing these it reinforced all the powers and instincts of the soul, and awakened artists to a clearer sense of the truth of beauty for which they aspired.

Art, therefore, ceased to be self-sufficient: it was recognized that, while it incorporates the cardinal virtues on which character is built, its very nature is spiritual. It leads us towards the eternal beauty, which haunted Plotinus.

Between reason, passion and imagination and the mystery of the Christian faith there is indeed a peculiar affinity, because they play in creative genius a part which recalls the Trinity in Unity. St. Augustine in his book on the Trinity spoke of the triple faculties in man of memory, intelligence and will; and these are the active development of yet another unity within us—that of mind, knowledge and affection.[8] Now it is when these turn to creative work that they function severally as reason, imagination and passion. When they contemplate beauty they see in it three congenial elements: for beauty, as Aquinas said, is found in perfection or wholeness, in proportion or harmony and in splendour. Wholeness shows the unity of order, proportion the excellence of relations, and splendour the revealed clearness of beauty and brilliance of colour.[9]

All these, in turn, disclose a trace of the final Trinity in Unity.

For, to quote the *Summa Theologica* again, there is in that glory the Primal Being of the Father; there is the expression and image of this in the Son; and the relation between them in the Spirit: and we trace this Trinity in created things, first in their being, then in their design or shape, and lastly in their relation one to another.[10]

Whatever is admired in the order of beauty gleams with this triple perfection, to attain which is the end of the true poet or maker. Insofar as he attains it, his work has an eternal value.

That is the dignity of fine art. It is haunted by the presence of ideal perfection in goodness, truth and beauty, communing with them as life, light, and love.[11]

To the creative artist who believes in the Trinity in Unity, therefore a new immediacy opens; he is offered a special insight into the mystery of creation. He sees by faith the end of man's yearning, for faith is the substance of things hoped for. He finds the Eternal Beauty; and, in his heart, he communes with it so deeply that he himself reflects its shining image.[12] For him, therefore, the world and its complexity are transfigured. Phenomena, like words, are but a transparent veil transfused with light divine; [13] and the Christian, whether poet or painter, whether architect, sculptor, or musician, sees the things of the universe not only created through the Christ, but glorified in Him: he accepts the Christ not only as the perfect Person incorporating the human into the Divine, but as the archetype of every single excellence, fitting each to each; for in him all things consist.[14]

As imagination finds in the Christ her prototype and her perfection, so the loftiest, most mysterious height in man—that ruling power which Augustine and Thomas called the *mens*, but which the French call *esprit*,[15] and which *is* spiritual—links both ideas and longings with the subtlety of that Spirit who, as life-giver, pervades all, even while transcending all.

The Christian Faith, in revealing these mysteries, not only explains the sublimity of genius, but it adds to genius a peculiar consecration. Faith establishes between Mind Uncreated and mind created that unique affinity which St. Paul termed grace.

As faith, therefore, elevates the order of reason, it feeds thought and imagination with memory and hope, and it inclines the heart to charity and love till reason, passion and imagination intermingle in an access of vitality as creative genius, while faith, hope and love intermingle in an access of heavenly grace.[16] The genius consecrated by such gifts of grace is purified and heightened; it attains the special quality of holiness. Holiness, therefore, when by being truly heroic it is powerful enough to master man's faculties and rule his sublimest essays, takes genius beyond its normal end to that unspeakable glory, that inaccessible light which the mystic finds as darkness, so dazzling is the beauty of its rays.[17]

In all these things grace has an affinity with genius, even

while it transcends genius. The exact moment when it begins to transform genius few can gauge; the Spirit of beauty blows free as the wind.[18]

It visits with inconstant glance
Each human heart and countenance,[19]

making holy only those who in the depths of their being have united their wills with Itself. Thus it comes that those who live in grace can see a hallowed significance in the words of a profane poet. While poetry and art are not as such what the theologian means by inspired, while there is a distinction between artistic beauty and the transforming contemplation of the religious mystic, yet faith finds its best expression in the Liturgy where noble words combine with music and ritual to move our nature as a whole; teaching also that every good and perfect gift is from above,[20] faith welcomes every expression of the beauty and grandeur of life.

As faith both explains and elevates the scope of reason, passion and imagination, so also it explains and elevates their fusion in creative work. If all things finely conceived are a gift from the Father of Lights—if God, as Ronsard said, is within the poet to perform miracles through his hands [21]—the access of high excitement by which the creative artist uses his materials for his design of ideal beauty is an act of union; as such it is an act of procreative love.

The genius who works by faith sees in the Incarnation of the Christ a far more intimate and significant example than in the creation of the world. For when the Eternal Word was made flesh by being conceived of the Holy Ghost in the Virgin Mary, the Divine Image and Splendour was made manifest in an incomparable immediacy.

To those who share in the grace, which in her was a unique fullness, there comes not merely a heightening, but an infinite change in the quality of creative inspiration—they move into that kingdom of peace and love where God is revered as Holy and demands a change of life, where the heart is melted by mercy and bows humbly to adore. When grace is received to sanctify a life, it lends contemplation a quality so heavenly that excellence begins to transform those to whom the Spirit, if recognized only as beauty, could give—in gleams and flashes— no more than evanescent suggestions.

The inspiration must be overwhelming, widely shared and

one with the portentous natural strength of genius before it can manifest once more the triumph of an Augustine, a Dante, a Michelangelo, a Wren, or a Bossuet. But, wherever Divine Grace hallows, it refines genius, makes it gentler and exalts it to holier life; it does so, above all, because leading to inward long communion with the Divine Persons, it transforms the very nature of the heart.[22]

While a Christian's worship thus both refines and enlarges his appreciation of beauty it should improve also his expression of it. It should do so because, as he considers the atonement, he, with St. Paul and St. John of the Cross, sees the outward world also glorified.

In ennobling art, the Christian religion shows more clearly what art is:—like first the Eternal Generation, and yet more like the Incarnation, of the Eternal Word, art and literature are each the generation of a logos, a concept. This concept owes its beauty to an ideal. The ideal, however, is not merely Platonic. It is a gift of vital communion with the Divine Mind: a communion with the Spirit who raises man's highest Faculties to perfection. At this juncture, we learn more by wonder than we do by psychological analysis; for, as St. Augustine said, there is something of man that the very spirit of man that is in him knows not, but only God Who made him knows.[23]

As St. Paul and St. Augustine saw revealed by grace the hidden glory and beauty, so Dante and Michelangelo connected it with the generation of ideal concepts, while St. John of the Cross found the source of beauty in a mystical intuition which was the calm of adoring love. Bossuet showed that man's place in the Divine design is to perfect nature, and that he received gifts from the creative Spirit precisely for this purpose. So orators and poets of the Church, in their clearer view of the beautiful and sublime, explain further the nature and scope of art.

So, also, does creative genius find in Church history a place from which it cannot be dislodged.

V

What, then, has art in the winding course of time's river given to the Christian faith? As literature it had keen interest in every enunciation of truth, every expression of worship. Every-

where beautiful words had been a light to the mind, giving to thought itself more strength, more precision, more completeness than it could attain without the effect of expression. But it had brought over from Greece two distinct ideas, one the value of the imitative arts as expressing, not merely for the subtle suggestiveness of words, but to the eye of sense and even to the touch, a claim on emotion, or passion. Even if it evoked, therefore, human longings, this claim suggested that these longings, when dealt with by a simplifying effort of reason in relation to a definite work of art, refined the imagination, and spiritualized it into the suggestion of an ideal: art was connected with a philosophy which insisted not only that mind was more real than nature, but even that mind and thought become more real as they are filled with ideas of a primal truth; such ideas can be discerned in and through the things of sense by the more mystical of metaphysicians, who finally contemplate them as purer and finer spiritual realities. So metaphysicians in explaining art refined it, and offered a cure for the inclination to lower the supreme ideal to a merely human form; for that is an inclination to which believers in a spiritual creator and father are too easily prone.

But art did more for religion than this: it strengthened the claims of the unseen with appealing interpretations of love and life, with cries from the human heart, with songs of desire and joy. It celebrated both the charm and dignity of nature, it told of trees and flowers growing up out of the earth, and of the aerial conflicts which burst forth as storm and lightning. Both alike were themes of praise; both therefore could furnish images and memorials to make the house of God more splendid. It made the senses minister to prayer and praise; it laid the finest things men knew as an offering upon the altar. It furthermore suggested that its own shapes and arrangements hinted the existence and function of a primal Artist. It offered to a stimulated imagination an ingenuity of device and technique as various as men's talents to show how an individual conception always gave its own significance to a subject which in itself was spiritual, and therefore universal. It blended, and, blending, exalted various types in great social acts of sacrifice and thanksgiving: it encouraged worshippers both to be more sympathetic with one another, and to lift themselves towards the sublime by cultivating taste: it taught that just as "man to get towards Him that's infinite must first be great",[24] so only conceptions

which are pure and lofty, only those which are dignified and delightful, are worthy of the mystery which men are happy to adore. It threw a viaduct across the ravine of time: it offered to each succeeding age the strongest conception which any age before had been vigorous enough to generate: it made tradition noble: it gave the Church Militant the encouragement of seeing that she had conquered in battles long ago, fiercer perhaps than most which were to come. It brought young worshippers up to a habit endorsed by time. It made popular high ventures of the rarest minds. Yet its standards discouraged personal excess. It associated commands and dogmas with images that could not but be charming and inspiring. It reinforced the dimmed faith, or the blankness of an idle, a conventional or wearied intercession with records of hearts of fire. To the discipline of technique it added excitement, beauty, and surprise. It reminded the uncertain and indifferent that, through the ages, the faith of Christ had been the inspiration of holiness, of heroism, and of genius. Imagination thus enforced with recurring urgency the sacramental truth that the Word had been made flesh, that the scene around us is the theatre of our redemption, and that the object of creation is to raise the magnetisms and attractions of the life of nature ever higher, till nature is absorbed by grace into unity with the Heavenly Spirit.

Art, as the expression of the imagination, had therefore proved herself not merely the handmaid, but the bride of faith, an intimate companion completing the subtle order of life; it is, in other words, a means of giving faith a delicacy and an irradiation which enhance its power; one should say more: art is the very bloom of faith, its living images faith's unfolding petals.

VI

What, one should in turn ask, has the Church given to art that creative genius had not already within herself?

In the first place, the Church saw nature as an art revealing the spirit of its Creator, and valid as a means of finding Him. From earth, with her thousand voices, the believer heard that there was rightness in her ways: for her true story was the wisdom of her Maker, who was working the ruthless drag towards chaos into a vast process of amelioration.

The universe was not a monstrous mechanism; life was not

an irony; nature was not an enemy; her elements could be sanctified into vehicles of grace: her fruits into the holiest communion. So the Church corrected, simplified, and fulfilled the idealism of Plato, preserving with a special flavour what she found salutary and right in ancient thought, and guiding into revealed truth the faculty of contemplation.

In the very fullest sense, the light of the Church was life. She introduced a corollary to her revelation that the Word had been made flesh and dwelt among us, for she suggested that, as the full human life of love led to the generation of further life, so the same generative approach consummated the life of the mind. The Word, like every other work of art, was conceived from the Mind being so absorbed in what it perceived that this knowledge meant a living unity of Knower and Known. So the Church completed and explained what Aristotle had taught about the rightness of thinking, and showed how at the same time Plato's doctrine of ideas suggested the absolute Mind from whom they came. She knew long before what Baudelaire was to declare, that *Tout déroule de la conception*.

The mysticism and idealism of Alexandria had insisted that the true beauty was spiritual: and was discovered by love. In St. Paul and St. Augustine this spiritual beauty was shown to be the image of the one Artist of the universe; the splendour of His truth flashed bright on them in His delight in companionship with men: it showed itself in a Beauty in which no humility, no sacrifice was refused, which loved to the extreme, and which had the strength and tenderness of the Passion and Cross of Christ.

On the one side, the Church could accept no idea of truth unless it transcended man's highest aspirations for beauty: her faithful were persuaded, therefore, that art's gift of stabbing man's senses into yearning was worth more to them than any science that claimed to be precise. On the other, they were taught by a supreme example—applied in the Church—that the good life was the charity which insists in identifying our own blessedness with that of other people.

Thus the Church gave the ideal of beauty a social elevation, and in the purity of her worship men found a fuller peace which needed, and expressed itself in Byzantine architecture. She made thus a new imagery of building, elaborate with significant patterns and pictures. She made it a home for people's worship. She purified the fancy. She set in order the results of observa-

tion. She gave the world a new art more gorgeous and more mysterious. She endowed serenity with sumptuousness. Where art had extended its successes by appealing to amorous excitement, she restrained it. Yet the Church gave a new scope to the talent for design. For it was in her masterpieces that image and proportion gave man the sense of holiness. Purer and loftier, yet more touching and more distinct, her works of genius had been ennobled by the prayer which is founded on sacrifice and looks upwards towards the skies. When cleansed by repentance and bowed in petition, intercession, thanksgiving, and adoration, passion was no longer pregnant with sensuousness, and did not need to be restrained except by what was taught it through the Passion and Cross of Christ.[25] The passion which fused hearts into unity was exalted and refined by the love which was the Holy Spirit. Life was more abundant. Beauty met grandeur and was transfused with a numinous glory.

VII

In the thirteenth century genius was led high by faith to swelling ranges of view over science and culture. The great examples of old time were studied in the *élan* of a new learning, of a new love of nature, of a new struggle with faction and barbarism. Genius became sublime, not in revolt against the staleness and fatigue, against the bitterness and disquiet, against the sense of waste, of loss, of void inherent in the human lot; but in tracing through envy and calumny, through hate and greed, through rapine and injustice, through sad affliction, through agony and death, through grotesque and wayward fancy, through the flesh and blood of human nature, through all varieties of mould and mind, the order of unity, the unity of order. Its reason was its strength. For in that resolute age the creative enjoyments of beauty came from life's strenuousness. Dante, said Browning,

> Loved well because he hated—
> Hated wickedness that hinders loving.[26]

Such men knew that it was a hard fight to lay hold on eternal life. And only by further effort could that life be glorified in their work. The artist like the soldier must face danger, endure

hardship; for medieval artists never forget that they must be men as well as spirits.

In the force of this conviction a new meaning was found for Aristotle's saying that the intellect is the eye of the soul, and for Plato's that the eyes are the natural doors and windows of the soul.[27] For St. Thomas Aquinas taught that the reason is whole in every part of the body: whole therefore in the eye, with that wholeness of man which is the interacting unity of mind and body. As the eye observes, the intellect contemplates, and, contemplating, enjoys, like the hart which drinks at the water-brooks which it has desired. We see truth one with love in Dante's Paradise, the kingdom which was a pure white rose. There everything

> *Viso ed amore avea tutto ad un segno.*[28]

The heaven of pure light was at once "a radiance of intellect with love replete" and "a love of the true good replete with joy". Like Wordsworth's daffodils, it flashed upon the eye: and yet—*una bellezza che laetizia era*[29]—it shone steadily upon the inward eye, making a bliss of solitude.

Strive hard, live whole, keep the heart hot in its full beat of blood, work together in your guilds and hierarchies, let your keenest scientific work rise with the incense of prayer, set the eye to watch how light's empire over colour transforms earth and air and water with countless changes till we feel that the sky is the vault of the soul's heaven, and know heaven's grace nearer still in the ceremonies where the priests do honour to the Virgin and her Son, and you will understand how the Middle Ages worked with such intensity to make stone flame like fire. Dante and the builders of Cathedrals were in travail in the same temper, triumphant in the same faith, torn by common suffering, affronted by kindred scandals. For each alike religion meant coping with every phase of life, the watch over every detail, and a fervour of exalted sacrifice to be made one with Christ's passion. We are all moved by the holiness of Catholic art in that age; we all bow before its grandeur; it shows us all how

> The tumult of the time disconsolate
> To inarticulate murmurs dies away,
> While the eternal ages watch and wait.[30]

[28] *Paradiso*, XXXI, 27: unto one mark had all its look and love (Longfellow).
[29] *Ibid.*, 134: a beauty that was joy.

VIII

It was not to be expected that the debt creative genius then owed to the Church would rise in geometrical or arithmetical progression through each succeeding century. The thirteenth century was a time of flood. Even when that early Renaissance was being continued with obvious *éclat*, it passed through less brilliant phases. But Rome gave it an heredity which neither Florence nor the North could give. There, where the hierarchy was centred, there where still they sought to solve the problem of universal order by drawing men together in their worship of the one true God (as Constantine had tried to do, when he first gave over Rome to the Popes), they did their work, they welcomed their pilgrims against a Roman background, where, alike on hill and in the open spaces, they saw the arch, the column, the statue, and the gigantic vaults of brick which spoke of order and dominion. It was this idea which was fortified by the full strength of the Middle Ages, those centuries which came central between the thirteenth and the sixteenth centuries. So with an ever nearer approach to nature, with a closer acquaintance with ancient genius, with a more thorough mastery of technique, came a completion of the Renaissance. The earlier phase had fought its fight against ferocity and barbarism. The later meant a struggle between the religious spirit and all that was strongest in man's own secular lordship. If he had not enough to satisfy his curiosity in ancient learning or contemporary exploration, if wealth could gratify that instinct for the sublime which, when narrowed to the lust of the eyes and the pride of life, found a satisfaction in worldly pomp and vanity, if the study of the human heart went with an interest in the human body, and men found the very aspect of flesh absorbing, either in the grace of the womanly form, in the lean flanks of the young athlete, or in the swollen muscles of maturer men, we see the distinguishing character of the new out-pourings of genius. It was above all the struggle for the unity of order against passion in the imagination.

In the religious art of the South we see this in the gradual evolution of St. Peter's from the Classical calm of Bramante's design, through the austere dignity of that of Michelangelo, to the rush and force of Bernini's sculpture, or the contortions in the pillars of his baldachino. The art and architecture of the South maintained the religious spirit against the prodigality and

exuberance of the age, and carried its masterpieces as far as Paris and London. This period adds precision to the Christian theory of æsthetics. As Michelangelo had insisted that a man's idea could stamp on his material a living concept of beauty, and so improve on nature, as Spenser had taught that ideal and heavenly beauty found its perfect example in the Christ, so St. John of the Cross found his vision of perfection in his inmost worship. He insisted that in the gift of the Spirit man's soul received beauty and was invested in an atmosphere of beauty through which the perfect beauty was seen. If we would seek in prose for the essence of his teaching we find it once more when Bossuet tells us that man owes his power as an artist to his share in the Creative Spirit which is Divine.

But it is a different story we read in our Elizabethan and other literary masterpieces of the North. There the wildness of excess drives men to madness and ruin, creating a tragedy as grim as before Christ was known—or it spoils the dignity of poetry with contortions and conceits. In France the sense of order returned with the Grand Monarque, but in English Literature, in spite of Bunyan, genius was more literary than spiritual, for even when Milton asserts the tradition of majesty, he concentrates on a study of revolt, and Satan reigns in the foreground of the interest. Milton lived on into the age of scepticism, and himself ignored Christ's Cross. It was not by the Courts of Paris and London, nor by their women, that the effort towards the sublime was thwarted, so much as by the range and temper of a new science. As William of Ockham had first undermined scholasticism in the fourteenth century, so Descartes laid a new mine three hundred years later. But metaphysics were not less a danger than the interest in the religions of Asia, in the divisions of Christianity, or in refusal to accept miracle since they could not distinguish it from witchcraft. Brilliance faded from the glory of consecrated genius.

IX

For this new temper no Church was prepared. Their systems had not been elastic enough, nor active enough in promoting physical or psychological research. They had failed to take due account of either passion or imagination, and even science was left out of account. For a last effort to refine the ancient subtle-

ties, for spasmodic efforts at new felicity or dignity in building, for a sense of the glories of light and colour which could be seen by an eye spiritually enlightened, for a life of spiritual fervour the Christian inspiration was enough. But there were many signs of disintegration, and at last the triumphs of five hundred years came to an end. Man walked out into a world of soot and sultriness no longer "invested with purpureal gleams".[31] Where once their interest was in monuments, now it was in mills: the sense of hierarchy was gone, and in no country was it easy to find clergy equal to their traditions.[32] If romance lingered, or came back to visit, it was among the scenes of nature. And it was amidst the inspirations of nature that mysticism in time helped new creations to attain once more to the sublime.

As we look at the record of consecrated genius in its highest achievement, we shall find still in music masterpieces on the supreme scale. Music, as the ordered movement of notes and tones, had from the beginning of the Church's life accompanied and completed worship in that sphere of sound which speaks so deeply to the emotions of men. From the time of Gregory the Great, a solemn tradition of music had enriched the Catholic Church with plain chant, while the peoples expressed themselves in their own melodies. At the time of Palestrina both were fused into a great work of individual genius, yet Western and rooted in tradition. The most elaborate music yet known was worked out in Oratorios, encouraged by the Roman Oratorians of the seventeenth century; and from these, when reason and the eye no longer served the religious imagination for its highest enterprises, it was in the moving world of music that religion proved that it was building with new power in the mysterious depths of man's nature what it could no longer achieve with literature or the imitative arts. Bach's genius ranged wide over regions, warm with feeling, yet never losing a lofty purity. His melodies are as exalted in religious feeling as Fra Angelico and as fine and delicate in workmanship. They are as lofty and fresh as the oratorios of Handel are serene, or the Masses of Mozart are impassioned. And later comes the massive sublimity of Beethoven, the Isaiah of musicians. But all these are works in a different element from the imitative arts, different also from literature.

And though the great list of names continues through Perosi, to Charles Wood and Mr. Balfour Gardiner of our own country

and our own day, to prove that the religious glory of Europe is still creative among us, yet from the time of Bunyan and Bossuet it would be hard to cite in the next two centuries a name which united the idea of *supremacy* in painting, in sculpture, or in literary style with a distinctly Christian inspiration. That, however, is no reason to think that religion has ceased for ever to inspire magnificence.

For when we know how slowly, how tentatively, and how seldom Christianity achieved magnificent things, we come to far other conclusions. The birth or growth of the Church did not mean an immediate triumph of her creative genius in relation to works of art. Even in power over words, her greatest inspirers were rare. Her work was rather either to refine or to incorporate the traditions of other cultures. She built her triumphs out of their materials. She moved among their traditions to correct them, to exalt them, or even to reject them. It was only when men had learnt to love nature simply and purely, and when at the same time by an immense scientific effort, combined with an equally strong faith, memory and imagination had been purified by hope, that she felt she could draw from the culture around her enough of true good to bring it all into the life of grace which was peculiar to herself; then she produced the Catholic genius of the thirteenth century; that age had been long prepared.

Nor in spite of the consecrated masterpieces of the succeeding five centuries did she ever win the general subservience of natures or minds. The rare men of genius who lived on the inspiration of saints were known and loved only by the few who enjoyed the loneliness of mountains. Christian culture had few triumphs and many reverses. Its story is an epitome of human nature. But even when at the end of the seventeenth century the burnt-out furnace was drenched in wintry weather, the fire was not extinguished. Its sparks and ashes were carried on the storm of scepticism: it had become inseparable from the traditions of Europe.

Such a position is more normal than triumph. It has never been the rôle of Christianity to reign unquestioned over man's reason, his passion, nor his imagination. Furthermore, mysticism must assume sway over gigantic energies before the raw materials of sound or stone or colour can be moulded to exquisite shapes significant with revelations of eternity. Words themselves need heroic originality before they have within

them the energy of truth. Through travail must men be born again as children of grace: without heroism, no holiness.

X

We shall therefore enter into the fuller life of a new Renaissance when (and only when) we can fuse into the truths and triumphs of another age the impulses which were twice renewed in the long continuity from the twelfth to the end of the seventeenth century. Through the thirteenth, the sixteenth, and the seventeenth centuries the Church produced her mightiest works of art when, in response to need and conflict, she mastered a new contribution of learning and a fuller acceptance of nature to the order of her own life and truth. In each epoch she felt a new zest in the intrinsic excellence of nature, and a fresh enthusiasm in the intrinsic grandeur of the human lot; and she had a strength within herself to consecrate both. With a firm hold upon the truths which the sixteenth century developed from the thirteenth, the spirit of Christendom, in face of conflicts and disorders, which, as in our own time, hurled aimless men like fiends or phantoms in their clouds of storm, was serene in the belief in Divine Love as a central magnetism. This was as much the ordering norm of the world as the Sun is to our planetary system, or the Papacy to the central body of Christendom.

This faith yet lives; it gives a spiritual import to the material organization which shortens space, which brings us into closer reaction on one another, which enables us to share diversions, and nourishes us with kindlier fruits of earth. Indeed, the ideal of a universal physical well-being is not the invention of pagan innovators: it is a step towards the Saviour's insistence upon the works of mercy, where the hungry are fed, the sick are healed, the naked are clothed. But while to the carnal man material well-being is the whole, the spiritual man sees that mind and body should react on one another to enrich human life with God's abundance. The aim of faith is not a levelling: it calls forth genius because it is in itself an order where, in spite of different functions, different talents, different fortunes, men are so united as to recognize in one another, and most of all in the unfortunate, the means of rising to their own fullest opportunities in the Body of Christ.

If this system were to stop with the moral relationship of man to man, it would not be inspiring. It is more far-reaching and mysterious. It sees the whole world of nature as cogent in the realm of spirit. Innumerable presences of life and reality crowd into communion with the hearts of men. They press upon man with that energy of act which showed to Dante their participation in the Supreme Activity from which they take their origin. Energy is too closely akin to life for us arbitrarily to divide it from the act which is a mind. This act is discerned by the senses in the light and power of electricity.

What happens within the nature of man is an index to the scheme of the universe. The sense of things perceived, the act of thought, and the work of doing things meet in a subtle inter-relation comparable to electrical vibrations. As St. John of the Cross suggested, there is in man an etheric element that fuses mind with body, an element susceptible to the magnetisms of the air as well as to the magic of intuitive sympathies. And what science now describes in the being of man, she finds also suggested in other phenomena. For in all is the presence of the Spirit, and nature is never spent.

Therefore we may ask, Is not the magnetism of love—which is essential to the generation of life—the secret of all life, and finally of all energy? Dante said, we remember, that neither Creator nor creature ever existed without love. In other words, he knew from an ancient wisdom that the universe is a series of magnetic attractions where the physical, the intellectual, and the spiritual play upon one another from within distinguishable orders. The idea is dawning again upon the specialized investigators of phenomena. Science detects in the infinitesimal unit of matter a combination of portentous force in an interplay of magnetic attraction. The latest discoveries of the physicist need to be compared with the detailed systems of Oriental philosophy which are now at the disposal of the Church to employ as she had employed the philosophies of Plato and Aristotle in those long centuries in which was built up their power of combining mysticism and science.

New learning and new science combine to give a new and inspiring significance to the Christian belief that we live in an order of unity in which the wisdom and spirit of the universe are always acting, since in each new love we find the manifestation of the Eternal Love. It is this magnetism which, tying the subtle knot that makes us man, winds us into the secret of

creation; we renew that secret both in our loves and in the things we make. These can become magnificent when, in the exhilaration of conquering vital truths, our sensuousness and our passion are high enough for mighty labours; when our faith is close in touch with science, and yet looks to govern the world from the blue above it; when memory, fed on fine choices, can teach imagination how to body forth the joys of hope; when sincerity, joining with humour, holds fast to the simple truth and strength that keep the details right; when we look at last for thankfulness and praise, and learn from the fullness of the world the masterpieces of the primal artists who stand among the chosen. For passion and imagination combine in dignity with reason; working together to create an excellence to admire, they point to God in His glory and His beauty. It is not enough for reason to have faith, but the imagination must rest in hope, and the passionate heart must love. All three need the grace of God. His revelation is not a scheme solely of philosophy or theology. It combines with story and poetry in the Bible. It combines with music and ritual in the Church's worship. Her basilica and cathedral are made more sacred and more inspiring by statue and painting, by mosaic and by stained glass.

In other words the theology of the priest needs to be combined with the love, the skill, the interest, the imagination of the layman before the Church fully gives glory in the highest.

Then indeed in the interplay of reason, passion and imagination genius will show how to refine, elevate and enlarge its own excitement of great faculties. Then it will reveal how much they in their grandeur owe to faith, hope and love. For these lead men to learn from God that they are, in a real and special sense, born again into the Eternal and Infinite when by faith, water and the Spirit, they enter the Church of the Trinity in Unity.

[1] Written in pencil in a copy of Middleton Murry's *Problem of Style*, now in the library of the British Institute of Florence.

[2] Ronsard, *Abrégé de l'Art Poétique*.

[3] Byron, *Don Juan*, II, Canto 168.

[4] See J. A. Stewart's brilliant essay on "Platonism in English Poetry" in *English Literature and the Classics* (ed. G. S. Gordon), especially p. 26.

[5] Browning, *Sordello*, I, 504–512.

[6] "Le poète, disait Platon, est un être ailé. Ce n'est pas l'action des choses visibles et matérielles qui engendre ses créations: il échappe a leurs prises, il plane au dessus d'elles, et reçoit d'en haut son inspiration. Mais si la conception de l'idée est ainsi comme immaculée, en revanche il est inconcevable que voulant se développer et s'exprimer l'idée se tienne à l'écart du donné et du matériel. Nulle pensée, pleine et réelle n'existe sans s'incarner dans une image, dans une forme, dans un symbole. (Preface, by Emile Boutroux, to *Le Sens de l'Art*, by Paul Gaultier. Cf. *Prière et Poésie*, by Henri Bremond.) Stevenson's phrase—"a work of human art" is from the final chapter of *The Wrecker*.

[7] "The Art of Man is the expression of his rational and disciplined delight in the forms and laws of the Creation of which he forms a part." (*Laws of Fésole*, opening sentence.)

[8] St. Augustine, *De Trinitate*, chapters IX, XV. For a comparison of these two analyses of St. Augustine see A. Gardeil, *La Structure de l'Dine*, vol. 1, 50–130. See also *Confessions*, Book XIII, Ch. XI.

[9] *Summa Theologica*, Iª, xxxix, 8, 5.

[10] *Op. cit.*, Iª, xxxix, 8.

[11] Cf., ch. XV, sec. 1.

[12] II.Cor. III, 16.

[13] Wordsworth, *Prelude* IV, 600–603.

[14] Col. I, 17.

[15] *De Trinitate*, IX; Aquinas, *De Veritate*, X; cf. Gardeil, *op. cit.*, 21–45.

[16] For a fuller discussion of this see R. Sencourt: *Carmelite and Poet*.

[17] I Tim. VI, 16. Dionysius Areopagita, *De Myst. Theologia*, I.

[18] St. John, III, 8.

[19] Shelley, *Hymn to Intellectual Beauty*.

[20] James, I, 17.

[21] Cf. note 2.

[22] Aquinas, *Summa Theologica*, Iª, viii. 3, xliii. 3.

[22] Augustine, *Confessions*, X, v.

[24] Donne, Epistle to Countess of Salisbury, *Works*, p. 202 (1929).

[25] "If the God-like and heroic Christ had never passed into the Man of Sorrows, would not an element have been wanting to the complex expressiveness of Botticelli and Leonardo, and to the modern feeling, which is our peculiar pride, for a beauty as wide as life." (Bosanquet, *History of Æsthetic*, p. 150.)

[26] Browning, *One Word More*.

[27] *Phædrus*, 255 : *Aristotelis Opera*, § 812a, 35, 39.

[30] Longfellow, *Divina Commedia*.

[31] Wordsworth, *Laodamia*.

[32] "Nécessairement encore l'incredulité introduit l'esprit raisonneur, les définitions abstraites, le style scientifique, et avec lui le néologisme—choses mortelles au goût et à l'éloge." (Chateaubriand, *Génie du Christianisme*, III.)

[33] Cf. E. I. Watkin, *The Bow in the Clouds*, 16.

As this enquiry draws to its close, one might be asked for an explanation of the choice of subjects. They were chosen first because their outstanding excellence was one with a beauty which has through all the ages challenged and held the admiration of cultured men and taught them great ideas. In the first three or four centuries after St. Paul, Christianity left nothing so wide in power or influence as the *Confessions* or *The City of God*. And again in the succeeding centuries Santa Sophia stands on an eminence equally secure. Neither among all the charm of Romanesque or Lombard architecture nor in any field of literature can we see up to the year 1000 any fresh subject to which people return with such unwearying admiration as San Marco, while the mosaics at Ravenna mingle the tradition of imitative arts in Constantinople and Sicily to prepare for it. And so onwards: St. Francis, the *Divine Comedy*, the Gothic Cathedral (especially as one sees it in the windowed glory of Chartres), each in its way commands an unquestioned eminence as later do Raphael and Michelangelo. But unless we pause to survey at Florence the continuity of achievement which introduces an artist of such elevated piety as Fra Angelico, and relates him to the Florentine Platonists, it will not be possible to see in a correct perspective the Platonic idealism inherent alike in the serenity of Raphael and in the passionate poetry and therefore in the whole genius of Michelangelo. Both of these great artists have been recognized for centuries as attaining a consummation.

What followed? A struggle between personal mysticism and piety, and the sense of splendour in a freer and wealthier world, a world of capitalism and commerce. The author had already treated of Rome's expression of this age in his *Genius of the Vatican*. He therefore turns to another field of his interest.[1] In this new phase of art Spain produces a man who alike as mystic, as poet, and as writer of prose is of peculiar, if not outstanding value in the history of Spanish culture. In the intense personal piety of the sixteenth century St. John of the Cross, like Spencer, stands on a high eminence, and at the same time he makes a valuable contribution to Christian æsthetic and shows his age's love of sumptuous effect. Contemporary with him are Titian and Veronese, whose pictures show art tending to master its religious inspiration, and who introduce us to another leading problem of the quality and significance of

Christian art. This question is carried farther in the case of the arresting artist, El Greco, who went from Venice to Toledo, and the answer is continued by a further comparison of the two great Spaniards Velazquez and Murillo, finally introducing the supreme Christian sculptor, Montañés. Again the discussion of these painters who belong to the period we have learnt to associate with Bernini and call Baroque (a period in which the author has made a concentrated study in *Outflying Philosophy*) suggests the names of two outstanding English writers, Milton and Bunyan. The one illustrates the grandeur which the sublimity of religion gave as a field to the imagination, while at the same time he also shows imagination mastering both piety and orthodoxy. The other shows, like Murillo, a popular art still wholly devoted to the traditional faith and fervour of the Christian religion. Rembrandt might have been introduced, but the continuity and balance of the subject seemed to be better served by a direct disciple of Bernini, and an instance from architecture; St. Paul's is the supreme example of the Baroque period in Northern Europe. Finally, after a reference to the disintegrating effect of Descartes and the Deists, the combination of personal piety with traditional grandeur is summed up in the comparison of Pascal with Bossuet, who, in style and theory, completes the story of the loftiest achievements of Christian art which secular culture has delighted to honour. For after the year 1700 we hear no more in Christian art the roll of majestic names.

The selection has been completed to show novelties of approach under the magnifying-glass of analysis, as well as to complete comparison and unity. It was for the same novelty of treatment that the Venus of Cyrene was preferred to the Parthenon, and the *Song of Songs* to *Wisdom* or *Job*. And it may also be said that these two studies fit into the unity of this enquiry, while at the same time they give opportunity for novel observations.

In Palestrina genius on the grand scale was traditional. He shows that religious music was not yet following the spirit of the age. After him the great polyphonic harmonies, still cultivated by the Oriental Churches, as they are commended by the Vatican, are varied by the growth of melodies, and counterpoint is changed for a composition where not only imagination has a wider range, but feeling a livelier variety. Religion accepted tune. And this, in turn, by the time of Purcell was leading to a distinctive excellence in the Church Music of

England and Germany by its quality of aspiration, its pure charm, and the grace of its felicity. The power to soar, and at the same time to touch the heart, was combined into a genius of supreme excellence in Bach, who kept all the grandeur of polyphony while freeing it for personal expression in melody. But Bach, in belonging to a later period, points to one of the conclusions of this enquiry: that although religion no longer ruled the cultured mind as such, yet it was about to mingle with approaches to nature, while whole faculties of man would uncurl and aspire, like the tendrils of the vine, in meeting religion in new frontier regions, and so building up a scheme of what Charles Du Bos liked to call natural supernaturalism. Music does this supremely in Beethoven, just as from frequent citation we have been able to suggest that poetry does in Wordsworth. And the same broad basis of inspiration also ennobles the genius of Burke. It was no small achievement of Christian art to have given something of its spiritual quality to art and music other than those of the Church.

This then leads to the final conclusion of this enquiry: that both the quality and the significance of Christian art have been formed by culture as a whole, and we may well see a new Renaissance, therefore, when the genius and the discoveries and the technique of the work which has succeeded Bossuet are mastered by the combined enterprise of skill and soul to generate new masterpieces of Christian culture, and so endow the mind with that more abundant life with which Christian genius from age to age has vindicated the sublimity of its inspiration and made its power real to reason, to feeling, and to imagination, and through grace severally exalted reason, passion and imagination by the life, the love and the light which are Divine.

For, as this enquiry shows, Christianity, though a faith once for all delivered to the saints, has within it a generative power to produce from new occasions a new life in the creative concepts of gifted and imaginative men. As the Creator's compassions are new every morning, so the life of faith—which to St. Paul was Christ—has an elasticity, a fecundity, and a variety which comprehends all nature in the riches of its own grace and truth; for it finds in God and His Glory the origin of every gift of nature or mind, and shows that they attain their own perfection when fitted to His Truth and to His Praise.

[1] See *Spain's Uncertain Crown* (1931), *Spain's Ordeal* (1939), and *Carmelite and Poet* 1943), by Robert Sencourt.

BIBLIOGRAPHY

THE classical work on the subject of Christian Art is Chateaubriand's *Génie du Christianisme* (1802). Professor Percy Gardner has recently written a slight sketch, *The Study of Christian Art*, and since this book was written, Mr. Edward Ingram Watkin has produced his valuable essay, *Catholic Art and Culture*.

An excellent philosophical dissertation is *Il Bello nel Vero*, by Agosto Conti (4 vols., Florence, 1890).

The subject is a recurring preoccupation of Ruskin. See the Library Edition of his *Works* (39 vols.).

On art itself the following are all classics:

Bosanquet, *History of Æsthetic*, 1892.
Menéndez y Pelayo, *Historia de las Ideas Esteticas en España*, 1883–1891.
Saintsbury, *History of Criticism in Europe*, 1900–1904.

The standard book of reference is:

Thieme und Becker, *Allgemeines Lexicon der Bildenden Künstler*.

THE EXORDIUM

I—THE SONG OF SONGS

An exhaustive list of books bearing on the subject appears in the Introduction to Ginsburg's *Commentary*, 1857.

All the latest works are referred to by Mr. H. H. Rowley—see *J.R.A.S.*, April 1938, pp. 251–276.

See also:

H. Ewald, *Dichter des Alten Bundes*, III, 333–426.
A. Reville, *Le Cantique des Cantiques*, Eng. trans., 1873.
Delitsch, *Hoheslied und Koheleth*, Leipzig, 1875.
Tiefenthal, *Das Hohelied*, Kemplen, 1889.
——, *Le Cantique des Cantiques*, Paris, 1883.
Reveilland, *Le Sublime Cantique*, Paris, 1895.
D. S. Margoliouth, *Temple Bible—Song of Solomon*, 1902.
G. Pouget et J. Guitton, *Le Cantique des Cantiques*, Paris, 1934.

For further articles:

S. R. Driver, *Introduction to the Literature of the O.T.*, Edinburgh, 1928, pp. 436–453.
J. M. Voste, "L'œuvre exégétique de Theodore de Mopsuestia", *Revue Biblique*, 1929, pp. 394, 395; 1930, pp. 362–377.
Cheyne, in *Encyclopædia Biblica*, 1899.
H. W. Rothstein, in *Hastings' Dictionary of the Bible*, 1902.
Professor Wheeler Robinson, *Encyclopædia Britannica*, 14th edn.
W. W. Cannon. *Song of Songs*. Cambridge, 1913.

II—THE VENUS OF CYRENE

Mariani, "La Venus di Cyrene" in the *Annuario della R. Academia di San Luca*, 1914–1915.
Sir R. Livingstone, *The Pageant of Greece*, 1923.
——, *The Mission of Greece*, 1928.
Percy Gardner, *Greek Art and Architecture*, 1922.
——, *A Grammar of Greek Art*, 1928.
E. A. Gardner, *The Art of Greece*, 1925.
——, *Poet and Artist in Greece*, 1933.
Lowes Dickinson, *The Greek Temper*.
Edwyn Bevan, *Hellenism and Christianity*, 1921.
S. Reinach, *Monuments nouveaux de l'Art Antique*, 1924.
C. Dugas, *Greek Pottery*, 1930.
H. B. Walters, *The Art of the Greeks*, 3rd edn., 1934.
O. Kern, *Die Religion der Griechen*.
J. D. Beazly, *Attische Vasenmaler*, Tübingen, 1925.
C. Jullien, *Histoire de Gaule*, 8 vols., 1906–1928.
E. Espérandieu, *Recueil Général des Bas-reliefs, Bustes et Statues de la Gaule Romaine*, 1907.
F. Benoît, *Arles, ses Monuments*, Lyon, 1917.
M. Clerc, *Aquæ Sextæ*, Aix en Provence, 1916.
Donnadieu, *Fréjus*, Paris, 1917.
J. Sautel et Imbert, *Les Villes Romaines de la Vallée du Rhône*, 1926.
Roger Peyre, *Nîmes, Arles, Orange, St. Rémy*, Paris, 1903.
A. Festugière, *Le Monde Grèco-Romain au temps de notre Seigneur*, Paris, 1935.

III—PHILO'S THEORY OF ART, ST. PAUL, AND THE THEORY OF BEAUTY IN
PLOTINUS

Drummond, *Philo Judæus*, 1888. 2 vols.
Philonis Alexandriæ Opera, Berlin, 1896.
E. Bevan on *Philo in the Legacy of Israel*, 1930.
E. Bréhier, *Les Idées Philosophiques et Religieuses de Philon*, 1928.
K. S. Guthrie, *The Message of Philo*, 1910.
Philo, Eng. trans., L. C. L. Colson and Whitaker, New York, 1929.
W. S. Conybeare and Howson, *St. Paul*, 1864.
F. W. Farrar, *St. Paul*, 2nd edn., 1883.
O. Pfleiderer, *Lectures on the Influence of St. Paul*, Eng. trans., 1885.
——, *Apostolic Christianity*, Eng. trans., 1906–1911.
W. M. Ramsay, *St. Paul the Teacher*, 3rd edn., 1897.
——, *The Teaching of St. Paul*, 1914.
T. R. Glover, *Paul of Tarsus*, 1925.
A. Deissmann, *Paul*, trans., 1926.
F. J. Foakes-Jackson, *St. Paul*, 1927.
H. Lietzmann, *Petrus und Paulus in Rom*, 1927.
C. A. A. Scott, *St. Paul, the Man and the Teacher*, 1936.
G. S. Mackenna (Ed.), *The Works of Plotinus*, 5 vols., 1919–1930.
H. Guyot, *Réminiscences de Philon chez Plotin*, 1906.
Ennéades, Texte etabli et traduit par E. Bréhier, 4 vols., Paris, 1924–1927.
W. R. Inge, *The Philosophy of Plotinus*, 1923.

J. Guitton, *Le Temps et l'Éternité chez Plotin et St. Augustin*, Paris, 1933.
G. Turnbull, *The Essence of Plotinus*, 1934.
J. Barion, *Plotin et Augustinus*, Paris, 1935.
F. H. Brabant, *Time and Eternity in Christian Thought*, Bampton Lectures, 1936.

PART I—THE RISE OF CHRISTIAN ART

IV—THE CONFESSIONS OF ST. AUGUSTINE

S. Augustinus, *Opera Omnia*, Migne, P.L., 12 vols., 1841–1849.
Dods, *Works of S. Augustine*, 1891–1896.
Vives, *Of the Citie of God*, Eng. trans., 1610.
Schaff, *Der Heilige Augustinus*, 1854.
Louis Bertrand, *St. Augustine*, Eng. trans., 1914.
C. Bruyère, *Christianisme et Néo-Platonisms dans la formation de St. Augustin*, 1920.
P. Fabo, *La Iuventud de San Agostin*, 1929.
Carl Adam, *Die geistliche Entwicklung des heiligen Augustinus*, 1930.
A Monument to St. Augustine, compiled T. F. Burns, 1930.
Mélanges Augustiniennes, Paris, 1931.
Confessions, tr. P. de Labriolle, Paris, 1933.

V—SANTA SOPHIA

George Young, *Constantinople*, 1920.
van Milligen, *Constantinople*.
L. March Phillipps, *The Works of Man*, 1908.
Lethaby and Swainson, *Santa Sophia*, 1894.
Whittimore, *Mosaics of Santa Sophia*, 1933.
George Sandys, *A Relation of a Journey*, 1615.
C. G. Fossati, *Aya Sophia*, 1852.
W. Salzenburg, *Altchristliche Baudenkmale von Konstantinopel*, 1854.
J. Strzygowski, *Origins of Christian Church Art*, 1923.
J. Wilpert, *Die Romaischen Mosaiken*, 1924.
J. A. Hamilton, *Byzantine Architecture and Decoration*, 1933.
C. H. Sherrill, *Mosaics*, 1935.

VI—RAVENNA AND SAN MARCO

E. Hutton, *The Story of Ravenna*, 1926.
Corrado Ricci, *Ravenna*, Bergamo, 1902.
J. R. Richter, *Die Mosaiken von Ravenna*, 1878.
Eugène Muntz, *La Mosaique Chrétienne*, 1893.
J. Kurth, *Die Mosaiken von Ravenna*, 1902.
J. Strzygowski, *Origins of Christian Church Art*, 1923.
J. Wilpert, *Die Romischen Mosaiken*, 1924.
Otto Demus, *Die Mosaiken von San Marco in Venedig*, Baden, 1935.
Ruskin, *Stones of Venice*.
L. Marangoni, "L'Architetto Ignoto di San Marco", *Archivio Veneto*, xii, 1933.

P. Saccardo, *Les Mosaiques de San Marco*, Venise, 1896.
R. Cattaneo, *La Basilica di San Marco*, Venice, 1878.
E. Hutton, *The Pageant of Venice*, 1922.
Crowe and Cavalcaselle, *History of Painting in Italy*, 3 vols., 1912.

PART II—THE MEDIEVAL CULMINATION

VII—ST. FRANCIS AND GIOTTO

Hilarin ffelder, *Ideals of St. Francis*, 1925.

The Bibliography (pp. 431–437) of this contains an excellent account of the sources of references for this chapter, including the lives by Thomas of Celano and St. Buonaventura. The translation is made by B. Bittle.

The following further references may be noted:

Thomas of Celano, *Lives*, trans., 1904.
P. Sabatier, *Description du Speculum Vitæ*, Paris, 1903.
——, *Vie de S. François*, edition définitive.
Fr. Cuthbert, *Life of St. Francis*, 1921.
The Little Flowers of St. Francis, tr. by T. W. Arnold, 1908.
G. G. Coulton, *From St. Francis to Dante*, 1906.
Jorgensen, *Der Heilige Franz*, Copenhagen, 1907.
G. K. Chesterton, *St. Francis*, 1923.
J. A. Symonds, *Renaissance in Italy*, III: *The Fine Arts*, 1882.
Thode, *Franz von Assisi und die Anfänge der Kunst*, 1885
——, *Giotto*, 1899.
W. von Bode, *Die Kunst der Frührenaissance*, 1882.
Crowe and Cavalcaselle, *History of Italian Painting*, II.
Vasari, *Lives of the Painters*.
Gillet, *Giotto*, in the *Cath. Encycl.*, Vol. VI.
Ruskin, *Giotto and his Works in Padua*, Library Edition.
——, *Mornings in Florence*.

VIII—DANTE

Divina Commedia, Scartazzini, 4 vols., Leipzig, 1874–1890.
De Vulgari Eloquentia, Ragna, Florence, 1896.

The best translations of the *Divina Commedia* are by:

Cary.
Longfellow,
M. B. Anderson (incorporated with Italian in "The World's Classics").
Laurence Binyon.

Of the *Inferno* and the *Paradiso*:

G. E. L. Bickersteth, 1933.
R. W. Church, *Dante*, 1888.
Nicola Zingarelli, *Dante*, Vita, 1914.
G. Santayana, *Three Philosophical Poets*, Harvard, 1910.
St. Thomas Aquinas, *Opera Omnia*, Migne, 1882.
Translation by the English Dominicans now almost complete.

E. Gilson, *Le Thomisme*, Paris, 1922.
——, *S. Bonaventura*, Paris, 1924.
——, *L'Esprit de la Philosophie Mediévale*, 1932.
St. Thomas Aquinas. Papers read by A. Whitacre, V. McNabb, A. E. Taylor, Gonne, T. F. Tout, Hugh Pope, Oxford, 1924.
J. Maritain, *Reflections sur l'Intelligence*, Paris, 1925.
H. Ghéon, *Le triomphe de S. Thomas*, S. Maximin, 1924.
F. Olgiati, *L'Anima del Umanesimo*, Milan, 1924.

IX—THE GOTHIC CATHEDRAL

Dehio und Bezold, *Die Kirchliche Baukunst des Abendlandes*.
A. Pugin, *Gothic Ornaments*, 1854.
W. Worringer, *Form in Gothic Architecture*.
R. A. Cram, *The Gothic Quest*, 1907.
Ruskin, *The Nature of Gothic Architecture*, 1854.
——, *Lectures on Art*.
R. de Lasteyrie, *L'Architecture Religieux en France*, 2 vols., 1926.
F. Bond, *Gothic Architecture in England*, 1905.
de la Porte et Houvet, *La Cathédrale de Chartres*, 1926.
H. Adams, *Mt. S. Michel and Chartres*.
H. Read, *English Stained Glass*, 1926.
Joseph and Elizabeth Pennell, *French Cathedrals*.
E. Mâle, "L'Architecture Gothique", *Rev. des Deux Mondes*, Feb. 15, 1926.
T. G. Jackson, *Gothic Architecture*, 2 vols, 1915.
L. Saint and H. Arnold, *Stained Glass*, 1913.

X—A CONTINUOUS RENAISSANCE

W. von Bode, *Die Kunst der Frührenaissance*, Berlin, 1923.
Ruskin, *Mornings in Florence*, Library Edition.
Tancred Borenius, *Florentine Frescoes*, 1930.
Ficino, *Proemium in Libro di Sole*, Florence, 1592.
F. Olgiati, *L'Anima del Umanesimo*, Milan, 1924.
Jacob Burckhardt, *Civilisation of the Renaissance in Italy*, trans. Middlemore, 1929.
Crowe and Cavalcaselle, *History of Italian Painting*, 3 vols., 1912.
Hausenstein, *Fra Angelico*, Eng. tr., 1928.
Vasari, *Opere*, 6 vols., Florence, 1878.
Boccaccio, *De Geneologia Deorum*.
J. A. Symonds, *Renaissance in Italy*, 3 vols., 1880–1882.

XI—THE SISTINE MADONNA

Vasari, *Lives of the Painters*.
Clement, *Michelange et Raphael*, 5th edn., Paris, 1886.
E. Muntz, *Raphael : sa vie son œuvre*, Paris, 1881.
Passavent, *Rafael und sein Vater*, Leipzig, 1839–1858.
Crowe and Cavalcaselle, *Life of Raphael*, London, 1882–1885.
B. Berenson, *Central Italian Painters*, 1897.
Adolfo Venturi, *Raffaello*, Firenze, 1920.
Sir C. Holmes, *Raphael*, 1932.
T. Vurzi, *Raffaello*, 1910.
G. Morelli, *Italian Masterpieces in German Galleries*, 1883.

XII—MICHELANGELO

Vasari, *Lives of the Painters*.
Varchi, *Opere*, 2 vols., Trieste, 1858.
Michelangelo Buonarroti, *Rime*, ed. C. Guasti, Florence, 1863; ed. C. Frey, Berlin, 1899.
——, *Liriche*, ed. G. L. Passerini, Venice, 1907.
A. Lusinga, *Michelangelo Poeta*, 1919.
L. von Scheffler, *Michelangelo, Eine Renaissance-Studie*, 1892.
Sir C. Holroyd, *Michelangelo Buonarroti*, 1911.
Venturi, *Michelangelo*, Eng. trans., 1928.
C. Frey, *Michelangelo, Sein Leben und seine Werke*, 1907.
A. Farrinelli, *Michelangelo e Dante*, 1918.
Romain Rolland, *Vie de Michelange*, 1906.
J. A. Symonds, *Life of Michelangelo*, 2 vols., 1893.
H. Thode, *Michelangelo und das Ende der Renaissance*, 1902.
C. C. Perkins, *Raphael and Michelangelo*, 1878.
D. Finlayson, *Michelangelo the Man*, 1935.
A. Condivi, *Michelangelo: La Vita*, 1928.
Fortunato Rizzi, *Michelangelo: Le Rime*, 1934.
Sir Joshua Reynolds, *Discourses on Painting*.

PART III—THE SPLENDOURS AND DANGERS OF BAROQUE

XIII—TWO PASSIONATE POETS: SPENSER AND ST. JOHN OF THE CROSS

Obras de San Juan de la Cruz, ed. P. Silverio, Burgos, 1929–1930.
Complete Works of St. John of the Cross, tr. by E. Allison Peers, 3 vols., 1934–1935.
Asín Palácios, *Un Precursor Hispano-Mussulman de San Juan de la Cruz*, Madrid, 1933.
——, *Islam and the Divine Comedy*.
J. Baruzi, *St. Jean de la Croix et le problème de l'Expérience mystique*, Paris, 1924.
P. Bruno, *Vie de St. Jean de la Croix*, Paris, 1929.
P. Crisógono de Jesus Sacramentado, *San Juan de la Cruz: su Obra literaria*.
E. Allison Peers, *St. John of the Cross*, 1932.
J. Fitzmaurice Kelly, *History of Spanish Literature*.
R. Sencourt, *Carmelite and Poet*, 1943.
Damaso Alonso, *La Poesia de San Juan de la Cruz*, 1942.

XIV—THE MUSIC OF PALESTRINA

Baini: *Memore Historico-Critiche di Palestrina* (Rome, 2 vols., 1828).
Bäumker: *Palestrina* (Freiburg, 1877).
Henry Coates: *Palestrina* (1938).
K. Jeffeson: *Palestrina and the Dissonance* (England, 1927).
Z. K. Pyne: *Palestrina* (Madrid, 1922).
S. Weinmann: *Das Konzil von Trient und die Kirchen Musik* (1919).
C. von Winterfeld: *Palestrina* (Breslau, 1832).

XV—FROM VENICE TO SEVILLE

F. Pacheco, *Arte de la Pintura*, Seville, 1849.
A. Palomino, *El Museo Pictorial*, Madrid, 1796.
Céan Bermudez, *Diccionario de las bellas Artes en España*, 3 vols., 1800.
P. de Madrazo, *Seville y Cadiz*, 1884.
W. Stirling Maxwell, *Annals of the Artists of Spain*, 3 vols, 1891.
Marcel Dieulafoy, *La Statuaire Polychrome en Espagne*, Paris, 1908.
A. E. Brinckmann, *Barokskulptur*, 1909.
M. B. Cossío, *El Greco*, 3 vols., 1908.
——, *El Entierro del Conde de Orgaz*, Madrid, 1914.
A. Buswioceanu, *Les tableaux de Greco dans la Collection Royale de Roumanie*.
Frank Rutter, *El Greco*, 1930.
R. Byron and Talbot Rice, *Birth of Western Painting*, 1931.
G. Hartley, *A Record of Spanish Painting*.
Rodríguez Sádia, *Velasquez*, Madrid, 1925.
C. Justi, *Velazquez und sein Jahrhundert*, Bonn, 1888, 2 vols.
A. L. Mayer, *Die Sevillane Malerschule*, 1911.
V. von Loga, *Die Malerei in Spanien*, 1923.
A. F. Calvert, *Murillo*, London, 1907.
W. Somerset Maugham, *Don Fernando*, 1933.
Havelock Ellis, *The Soul of Spain*, 1906.
S. Montoto, *Murillo*, Sevilla, 1923.
Thieme und Becker, *Allgemeines Lexikon der Bildenden Künstler*, vol. 25.

XVI—MILTON

Masson, *Life of Milton*, 3 vols., 1859–1880.
S. Johnson, *Life of Milton*.
W. S. Landor, *Imaginary Conversations*, ed. T. Earle Welby, 1933.
W. Raleigh, *Milton*, 1905.
Dénys Saurat, *Milton, Man and Thinker*, 1925.
E. M. W. Tillyard, *Milton*, 1930.
H. Belloc, *Milton*, 1935.
Sir Eric Maclagan, *Italian Sculpture of the Renaissance*, 1935.
H. Darbishire, *Early Lives of Milton*, 1932.
C. S. Lewis, *Preface to Paradise Lost*, 1943.
C. M. Bowra, *From Virgil to Milton*, 1945.

XVII—BUNYAN

W. M. Brown, *John Bunyan, his Life, Times and Work*, revised ed., 1928.
 This contains almost all that it is essential to know of Bunyan.
J. Bunyan, *Works*, 3 vols., ed. Offer, 1852.
Sir C. Firth, *Bunyan*, Eng. Assoc. Leaflet No. 19, 1911.
The Pilgrim's Progress, with Introduction by Sir C. Firth, 1898.
Macaulay, *Life of Bunyan*, ed. E. Maxwell, 1914.
E. G. Selwyn, *The Approach to Theology*, 1927.
J. B. Pratt, *The Religious Consciousness*, New York, 1926.

XVIII—ST. PAUL'S CATHEDRAL

C. Wren, *Parentalia*, 1750.
Loftie, *Inigo Jones and Christopher Wren*, 1893.
Geoffrey Scott, *The Architecture of Humanism*, 1914.
James Elmes, *C. Wren and his Times*, 1852.
Sir C. Wren, *Memorial Volume of the Institute of British Architecture*.
W. H. Ward, *Architecture of the Renaissance in France*, 2nd ed., 2 vols., 1926.
Lena Milman, *Wren*, 1908.
Catologue of the Library of Sir C. Wren in the Bodleian Library.
Sir Laurence Weaver, *Sir Christopher Wren*, 1928.
H. H. Milman, *Annals of St. Paul's*, 1896.

XIX—PASCAL AND BOSSUET

Pascal, *Oeuvres*, edn. Braunschwicg.
Bossuet, *Oeuvres*.
Descartes, *Oeuvres*.
Bremond, *Histoire Littéraire du Sentiment Religieux*, 6 vols.
Hazard, *Crise de la Conscience Europeenne*, 2 vols.
Enciclopedia Italiana, vol 12.